Christopher Pramuk's *The Artist Alive* is a multivalent exploration of how the popular arts hold the potential to transform consciousness. It is also a profound investigation for people of all ages into the transformative power of art in its myriad forms. I envy the young people who have the privilege of sitting in Chris's classes, where theology is taught not as a series of propositions or doctrines, but as the existential basis of all genuine religion that ties us to planet Earth by opening us to mystery, "radical amazement," and compassion. Pramuk's book establishes that everyone has access to a common core of creative power from which abundant life, "aliveness," pours continuously in a living stream despite the sorrows, injustices, suffering and brokenness we all experience. This is a book that takes a hard look at the world of our times yet offers hope. Enter its pages and find yourself recovering "beginner's mind," checking out YouTube recordings of your favorite artists, discovering new ones, moving and grooving to a deeper music that enables the mind to slowly descend into the heart and make the world a better place. As Pramuk puts it, "[T]his is one of our most urgent and beautiful tasks today: to teach to the imaginations of young people, to feed their wonder, to dare them to imagine, in spite of it all, a future of peace."

—Susan McCaslin
Poet, Author of *Superabundantly Alive:*
Thomas Merton's Dance with the Feminine

Christopher Pramuk shows with teacherly care how popular art, especially music, opens the way to transformation of self and society. This inviting book will be compelling reading for those who seek Christian meanings of artistry in ordinary life. *The Artist Alive* empowers readers not only to appreciate the Christian significance of everyday art, but to become artists in their own right who can learn new ways of Christian experiencing.

—Tom Beaudoin
Professor of Religion, Fordham University

A profound and beautiful book, *The Artist Alive: Explorations in Music, Art & Theology* allows us entry into the contemplative classroom of a gifted teacher. Drawing skillfully on religious and philosophical insights from a range of diverse traditions and perspectives, Christopher Pramuk allows us to experience musical and visual works of both popular and classic art—the Song of Songs to Pink Floyd—as "texts" or doorways through which the creative and spiritual dynamism inherent in each of us might be awakened. For those who seek such an awakening, *The Artist Alive* will be a treasured companion.

—Wendy M. Wright
Professor Emeritus of Theology, Creighton University

Christopher Pramuk's deft, utterly unique, theological and literary voice is in beautiful harmony with all the musicians and other artists he lovingly and brilliantly looks into.

With his signature spiritual depth and cultural humility, Christopher Pramuk invites readers of his latest book to participate in meaning-making through engagement with the arts, and with music in particular. Pramuk lives in the imagination that one is transformed, for good or ill, by the company one keeps. Readers are introduced to some of the guests with whom Pramuk has shared hospitality in his own interior spaces—the musicians who have formed him, as well as the thinkers who have informed him. Without any hint of patronizing, the author nurtures readers, brooding like a hen over an egg, attending to the reader's well-being so that as members of society, we may live into healthier, even holier, lives of meaning—into persons awakened, indeed, into *artists alive*. Engaging with Thomas Merton as well as other prophetic voices who respond with encouragement in times of 'endless war, crushing poverty, and horrific violence,' Pramuk's book is filled with practical insights and ample resources for teaching and discussing such things as paying attention, struggling for holiness, and uniting the secular with the sacred. Pramuk's latest offering is itself a work of wonder, resistance, and hope.

—Kim Vrudny
Professor of Theology, University of St. Thomas

Christopher Pramuk asks, "Can art be a vehicle of hope, stirring that wondrous if elusive capacity in human beings to imagine a more just, humane, and joyful future?" Pramuk does not take an easy path to answer the question. He probes topics that have been the source of deep questions and divisions: sexuality, race, technology, death, and our search for love and identity.

His approach is contemplative, seeking to listen attentively to a song or gaze deeply into a painting, carefully teasing out how it illuminates human experience or points towards a deeper reality. Yet Pramuk's approach is simultaneously communal, consistently inviting us to listen to the music, read the story, view the art, and note our own responses prior to reading his. It is an invitation to be fellow pilgrims, to bring our insights and experiences into play with the author's. He is not offering definitive answers, but opportunities to open our restricted imaginations.

Pramuk crosses the boundaries of time, culture, and genre to explore each topic. One chapter brings into conversation the music of the Indigo Girls, letters and poems of Rilke, and the Song of Songs, to explore sexuality, love, and identity. The uniqueness of Pramuk's approach, however, goes beyond his method and sources. His carefully crafted prose weaves sources, questions, and insights into a rich tapestry of love and hope, crafting a poetic and imaginative theological vision, a work of art in its own right.

—Paul Pynkoski
Member, International Thomas Merton Society

THE ARTIST ALIVE
explorations in music, art & theology

Christopher Pramuk

Publisher Acknowledgments

Thanks to the following teaching scholars who reviewed this work in progress:
Maeve Heaney, *Australian Catholic University, Brisbane, Queensland*
Gina Messina-Dysert, *Ursuline College, Cincinnati, Ohio*

Created by the publishing team of Anselm Academic.

The scriptural quotations in this book are from the *New American Bible, revised edition* © 2010, 1991, 1986, and 1970 by the Confraternity of Christian Doctrine, Inc., Washington, DC. Used by permission of the copyright owner. All rights reserved. No part of this work may be reproduced in any form without permission in writing from the copyright owner.

Cover image: Painting titled *Rust (David Gilmour, Live at Pompeii)*, © Pasquale Rapicano, artist, *www.gigarte.com/pasqualerapicano*

Printed in the United States of America

7090

ISBN 978-1-59982-838-1

For Lauri
———————

Author Acknowledgments

I would like to say thanks to my parents, Jack and Gladys Pramuk, for the gift of music lessons as a child, for gently holding me to it when I wanted to give it up, and for the gifts of our Catholic faith.

. . . to my piano teachers, Grace Copeland, Nathaniel Patch, and Bill Douglas, each of whose joy, zest for life, and passion for music washed over me in my younger days and will never leave me.

. . . to my lifelong friend, Kevin Hardesty, a brilliant actor, director, and musician, who helped me woo my first high school sweetheart to the tune of Dylan's "Don't Think Twice It's Alright."

. . . to my friend and mentor, Fr. Bill McNichols, for helping me plumb the spiritual depths of Robert Henri, Joni Mitchell, Hagia Sophia, northern New Mexico, and much, much more.

. . . to my colleagues at Regis University, especially John Kane, Kevin Burke, SJ, Julia Brumbaugh, Kari Kloos, Fredricka Brown, Tom Reynolds, Ken Phillips, Dan Justin, Tom Bowie, and Kristi Gonsalves-McCabe, for sharing with me your passion for Jesuit education and your life journeys.

. . . to my students at Regis University and in years past at Xavier University, with whom I journeyed through much of the material in this book, and to whom I owe many of its best insights.

. . . to my partners in this project at Anselm Academic, for their encouragement, patience, and visionary commitment to theological education and creative approaches to classroom teaching.

. . . to my siblings, Ed, Cathi, John, Mary, and Jackie, and our Aunt Mary, a.k.a., Sr. Christopher John Doherty, OSF, all of whom keep me laughing and celebrating life's ordinary magic.

Most of all, I want to thank my wife Lauri, for our twenty-five wonder-filled years together, and our kids, Isaiah, Grace, Sophia, and Henry, for keeping me bound so hard and beautiful to Earth, and in the words of Bruce Springsteen, "to the songs of the time and place we have inhabited."

May the arts ever enlarge your lives, and may the music of faith, hope, and love always find you when you most need it.

When the artist is alive in any person, whatever his kind of work may be, he becomes an inventive, searching, daring, self-expressing creature. . . . Where those who are not artists are trying to close the book, the artist opens it, shows there are still more pages possible.

—*Robert Henri*

The universe is a score of eternal music, and we are the cry, we are the voice.

—*Abraham Joshua Heschel*

Contents

Works Featured in Case Studies (by chapter)

CHAPTER 2 Pink Floyd, *The Dark Side of the Moon*, 1973

CHAPTER 3 Joni Mitchell, *Ladies of the Canyon*, 1970
 Bruce Cockburn, *Salt, Sun and Time*, 1974

CHAPTER 4 Jean Giono, "The Man Who Planted Trees," 1954
 Godfrey Reggio, *The Qatsi Trilogy*, 1982, 1988, 2002

CHAPTER 5 Stevie Wonder, *Songs in the Key of Life*, 1976
 John Howard Griffin, *Black Like Me*, 1961

CHAPTER 6 Billie Holiday, "Strange Fruit," 1939
 Peter Gabriel, "Biko," 1980
 U2, "Mothers of the Disappeared," 1987

CHAPTER 7 Indigo Girls, *Indigo Girls*, 1989
 Song of Songs, Chapters 1–8, Bible

CHAPTER 8 William Hart McNichols, iconography

CHAPTER 9 Bruce Springsteen, *Nebraska*, 1982; *The Rising*, 2002

Introduction
Seeds of Awareness

This book is inspired by an undergraduate course called "Music, Art, and Theology," one of the most popular classes I teach and probably the course I've most enjoyed teaching. The reasons for this may be as straightforward as they are worthy of lament. In an era when study of the arts has become a practical afterthought, a "luxury" squeezed out of tight education budgets and shrinking liberal arts curricula, people intuitively yearn for spaces where they can explore together the landscape of the human heart opened up by music and, more generally, the arts.

All kinds of people are attracted to the arts, but I have found that young adults especially, seeking something deeper and more worthy of their questions than what they find in highly quantitative and STEM-oriented curricula, are drawn into the horizon of the ineffable where the arts take us. Across some twenty-five years in the classroom, over and over again it has been my experience that young people of diverse religious, racial, and economic backgrounds, when given the opportunity, are eager to plumb the wellsprings of spirit where art commingles with the divine-human drama of faith.

From my childhood to the present day, my own spirituality[1] or way of being in the world has been profoundly shaped by music, not least its capacity to carry me beyond myself and into communion with the mysterious, transcendent dimension of reality. From high school to undergraduate and graduate school classrooms, I've also marveled at the impact of engaging the arts with students as a doorway into life's most enduring human, spiritual, and theological questions.

Can the so-called "secular" music of artists like Pink Floyd, Joni Mitchell, Lady Gaga, and Bruce Springsteen bear us into realms of the holy and sacred? Can the social and racial critique embedded in Stevie Wonder's music disturb our personal and collective consciences, perhaps even opening the eyes of the "blind" to see? To what extent do songwriters, painters, filmmakers, and other artists play a prophetic role in society and church? Can art be a vehicle of hope,

1. By *spirituality* I mean broadly the everyday way of life flowing from one's deepest beliefs, desires, and values; it is a way of living into our calling and identity as human beings. Everyone "has" a spirituality insofar as every person's self-understanding and behavior flow from core beliefs and values. *Christian spirituality* flows from faith in Jesus Christ, marked by openness to the love of God, self, neighbor, and the world through the power of grace or the Spirit who dwells in the community. There is no single normative Christian spirituality but there are many ways, unique to the gifts of persons and cultures, of following Jesus.

stirring that wondrous if elusive capacity in human beings to imagine a more just, humane, and joyful future? Such questions are implicitly theological insofar as they engage us in the search for answers to the deepest yearnings of human experience, and are attentive to moments in which that search confronts us with mysteries beyond understanding, not least, the ineffable reality believers name "God."[2]

This book is an invitation to explore some of the deepest questions rising from the human spiritual and social journey as mediated by artistic voices in both popular and religious culture. By facilitating engagement with classic works in music and the arts, both "secular" and "sacred," and by offering a contemplative framework for doing so, I hope this book might help you discover, or perhaps rediscover, as I have my whole life long, the wonder of the arts as a doorway into the life of spirit and sacred presence, the strange and beautiful interweaving of the human and divine. Rather than proposing clear or fixed "answers" it invites you into a process, a way of seeing, hearing, and praying through some of life's most enduring spiritual and theological questions.

With gratitude for all I have learned from my students through the years, I hope this book might provide to other students, teachers, and seekers an exemplar, and perhaps a dose of inspiration, for embarking on a similar journey. More broadly, I dare to hope this book will contribute something original and adventuresome to the flourishing body of discourse today on theology and the arts.[3]

From the outset one has to acknowledge formidable obstacles to such a project. In the first place, words like "wonder," "mystery," "faith," "God," "transcendence," and "the divine" are freighted with difficulties today in academic circles, and may not resonate favorably or intelligibly in the minds and hearts of many people. Is there room left in our classrooms to cultivate what once was called "art appreciation," even as prevailing models of education take their cues from the utilitarian presumptions and dictates of the marketplace? Are there adult mentors and professional educators in our hyperactive society prepared to share with young people the wisdom-practices of slowing down, the unpredictable delights of contemplating a classic album, a religious icon, a film scene, an epic poem?

2. By *theology* I mean, in the classic formulation of Saint Anselm, "faith seeking understanding." I also appreciate Jesuit Fr. Anthony De Mello's two-fold description of theology: "The art of telling stories about the Divine. And the art of listening to them." See Anthony De Mello, *The Song of the Bird* (New York: Doubleday, 1982), xvi. Both Anselm and De Mello underscore the active, dynamic, searching dimension of theological inquiry, a task that never ends because its final "object" is no object at all but the transcendent mystery of God, who lies beyond all grasp. In this sense I would describe theology as a lifelong conversation with wonder and mystery, a searching (and, at times, a being found) that is both personal and communal, discursive and poetical, all at once. The point to emphasize here is that spirituality and theology, while distinct, are inseparable. Both find their root in the experience of grace or holy Mystery as it breaks into human consciousness in historical time and space, and which ultimately lies beyond all attempts to define, contain, or manage it.

3. See "Additional Resources" at the end of the introduction.

I believe that the answer is a resounding yes. Long ago my students convinced me that the rewards of doing so are far and away worth the effort, notwithstanding some obstacles in the prevailing culture of higher education.[4]

A Contemplative, Case Studies Approach

The title of this book, *The Artist Alive*, takes its inspiration from the American painter and teacher Robert Henri (1865–1929), best known as the founder of the

Ashcan School of American realism. I knew nothing of Henri (pronounced "HENrye") until a few years ago, when a dear friend, the iconographer Fr. Bill McNichols, suggested I read Henri's classic work of 1923, *The Art Spirit*.[5] Eagerly I did, and as Fr. Bill predicted, I was deeply moved by the book. Its lengthy subtitle describes it as a compendium of "Notes, Articles, and Fragments of Letters and Talks to Students Bearing on the Concept and Technique of Picture-Making, the Study of Art Generally, and on Appreciation." In truth, the book is about *seeing*, or the art and discipline of perception. In Henri I seem to have stumbled upon a kindred spirit, someone who intuitively describes what I struggle to do each day in the theology classroom: namely, to open the doors of perception, imagination, contemplation, and critical thought.

Robert Henri

Library of Congress Prints and Photographs Division

4. One of the more prominent critics of higher education today is Yale professor William Deresiewicz, who laments its "toxic" atmosphere for the humanities and the loss of values traditionally served by a liberal arts education. See *Excellent Sheep: The Miseducation of the American Elite and the Way to a Meaningful Life* (New York: Free Press, 2014); see also the thoughtful review by Jackson Lears, "The Liberal Arts vs. Neoliberalism," *Commonweal* (Apr. 20, 2015).

5. Robert Henri, *The Art Spirit* (1923; repr., New York: Basic Books, 2007).

What intrigues me most is the image of "fragments" in Henri's subtitle. It suggests an image of the teacher not as a dispenser of fixed or predetermined truths but rather as a guide toward insight, as one who listens and responds, offering hints and gestures based on "fragments" or "found materials" of experience and latent wisdom in the students themselves. These can only be surfaced gradually and patiently, through an encounter from person to person that is at once structured, spontaneous, and free. Above all, Henri insists that "the art spirit" lives in everyone. "Art when really understood is the province of every human being," he writes. "It is not an outside, extra thing. When the artist is alive in any person, whatever his kind of work may be, he becomes an inventive, searching, daring, self-expressing creature."[6]

Thus the image of the "artist alive," as I hope to convey in these pages, is intentionally expansive, signaling as inclusive an understanding of the arts as possible. What Henri calls "the art spirit" points to a creative and spiritual dynamism that dwells in everyone, but which requires nurturing, encouraging, drawing out.[7] I've titled the book in homage to Henri and to artists and teachers everywhere who nurture in the human spirit something essential. What that "something" *is* eludes easy definition, but it is my hope that this book helps to awaken it within you, the reader, and to offer a common framework from which to explore it.

The Artist Alive invokes an alternative spirituality or way of orienting oneself in the world, more humane than the ubiquitous, globalized marketplace vision of reality that bears down on so many people, an alienating way of life in which not a few people feel themselves herded together, numbered, and ranked as mere consumers—little more than a "name on the door," to cite Joni Mitchell, or "just another brick in the wall," as Pink Floyd famously has it. Beginning with my own experiences of music as a child, chapter 1 attempts to paint a mosaic of the artistic sensibility—in religious terms, akin to a mystical-prophetic spirituality—that grounds the epistemological framework or contemplative "way of knowing" for the rest of the book. Drawing especially from Henri and from Jewish poet, mystic, and philosopher Abraham Joshua Heschel, chapter 1 charts a number of qualities or "seeds of awareness" that broadly characterize the artistic disposition—once again, *seeds that dwell in every person but that must be cultivated.* These include a capacity for wonder, amazement, and mystery; multi-sensory awareness, or synaesthesia; a quality of presence or heightened attunement to the gifts of the present moment; and critical resistance to conventional, predetermined, or culturally imposed ways of perceiving.[8]

6. Henri, *The Art Spirit*, 11.

7. It is not incidental that the word "education" comes from the Latin *educere*, "to draw out."

8. The epistemological-metaphysical framework established in chapter 1 is resonant with George Steiner's classic study, *Real Presences* (Chicago: University of Chicago Press, 1991). Steiner reinforces the contemplative and participatory dimension of the arts, where the best "criticism" is not didactic or reasoned analysis of a work but wholesale immersion via performance and contemplative appreciation.

Chapters 2 through 9 each take their inspiration from a single artistic work or the juxtaposition of several, evoking images and themes from the complex web of human life in relationship with self, others, the earth, and divine mystery. Art thus serves as a common "text" or "doorway" into shared reflection on our lives in public society, spiritual formation and discernment, ethics, race relations, environmental awareness, sexuality, justice, the question of God, and the life of faith. These chapters present case studies that aim to do the following:

- attend to evocative tonal, visual, and lyrical details in the artistic work at hand (the world *within* the text)
- reflect on the artist's historical and social location (the world *behind* the text)
- invite you, the reader, through deep listening, contemplation, and journaling, to respond to the work and its possible "surplus of meanings" in your own life's journey in society, and for some of us, in communities of faith (the world *in front of* the text)[9]

The conclusion steps back to ponder the whole mosaic, offering a number of summary insights and working conclusions at the intersection of music, art, and theology.

It should not surprise that people of all ages and backgrounds would relish the invitation to linger deeply, unhurriedly, in a single work of art, and to do so with others in a serious way. To immerse oneself in Pink Floyd's *The Dark Side of the Moon*, for example (the subject of chapter 2), as a whole work of art—by contrast to the downloading and consumption of single songs—and further to explore the creative processes of the band that gave birth to the album in its social and historical context, is both fascinating and potentially transforming. Beneath the complex synaesthetic or "psychedelic" landscape of *Dark Side of the Moon* are timeless, penetrating questions: Are human beings really capable of empathy, and if so, what empowers us to practice it? Does money, and the shiny perks that go with *lots of it*, promise happiness? What does it mean to be "sane" or "well-adjusted" in a hyperactive, technological, war-soaked environment? Has language itself been drained of meaning, tied inextricably to power and self-interest? Can primal wordless expression "speak," and touch the mystery of God, more directly and truthfully than words, doctrines, formal theology?

The tools of critical and contemplative appreciation practiced in this book invite the reader to develop more intentional habits of consuming music and other art forms. In truth I hope to persuade the reader that the arts at their most authentic and empowering have far less to do with "production" and

9. The "experimental" and contemplative approach I recommend in these chapters shares much with Roger I. Simon's recommendations in *Teaching against the Grain: Texts for a Pedagogy of Possibility* (New York: Bergin and Garvey, 1992).

"consumption" than with personal and social transformation. Indeed, one of the most compelling qualities that joins Pink Floyd with the other artists considered in this book is the degree to which they recognize and frequently resist in their work the unholy alliance between the arts and commerce—or, for that matter, the often very thin line between the adoration of their fans and idol worship. Indeed the "culture industry" itself, with its genius for co-opting and homogenizing even the most subversive artists under the lure of money and the banner of popular acclaim, will also have to be taken into account in the pages that follow.

It is important to note from the outset that many art forms—e.g., dance, pottery, photography, sculpture—do not serve as exemplars in my analysis. While chapters 4, 5, and 7 explore works from film, literature, and the Bible, and chapter 8 is centered on religious iconography, the balance leans decidedly toward music. Poetry also takes pride of place to the extent that song lyrics, the voices of poets as such, and the poetical texture of the Bible are integral to my method and voice as a theologian. In no way do I wish to imply that the arts not represented here are somehow inferior as portals to the divine. Indeed, my students across the years—including not a few dancers, sculptors, photographers, and the like—have taught me that insights arising from a deep engagement with music can resonate powerfully, if distinctly, across a wide range of art forms. The lean toward music in this book is simply a reflection of my own expertise and inevitable limitations.

While the works explored in these chapters reflect my own social location, artistic tastes, and biases—e.g., classic rock and folk music more than country, rap, or classical; North American artists more than Latin American, Asian, or African; Eastern iconography more than Western religious art—I have been careful to choose works representing a wide array of gender, racial, and cultural backgrounds. Each has attained the status of "classic" in its genre, and each, I have found, resonates widely with students of diverse backgrounds. Of course this will not always be the case for every reader. Catholic theologian David Tracy describes the "classic" as any truly significant book, person, work of art, or piece of music that bears a certain "excess of meaning" as well as a certain timeless-ness.[10] I will say much more about what makes a classic in chapter 2, but my point here is that even works of art that do not delight or move one personally can dramatically enlarge and even transform one's personal, spiritual, social, and theological horizons. This is especially so when the work is engaged in conver-sation with others.[11]

10. David Tracy, *The Analogical Imagination: Christian Theology and the Culture of Pluralism* (New York: Crossroad, 1981), 102.

11. In this sense the particular works I present are less important than the tools of appreciation at play. In other words, my aim is not to offer a fixed method or content to be adopted rigidly by others in considering a work, but rather a framework or model with which to experiment in ways fitting to the particular context and community at hand.

Along the way I introduce principles of hermeneutical theory (rules of interpretation) and insights from seminal figures in philosophy, theology, and art criticism from a range of religious and philosophical viewpoints: Roman Catholic (my tradition), Protestant, Jewish, Buddhist, humanist, atheist, and others. In keeping with the spirit of the artists themselves, I have tried to avoid academic jargon and to write in a key true to my own experiential and sometimes poetic voice.

For all of this, the greatest potential value of this book resides not in what I have written but in your engagement with the works at hand, or even better, reflection with others in the context of a class or group study. Because the power of art ultimately resides in the eye and ear of the beholder, that is, in the *whole person* who sees and listens, appendices A, B, and C provide guidelines for personal and classroom engagement, contemplative listening, seeing, and journaling, as well as practical suggestions for the teacher or group moderator, all intended to help you slow down and deepen your engagement with the material. As much as possible in group or classroom settings, ample time and space should be built into each session in ways that free both students and teacher to work (and play!) with the material at hand, developing tools of appreciation and insight together.

Appendix D details guidelines for a team project in which students have the opportunity to research and present to their peers a work of art or music of special significance to them. As with the journaling, this team project aims to reinforce the practice of interdisciplinary, communal learning from which this book rises. Appendix E offers guidelines for a final "Art and Spirituality" paper that aims to give free play to the art spirit itself as a creative capacity within each person. In everything that follows, facilitators should feel free to use and adapt what is most helpful or resonant in their particular context and pass over what is not.

Imagination and Sacred Mystery: Unbuffering the Buffered Self

Much of the terrain this book covers is "prereligious" or "pretheological," probing experiences, images, and narratives from ordinary and sometimes extraordinary human experience that give rise to artistic and theological expression. Indeed the discipline of theology comes into play the moment we seek *to communicate* our most formative life experiences with others, seeking meaning through the manifold languages and practices of faith, and indeed through the arts, as human beings and cultures give shape and direction to their experiences and beliefs, hopes and desires. In other words, as I hope the following chapters will bear out, the image- and language-worlds of the arts, theology, and spirituality share far more than what may be evident at first glance—and this is true, I suggest, whether or not you identify yourself as a "religious" or "spiritual" person. To put

it another way, the religious or spiritual quest faces its greatest challenge today not on the level of specific theological concepts or beliefs so much as in the more hidden or subterranean realm of human freedom and imagination. This crucial point bears some explanation.

In his magisterial work on the challenges confronting religious faith in "a secular age," philosopher Charles Taylor suggests that what has shifted dramatically for religion in the postmodern era is not really the faith-vision itself or the explicit *content* of religious belief so much as the *context* within which people decide for or against faith, what Taylor calls the "social imaginary."[12] In the face of a social imaginary characterized by a seemingly endless pluralism of life-options and possible commitments, the question of faith is no longer simply "Do you believe in God?"—where "God" implies certain shared assumptions and ideas about the divine. Today the more apt question is this: "In *which 'god'* (or gods) do you believe?" In whom or what do you place your ultimate security and trust? To what or whom do you commit your fundamental freedom?

Taylor worries in particular about the retreat of the modern secular self into a sort of solipsistic or self-enclosed bubble—what he calls the "buffered self"[13]—a self that suffers from a deep sense of instability, anxiety, and loss of meaning while at the same time doing everything it can to reflexively protect itself from vulnerability and pain over that loss. Against a cultural horizon of rapidly shifting, multiplying, and clashing worldviews, the buffered self takes refuge in a highly individualistic "therapeutic culture," in consumerism, and in various forms of "soft relativism."[14] While apathy reigns among the privileged, hopelessness takes hold of the poor and marginalized.

The notion of a social contract or common good that binds different groups together and to which "we" are all mutually beholden disappears in such a culture. Individual self-realization becomes the main agenda of life. As Jesuit theologian Michael Paul Gallagher remarks, "The question of God can seem to have gone asleep. The drama of decision is lost in a postmodern fragmentation of life-style."[15] If Taylor's sobering prognosis is accurate—it certainly resonates from where I stand—how can religious traditions respond to the existential isolation and rootlessness he describes?

Gallagher suggests that religion must strive to meet people, especially young people, at the "prereligious" levels of desire and imagination. On this frontier "the worlds of imagination—including art, poetry, music, and the new media—are more needed than a communication of theological content." Facing a social imaginary in which the very question of God "can seem to have gone asleep,"

12. Charles Taylor, *A Secular Age* (Cambridge: Harvard University Press, 2007), 146.

13. Taylor, *A Secular Age,* 303.

14. Taylor, *A Secular Age,* 484, 618.

15. Michael Paul Gallagher, "What Are We Doing When We Do Theology?," *Landas* 28, no. 1 (2014): 1–12.

theology needs to "create languages of attraction and of invitation," insists Gallagher. "It needs to be aware of the distance from explicit faith experienced by many people today, and indeed their allergy to many perceived forms of religion. We need a creative and less austere version of John the Baptist to prepare the way of the Lord today."[16]

Of course John the Baptist is the wilderness prophet who "prepared the way" for Jesus through his dramatic preaching and baptizing—confronting, challenging, and opening the minds, hearts, and imaginations of his hearers. Art, poetry, music, and new media can (and do) serve analogously today, Gallagher provocatively suggests, by addressing the desires of a people lost in the "wilderness" of postmodern culture. Like John the Baptist, the arts can "prepare the way" in our hearts for the experience and language of grace, the mystery of the divine, no matter a person's formal religious or spiritual background.

"Music, poetry, religion—they all initiate in the soul's encounter with an aspect of reality for which reason has no concepts and language has no names."[17] How might the arts serve as a kind of doorway to provoke and stir a deeper sense of divine presence, and therefore of hope, in people living, working, and surviving at street level, people in classrooms and coffee shops, sports arenas and shopping malls, synagogues and mosques, cathedrals and storefront churches—people who hunger for meaning, direction, and joy in their lives no less than the restless and anonymous crowds of Jesus' day? Might the tools of artistic appreciation cultivated in this book help to prepare the way for more sensitive, hopeful, and even joyful practices of shared theological reflection and vocational discernment?

"The theologian is a translator," notes Gallagher, "standing at the crossroads of cultures, receiving a vision within a tradition, and reimagining it so as to incarnate its transformative potential for now."[18] Gallagher, I believe, has it exactly right. Whether Christianity or Judaism, Islam or Hinduism, Buddhism or secular humanism, so much of the appeal and transformative potential of religious faith and practice takes place in "the zones of human freedom and of imagination." In Christian terms, this is the realm of grace, the Holy Spirit, "the creative artist of our freedom as we move into the flow of life. This is the zone of the inner word, the prereligious presence of God in each of us."[19] More important

16. Gallagher, "What Are We Doing When We Do Theology?," 3–4.

17. Abraham Joshua Heschel, *Man Is Not Alone: A Philosophy of Religion* (New York: Farrar, Straus and Giroux, 1951), 36.

18. Gallagher, "What Are We Doing When We Do Theology?," 11. To emphasize the prereligious realm is not to neglect the importance of doctrine but to frame doctrine within a larger operational map, "as dealing with theology as truth, which then has to be understood (systematic theology) for today and also inculturated in different worlds" (p. 11, n. 16). See also Michael Paul Gallagher, *Faith Maps: Ten Religious Explorers from Newman to Joseph Ratzinger* (New York: Paulist Press, 2010), following Jesuit theologian Bernard Lonergan, *Method in Theology* (London: Darton, Longman and Todd, 1972).

19. Michael Paul Gallagher, *The Human Poetry of Faith: A Spiritual Guide to Life* (Mahwah, NJ: Paulist Press, 2003), 134.

than clarity of ideas, doctrinal precision, or even ethical and moral norms—all crucial, to be sure—people "need to feel themselves part of a larger Story. Like the parables of Jesus, what is needed are . . . moments of human poetry that give voice to the language of desire. And this would be a response on the level of prereligious spiritual imagination."[20]

In sum, where the cultural ethos of a secular age tends to mesmerize the imagination (the realm of desire) with technological over-stimulation and flights of fantasy—or starve it through superficiality and deadening consumer-culture sameness—an approach to faith and the life of spirit that addresses the prereligious realm "of searching, of struggling to live genuinely, of being slowly transformed by the adventure of life"[21] can begin to reshape our impoverished hearts *as lovers*. Approaching theology through the arts can break open our hardened hearts to wonder and mystery, to the subtle movements of grace in silence, in solitude, in vital webs of relationship with the earth, with nonhuman creatures, and with other cultures. Theology "cannot remain merely cognitive." It needs "to develop existential and affective wavelengths" that can soften and break open the fearful or complacent shell of the buffered self. Theology, as Gallagher sums up beautifully, is called "to reach people's freedom through their imagination."[22]

To speak of theology openly and without embarrassment as a language of love is to imply a fierce commitment to love's possibilities amid a host of other possible responses: apathy, cynicism, loneliness, despair. This book is about the option for faith, hope, and love, "the Love that guides the sun and the other stars," in the words of the poet Dante, not in spite of the darkness that engulfs the larger human story but precisely in and through the darkness. Moreover, to speak of the formation of "lovers" in the context of the classroom is to risk a holistic and person-centered approach to education *as* spiritual formation that is well-suited to the arts, and surely no less to theology. I take theology here as that art and discipline in which human beings are invited and set free to think, question, pray, reason, and speak with one another of God, the loving Mystery who finally eludes all categories of speech—including theological ones! To speak *about* God in human words, of course, is to attempt what is logically not possible. To speak *from* God, if haltingly, in the language of the poets and mystics, is

20. Gallagher, *The Human Poetry of Faith*, 136.

21. Gallagher, *The Human Poetry of Faith*, 134.

22. Gallagher here cites Newman: "The heart is commonly reached, not through the reason, but through the imagination" ("What Are We Doing When We Do Theology?," 12, n. 17, citing Newman, *An Essay in Aid of a Grammar of Assent* [London: Longmans, Green, and Co., 1909], 92). By imagination Newman does not mean the realm of make-believe or fantasy but rather that dynamic, holistic, and cumulative faculty of human cognition that enlarges reason, which orders the data of experience and seeks to make sense of the whole. The act of faith depends on the imagination's capacity to hold together multiple and sometimes apparently conflicting experiences, perceptions, or "antecedent possibilities, those attitudinal preambles that make faith either existentially credible or incredible" (*The Human Poetry of Faith*, 133).

quite another matter. For Love yearns to speak, is diffusive of Itself, and cannot remain silent. Both the artist and the theologian who have come to trust in Love are compelled to sing for a silent yet everywhere symphonic God.[23]

All of this is to finally confess that my interest in these pages is neither neutral nor pedagogically "innocent." As a whole person myself—scholar, teacher, musician, husband, father, person of faith—I write from the desire to deepen my own sense of God's friendship in the midst of my stumbling journey while also trying, in the somewhat archaic phrase of Saint Ignatius, "to help souls"—by which I mean, in all humility, to help others discern God's hidden presence in their lives, especially those who live under the shadow of doubt, apathy, loneliness, or looming despair. The painting by Italian artist Pasquale Rapicano that graces the cover of this book—*Rust (David Gilmour Live at Pompeii)*—somehow captures for me this human yearning for transcendence and grace that I have discovered in music since my childhood, not least in the artistry of Pink Floyd's David Gilmour. There is a swirl of shadow and light, motion and color, in Gilmour's luminescent solo guitar-work, instantly recognizable, which centers me down bodily and carries me skyward even to this day. I am very grateful to Rapicano for the permission to share his beautiful work.

Much more will be said along the way about resonances across the arts, spirituality, and the language of faith. For now perhaps it is enough to make clear that it is from within this space of gratitude and commitment to a community of faith that I write, and invite you to join with me in this exploration of the arts as a doorway into a lifelong journey toward greater empathy and wonder, solidarity, and new being in grace. I ask in advance your pardon wherever my efforts to speak may offend, assume too much of the reader, or fall well short of their subject. I trust and urge you to fill in the gaps with your own poetry, your own images, your own music, your own silence.

Additional Resources

Groundbreaking studies at the intersection of the arts and theology include the following:

Begbie, Jeremy, ed. *Beholding the Glory: Incarnation through the Arts.* Grand Rapids: Baker Academic, 2001.

23. Drawing from Canadian theologian Bernard Lonergan and Pope Benedict XVI, Gallagher suggests that theology today, insofar as it seeks to meet people where they live, should stop attempting to be falsely "objective" and pay more attention to the living context or "spiritual adventure" of theologians and ordinary people of faith. "The foundation of theology has shifted from texts and authorities to interiority. The old foundations for theology were externalist, logical, a question of conclusions drawn from premises. The lived horizon of the theologian was often forgotten but in fact is central. All this emphasis challenges theologians not to imitate a neutral model of academic work, one that is so naively and universally accepted in university culture today." Gallagher, "What Are We Doing When We Do Theology?," 10.

————. *Theology, Music and Time.* Cambridge, UK: Cambridge University Press, 2000.

González-Andrieu, Cecelia. *Bridge to Wonder: Art as a Gospel of Beauty.* Waco, TX: Baylor University Press, 2012.

O'Connell, Maureen. *If These Walls Could Talk: Community Muralism and the Beauty of Justice.* Collegeville, MN: Liturgical Press, 2012.

Robinson, David C., ed. *God's Grandeur: The Arts and Imagination in Theology.* Maryknoll, NY: Orbis, 2006.

Saliers, Don E. *Music and Theology.* Nashville: Abingdon, 2007.

Viladesau, Richard. *Theology and the Arts: Encountering God through Music, Art and Rhetoric.* New York: Paulist Press, 2000.

Vrudny, Kimberly. *Beauty's Vineyard: A Theological Aesthetic of Anguish and Anticipation.* Collegeville, MN: Liturgical Press, 2016.

————, ed. *Visual Theology: Forming and Transforming the Community through the Arts.* Collegeville, MN: Liturgical Press, 2009.

Other titles with emphasis on music include the following:

Beaudoin, Tom, ed. *Secular Music and Sacred Theology.* Collegeville, MN: Liturgical Press, 2013.

Hodge, Daniel White. *The Soul of Hip Hop: Rims, Timbs and a Cultural Theology.* Westmont, IL: InterVarsity, 2010.

Keuss, Jeffrey F. *Your Neighbor's Hymnal: What Popular Music Teaches Us about Faith, Hope, and Love.* Eugene, OR: Wipf & Stock, 2011.

Marsh, Clive, and Vaughan S. Roberts. *Personal Jesus: How Popular Music Shapes Our Souls.* Grand Rapids: Baker Academic, 2012.

Nantais, David. *Rock-A My Soul: An Invitation to Rock Your Religion.* Collegeville, MN: Liturgical Press, 2011.

Scharen, Christian. *Broken Hallelujahs: Why Popular Music Matters to Those Seeking God.* Grand Rapids: Brazos, 2011.

An enormous body of literature expounds the benefits and methods of integrating the arts into the classroom. Studies with an emphasis on teaching as formation of the whole person include the following:

Edwards, Linda Carol. *The Creative Arts: A Process Approach for Teachers and Children.* 2nd ed. New York: Prentice Hall, 1997.

Henri, Robert. *The Art Spirit.* New York: Basic Books, 2007. First published 1923 by J. B. Lippincott (Philadelphia).

Knippers, Edward. "Toward a Christian Pedagogy of Art." In *Teaching as an Act of Faith: Theory and Practice in Church-Related Higher Education*, edited by Arlin Migliazzo, 188–209. New York: Fordham University Press, 2002.

"I Asked for Wonder"

Rediscovering the Artistic Spirit

> What keeps me alive is my ability to be surprised. . . . I am surprised every morning that I see the sun shine again. . . . When I see an act of evil, I am not accommodated—I don't accommodate myself to the violence that goes on everywhere. I'm still surprised. That's why I'm against it; why I can fight against it. We must learn how to be surprised, not to adjust ourselves. I am the most maladjusted person in society.
>
> —*Rabbi Abraham Joshua Heschel*

> There are moments in our lives, there are moments in a day, when we seem to see beyond the usual. Such are the moments of our greatest happiness. Such are the moments of our greatest wisdom. If one could but recall his vision by some sort of sign. It was in this hope that the arts were invented. Sign-posts on the way to what may be. Sign-posts toward greater knowledge.
>
> —*Robert Henri*

When I was eight or nine years old, learning to play the piano was my doorway into a world of wonder. Our piano lived in the basement. I was scared of the basement. Every afternoon, reluctantly but dutifully, I would descend the stairs groping in the dark, until my hands found the small lamp that rested on top of the piano. A turn of the switch and the old console lit up before me. Those moments of relief and silence as I settled onto the bench were almost magical. The monsters now scattered, I could breathe again. As I struck the first chords, feeling the hammers strike against strings and vibrate through my body, I seemed to dissolve into the sound, no longer conscious of myself as a separate, observing being. The play of music seemed to take my breath away and give it back in the same stroke. Time dissolved, touching the eternal. I was alive, discovering that this life, this being, is flush with light and grace.

But there was darkness, too, and foreboding, as I learned to improvise and experiment across minor keys and dissonant modes, the piano perhaps teaching

me the art of discernment and attention. Behold, life will come before you in so many keys and disparate colors! I can remember many times, when my father would call down from the top of the stairs for dinner, I would stop playing, draw a deep breath, and whisper into the dark basement air, "Thank You." To whom I imagined saying these words as a nine-year-old, I cannot say for sure, yet I always felt—and still do—a palpable sense of "presence" at the piano, a something or someone other than me, at once with me, yet also rising from me, bearing my spirit into the rhythms of the day.

Musician Eddie Vedder, lead singer of Seattle's pioneering grunge band Pearl Jam, remembers a similar kind of presence that accompanied him as a teenager. "When I was around 15 or 16," he recalls, "I felt all alone. . . . I was all alone—except for music."[1] I don't know whether Vedder would link the gift of music in his life explicitly with faith or a religious sensibility. I do know that when I listen to him sing, something of that ineffable mystery I call grace stirs within me.

Listen, for example, to a track called "Light Today"[2] from Vedder's spare solo album *Ukelele Songs*, and see if you aren't stirred by wonder, as Vedder sings mantra-like over rhythms of ocean surf, conjuring the sun as it rises over water. Or search the song "Better Days,"[3] from the film *Eat, Pray, Love*, starring Julia Roberts. Turn up the volume on your headset, and see if you aren't carried skyward on the wild wings of Vedder's soaring voice. *My love is safe for the universe / see me now I'm bursting.* How is it that one man's voice can pulse with so much joyful ecstasy and world-weary sorrow at the same time? Might the crucible of loneliness he endured during his teenage years account for the pathos in Vedder's voice, give hints of insight into the darker notes of the human condition, a pathos perhaps many listeners will recognize, even feel bodily?

Radical Wonder: The Forgotten Mother Tongue

When Motown great Stevie Wonder (born Stevland Hardaway Morris) came into the world six weeks premature, underdeveloped optic nerves and an incubator over-rich with oxygen left the newborn without his sight. As he grew, his

1. Robert Hilburn, "He Didn't Ask for All This," *Los Angeles Times*, May 1, 1994.

2. Eddie Vedder, *Ukelele Songs*, Monkeywrench Records, 2011. Songs cited throughout this book are readily available via YouTube and other internet sources. For reasons of copyright protection and because internet domains are frequently unstable, web addresses will not always be provided here, with the exception of web domains officially authorized by the artist or archival material in the public domain. The reader is encouraged to search relevant songs and works of art cited in the text and wherever possible to rely on official web domains of the artist. Song lyrics are also easily located via internet search. Where lyrics appear directly in the text, I cite brief portions only to facilitate scholarly analysis, generally permissible under current US copyright law.

3. *Eat, Pray, Love: Original Motion Picture Soundtrack*, Monkeywrench Records, 2010. Official music video, Sony Pictures Entertainment, *https://www.youtube.com/watch?v=wJdgkyOzWOs*.

mother brought him to numerous doctors and faith-healers, unable to accept that there was no cure for her son's blindness. One day, as Wonder recalls, after yet another episode of strangers "digging into my eyes," the boy said to his mother, "You know, Mama, maybe, maybe God doesn't mean for me to see. You know, maybe God meant for me to do, to be, something else."[4] Whether or not divine providence accounts for Wonder's blindness, who can doubt that his music has inspired something akin to the miraculous in millions of listeners ever since he first burst onto the scene in 1963 as "Little Stevie Wonder"? Who is this child who wows audiences with his harmonica and a smile that could light up a football stadium? Berry Gordy, the founder of Motown records, explains that the stage name "Wonder" stuck as people who heard the kid play were describing him as "The Eighth Wonder of the World."[5]

Asked about his songwriting process, Wonder says that it has been the same from his childhood. "I just play and songs sort of happen. Like a painter, I get my inspiration from experiences that can be painful or beautiful. I always start from a feeling of profound gratitude—you know, 'Only by the grace of God am I here'—and write from there. I think most songwriters are inspired by an inner voice and spirit. God gave me this gift, and this particular song was a message I was supposed to deliver."[6] In an interview with Larry King, Wonder suggested that physical blindness has been for him a great gift: "I think I've got a pretty good imagination. And I think that, you know, we really feel before we see. We really hear before we see. . . . But when you have preconceptions, if your vision gives you preconceptions, then you've got a problem with yourself."[7]

Could a blind person be more attuned to reality than many with working eyes to see? Can the brilliance of Wonder's music, or the joyfulness that shakes the soul of the rapt listener, be explained? Think about it. *We really feel before we see. We really hear before we see.* From the watery womb, human beings are formed and emerge into life with the capacity for multisensory perception, what scientists call "synaesthesia," the "simultaneous blending or convergence of two or more senses, hence a condition of heightened perception."[8] What if we practiced such heightened receptivity every day—what Wonder calls "a pretty good imagination"—in our daily activities beyond the womb? What miracles might be revealed that we now habitually, blindly pass over?

4. "Stevie Wonder," *Biography*, TV documentary, aired June 8, 1994, with host Jack Perkins; part 2, *https://www.youtube.com/watch?v=RMwnUFDplcM*.

5. "Stevie Wonder," *Biography*, part 1, *https://www.youtube.com/watch?v=tCx077iTXb4*.

6. Marc Meyers, "How Stevie Created 'Love's in Need of Love Today,'" *The Wall Street Journal*, March 17, 2015.

7. Larry King Live, December 5, 2010; *http://transcripts.cnn.com/TRANSCRIPTS/1012/05/lkl.01.html*.

8. Don E. Saliers, *Music and Theology* (Nashville: Abingdon, 2007), 1. We will revisit this phenomenon in chapter 2 with reference to the music of Pink Floyd.

Let me return to my nine-year-old self, lost in the reverie of improvisation at the piano. The rationalist might hear my story and, citing a host of empirical studies, explain such episodes as the explosion of neurons firing throughout my nervous system and developing brain as a young child. And I would not necessarily disagree. The neurological explanation bears its own beauty and complexity. But can it account for the whole experience? Perhaps I really was—metaphysically speaking, as it were—tuned into something more than the play of neurons firing across synapses inside my head. Perhaps those encounters with the piano were my initiation into what the great Jewish poet and philosopher Rabbi Abraham Joshua Heschel calls the "forgotten mother tongue,"[9] the language of wonder and radical amazement, *before* I would have a chance to grow up and forget—before adult sophistication, the best professional education that money can buy, and a host of "reality checks" would threaten to squeeze the last remnants of all such language out of me.

Abraham Joshua Heschel

© Everett Collection / Newscom

The question of wonder's deepest metaphysical source brings us straight into the heart of the religious sensibility, the question of faith. Notice how Stevie Wonder links his own artistic creativity (an "inner voice and spirit") with a palpable sense of being held every moment, as it were, in the presence of the divine: "Only by the grace of God am I here." Such experiences seem to suggest the reasonable possibility that artistic creativity springs from neither a purely natural biological process nor a sheer act of will.

Of course not every artist or every act of artistic creativity can or ought to be described in this way. Yet like Stevie Wonder many artists describe a sense of gratuitousness within the creative process itself, an element of surprise and grace, a kind of "presence," even, that breaks into the creative act and cannot

9. Abraham Joshua Heschel, *Man Is Not Alone: A Philosophy of Religion* (New York: Farrar, Straus and Young, 1951), 75.

be predicted, measured, compelled or quantified. As Heschel puts it, "We sense more than we can say," gesturing to a sensitivity that "precedes conceptualization, on a level that is responsive, *immediate, preconceptual*, and *presymbolic*."[10] Artistic creativity seems to spring from this primordial level of perception and insight, and from the need in human beings, as it were, to do the impossible: to express the inexpressible. Whether the artist is a self-described religious person or not would seem to be quite secondary to the giftedness embedded in the sense of wonder itself, our attunement to the ineffable, and the creativity that springs forth from the deep-seated human impulse to respond to it.

Between Wonder and Despair: Roots of the Religious-Prophetic Sensibility

Sixty years ago, under the shadow of World War II, Heschel worried about the diminishment of our capacity for wonder as a species. "As civilization advances the sense of wonder almost necessarily declines," he wrote in 1951. The human race "will not perish for want of information, but only for want of appreciation."[11] A glimpse into Heschel's life experience as a young man will shed light on his anxiety about our collective capacity for wonder.

Born in Warsaw, Poland, in 1907, the sixth child of parents descended from prominent Hasidic rabbis, Heschel had been groomed from childhood to lead the Warsaw Jewish community of which his father was rabbi. In 1927, he began his doctoral studies at the University of Berlin, enrolling simultaneously at one of the finest rabbinical seminaries in the world. For ten years he would study in Berlin, a city whose "magnificent streets" he loved. In those same ten years, Adolf Hitler would rise to power. Imagine at the tender age of twenty finding yourself living in a cultural landscape almost completely foreign to your own, and, moreover, a political atmosphere of increasing contempt and peril for "your kind." How to maintain your equilibrium? Poetry would become a lifeline for Heschel in these years, a means of inscribing his fierce faith in God *and* his faith in the sacred dignity and goodness of human beings as embodiment of the divine image.

Heschel's first book of poems, the most intimate of all his work, was published in 1933, the year Hitler came to power. Its title, *The Ineffable Name of God: Man*, belies the inhumane fury that was about to engulf Europe. His poems announce themes that would haunt his thinking for the rest of his life: the struggle for holiness in the midst of evil; awe and silent wonder before nature;

10. Abraham Joshua Heschel, *God in Search of Man* (New York: Farrar, Straus and Cudahy, 1955), 115.

11. Heschel, *Man Is Not Alone*, 37.

God's passionate pursuit of human friendship; an unwavering ethical commitment to repair the broken world; loneliness and even indignation before God's silence and seeming distance from a world spiraling into ideological fury and violence.[12] Significantly many of Heschel's poems pulse with playful longing for "an unknown lady in a dream," an erotic sensibility not alien or threatening to the young man's faith but deeply resonant with his longing for God. To her, he writes, "Your eyes are greetings from God. / Your body—an oasis in the world, / joy for my homeless glances."[13]

Gathering all of the poems within one all-encompassing desire, the young poet asks God to increase, not diminish, his sense of wonder. "I asked for wonder instead of happiness, and You gave them to me."[14] Heschel, it seems, had been willing to sacrifice peace and good fortune in exchange for a lifetime of wonder and radical amazement. Yet he discovers that sacrificing peace and good fortune does not cost him happiness at all—for he has found it in wonder! Was Heschel out of his senses? Or, to the contrary, was the young poet and scholar—not unlike Stevie Wonder—discovering a way *back* to our senses? Might the poets help us to recover holistic ways of insight, truth, and wisdom that we have forgotten?

I asked for wonder instead of happiness, and You gave them to me. Notice the spark of tension flashing between the poet's first-person intimacy with God and his looming sense of alienation, the threat of despair. As a modern person of faith, Heschel contains both: "You gave *them* to me."[15] To wonder for Heschel is not only to stand in awe at the beauty of the world and the glories of human accomplishment; it is also to shudder at the world's terrible brokenness, our seeming inability to break free of prejudice and fear, greed and violence. To stand in wonder is to stand in shock at our seeming addiction to war, our willful failure to bridge the boundaries that divide us from other humans, from non-human creatures, and from the planet Earth. Who would wish to grow in such unsettling awareness? It seems an insane option, not least for a young Jew in the heart of the Nazi empire: to allow the world's joy *and* its pain to break open our hearts when it is so tempting to close one's eyes or to escape in various forms of distraction. "Wonder is not a state of esthetic enjoyment," Heschel would write two decades later. "Endless wonder is endless tension, a situation in which we are shocked at the inadequacy of our awe, at the weakness of our shock, as well

12. See Edward K. Kaplan, introduction, in Abraham Joshua Heschel, *The Ineffable Name of God: Man*, poems translated from the Yiddish by Morton M. Leifman (New York: Continuum, 2004), 7–18. Here and in what follows I am indebted to Kaplan's masterful interpretation of Heschel's poetry.

13. Heschel, *The Ineffable Name of God: Man*, 89.

14. Heschel, *The Ineffable Name of God: Man*, 23; the translation I adopt is taken from Edward K. Kaplan and Samuel H. Dresner, *Abraham Joshua Heschel: Prophetic Witness* (New Haven: Yale University Press, 2007), 183.

15. Kaplan and Dresner, *Abraham Joshua Heschel: Prophetic Witness*, 183.

as the state of being asked the ultimate question."[16] Between history and the act of faith stand "immense mountains of absurdity."[17]

Narrowly escaping the catastrophe engulfing Europe in 1940, Heschel arrived as a refugee in New York City at age thirty-three, fully aware "that his family and the thousand-year-old Jewish civilization of Europe were being annihilated."[18] Twenty-five years later, he defined himself in terms of that unspeakable event: "I am a brand plucked from the fire, in which my people was burned to death. I am a brand plucked from the fire of an altar to Satan on which millions of human lives were exterminated to evil's greater glory."[19] Like so many intellectuals of his generation who were impacted by the war, Heschel understood the difficulties confronting any attempt to find meaning after Auschwitz and Hiroshima, much less to do "theology" or engage in "God-talk" in any traditional sense. To wonder is not just to contemplate the beautiful stuff. A sense of wonder includes our terrible awe before the demonic elements of human experience.

Haunted by God

"Any genuine encounter with reality," writes Heschel, "is an encounter with the unknown. We sense more than we can say."[20] "Wonder" and "radical amazement" are the terms Heschel uses to describe this sense of being caught up speechless by life's endless mysteries—and still more, the sense that we ourselves are the object of God's questioning and concern. Paradoxically, it is the *gap* between what we sense and what we can say—described negatively as the "ineffable"—which discloses divine Presence and meaning. In other words, the certainty of God's realness does not follow directly from "experience" as such, suggests Heschel, but rather "from our *inability* to experience what is given to our mind,"[21] the *poverty* of our intellectual categories before the allure and meaning of life. How can human beings affirm the realness of God, a living sense of the sacred, even amid apparent absurdity? It begins, as noted above, with a sense of wonder that "precedes conceptualization, a level that is responsive, immediate, preconceptual, and presymbolic."[22] To recall a key point from the introduction borrowing from Charles Taylor and Michael Paul

16. Heschel, *Man Is Not Alone*, 68–9.

17. Abraham Joshua Heschel, *Abraham Joshua Heschel: Essential Writings*, selected with an introduction by Susannah Heschel (Maryknoll, NY: Orbis, 2011), 173.

18. Edward K. Kaplan, *Holiness in Words: Abraham Joshua Heschel's Poetics of Piety* (Albany, NY: State University of New York, 1996), 10.

19. Abraham Joshua Heschel, "No Religion Is an Island," *Union Seminary Quarterly Review* 21, no. 2 (January 1966): 117–34; also Kaplan, *Holiness in Words*, 10. Heschel's mother and two unmarried sisters perished in the Warsaw Ghetto, while a third sister who lived in Vienna was sent to Treblinka with her husband and murdered in Auschwitz.

20. Heschel, *God in Search of Man*, 115.

21. Heschel, *God in Search of Man*, 117.

22. Heschel, *God in Search of Man*, 115.

Gallagher, what breaks through the shell of the postmodern, "buffered self" are "moments of human poetry that give voice to the language of desire."[23]

And here potentially is where the mystic and the theologian share common ground with the musician, the poet, the artist. Religion at its existential core, says Heschel, by training the mind to attune itself to the ineffable pulsing in everyday life, moves us beyond the beautiful and beyond even the good to the *holy*, the "mood of reverence" that hovers within and beyond all things. The language of the mystics, prophets, and saints—"The kingdom of heaven is like a mustard seed," says Jesus (Matt. 13:31)—is not so far from the language of the poet—"To see a world in a grain of sand / And a heaven in a wild flower," says Blake. Both seek to open our eyes, to stir our wonder.[24]

Yet Heschel also, as noted above, worried about our capacity for wonder in an age of mass industrialization, instant communication, and increasing captivity to utilitarian concerns. Enthralled by humanity's wholesale mastery of nature and mesmerized by modern technological achievement, people increasingly, he thought, risk losing the sense of mutual vulnerability, dependence, and finitude from which empathy and ethical living in society flow. "The beginning of our happiness lies in the understanding that life without wonder is not worth living. What we lack is not a will to believe but a will to wonder."[25] Heschel was far from alone in these concerns. "[We] have to face the fact," observed Rev. Martin Luther King Jr., "that modern man suffers from a kind of poverty of the spirit, which stands in glaring contrast to his scientific and technological abundance. We've learned to fly the air like birds, we've learned to swim the seas like fish, and yet we haven't learned to walk the earth as brothers and sisters."[26]

In an influential essay in 1958, the famous German physicist Werner Heisenberg suggested that the human race now finds itself "in the position of a captain whose ship has been so securely built of iron and steel that his compass no longer points to the north but only towards the ship's mass of iron."[27] The

23. Michael Paul Gallagher, *The Human Poetry of Faith: A Spiritual Guide to Life* (Mahwah, NJ: Paulist Press, 2003), 136.

24. Heschel described his own phenomenological approach to religious language as "depth theology." "Theology speaks for the people; depth theology speaks for the individual. Theology strives for communication, for universality; depth theology strives for insight, for uniqueness. Theology is like sculpture, depth theology like music. Theology is in the books; depth theology is in the hearts. The former is doctrine, the latter an event. Theologies divide us; depth theology unites us." See Abraham J. Heschel, *The Insecurity of Freedom: Essays on Human Existence* (New York: Farrar, Straus and Giroux, 1966), 115–26.

25. Heschel, *God in Search of Man*, 117.

26. From news footage, KPIX-TV, San Francisco, February 27, 1967, at *https://diva.sfsu.edu/collections/sfbatv/bundles/190080*; see also "The Man Who Was a Fool," in Martin Luther King Jr., *Strength to Love* (Philadelphia: Fortress Press, 1981), 75.

27. Werner Heisenberg, "Role of Technology in Man's Relationship with Nature," in *The Physicist's Conception of Nature*, ed. Peter Y. Chou (New York: Harcourt, Brace & Company, 1958), cited in Thomas Merton, *Love and Living*, ed. Naomi Burton Stone and Patrick Hart (New York: Farrar, Straus and Giroux, 1979), 76–77.

moral and spiritual peril of the "ship's captain" can be averted, judged Heisenberg, only if he recognizes what has gone wrong—that his compass no longer responds to the magnetic forces of Earth—and "tries to navigate by some other means—for instance, by the stars."[28] What would it would look like, I wonder, to learn (or relearn) how to "navigate by the stars" in an age such as ours when Google Earth and other technological marvels let us "see" nearly every street corner and star in the universe, and seem to place these multiverses in the very palm of our hands? Our crisis, it seems, is both scientific *and* spiritual: Are we capable as a species of reorienting our "compass" to the shifting forces of our wondrous but deeply wounded planet?

Seeds of Wonder, Resistance, and Hope

When Saint Francis of Assisi gazed upon the starry heavens, he did not respond with the utilitarian eye of the economist or market trader. He responded with naked wonder, awe, and kinship; he sang of "Brother Sun" and "Sister Moon" with the heart of a mystic and poet. When Julian of Norwich in fourteenth-century England looked out from her hermitage upon green hills illuminated under a gentle dawn sky, she sang in her heart to "Jesus our Mother," an intuition of the sacred feminine who sings in the fecund beauty of Earth herself. In our own time, Pope Francis, when asked about his choice of name, recalled that the moment he was elected to become pope, a brother cardinal from Brazil "embraced me and kissed me and said: 'Don't forget the poor' . . . and that struck me . . . the poor. . . . Immediately I thought of Saint Francis of Assisi. Francis was a man of peace, a man of poverty, a man who loved and protected creation. These days we do not have a very good relationship with creation, do we?"[29] Notice how Francis links reverence for creation with concern for the poorest peoples of the earth. A God-haunted wonder joins them both.

The poets and prophets, scientists and saints, teach us that the capacity for wonder is not enough. If we do not cultivate *the will to wonder* in ourselves, our children and grandchildren, a singing reverence for life in all its forms, it risks atrophying and dying in us a slow but inevitable death. Here perhaps is the gift and burden of human freedom in history: every generation must learn anew how to "navigate by the stars," to hear the transcendent call of freedom in response to the crises of the times. Once again, as noted in the introduction, even more vital for religious traditions today than clarity of belief statements or even ethical norms, people "need to feel themselves part of a larger Story," a story that speaks

28. Merton, *Love and Living*, 77.

29. Pope Francis, *Address of the Holy Father Pope Francis*, March 16, 2013, *https://w2.vatican.va /content/francesco/en/speeches/2013/march/documents/papa-francesco_20130316_rappresentanti-media .html.*

to our deepest human desires for connection, meaning, relationship, love. "And this would be a response on the level of prereligious spiritual imagination."[30]

Perhaps the key point is this: such creative responses are not limited to the explicitly religious or theological realm. Like the astrophysicist who awakens our sense of wonder and participation in the drama of a still-evolving cosmos, the computer programmer who "shows" us the rings of Jupiter on our smartphones, and the mystic who sings of the sacred Presence that pulses from within all of it—the great poets and artists open doorways of perception into a world pulsing with vitality and spirit.[31]

When Jesus of Nazareth addressed his disciples and the crowds with words like, "Let those who have ears to hear, hear" (Matt. 13:9), and "Do you have eyes and not see, ears and not hear?" (Mark 8:18), scholars tell us he was speaking as a poet of Jewish wisdom (cf. Isa. 6:10; Jer. 5:21; Ezek. 12:2), appealing not just to the head but to the whole person of his listener: heart, body, mind, senses, and imagination. Like a lure flashing before a school of fish, Jesus' words dance before the imagination, interrupting our conventional assumptions about God and "the way things are" in the realm of human possibility. This, too, is the gift of the poet and artist, but it is not always an easy or pleasant gift to receive. To be "born again," borrowing from Jesus' own vivid imagery (John 3:3–8), is to break free of conventional wisdom and to risk the vulnerability of a poet's kind of faith: listen to the silences, hear the forgotten histories, let the music of things seen and unseen speak to you, awaken you from your slumber. Nothing is impossible with God. But can we believe it?[32]

The will to wonder is a subversive act, an act of resistance against every force of distraction or despair that would deaden our attunement to life's possibilities. The Buddhist tradition calls it Beginner's Mind, that capacity for wakefulness with which every person is born. It is the joy of living mindfully, as if every minute life begins all over again. The Christian mystical tradition calls it purity of heart, a posture of loving awareness that flows like nutrients through the vine from Christ himself, who says, "Amen, I say to you, unless you turn and become like children, you will not enter the kingdom of heaven" (Matt. 18:3). Heschel calls this will to wonder radical amazement, a heightened sensitivity

30. Gallagher, *The Human Poetry of Faith*, 136.

31. For a wonderful example of theology attuned to both the poetical and scientific spirits, see Dennis Hamm, "Reading Hopkins after Hubble: The Durability of Ignatian Creation Spirituality," *Horizons* 41, no. 2 (2014): 275–95.

32. "Speech about hope," writes biblical scholar Walter Brueggemann, "cannot be explanatory and scientifically argumentative; rather, it must be lyrical in the sense that it touches the hopeless person at many different points. More than that, however, speech about hope must be primarily theological, which is to say that it must be in the language of covenant between a personal God and a community. Promise belongs to the world of trusting speech and faithful listening." See *The Prophetic Imagination*, 2nd ed. (Minneapolis: Augsburg Fortress, 2001), 63–64, 67; also Walter Brueggemann, *Finally Comes the Poet: Daring Speech for Proclamation* (Minneapolis: Fortress, 1989).

to the divine Presence that bears an ethical imperative, a sense that something urgent is being asked of us.[33] In every tradition, the language of wonder is poetry, music, liturgy, the arts—indeed, this is why, as Heschel insists, "it is certainly no accident that the Bible is written in the language of poets."[34]

"The readiness is all," proclaims Shakespeare from the lips of Hamlet. What thrills me in the classroom are those moments when the "readiness" of my students' already wonder-saturated horizons are enlarged further by the encounter with a great musician, poet, storyteller, or artist. As Heschel urged and encouraged his contemporaries, in a thousand different ways, we must never allow the seeds of amazement that dwell in each of us to atrophy or be relegated to a fondly remembered but ever-more-distant childhood past. We must do everything we can to intensify and deepen our sense of wonder and that of our children, not least through rigorous immersion in the arts our whole lives long. What the theologian shares with the artist is a grammar of desire and imagination already "written on human hearts by the divine creator," and thus a vital search for new forms of expression that will engage and transform the whole person.[35]

Awakening the Artistic Spirit in Ourselves and Others

One of the most compelling accounts I have yet seen of the arts as a doorway to insight and wisdom belongs to Robert Henri, the celebrated painter and teacher of the Ashcan School of American realism, in his 1923 classic, *The Art Spirit*. As I noted in the introduction, the book is really an extended meditation on seeing, or, more precisely—keeping Stevie Wonder in mind—the art and discipline of *perception*, not limited to visual stimuli. In the opening lines of the book, Henri writes,

> Art when really understood is the province of every human being. It is not an outside, extra thing. When the artist is alive in any person, whatever his kind of work may be, he becomes an inventive, searching, daring, self-expressing creature. . . . Where those who are not artists

33. See "What to Do with Wonder," in Heschel, *Man Is Not Alone*, 68–69. The integral link between wonder and ethics—or better, the mystical and the prophetic, the latter being the consciousness "that something is asked of us"—will be emphasized in our exploration of the various artistic case studies throughout this book.

34. Heschel, *Man Is Not Alone*, 37.

35. Pope Benedict XVI, "Message for World Day of Peace," *America* 196, no. 2 (2007): 2; cf. Mark S. Burrows, "'Raiding the Articulate': Mysticism, Poetics, and the Unlanguageable," in *Minding the Spirit: The Study of Christian Spirituality*, ed. Elizabeth A. Dreyers and Mark S. Burrows (Baltimore: Johns Hopkins University Press, 2005), 348. Much in the spirit of Heschel's depth theology and Gallagher's emphasis on engaging the imagination, Burrows asks, can we find a manner of thinking, writing, and *teaching* theology in our classrooms and churches that would embrace the poetical and artistic imagination as constitutive of its very method?

are trying to close the book, the artist opens it, shows there are still more pages possible.[36]

Notice again Henri's insistence that the capacity for aesthetic insight and creativity is not just a mark of the expert, but "is the province of every human being." One does not have to be Vincent van Gogh or Stevie Wonder to come alive in heightened wonder and appreciation. The spirit of the artist beats in our very blood, whether we want it to or not.

The "art spirit" is that secret intuition that Reality is much more than what can be explained and quantified, bought or sold, demonstrated or proven. Remembering my nine-year-old self sitting before the piano in the dark, to surrender to the art spirit is to allow the doors of perception to expand, opening onto realms of presence and meaning that are real and *trustworthy*, even if hidden. But there is more, says Henri. The art spirit is that latent capacity and desire in all persons—we might call it empathy, or even love—that surrenders itself to ever-widening circles of discovery, generating, like ripples in a pond, what Henri calls "the Brotherhood."

> Those who are of the Brotherhood know each other, and time and space cannot separate them. The Brotherhood is powerful. It has many members. They are of all places and of all times. . . . If the artist is alive in you, you may meet Greco nearer than many people, also Plato, Shakespeare, the Greeks. In certain books—someway in the first few paragraphs, you know you have met a brother.[37]

If the artist is alive in you, says Henri, *there is no person, past or present, who is not potentially your sister or brother.*

It is fascinating to consider that two decades earlier, W. E. B. Du Bois, in his classic of 1903, *The Souls of Black Folk*, voiced a similar insight about the fellowship across time and space that he discovered in books, unbound by race, place, or culture. "I sit with Shakespeare and he winces not," wrote Du Bois. "I summon Aristotle and Aurelius and what soul I will, and they come all graciously with no scorn nor condescension."[38] For Du Bois, of course, the sense of kinship he discovered in literature was tinged with painful irony, set against his experience of the daily body blows of racism, wherein the natural bonds of human fellowship were *shattered* by the race veil in America. To this day *The Souls of Black Folk* remains a devastating indictment of racial injustice, a prophetic summons to build a more humane, just, and beautiful society than the one we have inherited.

Clearly not every work of art positively nourishes the human spirit or cultivates empathy and understanding between peoples. Neither would every artist

36. Robert Henri, *The Art Spirit* (1923; repr., New York: Basic Books, 2007), 11.

37. Henri, *The Art Spirit*, 15–16.

38. W. E. B. Du Bois, *The Souls of Black Folk* (Chicago: A. C. McClurg, 1903), 109.

link their creative process with a sense of kinship in God or the wider human community. Indeed, some of the most renowned "artists" in history have been notoriously, pathologically antisocial. In Du Bois's era, for example, D. W. Griffith's infamous propaganda film, *The Birth of a Nation*, demonized African Americans while lionizing the Ku Klux Klan through the powerful new medium of moving pictures. The music of Wagner was employed to similar ends in the anti-Semitic machinery of Hitler's Third Reich. Much closer to home, a considerable slice of video gaming and pop music culture today—rock and rap music video in particular since the dawn of MTV—is flush with images of misogyny and sexualized violence. These now ubiquitous "art forms" seem to have normalized for many consumers a kind of pornographic gaze, where the objectification of human bodies is linked explicitly to gendered and racialized hierarchies of power and sexualized violence. Here the seductive power of music and provocative visual imagery, underwritten by corporate profits, reveals its darker impact on culture.[39]

Nevertheless, as a powerful countersign to the dehumanizing impact of such mass media on ordinary people's lives, Henri witnesses to the potentially humanizing gaze of the artist, as he celebrates the many and diverse subjects ("My People") whom he is drawn to paint.

> My People may be old or young, rich or poor, I may speak their language or I may communicate with them only by gestures. But wherever I find them, the Indian at work in the white man's way, the Spanish gypsy moving back to the freedom of the hills, the little boy, quiet and reticent before the stranger, my interest is awakened and my impulse is to immediately tell about them through my own language—drawing and painting in color.[40]

Just as Stevie Wonder's unforgettable *Songs in the Key of Life* come to us in vibrant colors of rhythm, sound, and poetry, so do Henri's portraits rise from a heart that gazes on other human beings—male, female, black, white, yellow, red, and brown—through eyes of kinship and love, not objectification, fear, or hatred. Henri's "language" is paint on canvas, but each brush stroke rises from a heart of empathy; his protest, in beauty, rises from love—a "reaching toward" the subject that refuses the violence of objectification or imposed uniformity.[41]

39. See *Dreamworlds 3: Desire, Sex and Power in Music Video*, dir. Sut Jhally (Media Education Foundation, 2003). We explore these themes in considerable depth in chapter 7.

40. Henri, *The Art Spirit*, 141. An internet search of Henri's work unveils an astonishingly beautiful catalogue of portraits.

41. Recall Stevie Wonder, "[If] your vision gives you preconceptions, then you've got a problem with yourself." It is moving to juxtapose Henri's portraits as a celebration of human diversity against Stevie Wonder's recollection of his first experience of "the whole color thing" as a child, being called the "N" word by a group of other kids (see "Stevie Wonder," *Biography*, part 2). Chapter 5 explores the racial dimension of Wonder's life and music in some detail.

And love, finally, is what gives birth to hope, the graced capacity to imagine again.[42] Thus Henri writes, "There are moments in our lives, there are moments in a day, when we seem to see beyond the usual. Such are the moments of our greatest happiness. Such are the moments of our greatest wisdom. If one could but recall his vision by some sort of sign. It was in this hope that the arts were invented. Sign-posts on the way to what may be. Sign-posts toward greater knowledge."[43] It is this tenacious capacity for imagination and hope, I wish to suggest, our capacity "to see beyond the usual" and to raise up "sign-posts on the way to what may be," which accounts for the lively resonance between artistic creativity and prophetic religious faith. And just as Stevie Wonder's creativity is inseparable from the black church and streets of urban Detroit in which he was formed, so is Heschel's God-haunted vision of things saturated with the religious sensibilities of the Hasidic Jewish community of Eastern Europe in which he was formed. The artistic-prophetic spirit emerges from within and *for* the life of the community.

But then each of us will have to ask: Who, precisely, are My People? Is my capacity for empathy bound only to those who look like me, think like me, pray like me? To what extent do I fall prey to the habit of "othering" and scapegoating those who are different, reinforced by the feeling that God is on "our side"? Indeed without a sense of kinship binding me to all things in the vast web of creation, to people and cultures well beyond my limited field of vision, how easy it is to take refuge inside the "buffered self," or worse, inside a kind of political or religious tribalism, motivated not by the will to wonder but *the will to survive*, to endure, to conquer, to preserve "our way of life" by any means necessary.

Against all such presumption, the authentic prophet is painfully aware of his own people's limitations, the dangers of corporate blindness. His cry is a twin cry of love for his people and of internal social critique and resistance, questioning everything from the divine perspective. It is the pathos of Marvin Gaye pleading, "What's Going On?" and Dr. King asking, "Where do we go from here?" in the midst of social upheaval. It is the cry of the mystic linking "Us" and "Them" into one mosaic human family. No wonder the prophets are never safe in their own country! To proclaim the fundamental goodness and unity of the human race is not mere Sunday school talk. For Gandhi, King, and Jesus, as for countless other nameless prophets and peacemakers, such ideas were and remain a threat to the reigning order of things. "If love and nonviolence be not the law of our being," confessed Mahatma Gandhi, "the whole of my argument falls to pieces."[44]

42. See William F. Lynch, *Images of Hope: Imagination as Healer of the Hopeless* (Baltimore: Helicon, 1965); also Christopher Pramuk, *Hope Sings, So Beautiful: Graced Encounters across the Color Line* (Collegeville, MN: Liturgical Press, 2013).

43. Henri, *The Art Spirit*, 9.

44. Cited in *Gandhi on Non-Violence*, ed. Thomas Merton (New York: New Directions, 1964), 17.

Before concluding this chapter I'd like to share one more story from the realm of music that powerfully evokes for me the spirit of heightened receptivity and attunement that characterizes the artistic-prophetic disposition as I have described it, a faith in divine-human possibilities for which, as Heschel writes, "reason has no concepts and language has no names."[45]

The Possibilities of Presence

In the deep winter of 1986, under the dark cloak of night, two musicians set up their instruments in the sanctuary of the Cathedral of Saint John the Divine in New York City, the largest Baroque church in the world. Cellist Eugene Friesen and pianist Paul Halley had played together for years with jazz and world music pioneer Paul Winter, but they had never played or recorded apart from Winter's band. Alone together in the silence of the vast sanctuary, save a recording engineer, the two began to play, tentatively at first, and then, as the night deepened, with greater confidence and abandon, circling around each other in a kind of dance, structured and spontaneous, disciplined and free. None of the music was rehearsed. The nine songs that came to birth that night were drawn forth, as it were, "out of nothing," from the womb of the cavernous cathedral. The acclaimed album *New Friend*[46] is the astonishing result, unlike anything I have heard before or since.

I often play for my students the album's final track called "Full Circle." After settling into silence for several moments, I invite the class to imagine sitting unseen in the choir loft of the great church, gazing down upon the musicians, waiting and listening. Friesen breaks through the silence first with percussive strikes on the cello, laying down a spare melody in space and time. The circle opens, the piano enters the dance, and the two musicians are off, circling in spirals, moving in, leaning out, turning around and around—now bearing us with them on glorious waves of sound. On one occasion in class, when the song had ended and I asked students for their impressions, a long silence ensued. Suddenly a burly baseball player in the back row, a young man who rarely spoke up in class, thrust his hands into the air and exclaimed, "Dr. Pramuk, that was *a fucking miracle.*" Of course we all erupted with laughter. But there wasn't a person in the room who didn't share the sentiment exactly. For the rest of the semester, whenever we found ourselves caught up short for words, "AFM" became our go-to turn of phrase. And why not? There is more than a hint of the miraculous in the human spirit, if our eyes are open to behold, our ears open to wonder.

In truth, of course, Friesen's and Halley's music was not created out of nothing. The two musicians brought *themselves* to the dance, including the long

45. Heschel, *Man Is Not Alone*, 36.
46. Eugene Friesen with Paul Halley, *New Friend*, Living Music, 1986.

history of their friendship. Moreover, years of solitude, sacrifice, and discipline mastering their instruments—not unlike my nine-year-old self practicing scales at the piano—had gifted each artist with an unconscious technical virtuosity and a complete freedom to sing through their instruments when they finally "came out to play." Indeed, one could say that decades of seemingly disconnected moments had prepared both men for this singular encounter in the sanctuary of Saint John's. And just as in life itself there was considerable risk in this unrehearsed experiment. It might have failed. Thus in many respects it was an act of courage and trust—many such acts over the course of many years—that gave birth on this night to something wholly unpredictable, spontaneous, beautiful.

And still there was another factor at play, another *presence*, not obvious at first glance: the cathedral itself. During an interview about the album, Friesen describes Saint John the Divine as "an acoustical place that has a spirit, a magic of its own, a place that affects our improvisations." The cathedral, he says, "was kind of a third musician whose sound is very much present on the album."[47] How can great blocks of stone, stained glass, and vast empty space constitute a living spirit, a real presence? To the empirical mind it makes no sense. To the artist and poet, the mystic and prophet, such awareness is the beginning of insight, the seed bud of unforeseen possibilities springing to life in the pregnant spaces between freedom and imagination.[48]

You Are Not a Machine

In one of the last interviews he gave before his death, Rabbi Heschel was asked what advice he would give to young people. He replied,

> I would say, let them remember that there is a meaning beyond absurdity. Let them be sure that every little deed counts, that every word has power, and that we can do, everyone, our share to redeem the world, in spite of all absurdities, and all the frustrations, and all the disappointment. And above all, remember that the meaning of life is to build life as if it were a work of art. You're not a machine. When you're young, start working on this great work of art called your own existence.[49]

47. Bob Protzman, "Cellist Friesen Takes Music into a New Age," *Chicago Tribune*, December 11, 1986, *http://articles.chicagotribune.com/1986-12-11/features/8604020831_1_paul-winter-consort-jazz-elements-classical-music*.

48. This observation forms the core of music therapist Susan Elizabeth Hale's study of sacred spaces around the world in her mind-expanding book, *Sacred Sound, Sacred Space: The Acoustic Mysteries of Holy Places* (Wheaton, IL: Quest, 2007).

49. Interview with Carl Stern, 1972; cited in Arnold Eisen, "The Opposite of Good Is Indifference," interview with Krista Tippet, *On Being*, NPR, June 5, 2008, *https://onbeing.org/programs/arnold-eisen-the-spiritual-audacity-of-abraham-joshua-heschel/*.

The artistic spirit as explored in this book is that spirit of heightened receptivity and creative response that resists unthinking conformity to The Way Things Are, daring us to imagine again what is possible in a world charged with grace. We are not machines; we are human beings, created in the divine image. Always and everywhere a third musician haunts our movements in time and space, galvanizing our courage, inviting us to participate in the general dance of life's renewal and flourishing. "See, I am doing something new! Now it springs forth, do you not perceive it?" (Isa. 43:19)

In the whispering of the grass under our feet; in the turning of leaves in the half-light of dusk; in the music of children's laughter when they are really free to be children; in the desires and dreams that stir through our own childlike wonder before the beauty of the earth and the earthen pathways that unfold before our feet; perhaps in such moments we can catch an echo of the voice of God, a murmur from the sacred depths of our own being, asking: Are you listening? Are you awake? We must help each other learn again, with every waking hour, "how to be surprised, not to adjust ourselves."[50]

This book is written from the conviction that lying dormant in every person, indeed, in the stuff of the earth and the dark matter of the cosmos itself, are the seeds of an eternal loving Presence—the "mark of God," to borrow an image from the prophet Job. These seeds, however, must be nurtured. "Love by itself is hollow," says Stevie Wonder. "For love to be effective it has to be fed."[51] When we allow the seeds of love to be fed, look out! For life made from love is AFM. While it is true that not every work of art nurtures the human spirit in life-affirming ways, nevertheless the arts in every era have nourished humankind's will to wonder, the deep taproot of empathy and communion, justice and love. More than our scholars and theologians, and certainly more than our politicians and daily newsmakers, it is the world's artists who can help us reclaim the will to wonder, and so enkindle hope, even, perhaps especially, in places of apparent hopelessness. That is a bold hypothesis, I admit. In the pages that follow, I invite you to test its truthfulness, its latent possibilities, for yourself, and even better, to test it in conversation with others.

In 1963, a gray-bearded Heschel, at age fifty-six looking every bit the Hebrew prophet, marched arm in arm with Rev. Martin Luther King Jr. and thousands of ordinary Americans of every age, race, and creed, singing songs of freedom, united in their commitment to build a more just society. Of marching with King, Heschel would famously say, "I felt my feet were praying." Perhaps their courage and will to wonder, and that of the artists explored in this book, can galvanize our own.

50. ABC News interview, November 1971, cited in Heschel, "The Spiritual Audacity of Abraham Joshua Heschel."

51. Meyers, "How Stevie Created 'Love's in Need of Love Today.'"

When I wander through avenues
of poems, of dazzling visions—
I compress into that precious space
my young, raw secrets.

I don't want to plaster posters of God
on all wide-open street corners,
but instead, celebrate the birthday of eternity
in the tiny corner of every moment.

I want to set up—old sowings
from the harvest of my spirit—
verbal wine for distant generations
in the coolest abyss of a poem.

—"Untitled," Abraham Joshua Heschel[52]

Addendum and Additional Resources

The language of theology, or talk about God, faces considerable challenges in our time. First among these for many people is epistemological. How to speak credibly of God in a post-Darwinian universe and advanced technological milieu? In the face of human and planetary suffering? When not a few self-identified religious people (and their leaders) appear to be hypocritical or even corrupt? When the language of theology or doctrine itself seems abstract, bereft of poetry and connection to human experience?

Critical, then, to any effective introduction to theological method (and religious formation) is the bridging of traditional language and religious wisdom about God (revelation, scripture, liturgy, theology) to the contours of ordinary human experience. What Rabbi Abraham Joshua Heschel calls "depth theology"—a poetical and phenomenological account of religious experience—corresponds closely to the language of "grace" in the Catholic tradition, especially as articulated by the German Jesuit theologian Karl Rahner, and more broadly, to the poetical sensibilities of the Christian mystical tradition as described by Mark Burrows.

Jewish scholar Edward Kaplan is a masterful translator of Heschel's depth theology, and Catholic popular spiritual writer Bill Huebsch does the same for Rahner's theology of grace. Much in the way of Heschel, the German Lutheran

52. Heschel, *The Ineffable Name of God: Man*, 134. Used with permission from Continuum US, an imprint of Bloomsbury Publishing Inc.

and pioneering feminist theologian Dorothee Soelle brings a compelling poetical and political lens to theology that encourages readers to discover God in ordinary experience, especially in social movements that seek justice and the common good. The late American writer David Foster Wallace challenges students in his famous Kenyon College commencement speech to break free of the "default-setting," while Rabbi Harold Kushner chronicles his crisis of faith after his son's death, and how it brought him to a radically revised notion of how God relates to the world through the "incarnation" of caring people. Jesuits John Haught, George Coyne, and Dennis Hamm bring evolutionary and cosmic perspectives to the table, merging religious, scientific, and poetic insights in ways that my students have found very compelling.

Books

Haught, John F., SJ. *The New Cosmic Story: Inside Our Awakening Universe*. New Haven: Yale University Press, 2017.

Huebsch, Bill. *Grace: God's Greatest Gift*. New London, CT: Twenty-Third Publications, 2009.

Kaplan, Edward K. *Holiness in Words: Abraham Joshua Heschel's Poetics of Piety*. Albany, NY: State University of New York Press, 1996.

Rahner, Karl, SJ. *Karl Rahner: Spiritual Writings*. Maryknoll, NY: Orbis, 2004.

Soelle, Dorothee. *Theology for Skeptics: Reflections on God*. Minneapolis: Fortress, 1995.

Articles, Interviews, and Speeches

Burrows, Mark S. "Raiding the Inarticulate: Mysticism, Poetics, and the Unlanguageable." In *Minding the Spirit: The Study of Christian Spirituality*, edited by Elizabeth A. Dreyer and Mark S. Burrows, 341–62. Baltimore: Johns Hopkins University Press, 2005.

Hamm, Dennis, SJ. "Reading Hopkins after Hubble: The Durability of Ignatian Creation Spirituality." *Horizons* 41, no. 2 (December 2014): 275–95.

Heschel, Abraham Joshua. "Knowledge by Appreciation." In *Man Is Not Alone: A Philosophy of Religion*, 35–41. New York: Farrar, Straus and Young, 1951.

McDermott, Jim. "The Fertile Universe: An Interview with George V. Coyne, Former Director of the Vatican Observatory." *America* (Oct. 23, 2006): 18–20.

Rolheiser, Ronald. "To Be Fully Human: Rolheiser Gets to the Essentials." Interview with John Allen. *National Catholic Reporter*, May 25, 2010. *Https://www.ncronline.org/news/spirituality/be-fully-human-rolheiser-gets-essentials*.

Wallace, David Foster. "This Is Water." 2005 commencement speech at Kenyon College, adapted in *The Wall Street Journal*, September 19, 2008. Video available via YouTube and in numerous other forms.

Music, Audio, and Visual

An accounting of songs, films, lectures, or other art forms that give expression to wonder and the ineffable dimension of human life would, of course, be endless. Here are a few of my favorites. (What are yours?)

Cockburn, Bruce. "World of Wonders." *Slice O Life: Live Solo.* Rounder, 2009.

Friesen, Eugene. "Full Circle." *New Friend.* Living Music, 1986.

Kushner, Rabbi Harold. "When Bad Things Happen to Good People." Video lecture. 1985. *Https://www.youtube.com/watch?v=AKx-iJG5qrE.*

McFerrin, Bobbie. "Common Threads." *Medicine Man.* EMI, 1990.

———. "Ave Maria." Live in concert. 2006. *Https://www.youtube.com/watch?v=PgvJg7D6Qck.*

McLachlan, Sarah. "Fumbling Towards Ecstasy." *Fumbling Towards Ecstasy.* Sony Legacy, 1994.

Vedder, Eddie. "Light Today." *Ukelele Songs.* Monkeywrench Records, 2011.

———. "Better Days." *Eat, Pray, Love.* Monkeywrench Records, 2010.

"Us and Them"

Pink Floyd: Empathy, Alienation, and Madness in Post-War Europe

> What can we gain by sailing to the moon if we cannot cross the abyss that separates us from ourselves?
>
> —*Thomas Merton*

> *Dark Side of the Moon* was an expression of political, philosophical, humanitarian empathy that was desperate to get out.
>
> —*Roger Waters*

Art engages human beings in such complex and variable ways that it may seem superfluous, if not self-indulgent, to stop and ask what it might be for. It should not surprise that artists themselves are often reluctant to offer "explanations" for what their work aims to communicate.[1] One of my students, responding to her first exposure to Pink Floyd's *The Dark Side of the Moon*, put it this way: "To try and explain the impact of the album would be fruitless because then one would start to sound like a textbook." (A dreaded fate for any writer!) "The full expression of thoughts and ideas," she continued, "can only come out as already presented and would be dragged down by words. Listening to the album definitely taught me something, but I have yet to process it enough to communicate it. I guess I'll just have to listen again."

And perhaps this is the key point. It is the deep listening, the lingering with the work of art, that matters. The best grasp of a work of art comes not in theoretical analysis or formal criticism of the work but in its performance and reception, that moment in which the work becomes the occasion for the

CASE STUDY

Pink Floyd, *The Dark Side of the Moon*

1. Alain de Botton, "What's the Point of Music? Ask Peter Gabriel," *The Guardian*, Feb. 10, 2016, *https://www.theguardian.com/music/2016/feb/10/peter-gabriel-alain-de-botton-music-and-emotion ?CMP=twt_a-science_b-gdnscience*.

meeting of multiple freedoms, the merging of the artist's insight and creative freedom with that of the listener, viewer, or larger audience.[2]

What (and Who) Makes a Classic?

By their very nature, the arts touch us in ways that are more diverse, complex, and ineffable than any theorist or theoretical framework can describe. Nevertheless certain insights from the realm of art criticism and hermeneutical theory (theory of interpretation) can be helpful in providing a shared framework for reflection on how the arts rise from, touch, and shape human experience.

Catholic theologian David Tracy is one theoretician whose work has been enormously helpful to me and many others in thinking about what is going on when we are moved and even transformed by a classic book, person, film, or work of art. In his landmark book, *The Analogical Imagination*, Tracy describes the "classic" as any truly significant book, person, work of art, or piece of music that bears a certain "excess of meaning" as well as a certain timelessness.[3] The classic confronts and provokes us in our present horizon with the feeling that "something else might be the case."[4] By contrast to mere period pieces, "which are meaningful for a time but which one eventually 'grows out of,' genuine classics transform one's horizon. They bring a meaning that is both particular and universal, and give rise to limit-experiences that can bear the power of the *whole*."[5]

Tracy's definition, like the classic itself, is both provocative and evocative. What can he mean by suggesting that a truly significant work of art confronts us "with the feeling that 'something else might be the case'"? How can a singular piece of music or literature give rise to experiences that "bear the power of the *whole*"? In the introduction, I suggested that the arts engage us largely in the precognitive and prereligious realms of desire and imagination. Similarly, Don Saliers describes music as "the language of the soul made audible."[6] What would a "precognitive" or felt sense of human existence and the confrontation

2. See George Steiner, *Real Presences* (Chicago: University of Chicago, 1989); also Mark S. Burrows, "Words That Reach into the Silence: Mystical Languages of Unsaying," in *Minding the Spirit: The Study of Christian Spirituality*, ed. Elizabeth A. Dreyer and Mark S. Burrows (Baltimore: Johns Hopkins, 2005), 341–61.

3. David Tracy, *The Analogical Imagination: Christian Theology and the Culture of Pluralism* (New York: Crossroad, 1981), 102.

4. Tracy, *Analogical Imagination*, 102, citing Dorothy Van Ghent.

5. "David Tracy," in *The Boston Collaborative Encyclopedia of Western Theology*, http://people.bu.edu/wwildman/bce/tracy.htm, citing Tracy, *Analogical Imagination*, 115, and T. Howland Sanks, "David Tracy's Theological Project: An Overview and Some Implications," *Theological Studies* 54 (1993): 713.

6. Don E. Saliers, *Music and Theology* (Nashville: Abingdon, 2007), 4.

with our most profound "limit experiences"—birth, death, ecstasy, longing, joy, despair—*sound like*? If music is the sound of the soul made audible, what would a "prereligious" understanding of the divine—a felt sense of God's *realness*, or the soul's deep longing for God—sound like musically, without reference even to the word *God*?

It might sound something like "Great Gig in the Sky," the fourth track on *The Dark Side of the Moon*, as such longing is borne into the heights and depths by British singer Claire Torry's wordless, soulful singing, morphing at times into primal screaming. Or it might not. As Tracy insists, the very "surplus of meaning" in the classic prevents any single interpretation or "monologic conception of truth" from holding sway.[7] The classic claims a certain authority—Torry's extraordinary vocal claims authority—not by delivering a set of static truths, says Tracy, but rather by raising "certain fundamental questions that haunt us with the weight and excess of meaning that bears upon our finite horizon from the whole."[8]

I have often begun class at the start of a new semester by inviting students to join with me in listening to (lingering with) "Great Gig in the Sky." The range of their responses—the "intensification" of human experience that confronts us in Torry's wailing, the "fundamental questions that haunt us"—always amazes me. Is it a cry of suffering? Of religious longing? Of sexual ecstasy? Is it the painful yet joyful catharsis a woman feels when birthing a child? Is it the unutterable anguish she feels when losing one? If my students' diverse reactions are any measure, the song "bears the power of the whole" insofar as it touches something universal in human experience, yet precisely *what* that "something" is remains elusive.

Tracy offers no epistemological theory (theory of knowledge) for how the deepest truths of human experience are borne by or perceived in the classic; rather he affirms that such understanding *happens*, like an event.[9] Reflecting on the "event-like" durability of Pink Floyd's most widely acclaimed album, journalist and broadcaster Robert Sandall writes, "There is no question in my mind that *Dark Side of the Moon* is one of the most important artistic statements in the last 50 years probably. It touched many people all over the world in ways that could not simply be put down to the fact that 'Oh, they're nice tunes,' and 'Oh, I like that bit at the end.' I mean, this was a complete experience."[10] The album is certainly a "complete experience," in senses that we will explore in what follows. Indeed before reading further, it is important simply to listen to the

7. Tracy, *Analogical Imagination*, 113.

8. "David Tracy," *Boston Collaborative Encyclopedia*; citing Tracy, *Analogical Imagination*, 430.

9. Tracy, *Analogical Imagination*, 102.

10. Cited in David MacGregor Johnston, "*I and Thou* and 'Us and Them': Existential Encounters on *The Dark Side of the Moon* (and Beyond)," in *Pink Floyd and Philosophy: Careful with That Axiom, Eugene!*, ed. George A. Reisch (Chicago: Open Court, 2007), 136; originally from the documentary *Pink Floyd: Dark Side of the Moon*, dir. Matthew Longfellow (Eagle Rock Entertainment, 2003).

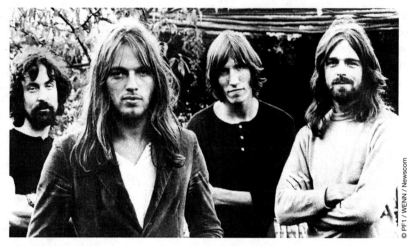

Nick Mason, David Gilmour, Roger Waters, and Rick Wright of Pink Floyd

album, immerse yourself in it contemplatively, and even better, try your hand at journaling from it (see appendix C).

Dark Side of the Moon is often described as a work of "cinematic proportions," a "concept album"—meaning a thematic whole, by contrast to a collection of thematically disconnected songs—that draws on all the resources of cinematic storytelling: words and silence, images and music, motion and sound effects. If one were to measure the album's impact in quantitative terms alone, as perhaps record company executives tend to do, to say that *Dark Side* has "touched many people all over the world" is an epic understatement. At more than fourteen years straight on the Billboard charts and some fifty million copies sold globally, it ranks in the top five selling albums of all time. When the band members began working on the project in 1972, surely neither they nor their record company could have imagined the cult status their summary labors would bear some five decades later. What is the "power of the whole" that makes *Dark Side of the Moon*, including its iconic pyramidal cover image, such an enduring realization of art's power to move human beings?

However individual listeners might respond to this question, the question itself is inseparable from the life stories and "limit experiences" of the artists who created the album at a particular moment in the world's social history and in response to the signs of the times. To say it in terms of hermeneutical theory, to grasp the full measure of *Dark Side*, we would need to know something about the "world behind the text":[11] the historical, cultural, and social context that shaped the lives of the artists who created the album. We would begin with the four members of Pink Floyd: bassist and lead vocalist Roger Waters (b. 1943),

11. The phrase is borrowed from Hans Georg-Gadamer's landmark hermeneutical study, *Truth and Method* (New York: Sheed and Ward, 1975), 254–64.

cofounder of the band in 1965 and sole lyricist on *Dark Side*; guitarist and colead vocalist David Gilmour (b. 1946), who joined the band in 1968 when cofounder Syd Barrett left due to mental illness; keyboardist, vocalist, and founding member Rick Wright (1943–2008), whose improvisational jazz stylings were a crucial part of the band's spacious and richly layered sound; and drummer Nick Mason (b. 1944), the only constant member of the band from its formation, and the creative force behind much of the experimentation with aural effects that mark the group's psychedelic sound.[12]

Yet the panoramic whole of the Pink Floyd sound is considerably greater than the sum of these four parts. To the band members we would have to add several others whose presence is felt palpably throughout *Dark Side of the Moon*: producer and studio engineer Alan Parsons; singer Claire Torry; saxophonist Dick Parry; and above all, Syd Barrett, whose mental breakdown and departure from the group several years earlier had profoundly affected Waters. Intimations of the slow slipping of the mind into insanity appear throughout *Dark Side*, and climactically in its penultimate track, "Brain Damage." The soaring lunar imagery in that song—"I'll see you on the dark side of the moon"—carries over into "Eclipse," the album's sweeping final track, both songs conjuring the specter of "lunacy" and its meaning in days of old: to be "touched" by the moon.[13] Barrett's illness had become a unifying theme in Waters's lyrical vision and a powerful figure for a whole world slipping—if often quite respectably—into madness.

"It Can't Be Helped if There's a Lot of It About": The Horror and Banality of War

For many people who lived through the Second World War, and for young people in particular who came of age during the post-war period, the world indeed seemed to have descended into madness. To my mind the track that anchors *Dark Side* thematically, "Us and Them," is at once the album's most beautifully realized song, and lyrically, its most unsettling. Opening the second half of the record—track one on side two of the original vinyl—"Us and Them" is most clearly a lament for war and the carnage it makes, literally and figuratively, of the human race. Adopting the perspective of ordinary men sent to kill and die in battle by generals and politicians who sit far from the front lines, the song feels like both a piercing lament (in its sweeping minor key passages) and an oddly peaceful protest (in its crystalline major key verses), questioning a state of affairs that would normalize war and its horrific effects as simply *the way things are* and must be.

12. Mason also served as a kind of bridge between Waters and Gilmour through various conflicts over the decades. Indeed the respective genius, ego, and drive of Waters and Gilmour would make for a volatile mix throughout the band's history. See Nick Mason, *Inside Out: A Personal History of Pink Floyd* (San Francisco: Chronicle, 2005).

13. Alan Di Perna, *Pink Floyd: The Story behind Every Album* (New York: Harris, 2015), 46.

Roger Waters, who lost his father in World War II, had discovered a way lyrically to poke his middle finger in the eye of the politicians and profiteers who construct this so-called real world, much of it predicated on money and the relentless drive of capitalism: "the price of tea and a slice." Against the presumption that "it can't be helped if there's a lot of it about"—i.e., endless war, crushing poverty, and horrific violence—"Us and Them" is a kind of anthem, or perhaps an elegy, on behalf of a youthful generation pushing back hard and beautiful against the tumultuous world they had inherited. Born in 1943, on the eve of Hiroshima and the world's discovery of Auschwitz, Waters seems implicitly to ask, "Is this really the best we can manage?"

Repeatedly in interviews, Waters has suggested that what most haunted him during the creation of *Dark Side of the Moon* was the question of empathy: "those fundamental issues of whether or not the human race is capable of being humane."[14] Perhaps the earliest thread of Pink Floyd's poetic ruminations on empathy appear in the 1971 album *Meddle*, in the song "Echoes": "Two strangers passing in the street / By chance two separate glances meet / And I am you and what I see is me."[15] Empathy, as the lyric suggests, is not just the *capacity* to "feel with" another person, from the inside of their life-situation; it is also the *willingness* to move beyond one's self-interest to do so. Are human beings capable of empathy in this sense, as "Echoes" and "Us and Them" suggest: to recognize "Me" and "You" as reflective images of one common humanity? Or are we destined to continue dividing up the world, "round and round and round," into camps bent on mutual destruction? Against the fresh horror of war and the economic, cultural, and ideological machinery dedicated to its propagation, *Dark Side of the Moon*, says Waters, "was an expression of political, philosophical, humanitarian empathy that was desperate to get out."[16]

The question of sanity also emerges with bleak poetic force in *Dark Side*, from disjointed voices speaking about madness and deranged laughter laid over the opening tracks to the unsettling imagery of "Brain Damage" as the album nears its climactic conclusion. "The lunatic is in the hall / the lunatics are in the hall / The paper holds their folded faces to the floor / And every day the paper boy brings more." Yet while much of *Dark Side* is organized thematically around the grim realities of war and the descent toward madness, the musical tenor of many of its tracks is anything but violent, chaotic, or cacophonous. As music writer Alan Di Perna observes, the shimmering, echoey vocals of David Gilmour in "Us and Them," for example, is "oddly peaceful," "as though we were viewing the horrors and folly of human behavior from somewhere up in the clouds." Di Perna continues, "The sedated quality that infuses much of *Dark Side's* music suggests the catatonic withdrawal of the insane: the eerie inner peace of some-one who is beyond feeling, who has severed himself from the disturbing events

14. Cited in Johnston, "*I and Thou,*" 124.

15. See Johnston, "*I and Thou,*" 125.

16. Johnston, "*I and Thou,*" 134.

of life."[17] And indeed, we might add, how tempting it is "to sever oneself" from a human race that seems so bent on self-destruction.

We tend to think of the opposite of empathy as hatred, and that is true enough, for hatred implies toxic and destructive feeling for another person or group, crippling one's capacity to feel another's humanity "from within." But what stands in the way of empathy is not only hatred, but apathy: to *feel nothing*, no regard at all, for the other. Apathy is a kind of deadening of natural human openness to the wonder and beauty of life itself, a deadening of curiosity toward and active engagement with others. At its extreme, apathy yields to cynicism, that despairing and often mocking question that short-circuits every movement toward meaningful action: Why bother?[18]

For those like myself born at the end of the Baby-Boomer generation, and certainly for young people born two or three decades removed from the 1960s and 1970s, it may be difficult to fully grasp the "world behind the text" of *Dark Side*, the explosive atmosphere of the early 1960s in which the band members of Pink Floyd were coming of age. It was an era that Thomas Merton, the famous Catholic monk and spiritual writer, grimly called "a season of fury." Merton's friend and Catholic Worker peace activist Jim Forest remembers what it felt like in those years to be both American *and* a Roman Catholic, and more to the point, how those two deeply rooted cultural identities were, for many Catholics, inseparable:

> It was ten years since the first hydrogen bomb had been exploded, seventeen years since the destruction of Hiroshima and Nagasaki by much less powerful atom bombs. Americans were spending hundreds of millions of dollars on fallout shelters as a means of surviving nuclear war. . . . Both the United States and the Soviet Union had large programs for the development and stockpiling of chemical and biological weapons. "Peace" was a suspect word. Those who used it risked being regarded as "reds" or "pinkos." . . . The Roman Catholic Church in America in 1962, after many years of struggle with anti-Catholic prejudice, could be relied on to have a supportive attitude regarding America's economic system and foreign policy. Over many a Catholic parish or school entrance were carved the words, *Pro Deo et Patria*—for God and country. Many Catholics had made a career in the military, the FBI, and the CIA. For the first time, there was a Catholic in the White House.[19]

17. Di Perna, *Pink Floyd*, 46.

18. It is an interesting thought experiment: Which disposition, hatred or apathy, is more destructive and life-threatening to the flourishing of life on the planet? Which is more crippling to compassion, a commitment to justice, and the willingness to contribute one's particular gifts in service of the common good?

19. James Forest, foreword, in Thomas Merton, *Peace in the Post-Christian Era*, ed. Patricia A. Burton (Maryknoll, NY: Orbis, 2004), vii–viii. Merton's analysis of the "threat of communism" during the Cold War anticipates much of the political rhetoric surrounding the "war on terrorism" since the terrorist attacks of September 11, 2001, and the impact of such language in the public imagination as a driver of domestic and foreign policy.

In short, no less than their Protestant neighbors, most Catholics were deeply invested in the "American dream," the projection of US power throughout the world, and eager to do their part to maintain it. Such unswerving patriotism was generally reinforced and sanctified by the Church.

I have an older friend who vividly remembers the air raid drills that regularly interrupted the normal course of the day at his Catholic elementary school in the early 1960s. It was the height of the Cold War, when many Americans lived in constant fear that Russia was poised to attack major US population centers with nuclear missiles. My friend recalls the kindly Catholic nuns who were his teachers, as the air raid sirens went off, saying something like this: "Boys and girls, sit calmly on the floor beneath your desk, put your arms over your head, and *kiss your asses goodbye.*" Granted that last part of the story may be my friend's rhetorical flourish, but you get the point. It was an atmosphere in which, as a former professor recalls, "The whole country was having a nervous breakdown"[20]—not least those in positions of religious or political authority to whom young people looked for clarity, wisdom, and guidance. To question those authorities, much less to openly protest, was to risk being set apart from one's family, church, and other support networks, and targeted as unpatriotic, irreligious, and even blasphemous, insofar as God and country were joined in the popular consciousness. Yet what if, as the lyrics of "Brain Damage" suggest, it is precisely the "sane" ones, those "well-adjusted" to the status quo, including those in positions of authority, who are leading the world into madness, or at least permitting it by their silent complicity?

"And Every Day the Paper Boy Brings More": The Meaning of Sanity in an Insane World

The year 1961, when Roger Waters was eighteen, saw the trial of Adolf Eichmann, a lieutenant colonel in the Nazi party and one of the premier architects of Hitler's Final Solution. In a media event covered by live television feeds and reporters from around the world, Eichmann would be found guilty by an international court and hanged. Thomas Merton, in a remarkable essay published a few years after the trial, observed, "One of most disturbing facts that came out in the Eichmann trial was that a psychiatrist examined him and found him *perfectly sane.*" Merton continues,

> I do not doubt it at all, and this is precisely why I find it disturbing. If all the Nazis had been psychotics, as some of their leaders probably were, their appalling cruelty would have been in some sense easier to understand. It is much worse to consider this calm, "well-balanced," unperturbed official, conscientiously going about his desk work, his

20. Lawrence Cunningham, in *Soul Searching: The Journey of Thomas Merton*, dir. Morgan Atkinson (Duckworks, 2006).

administrative job in the great organization: which happened to be the supervision of mass murder. He was thoughtful, orderly, unimaginative. He had a profound respect for system, for law and order. He was obedient, loyal, a faithful officer of a great state. He served his government very well. He was not bothered much by guilt.[21]

Much like Waters's shift to the first-person perspective in "Brain Damage"—"There's someone in my head but it's not me"—Merton's essay gradually reverses our gaze from Eichmann to interrogate his readers, which is to say us, *our world*, the "world in front of the text," and more precisely, the cultural milieu of "Western civilization" that could produce such a person as Eichmann and follow lockstep in carrying out the murder of six million Jews. Questioning the very meaning of "sanity" in such a society, our complacent assumptions about who is and who is not sane, Merton confronts us with the disturbing possibility (to recall Tracy) that "something else might be the case."

> The sanity of Eichmann is disturbing. We equate sanity with a sense of justice, with humaneness, with prudence, with the capacity to love and understand other people. We are relying on the sane people of the world to preserve it from barbarism, madness, destruction. And now it begins to dawn on us that it is precisely the *sane* ones who are the most dangerous.
>
> It is the sane ones, the well-adapted ones, who can without qualms and without nausea aim the missiles and press the buttons that will initiate the great festival of destruction that they, *the sane ones*, have prepared. What makes us so sure, after all, that the danger comes from a psychotic getting into position to fire the first shot in a nuclear war? Psychotics will be suspect. The sane ones will keep them far from the button. No one suspects the sane, and the sane one will have *perfectly good reasons*, logical, well-adapted reasons, for firing the shot. They will be obeying sane orders that have come sanely down the chain of command. And because of their sanity they will have no qualms at all. When the missiles take off, then *it will be no mistake.*[22]

Lest one feel exempt from such a critique, Merton then turns his gaze on the church, asking whether Christians are in fact called "to be 'sane' like everybody else," to assume "that we *belong* in our kind of society," that "we must be 'realistic' about it. Certainly some of us are doing our best along those lines already. There are hopes! Even Christians can shake off their sentimental prejudices about charity, and become sane like Eichmann."[23] The grim sarcasm of

21. Thomas Merton, "A Devout Meditation in Memory of Adolf Eichmann," in *Raids on the Unspeakable* (New York: New Directions, 1966), 45.

22. Merton, "A Devout Meditation," 46–47.

23. Merton, "A Devout Meditation," 48.

Merton's voice here—adopting something of "Eichmann's own 'double-talk' about himself," which permitted him and millions of other cultured Europeans, which permits all of us in varying degrees, to rationalize evil—is not so distant, I think, from the anguished but deeply humane tenor of *Dark Side of the Moon*.

At one level, *Dark Side* rises from Waters's desire to get "inside the head" of his friend Syd Barrett, refusing to write him off as simply mad; but from there, and much more expansively, *Dark Side* rises from Pink Floyd's career-long refusal to turn a blind eye to the dark undercurrents of Western "civilization." Thus both Waters and Merton, through the power of poetic artistry, raise "certain fundamental questions that haunt us with the weight and excess of meaning that bears upon our finite horizon from the whole."[24] Merton concludes,

> I am beginning to think that "sanity" is no longer a value or an end in itself. The "sanity" of modern man is about as useful to him as the huge bulk and muscles of the dinosaur. If he were a little less sane, a little more doubtful, a little more aware of his absurdities and contradictions, perhaps there might be a possibility of his survival. But if he is sane, too sane . . . or perhaps we must say that in a society like ours the worst insanity is to be totally without anxiety, totally "sane."[25]

The costs of unthinking conformity, of adjusting ourselves to a way of life that, while it may seem "commonsensical," eminently "reasonable," productive, and efficient, is at the same time utterly void of compassion—"I was only following orders," was Eichmann's trial defense—are very high indeed, warns Merton. "And every day," Waters chimes in, "the paper boy brings more." Every day brings more evidence that Eichmann's kind of sanity is more pervasive in our society than we might care to think.[26] Thus again through the power of poetic artistry, both Merton and Waters interrogate the social realities we bring to our listening of *Dark Side of the Moon* today.

Even so, neither *Dark Side of the Moon* nor Merton's contemplative Christian vision of reality ends in complete despair, ironic detachment, or impotent sarcasm. For the attentive listener, those "with eyes to see and ears to hear," both Waters and Merton hold out the possibility that "something else might be the case," that we do not have to passively accept the way things are. We are capable of building a more humane and empathetic world, but are we willing? Neither artist offers easy answers, "pie in the sky" hope, or cheap grace—the idea, for

24. Recalling David Tracy on the classic, n. 8 above.

25. Merton, "A Devout Meditation," 49.

26. About "Brain Damage" an undergraduate wrote in her journal, "I interpret this song as a plea to examine how we live our lives. It is another reminder to check, periodically, if the person in my head really is me, to see whether I am considering my thoughts and actions or whether I've gone on auto-pilot to manage a difficult time." And another: "Perhaps the worst kind of insanity is to recognize that one is walking in the midst of a robotic society."

example, that "God will fix it," or, "All will be well one day in Heaven." The way forward cannot be predetermined by any political or religious ideology; still less can it be imposed by force or violence. With typical understatement, Waters hints at the way forward: "It's about the potential that human beings have for recognizing each other's humanity and responding to it, with empathy rather than antipathy," and "trying to be true to one's path" along the way.[27] Just as the pulsing of a human heartbeat and the opening lyric of *Dark Side* beckon the listener simply to "Breathe, breathe in the air / Don't be afraid to care," Merton, too, urges us to reclaim the tenderness and fiercest strength of the human heart: our basic "capacity to love and understand other people."[28]

"Hanging On in Quiet Desperation": The Relentless Pace of Modern Existence

Thirty years after the release of *Dark Side*, Waters recalled the moment it came to him that one could make an entire album about "all the pressures and difficulties and questions that crop up in one's life that create anxiety. And the potential you have to choose the path that you're going to walk."[29] In a word, Waters wanted *Dark Side* to express what it feels like to spend so much of our lives "on the run." Enter the opening tracks, which draw the listener into the narrative of a life treading frantically against the stream of time. The use of immersive sound effects—a human heartbeat, ticking clocks, running footsteps, heavy breathing, the disembodied voices of airport flight announcements, all rotating stereophonically *inside your head*—evoke a familiar, unsettling sense of alienation: alone in the crowd, moving through jetways of stainless steel and glass, artificial trees and concrete, cut off from equally hurried others, cut off from oneself, cut off from the earth.

In 1921, philosopher Bertrand Russell argued that industrialism "forces men, women, and children to live a life against instinct, unnatural, unspontaneous, artificial." He continued,

> Where industry is thoroughly developed, men are deprived of the sight of green fields and the smell of earth after rain; they are cooped together in irksome proximity, surrounded by noise and dirt, compelled to spend many hours a day performing some utterly uninteresting, monotonous mechanical task. . . . The result of this life against instinct is that industrial populations tend to be listless and trivial, in

27. Cited in David Detmer, "Dragged Down by the Stone: Pink Floyd, Alienation, and the Pressures of Life," in *Pink Floyd and Philosophy*, 67; citing John Harris, *The Dark Side of the Moon: The Making of the Pink Floyd Masterpiece.*

28. Merton, "A Devout Meditation," 46.

29. Cited in Di Perna, *Pink Floyd*, 42.

constant search of excitement, delighted by a murder, and still more delighted by a war.[30]

Well before Russell, Karl Marx had famously argued that whenever others control and direct my work, and reap enormous profits from it, I become alienated not only from my labor and innate creativity but also from my very humanity. The industrial worker, Marx concludes, "only feels himself freely active in his animal functions—eating, drinking, procreating . . . ; and in his human functions he no longer feels himself to be anything but an animal. What is animal becomes human and what is human becomes animal."[31] Or as Waters has it: "Run, rabbit run / Dig that hole, forget the sun / And when at last the work is done / Don't sit down it's time to dig another one." On their brilliant follow-up to *Dark Side*, the 1975 album *Wish You Were Here*, Pink Floyd frames this critical Marxist insight in still bleaker ironic imagery: "Welcome my son, welcome to the machine."[32]

Theologian Michael Paul Gallagher, whose ideas on faith and imagination we explored in the introduction, says this about the spaces we inhabit much of our lives, both literally and figuratively:

> We've been stuck for so long in a kind of narrow rationality. We fight with one another over ideas, and we forget that really most of our life is made out of the images we live from. Many people would say that we're caught in a kind of a cultural desolation, as it were, paralyzed in small spaces. I sometimes think that an airport is the most [desolate] place in the world. . . . It's pragmatic, everybody's worried about security, and duty-free, and rushing [about]. It's not a very spiritual space. And it induces in me a disposition *where wonder is not possible.* How do we get out of the small spaces towards that disposition where we can wonder, really wonder, and wonder together?[33]

Here we might recall, from chapter 1, Rabbi Heschel's description of wonder as "the forgotten mother tongue." The opening tracks of *Dark Side of the Moon* might be heard as a lament for the gradual asphyxiation of wonder as we move into the adult world, a world that seems constructed in every way to keep us on the run. What, or *who*, it might be good to ask, are we running from?

Part of the musical brilliance of *Dark Side* is the way it heightens all the listener's senses, if sometimes with a shock, to this very question. To immerse oneself in "Speak to Me / On the Run" is to feel oneself alive, being born even, as suggested by the heartbeat and "birthing" cries of singer Claire Torry, and at

30. Cited in Detmer, "Dragged Down by the Stone," 68.

31. Cited in Detmer, "Dragged Down by the Stone," 68.

32. Pink Floyd, "Welcome to the Machine," *Wish You Were Here*, Columbia, 1975.

33. Michael Paul Gallagher, "Dialogue between Faith and Imagination," *https://www.youtube .com/watch?v=JK3dpFbCtDQ.*

once *closed in upon* and suffocated by the relentless pressures and pace of modern life. By contrast to the watery womb and comforting throb of a mother's heartbeat, the world into which we are "thrown" at birth does not feel like an entirely welcoming, life-sustaining place.[34] The album's beautifully realized third track, "Time," which jars the listener to attention with a cacophony of alarm clocks all striking at once, drives home the album's narrative of modern existence as a relentless race against time, each day's end finding us "shorter of breath, one day closer to death." The song also boasts, as Di Perna observes, "one of the best guitar solos David Gilmour ever committed to disc,"[35] which is saying something. Gilmour's solo work here is transcendent.

The technological wizardry that envelops the listener throughout *Dark Side*, much of it the fruit of producer Alan Parsons's genius in the studio, cannot be dismissed as mere "electronic noodling" with synthesizers and tape loop machines. The band's obsessive experimentation with sound effects, ambient recordings, and snippets of unrehearsed interviews with roadies, famous musicians, and even the doorman at Abbey Road studios, served the band's artistic vision at every stage: to communicate the alienating effects of modern-day existence as it really is, and thus to facilitate in the listener the realization of truths we *already know intuitively* but that we tend to run from, or simply deny. One does not have to share Gallagher's disdain for airports to feel that something is out of kilter in the "rat race" of modern life. Increasingly the world we have constructed seems a place "where wonder is not possible." Why do we choose to construct and inhabit "such small places"? *Dark Side of the Moon* is the cry of the alienated soul made audible.

Once again the notion of synaesthesia is helpful here: the "simultaneous blending or convergence of two or more senses, hence a condition of heightened perception."[36] In her book *Sacred Sound, Sacred Space*, pioneering music therapist Susan Elizabeth Hale describes the physically small but synaesthetically very large world of sound in which human life is nurtured before birth:

> The inner ear is complete at four-and-a-half months in utero, 135 days after conception. . . . The fetal ear is comparable to a fully functioning adult ear. We hear our mother's heartbeat as a steady song. . . . In utero, an aural field is created that keeps our growing body in place. Mother's heartbeat and breath entrain us with a steady pulse to lock in our own inherent patterns. Our senses develop out of the matrix of the ear. Touch, taste, smell, and sight all have their foundation in the ear, which . . . "precedes the nervous system." In evolutionary terms, hearing is at least three hundred million years old. . . . During birth

34. The "thrown" character of modern existence is a persistent theme of twentieth-century existentialists such as Jean Paul Sartre. See Detmer, "Dragged Down by the Stone," 66.

35. Di Perna, *Pink Floyd*, 45.

36. Don Saliers, *Music and Theology*, 1; noted in chapter 1 with reference to Stevie Wonder.

we receive the imprint of our entire body surface as we pass through the vagina. The skin, the body's largest organ, is an extension of the ear. In the birth canal we "hear" with our skin as well as our ears. Our sound-body is mapped.[37]

In sum, it is here, says Hale, "in a woman's pregnant body, in the mysteries and miracles of birth," that we receive the "blueprint" for life. "This is where we become music."[38] Birth outside the mother's body then is a kind of "sonic labor," as the air that we share with every other creature on the planet rushes into our lungs for the very first time. The music of Life itself invites us to be.

If *Dark Side* represents a cry of loss and resistance against the rat race of modern existence, perhaps it also expresses the soul's longing for itself to "become music" again, that is, to rediscover what we already are: encoded from the very beginning to be in harmonic relationship with the world outside ourselves. *Dark Side* may even represent the implicit longing to rediscover the Great Mystery that binds human beings and cultures together under the name "God." It is not incidental that "Great Gig in the Sky" follows "Time," with its sonorous image of a bell tolling from "far away across the field" and calling "the faithful to their knees." If God is "the name we give to that voice in us which summons us to go beyond ourselves,"[39] then the marriage of Rick Wrights' sublime piano voicings and Claire Torry's vocal in "Great Gig in the Sky" may be one of the finest musical expressions of theological eros—the deep longing to touch and be touched by the divine—ever recorded. The flow of Life that tethers all things together in the Great Mystery—for many ancient cultures, the Great Mother—"beats in our very blood," says Merton, "whether we want it to or not."[40] In a similar flash of contemplative insight, Lebanese-American poet Kahlil Gibran writes of our primordial connection to all things from before the very beginning: "Your children are not your children. They are the sons and daughters of Life's longing for itself."[41] Might we grasp in Torry's singing something of "Life's longing for itself," the cry of the forgotten Mother tongue?

Spirituality, we might say, is no more and no less than the soul's "longing for itself" to discover the unique part it will play in the great symphony of Life. It is learning, with help from others, to listen to the spirits by which we choose to live our lives, and of "trying to be true to one's path" along the way. It is the creative gift and labor—the "giving birth"—of a lifetime.

37. Susan Elizabeth Hale, *Sacred Space, Sacred Sound: The Acoustic Mysteries of Holy Places* (Wheaton, IL: Quest, 2007), 2–3.

38. Hale, *Sacred Space*, 1.

39. Dorothee Soelle, *The Inward Road and the Way Back*, trans. David L. Sheidt (Eugene, OR: Wipf and Stock, 1975), 34, citing Reimar Lentz.

40. Thomas Merton, *New Seeds of Contemplation* (New York: New Directions, 1962), 297.

41. Kahlil Gibran, *The Prophet* (Hertfordshire, UK: Wordsworth Classics, 1996), 8.

"But Don't Take a Slice of My Pie": The Lure of Commercial Success

No discussion of *Dark Side* could be complete without reference to "Money," possibly the best-known song in the entire Pink Floyd catalog, and certainly the album's greatest hit. Earlier I made the case for "Us and Them" as *Dark Side's* thematic anchor, but one might just as easily place "Money" in that position. With its unusual 7/8 time signature, driving bass groove, ripping saxophone and guitar solos, and deliciously sardonic lyrics, "Money" closes out side one in straight-ahead rock and roll style as if to proclaim that what *really* gives life its meaning and purpose and makes the whole world go around is *cash*, and lots of it. If "Us and Them" seems to beckon us beyond the horrors of war toward kinship with other human beings, "Money" elevates the lure of materialism far above relationships in the hierarchy of happiness: "New car, caviar, four-star daydream / Think I'll buy me a football team." The song is satire at its best, but satire from which the band did not exempt itself as rising gods in the music industry pantheon.

The band's growing disillusionment with the drive for wealth and fame, as well as their own place in the rock industry "machine," would find climactic expression in its 1979 double-album masterwork, *The Wall*, which began as a visual concept for a live show in which a literal wall would be constructed between the band and audience during the concert. Thus "Money" on *Dark Side* anticipates another of the band's most emblematic and perfectly realized songs, "Comfortably Numb," from *The Wall*. Both songs in quite different ways suggest an existence in which the individual seems more and more desperately isolated, alone, and alienated from others and from self—the individual, to recall Gallagher, "paralyzed in small spaces."[42] Whether from straight-ahead ambition, accumulation, and greed as driven home in "Money" ("Don't give me that do-goody-good bullshit") or from social isolation, addiction, and gathering despair as powerfully evoked in "Comfortably Numb" ("Your lips move but I can't hear what you're saying"),[43] Waters narrates the inner landscape of postmodern alienation and spiritual emptiness about as sublimely, I think, as any rock lyricist of the era. And once again, David Gilmour's lead guitar solos on "Comfortably Numb" drive the narrative ecstatically and painfully down into the marrow.

In their influential work *Dialectic of Enlightenment*, Max Horkheimer and Theodor Adorno, critical theorists of the German Frankfurt School of philosophy, argued that "mass culture" as mediated by television and other forms of mass media has brought with it an unparalleled pressure toward social conformity, or "uniformity of expectation and desire," such that "the whole world is made to

42. Recall also philosopher Charles Taylor's notion of the "buffered self," as explored in the introduction.

43. Pink Floyd, "Comfortably Numb," *The Wall*, Columbia, 1979.

pass through the filter of the culture industry."[44] Within the now-globalized system of a culture industry that identifies human beings "merely as customers and employees," even truly novel artistic attempts to critique or circumvent the values of the dominant culture ultimately fail; more precisely, they tend to be absorbed and commodified into the cultural machine. Even works of art that represent revolutionary departures from the norm (e.g., as "protest art") are regarded, in the name of "style" or "innovation," "as calculated mutations which serve all the more strongly to confirm the validity of the system."[45] In other words, in an age of mass communication and mass marketing, works of art that spring from a revolutionary or "counter-cultural" spirit tend to be absorbed and their subversive content pacified by the culture industry.

The intended parody and cultural subversion of songs like "Money," "Comfortably Numb," and "Have a Cigar" (from *Wish You Were Here*) were certainly not lost on Pink Floyd, but can the same be said of the legions of fans who have "worshiped" the band and their music without themselves risking the more difficult path of critical self-reflection and cultural resistance as captured in such songs? As Waters recalls,

> It was magical in the early days of Floyd but the magic was eaten by the numbers. . . . [By 1977] when we were playing only big stadiums and selling out everywhere . . . all everyone was talking about was grosses and numbers and how many people there were in the house. And you could hardly hear yourself think. You could hardly hear anything [on stage] because there were so many drunk people in the stadium, all shouting and screaming.[46]

At what point does genuine communion between artist and audience give way to a kind of idolatrous or hedonist dynamic of escape, apathy, and social disengagement, the dead-eyed path toward "comfortably numb"? For Waters, the specter of tens of thousands of fans turning themselves into drunken automatons was not so far from the mass conformity and mindless adulation showered upon Hitler during the Nuremberg rallies.[47]

Thus while both *Dark Side* and *The Wall* stand as brilliant monuments to an era in which rock and roll "really did loom larger than life"[48] and epitomize the power of countercultural movements, they also represent the band's trenchant

44. Cited in Matthew Minix, "Mass Culture or *Mass* Culture? The Frankfurt School's Critique of the Culture Industry vs. the Catholic Imagination of Bishop Fulton J. Sheen," in *God's Grandeur: The Arts and Imagination in Theology*, ed. David C. Robinson (Maryknoll, NY: Orbis, 2006), 225.

45. Cited in Minix, "Mass Culture," 226.

46. Cited in Di Perna, *Pink Floyd*, 66.

47. The comparison is made bleakly clear in the live-action/animated film *The Wall*, directed by Alan Parker (MGM, 1982).

48. Di Perna, *Pink Floyd*, 72.

indictment of corporate rock and the now-ubiquitous culture industry, where the lines between artistic freedom and the commodity culture seem precariously thin. The band's own struggles with these combustible forces would prove too great to hold the group together much beyond *The Wall*.

"Into the Valley of the Human": Art and the Sacred Dimension

Our exploration of *Dark Side of the Moon* has traversed three distinct but inseparable worlds:

- the world *behind* the text (the historical, social, and existential context of the artists)
- the world *within* the text (the immersive content of the album itself as an aesthetic whole and as the convergence of many parts)
- the world *in front of* the text, which is our world, the world of the listener, the questions that *we* bring to the album when we listen

By contrast to a period piece, the mark of a classic is its capacity to cross these worlds meaningfully over the course of many generations and in diverse cultural settings.[49]

The classic stirs something ineffably deep across social boundaries that we might dare to call our common humanity, the wellspring of empathy that sleeps in everyone. Whether those elements of "common humanity" borne by the classic are in fact life-giving, such as love and compassion, or life-diminishing, as in greed or hatred, we can dare to speak of a "we" at all because the mature person recognizes such human qualities in themselves and in the collective social body. Arguably more than ideas or concepts, philosophical or religious systems, art plunges us directly "into the valley of the human,"[50] where we are able to recognize the basic contours of human experience in one another.

But I have also suggested that art lifts us, at least implicitly, to the heights of the divine, and that this may be so even for an outwardly "secular" work such as *Dark Side of the Moon*. Classic religious thinkers like Heschel or Merton would suggest that great art touches the divine not in opposition or inverse proportion to the work's human elements but rather in direct proportion to its most human elements: in the ecstatic singing of Claire Torry, for example,

49. As David Gilmour observes of *Dark Side*, "The ideas that Roger was exploring apply to every new generation. They still have very much the same relevance as they had." See Johnston, "*I and Thou*," 137–38.

50. The phrase is borrowed from Jesuit scholar William Lynch, *Images of Hope: Imagination as Healer of the Hopeless* (Baltimore: Helicon, 1965), 117.

which seems to capture both a yearning for transcendence and a realization of it at the same time.[51]

In other words, from a contemplative point of view, there is no such thing as a purely secular or a purely spiritual experience, if by "spiritual" we mean divorced from history or abstracted from the body, from what it feels like to live *in the flesh* through time and space as individuals and as members of the social body. *Dark Side* is a "spiritual classic" not because the music draws us into some holy realm *apart* from human experience but precisely because it plunges the listener wholesale into the valley of the human, everywhere limned with sacred potentiality.

Perhaps it is enough to say, with Tracy, that the album still claims our attention "because of the intensification of meaning and value" that occurs in the work.[52] Yet insofar as *Dark Side* helps us to slow down, to "breathe in the air" and reflect on the state of our being honestly and directly instead of running from it, then we are drawing nearer, in religious terms, to the divine Presence in whom we secretly live, move, and discover our true being. To my mind, *Dark Side of the Moon* at least hints in such theological, or theopoetical, directions. Revising Waters slightly, we might say that *Dark Side* appeals to that sacred capacity in each of us "for recognizing each other's humanity and responding to it with empathy." It urges us not toward numbness and conformity but toward vitality and wakefulness, helping us, in Merton's words, to cross "the abyss that separates us from ourselves."[53] Confronting that abyss is rarely comfortable or easy, but it is the way that opens out toward greater freedom, fulfillment, and joy in the community of all things.

Addendum and Additional Resources

Extending the bridge between epistemology and faith to the realm of the arts, the articles by Detmer and Johnston provide insightful analyses of Pink Floyd's music against the horizon of modern (and postmodern) existence. Merton intensifies themes raised by Detmer and Johnston with an eye on Auschwitz, the Vietnam War, and the self-justifying language of all war, which has much in common with the circular logic of advertising. In one of the best treatments of the topic I've seen,

51. See, for example, Thomas Merton, "Message to Poets," in *Raids on the Unspeakable*, 155–61; Abraham Joshua Heschel, *The Ineffable Name of God: Man* (New York: Continuum, 2005). During the recording sessions for *Dark Side*, before "Great Gig in the Sky" was titled, the band had marked out the song's place in the sequence of tracks with the heading, "God, death, religion," and their coaching of Claire Torry as to what they had in mind for her vocal emphasized these themes. See the documentary *Classic Albums: Pink Floyd: Dark Side of the Moon* (Eagle Rock Entertainment, 2003).

52. As one student wrote in his journal, "This album has changed my music experience completely. And music as a whole was changed because of this album. You really don't see this kind of complexity anymore and it's something that should be cherished."

53. Thomas Merton, *The Wisdom of the Desert* (New York: New Directions, 1960), 11.

Catholic theologian Monika Hellwig explores the tensions in the religious believer's life between conformity to societal expectations and the prophetic call to resistance and dissent when human dignity is systematically violated. Hellwig's article provides a superb framework for the appreciation of "countercultural" expressions in music and popular culture, present to past, not least the 1960s counterculture. Musicologist Don Saliers complements the material in this chapter with his discussion of synaesthesia and the permeable boundaries between "sacred" and "secular" music.

Books, Articles, and Essays

Detmer, David. "Dragged Down by the Stone: Pink Floyd, Alienation, and the Pressures of Life." In *Pink Floyd and Philosophy: Careful with That Axiom, Eugene!*, edited by George A. Reisch, 61–80. Chicago: Open Court, 2007.

Hellwig, Monika. "Conformity and Critical Dissent." In *Public Dimensions of a Believer's Life: Rediscovering the Cardinal Virtues*, 1–12. Lanham, MD: Rowman & Littlefield, 2005.

Johnston, David MacGregor. "*I and Thou* and 'Us and Them': Existential Encounters on *The Dark Side of the Moon* (and Beyond)." In *Pink Floyd and Philosophy: Careful with That Axiom, Eugene!*, edited by George A. Reisch, 121–38. Chicago: Open Court, 2007.

Merton, Thomas. "A Devout Meditation in Memory of Adolf Eichmann." In *Raids on the Unspeakable*, 45–49. New York: New Directions, 1966.

———."War and the Crisis of Language." In *Passion for Peace: The Social Essays*, edited by William H. Shannon, 300–14. New York: Crossroad, 1997.

Saliers, Don. "Sound, Synaesthesis and Spirituality." In *Music and Theology*, 1–9. Nashville: Abingdon, 2007.

———. "Beyond 'Sacred' and 'Secular,'" in *Music and Theology*, 55–64. Nashville: Abingdon, 2007.

Music, Audio, and Visual

Themes of alienation and the human costs of war—especially its impact on the young—in Dylan, Springsteen, Sting, and Withers further illumine the "world behind the text" in Pink Floyd's music.

Classic Albums: Pink Floyd: Dark Side of the Moon. Directed by Matthew Longfellow. Eagle Rock Entertainment, 2003.

Dylan, Bob. "Masters of War." *The Freewheelin' Bob Dylan*. Columbia, 1963.

Pink Floyd. "Comfortably Numb." *The Wall*. Columbia,1979.

Springsteen, Bruce. "Shut Out the Light." *Tracks*. Columbia, 1998.

Sting. "Russians." *The Dream of the Blue Turtles*. A&M, 1985.

———. "Fragile." *Nothing Like the Sun*. A&M, 1987.

Withers, Bill. "I Can't Write Left-Handed." *Bill Withers Live at Carnegie Hall*. 1973.

3

"Back to the Garden"

Joni Mitchell and Bruce Cockburn: Poets of the Canadian Counterculture

> To contemplate is to be in love.
> —*Walter Burghardt, SJ*

> The Poetry of the earth is never dead.
> —*John Keats*

Late one evening in 1966, a young woman stepped through the doorway of a coffeehouse in the Yorkville neighborhood of Manhattan's Upper East Side, and noticed another young woman tuning her guitar on a small stage in a dark corner of the room. Her long blonde hair hanging like parted curtains over her face, the musician spent several long moments adjusting the strings, and then, evidently satisfied with her tunings, she began to play.

The woman who had walked in stood near the doorway, spellbound. Her name was Malka Marom, and the woman singing in near darkness on the stage was Joni Mitchell. Some forty years later, Marom recalled the moment that would alter her life forever. "I was going through a divorce then, and I just felt, I don't know what it was—talk about a new way of conveying, through music, through words, a new way of conveying an existential reality—I just started to sob. She sang it so real, so true, as if she were singing for me. She was my voice, you know, she was everybody's voice, she was like a universal voice." All distance between the artist and her listener seems to have dissolved, the two strangers now bound together in unexpected intimacy. "I was *amazed* that she was so young. You know, there was so much wisdom in her work."[1]

CASE STUDIES

Joni Mitchell, *Ladies of the Canyon*
Bruce Cockburn, *Salt, Sun and Time*

1. From *Joni Mitchell: Woman of Heart and Mind: A Life Story*, dir. Susan Lacy and Stephanie Bennett (Eagle Rock Entertainment, 2003); hereafter *Woman of Heart and Mind*.

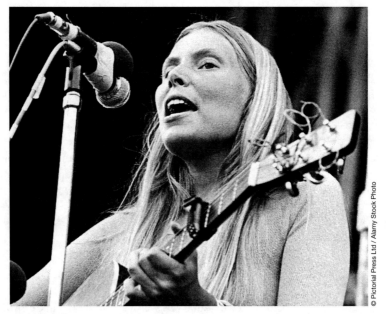

Joni Mitchell

The song was "I Had a King," a beautifully spare and plaintive lament for the ending of Joni Mitchell's own brief and ill-fated marriage to Chuck Mitchell: "I had a king dressed in drip-dry and paisley / Lately he's taken to saying I'm crazy and blind / He lives in another time / . . . I can't go back there anymore / You know my keys won't fit the door. / You know my thoughts don't fit the man / They never can."[2] The song would find a much larger audience in 1968 as the opening track on Mitchell's first album, the self-titled *Joni Mitchell*, also known as *Song to a Seagull*, a strikingly mature debut work for this twenty-four-year-old painter and songwriter from Alberta, Canada.

But in 1966, Mitchell was still finding her way before uninitiated audiences in America. David Crosby—founding member of The Byrds and then Crosby, Stills and Nash—recalls hearing her play for the first time in Greenwich Village: "She rocked me back up against the back wall of that place and I stood there just transfixed. I couldn't believe there was anybody that good."[3] Musician Lachlan MacLearn remembers seeing Mitchell walk onto the stage at the famed Newport Folk Festival in the summer of 1966:

It was a breezy summer's evening and the crowd was restless. I remember thinking that this newcomer, whoever she was, was stepping into

2. *Joni Mitchell* (*Song to a Seagull*), prod. David Crosby, Reprise, 1968.

3. *Woman of Heart and Mind.*

some serious company. . . . The song was "Michael from Mountains." And by the end of the first verse, the crowd had gone from bordering-rude to pin-drop silence. I was riveted. When the song ended, the strangest thing occurred. For at least five seconds the place was dead silent—ten or fifteen thousand people—dead silent—and then a huge release of cheers and applause.[4]

What is it about Joni Mitchell that has transfixed so many listeners and audiences down through the years? David Crosby reaches for an explanation: "She can distill an experience or a feeling into song better than anyone. She is one of those ones where the sparks all connect, you know? There's some magic that took place there."[5] What is this magic, this resonance that moves the soul of the receptive listener? Empathy? Poetic genius? Pure creative talent? Dare we call it AFM?[6]

Poets and Prophets of a Restless Generation

While Joni Mitchell belongs to the same postwar generation as Pink Floyd, she embodies an artistic trajectory within the 1960s counterculture epitomized by coffeehouses and iconic open-air festivals such as Woodstock in contrast to Pink Floyd's psychedelic walls of sound, electronic studio experimentation, and the large-scale, sound-and-light spectacle of arena rock. The coffeehouse and small-club environment called forth a much more intimate form of musical expression: the "singer-songwriter," typically alone on stage, with nothing between them-selves and audience but a guitar, a microphone, and the power of the poetic word to draw people together. As a student wrote in her journal of Joni Mitchell, "Her musical talent is great but so also is her talent for empathy. . . . Emotions are very hard things to put into words, and I think that's what singers and songwrit-ers do for people. People can listen to a song and say 'yes, that's exactly how I feel.' It's very comforting just to know that somebody understands what you're feeling."

At the same moment Joni Mitchell was breaking onto the burgeoning folk music scene in the United States—with others like Bob Dylan, Joan Baez, Phil Ochs, Odetta, and James Taylor leading the way—another extraordinary young singer-songwriter was cutting his musical teeth in small clubs in his hometown of Ottawa, Toronto, and other cities across Canada. Two years Mitchell's junior, Bruce Cockburn (pronounced *Coe*-burn) would eventually become one of the most celebrated artists in Canada and indeed around the world. Though far less

4. From Wally Breese, "Biography: 1964–1968 Early Years," 1998 Biography Series by Wally Breese, *Joni Mitchell*, http://jonimitchell.com/biography/.

5. *Woman of Heart and Mind.*

6. A technical theological term introduced near the end of chapter 1.

Bruce Cockburn

a household name in the United States than is Mitchell, Cockburn is revered by Canadians and by musicians worldwide as one of the finest guitarists and poets of his generation.[7] He is also widely respected—and sometimes maligned—for his tireless political activism on issues from indigenous rights and landmines to the environmental crisis and debt relief for developing nations, working with organizations like Oxfam, Amnesty International, Doctors Without Borders, and Friends of the Earth.

Much like Mitchell's, Cockburn's music reverberates with intense powers of observation about human experience along with a deep sense of spiritual connection to the natural world. As Canadian author William Paul Young observes, "There's a profound sense in Bruce's music of caring for the planet, caring for other human beings. He becomes a conduit to attach our emotional and spiritual lives, to infuse ourselves into the reality of some of the damage and the hurt that exists in the world today."[8] Cockburn himself puts it this way: "The harder everything gets the more dependent on each other we're going to be, and that's where we need to be putting the work in. So being able to share a bunch of feelings with people, a vision of life with people, to me seems like an essentially

7. Cockburn has been honored with twelve Juno Awards (Canada's premier music awards, akin to the Grammy Awards in the United States), induction into the Canadian Music Hall of Fame, a Governor General's Performing Arts Award, and in 2003 was made an Officer of the Order of Canada.

8. Cited in *Bruce Cockburn: Pacing the Cage*, dir. Joel Goldberg (True North, 2013); hereafter *Pacing the Cage.*

hopeful enterprise."[9] Here is the central theme of this chapter: to share one's emotional journey and a vision of life with other people *is an essentially hopeful enterprise*. This is the gift that both Joni Mitchell and Bruce Cockburn have been to me since I first began listening to their music in my early twenties, and which many of my students have come to appreciate.

Joni Mitchell's third studio album, *Ladies of the Canyon* (1970), is a masterwork of lyrical insight married to sophisticated guitar and piano arrangements. While the album boasts three of her best-known early classics, "Big Yellow Taxi," "Woodstock," and "The Circle Game," its lesser-known songs paint intimate portraits of human life in motion: the dance of friendship and conversation, daydreams and dreams dying, the yearning for meaning and fulfillment amid the relentless pace of modern existence. Cockburn's fifth studio album, *Salt, Sun and Time* (1974) is one of his most spare yet richly evocative works in a career spanning almost five decades and thirty-two albums. While *Ladies of the Canyon* chronicles the rhythms of life from small towns and big cities to the rugged canyons of southern California, Cockburn's visual landscape is decidedly nautical. As its title suggests, much of *Salt, Sun and Time* was inspired by the sea, evoking the solitude and wonder of an Earth-haunted pilgrim.

Once again, before reading on, I urge you to immerse yourself in both albums, let yourself linger in their synaesthetic landscapes, observe what arises, and journal from them. See if you don't discover that both artists do much more than "share a bunch of feelings with people." They also share a "vision of life," as Cockburn has it, a contemplative way of seeing and embracing life's wonders, large and small, which come before us every day. Perhaps above all, both artists share an intense appreciation for beauty, a poetic eye that revels "in the small glories of particularity" and reaches for poetry as "the crystallization of life, reality given distinction and definition."[10]

"Coloring the Sunshine Hours": The Art of Paying Attention

Poet Andrew Rumsey describes the particular gift of poetry—and here we may add the gift of outstanding songwriting—in terms of its capacity to deepen human consciousness in three dimensions: *attention, presence,* and *resonance*. Poets are driven first, says Rumsey, "by the desire to really *see* what is before them, to *attend* to particulars in all their uniqueness and diversity."[11]

9. *Pacing the Cage.*

10. Andrew Rumsey, "Through Poetry: Particularity and the Call to Attention," in *Beholding the Glory: Incarnation through the Arts,* ed. Jeremy Begbie (Grand Rapids: Baker Academic, 2001), 47–63.

11. Rumsey, "Particularity and the Call to Attention," 51.

Ladies of the Canyon is nothing if not a sublime case study in the art of paying attention. Its opening four tracks unfold like a succession of landscape paintings, each song inviting us to see and to savor the "glories of particularity" hidden, as it were, in plain sight: that delightful time at the break of day when a small town begins to awaken and people begin their dignified rhythms of work and leisure ("Morning Morgantown"); a solitary street musician playing "real good for free," while crowds bustle by unawares ("For Free"); the dance of "comfort and conversation" between two friends, meeting over coffee or a simple meal of "apples and cheeses" ("Conversation"); the beauty of three women, each with a distinctive energy and gift she brings to the community ("Ladies of the Canyon").

What leaps out in Mitchell's songwriting is not only the "distinction and definition" given to every element of the scene, as Rumsey notes of effective poetry; it is also "the *arrangement* of these particulars together that is crucial; their unique relationship in space and time upon which so much depends."[12] Thus from "Ladies of the Canyon," the title track of the album:

Trina takes her paints and her threads / And she weaves a pattern all her own
Annie bakes her cakes and her breads / And she gathers flowers for her home
For her home she gathers flowers / And Estrella dear companion
Colors up the sunshine hours / Pouring music down the canyon
Coloring the sunshine hours / They are the ladies of the canyon[13]

The poet attunes our attention to those hidden "colors," as it were, which "pour music down" and "weave a pattern" all their own in and through human life in community.

The wonderment that is "the crystallization of life" cannot be expressed in abstract generalities but can only be brought to life for the listener through concrete details or metaphors that break open the imagination. Consider the play of imagery and metaphor in "Never So Free," for me one of the most beautiful and haunting tracks on Cockburn's *Salt, Sun and Time.*

Fishing boat stretched out at low tide / Dog and a black man work on the deck
Bright as a bottle, sunlight skips wave to wave
Part of a map of somewhere / Teases my foot like a haunting dream
Never so free, I'm lost in the seagulls' flight[14]

The term "resonance," as Rumsey notes, "has a wonderful *suggestive* capacity."[15] In other words, the meaning of a good metaphor or effective storytelling remains

12. Rumsey, "Particularity and the Call to Attention," 52.

13. Joni Mitchell, *Ladies of the Canyon*, Reprise, 1970.

14. Bruce Cockburn, *Salt, Sun and Time*, True North, 1974.

15. Rumsey, "Particularity and the Call to Attention," 59.

open and allusive. What can it mean to say that "Part of a map of somewhere / Teases my foot like a haunting dream"? No singular or "correct" interpretation can be pinned down. The image will reverberate differently (or not) in every listener. In other words, the metaphor bears power to the degree it "captures a subject while at the same time setting it free. It reveals the particular to us almost *by* releasing it to mean more than we can express."[16] It is just this "almost" and "more than" quality of metaphorical speech, the poet's refusal to fix the meaning or truth of a scene for us, which accounts for the power of so much of Mitchell's and Cockburn's music. Like impressionist painters, both artists "gesture" and "allude" far more than they circumscribe and define. The ineffable remains.

"Something Is Shining Like Gold": Hints of the Divine Presence

"Little 'annunciations' bombard the poet,"[17] notes Rumsey, and *Salt, Sun and Time* might be described as a mosaic of Monet-like annunciations. The album's fourth track, "Stained Glass," bears the listener across the fluid boundaries between the inner and outer worlds of human experience:

> Small windows / Looking outward / Show me a sequined sky /
> Rubies shine in my glass of wine / Like today I'm far away /
> I see your face behind each time-blurred pane . . . /
> Across a fold in space you touch my hand.

The poet trains the listener's eye to look out for small epiphanies. Even a glass of wine holds a beautiful secret for those with eyes to see. Reality comes before us with a certain "otherness," a kind of *presence* that both demands and eludes verbal expression. And so the poet reaches for metaphor to give voice to the ineffable, seeking to bridge the gap between what we sense and what we can say.

Once again, as noted in chapter 1, notice how the word "presence" connotes a reality that is both spatial and temporal. It says, I am here, now, in this place, in this moment. I am not somewhere else. My whole being is fully present. And because I am fully present, reality is present to me with breathtaking clarity. Whether standing on a busy street corner watching a musician "playing real good for free," or mesmerized by "diamonds" sparkling on the sea, the poet's gift is the gift of *resonance*—patterning language in ways that move the soul of the receptive listener. Arguably every track of *Salt, Sun and Time*, including the instrumentals, reflects a mind and heart seeking to pay attention, "to refine, to clarify, to intensify that eternal moment in which we alone live."[18]

16. Rumsey, "Particularity and the Call to Attention," 59.

17. Rumsey, "Particularity and the Call to Attention," 54.

18. William Carlos Williams, quoted in Rumsey, "Particularity and the Call to Attention," 51.

Cockburn gestures a step further still, intimating that *God*—for believers, the Divine Other at the heart of reality—seeks to bridge the gap between eternity and history, and has done so in the person of Jesus Christ. In "All the Diamonds," the opening track of *Salt, Sun and Time,* the poet sees Christ—without ever using the name—coming toward us, shipbound and shining, "like a pearl in a sea of liquid jade"; and again, "like a crystal swan in a sky of suns." The finger-style guitar pattern through which Cockburn draws the listener into the narrative is itself like diamonds, sparkling rhythmically before the eyes, disappearing and reappearing again across an undulating sea. In numerous interviews over the years, Cockburn has described "All the Diamonds" as a turning point.

> This is a song I wrote the day after I actually took a look at myself and realized that I was a Christian in fact—which I guess is a kind of conversion. It was a very long term, slow [conversion], not the light and voice from heaven like Saint Paul. But when it finally was over, I had to look at my life and either commit myself to it, or pass. Fortunately I was invited to commit myself to it and I wrote this song right after . . .[19]
> . . . It's emotional, in a way. It marks a signal moment in my life. It's there. But I have to think when I perform it now, because I don't want to be associated with certain aspects of the Christian culture and tradition. I'm not so inclined to think of the imagery of what we associate with Christianity—the guy on the cross with the beard. It's not so much that, as it is about what we call the Holy Spirit.[20]

That last point is significant, effectively keeping Cockburn's music open to a much wider audience than a Christian one. Indeed, though he has long identified publicly as a Christian, Cockburn's lyrics are rarely confessional in an overt sense. In a 2002 interview, he described his faith as "less attached to the visual imagery [of Jesus] that we read about in the Bible" and more like "an ongoing process of trying to understand things more deeply."[21] Where Christ is present in Cockburn's songs, he often remains nameless, shimmering from within things, just behind the veil. "I have the sense of Christ as a bridge in a way, but an organic, living, breathing, pulsating bridge from me to God."[22]

Above all, the divine seems to shine for Cockburn in persons—beautiful, broken persons. In "Rumours of Glory," from the 1980 album *Humans,* he observes people massed together in a crowd—"each one alone but not alone"—each person's

19. From "Bruce Cockburn: Live at Hastings Lake, Alberta, Lutheran Student Movement National Study Conference," August 30–31, 1979, cited in *The Cockburn Project, http://cockburnproject .net/songs&music/atd.html.*

20. From Brad Wheeler, "Bruce Cockburn Set for Luminato Honours," *The Globe and Mail,* June 16, 2010, *http://cockburnproject.net/songs&music/atd.html.*

21. Bruce Cockburn, "All the Diamonds . . . on One Album," interview with Paul Alkazraji, January 27, 2002, *The Cockburn Project, http://cockburnproject.net/news/20020127paul.html.*

22. Cockburn, "All the Diamonds . . . on One Album."

face opaque behind a shroud of anonymity and yet translucent all at once. "Behind the pain / fear / etched on the faces / something is shining / like Gold but better / Rumours of glory."[23] The divine presence—the potential for generosity, creativity, love, "glory"—is discernible in every human face, suggests the poet, yet how easy it is to miss, to see only pain, loneliness, fear. Thus by contrast to many Christian artists, whose lyrics seem to identify faith with certitude, and whose Christ tends to appear frozen in flood-lit glory far above the messiness of history, Cockburn's music reflects the faith of a world-haunted pilgrim, traveling in the shadowlands between life and death, despair and hope, defeat and glory. For the pilgrim believer, Christ remains a "rumour," stirring in all things, "like Gold but better."[24]

To say it another way, the poet's sense of presence must always, and often in the same breath, contend with *absence*, with not-seeing, with longing and uncertainty, with death. Indeed, as Rumsey notes, poetry gains definition and resonance precisely from the contrast between presence and absence, "for in an absent world, the presents are all the more vital."[25] The play of paradoxes—light and darkness, life and death, joy and pain, desire and fulfillment—suffuse Cockburn's lyrics, reflecting the tension of a faith always *in motion*, ever searching, sometimes finding, and sometimes being found, as hints of the divine break through. And yet sometimes the absence, the seeming God-forsakenness of human existence, simply overwhelms. Once again, to recall Heschel from chapter 1, the sense of wonder and awe includes the painful, the hard, the unspeakable.

"In the Valley of the Shadow of Death": The Poet as Prophet

Nowhere does absence and despair overwhelm the songwriter more piercingly than in Cockburn's devastating recording of 1984, "If I Had a Rocket Launcher,"[26] a song written after he had spent several days visiting Guatemalan refugee camps in the border region of Chiapas, Mexico.[27] A day after leaving

23. Bruce Cockburn, *Humans*, Rounder, 1980.

24. Compare to the beautiful Hindu greeting, "Vanakkam. Namaste," which means, "the divine presence in me greets the divine presence in you." Or the poetry of David Whyte: "To be human is to become visible / while carrying what is hidden as a gift to others. / To remember the other world in this world / is to live in your true inheritance." See David Whyte, "What to Remember When Waking," *Awakin.org., http://www.awakin.org/read/view.php?tid=994*.

25. Rumsey, "Particularity and the Call to Attention," 55.

26. From Bruce Cockburn, *Stealing Fire*, True North, 1984. The official music video is here: *https://www.youtube.com/watch?v=N7vCww3j2-w*, and numerous live performances can be found via the internet.

27. In early 1983, at the invitation of the world hunger organization Oxfam, Cockburn and a group of other Canadian artists spent several weeks in Nicaragua and other Central American countries devastated by years of conflict and so-called low-intensity warfare, a war financed and more or less directed by the US government.

the camps, where the refugees he met "were starved, denied medical care, and were still subjected to [brutal, cross-border] attacks by the Guatemalan army," Cockburn sat in his hotel room, and over tears and a bottle of scotch, set down his experience in song.[28] Set darkly over a hypnotic guitar riff, verse one paints a scene of descending dread as a helicopter gunship approaches the refugee camp, "second time today," while "everybody scatters and hopes it goes away." The second verse unleashes contempt for military generals and "their stinking torture states," while verse three raises a piercing lament for the people of Guatemala, "with a corpse in every gate." The final verse looks almost desperately to the future, as the singer confesses his determination "to raise every voice, at least I've got to try." The refrain warns anybody who will listen, everybody and nobody at once, "If I had a rocket launcher / some son of a bitch would die."[29]

In repeated interviews about the song, Cockburn is quick to point out that the lyrics reflect his very raw and personal experience of the camps: "I can't imagine writing it under any other conditions."[30] At the same time, he gestures to something more: "Aside from airing my own experience, which is where the songs always start, if we're ever going to find a solution for this ongoing passion for wasting each other, we have to start [by confronting] the rage [within ourselves] that knows no impediments, an uncivilized rage that says it's okay to go out and shoot someone."[31] In his notebooks from the refugee camps, alongside the names and stories of the survivors, Cockburn had scribbled these words: "I understand now why people want to kill."[32]

In a recent documentary, Bono, lead singer of the Irish rock band U2 and one of the music-world's most prominent humanitarians, asks, "Why do we need art, why do we need the lyric poetry of the Psalms?" He responds, "Because the only way we can approach God is if we're honest."[33] Much like Cockburn, Bono has long been publically "out" as a Christian, yet he shares Cockburn's suspicion

28. Cited in Bruce Cockburn, *Bruce Cockburn: Rumours of Glory: 1980–1990*, ed. Arthur McGregor (New York: OFC Publications, 1990).

29. For an extended analysis alongside other examples of protest music and in the context of Ignatian spirituality, see Christopher Pramuk, "Beauty Limned in Violence: Experimenting with Protest Music in the Ignatian Classroom," in *Transforming Ourselves, Transforming the World: Justice in Jesuit Higher Education*, ed. Mary Beth Combs and Patricia Ruggiano Schmidt (New York: Fordham University Press, 2013), 15–29.

30. Bruce Cockburn, "The Long March of Bruce Cockburn," interview with Richard Harrington, *Washington Post*, October 19, 1984, *https://www.washingtonpost.com/archive/lifestyle/1984/10/19/the-long-march-of-bruce-cockburn/9d67d55a-deb7-4139-9605-abe1294f0c94/?utm_term=.a901379ec283.*

31. "The Long March."

32. From Steve Pond, "Bruce Cockburn Launches a Hit," *Rolling Stone*, May 23, 1985, cited in *http://cockburnproject.net/songs&music/iiharl.html.*

33. "Bono Discusses the Psalms with Eugene Peterson," *Sojourners*, 4/27/2016, *https://sojo.net/articles/watch-bono-discusses-psalms-urges-christian-artists-be-more-honest.*

of music marketed as "Christian."[34] In contrast to the Bible, and the Psalms in particular, Bono suggests that a lot of Christian music suffers from a "lack of realism," failing to confront the moral complexity and emotional struggle that attends a relationship with God. The psalmist, by contrast, "is brutally honest about the explosive joy that he's feeling and the deep sorrow or confusion," says Bono. "And that's what sets the Psalms apart for me. And I often think, 'God, well why isn't church music more like that?'"[35]

In other words, if the Bible would be our guide to the divine-human relationship, authentic faith is not an escape from suffering, struggle, and doubt; rather, faith is the reassurance and trust that we are not alone in our inevitable, human anguish. It would be more authentic and truthful, says Bono, if Christian artists would "write a song about their bad marriage, write a song about how they're pissed off at the government, because that's what God wants from you, the truth. Weigh the truth . . . the truth will set you free. It will blow things apart."[36] As Cockburn discovered in the Guatemalan refugee camps, faith is not an escape from evil and senseless suffering, but a deepening, sometimes terrifying plunge into "the valley of the human."[37]

Like almost no other artist in my pilgrimage of fifty years, Cockburn has gifted me with a soundtrack for seeing beneath the surfaces of a world caught in the "valley of the shadow of death," as the author of Psalm 23 famously puts it, even as that same world shimmers with resurrection hope. In Cockburn's telling, the dark light of faith remains a suggestive half-light, fiercely hopeful and committed to life, yet always shadowed by the brutality and apparent meaninglessness of the cross.

Somehow that vision of light *in* darkness, with eyes open on the terrible injustices of the world, is profoundly consoling. Cockburn is that rare artist whose work blends both the mystical and the prophetic strands of the Christian tradition, in which to live, and, yes, to struggle with others in the womb of faith "is an essentially hopeful enterprise." "Like small windows / looking outward," the face of Christ—for Christians, the incarnate love and mercy of God—breaks through the veil between despair and hope, intellect

34. Canadian theologian Brian Walsh, author of a compelling theological study of Cockburn's music, observes that "Bruce has said that biblical faith hangs on loving God and loving neighbor and it seems that [a lot of religious practice] is all about loving God and hating their neighbor." In *Bruce Cockburn: Pacing the Cage*, dir. Joel Goldberg (True North, 2013); see also Brian Walsh, *Kicking at the Darkness: Bruce Cockburn and the Christian Imagination* (Grand Rapids: Brazos, 2011). Cockburn himself puts it rather more pointedly: "Well you know human history is largely filled with bullshit, and one of the most obvious ways the bullshit is expressed is through publicly acceptable religious affiliation. . . . [There can be] a lot of pathology involved in human beings' religious faith" (*Pacing the Cage*).

35. "Bono Discusses the Psalms."

36. "Bono Discusses the Psalms."

37. See chapter 2; the image is borrowed from William Lynch, *Images of Hope: Imagination as Healer of the Hopeless* (Baltimore: Helicon, 1965).

and imagination. "I see your face behind each time-blurred pane . . . / Across a fold in space you touch my hand."

About writing from within those liminal, threshold, or "in-between" spaces, Cockburn explains, "There's a subconscious element that goes into the songs, it's subtle, it's not like I go into a trance and write whatever comes to my head, but if I let myself go in terms of imagery and just write the imagery that comes to mind, it's very expressive of genuine feelings that I may not even know I have, that I find out I have when I see what I wrote." A similar sensibility marks his relationship with touring. "If there's a spiritual aspect to being on the road it has to do with the performances. It becomes about communicating, and about being a conduit for whatever it is that comes through. I don't even want to call it a message, I think it's an energy."[38]

"Seeing through the Eyes of the Heart": The Contemplative Way

The artistic eye, as we have seen, is an eye that lingers, that "takes the time" to be present and truly see. The artist in this sense is a contemplative, cultivating an approach to the physical world and especially to *time* that is slowed-down and deliberately attentive. In one of my favorite essays on the subject, the late Jesuit scholar Walter Burghardt describes contemplation as "a long loving look at the real."[39] "To take a long loving look at something—a child, a glass of wine, a beautiful meal—this is a natural act of contemplation, of loving admiration."[40] Burghardt invites us to linger with each word: *real . . . long . . . look . . . loving.* "This real I *look* at. I do not analyze or argue it, describe or define it; I am one with it. I do not move around it; I enter into it. Lounging by a stream, I do not exclaim 'Ah, H_2O!' I let the water trickle gently through my fingers."[41] It is easy enough, in other words, to look at "the real world" objectively, coolly detached from the various "objects" of my gaze. It is another thing altogether, much riskier and more vulnerable, to approach reality through "the eyes of the heart,"[42] with the kind of empathy that commits your whole person.

38. Cockburn, "All the Diamonds . . . on One Album."

39. Walter Burghardt, "Contemplation: A Long Loving Look at the Real," in *An Ignatian Spirituality Reader*, ed. George W. Traub, SJ (Chicago: Loyola, 2008), 89–98.

40. Burghardt, "Contemplation," 91, citing Carmelite William McNamara.

41. Burghardt, "Contemplation," 92.

42. The image is borrowed from the Christian mystical tradition. The Trappist monk and spiritual writer Thomas Merton describes contemplation as "spiritual wonder. It is spontaneous awe at the sacredness of life, of being. It is a vivid realization of the fact that life and being in us proceed from an invisible, transcendent and infinitely abundant source" (*New Seeds of Contemplation* [New York: New Directions, 1961], 1). William McNamara calls it a "pure intuition of being, born of love. It is experiential awareness of reality and a way of entering into communion with reality" (Burghardt, "Contemplation," 91).

Once again the notion of synaesthesia comes into play, undergirding a holistic spirituality that engages all the senses. Pushing back against a history of Western Christian ambivalence and even outright animosity toward the "flesh" as intrinsically an enemy of the "spirit," Burghardt underscores the importance of the body in any discussion of contemplation. "I am not naked spirit; I am spirit incarnate; in a genuine sense I *am* flesh. And so I am most myself, most human, most contemplative, when my whole person responds to the real. . . . Contemplation is not study, not cold examination, not a computer. To contemplate is to be in love."[43] Canadian theologian Brian Walsh, commenting on the seamless intersection of art and spirituality in Cockburn's music, echoes Burghardt strongly when he insists that spirituality "isn't simply a matter of one's religious practices. It's more a matter of one's most fundamental orientation, one's most fundamental worldview, *how one leans into life*, how one experiences life, how one sees and engages the world."[44]

If the contemplative way is indeed our "most human" way of leaning into the world, then why does it so elude us? At least part of the problem, suggests Burghardt, is that we are *taught out of this mode of awareness* as we move from childhood into adulthood. "All the way through school we are taught to abstract; we are not taught loving awareness."[45] According to the prevailing value system of American culture, "a good education" is one that prepares students to adapt as seamlessly as possible to a "utilitarian" worldview: a way of life in which only useful activity, or "the profit I can extract from an experience or a possession,"[46] is deemed valuable. Joni Mitchell confronts this ethos head-on, recognizing its power *over her*, in "For Free," the second track on *Ladies of the Canyon*: "Now me I play for fortunes / And those velvet curtain calls / I've got a black limousine / And two gentlemen / Escorting me to the halls."[47] Resisting a way of being that values production and profit over all else, Burghardt insists that contemplation, or "wasting time" to enjoy a conversation, a walk through the neighborhood, a glass of wine with a friend, is not a luxury, still less is it an esoteric discipline for the privileged few. It is the rediscovery of our full humanity, "the mark of a lover."[48]

To say it another way, while our educational frameworks seem increasingly bent toward quantitative assessment and technical *mastery*, the arts mediate

43. Burghardt, "Contemplation," 92–93. Beneath Burghardt's affirmation of the body is a profoundly incarnational Christian and Catholic sacramental view of reality—i.e., rooted in the mystery of the Incarnation, a communal encounter with God "become flesh" in the person of Jesus. Burghardt is also drawing from his Ignatian or Jesuit heritage, at the heart of which is the Spiritual Exercises of Saint Ignatius of Loyola, whose distinctive spirituality places great emphasis on imaginative communion with reality through all the senses.

44. *Pacing the Cage.*

45. Burghardt, "Contemplation," 91.

46. Burghardt, "Contemplation," 90.

47. Joni Mitchell, "For Free," *Ladies of the Canyon*, Reprise, 1970.

48. Burghardt, "Contemplation," 98.

and intensify our confrontation with *mystery*, "a way of entering into immediate communion with reality" that eludes quantification. "You can study things," as Burghardt notes, "but unless you enter into this intuitive communion with them, you can only know *about* them, you don't *know* them."[49] The contemplative way underscores the immersive experience of "falling in love" not simply as "knowing another's height, weight, coloring, ancestry, IQ, [and] acquired habits," but rather as "the single, simple vibration that gives us such joy in the meeting of eyes or the lucky conjunction of interchanged words."[50] Whether falling in love with a person or with the physical world as it touches our senses—trees, lakes, mountains, a child lapping an ice cream cone, Beethoven's "Moonlight Sonata"—"something private and singular and uniquely itself is touched—and known in the touching."[51]

If contemplative knowing is shaped from beginning to end by love—by "the single, simple vibration" that brings forth joy in those who know and are known by love—it would seem to describe a very different kind of "knowing" and "possessing" than that which can be purchased or exchanged through more superficial or merely transactional relationships. "Love: It's what makes a Subaru a Subaru."[52] The contemplative will ask, "Is it *really*?" Despite the claims of advertisers, surely love is something more than our relationship with a car (even a beloved one!), or our identity as a consumer, a "keeper of the cards," as Joni Mitchell sings in "The Arrangement." To what extent have I been formed to identify love with the mere possession or ownership of an "object" of my desire—a car, a smart phone, a one-night stand—without the real encounter and mutual vulnerability that love entails?[53] By celebrating the joys and heartbreaks of authentic friendship, vulnerability, and love in their music, Mitchell and Cockburn press us to think beyond the superficial promises of the "in crowd / chasing after every trend," as Cockburn sings in "Don't Have to Tell You Why." And, by the way, is there any greater lyric than this one? "Just want to stand on some hillside / In Wales with you / And fly — don't have to tell you why."

For Mitchell and Cockburn, the "rainbow's real end" is not a stack of golden credit cards, a swimming pool in the backyard, or a "man-made stream" running through a suburban shopping mall. Most thoughtful people, I daresay, will recognize the truth embedded in such critiques of contemporary consumer culture, but that same culture lulls us to sleep with superficial images of love, beauty, and

49. Burghardt, "Contemplation," 91.

50. Walter Kerr, cited in Burghardt, "Contemplation," 92.

51. Walter Kerr, cited in Burghardt, "Contemplation," 92.

52. The near ubiquitous slogan of Subaru car advertisements for many years up to the time of this writing.

53. Thus Burghardt suggests, "Don't try to 'possess' the object of your delight, whether divine or human, imprisoned marble or free-flowing rivulet; and don't expect to 'profit' from contemplation, from pleasure" ("Contemplation," 96).

happiness. The artist seeks to wake us up, to help us see beneath the surface of things. Yet that awakening can be quite unsettling to the degree it interrupts our consciousness with the painful realization that "something else might be the case."[54] Much like the biblical psalmist and prophets, Mitchell and Cockburn "refuse to put lipstick on the truth."[55] While in our hearts we may sense that "the grind is so ungrateful," we've been taught that "the grind" *is* Reality, simply the Way Things Are and Must Be. Joni Mitchell suggests otherwise, whispering mantra-like in our ear, "You could have been more / You could have been more / You could have been more."[56] To recall Stevie Wonder, real love, not least love of oneself, "has to be fed."[57] The arts feed us in part by helping us to grasp the deeper truth of reality through the eyes of the heart. You are much more than "a name on a door,"[58] immeasurably more valuable than your looks, your title, your income.

"And the Seasons Go Round and Round": Life as Pilgrimage

It is difficult enough to subject beautiful poetry or allusive lyrics to theoretical analysis; it may be even more difficult to pin down the qualities of a great instrumental or vocal performance. Yet clearly Joni Mitchell's guitar, piano, and vocal stylings are inseparable from the lyrical content of her work, no less than Cockburn's dizzying command of the guitar serves to complement, intensify, and reinforce the rhythmic and emotive qualities of his singing. James Taylor, perhaps the most iconic singer-songwriter of the 1960s folk music scene, likens Mitchell's guitar-playing to her painting: "When I first heard Joni's music, you know, I was amazed. It was truly unique. Joni invented everything about her music, including how to tune the guitar. From the beginning of the process of writing it, she's building the canvas as well as putting the paint on it."[59] Mitchell herself describes, if somewhat defensively, the relationship between her unique guitar tunings and the creative wellspring of her inner emotional life:

54. From David Tracy's description of the classic as discussed in chapter 2. See David Tracy, *The Analogical Imagination: Christian Theology and the Culture of Pluralism* (New York: Crossroad, 1981), 102, citing Dorothy Van Ghent.

55. *Woman of Heart and Mind.*

56. Joni Mitchell, "The Arrangement," *Ladies of the Canyon.*

57. See chapter 1.

58. Mitchell, "The Arrangement." From the beginning of her career Mitchell has professed a deeply ambivalent relationship with popular acclaim and fortune. Between the release of *Ladies of the Canyon* and *Blue*, her introspective, critically acclaimed fourth album, she lived alone for a time in the Canadian wilderness. "Fame made me really nervous and uncomfortable. I began to dislike more and more being a public person. So I isolated myself and made my attempt to get back to the garden." *Woman of Heart and Mind*, with a nod to her song "Woodstock."

59. *Woman of Heart and Mind.*

"For years, everybody [talked about] 'Joni's weird chords.' . . . [But the chords I created] *feel like* my feelings. I called them 'chords of inquiry,' [because] they have a question mark in them. There were so many unresolved things in me that those chords suited me, you know? I'd stay in unresolved emotionality for days and days and days."[60]

Once again, it is not only the "distinction and definition" given to each element of a song—rhythm, instrumental arrangement, vocal delivery—that accounts for its resonance (or lack thereof) in a particular listener or audience; it is also, and equally, "the *arrangement* of these particulars together that is crucial; their unique relationship in space and time upon which so much depends."[61] The movement and repetition, the spacing and accentuation, of tonal patterns created by the guitarist's fingerpicking or strumming technique builds an emotional scaffolding upon which the singer can weave a storyline. Stephen Holden describes the "something more" that Mitchell creates through her evocative guitar and piano playing throughout *Ladies of the Canyon*: "Joni looks for this magical riff, this little piece of rhythm and harmony and melody that's going to set up an extraordinary mood. And when she finds it, you can almost see her and feel her and hear that from the opening of these tunes, it envelopes the listener. But think how it envelopes *her* when she finds it."[62]

The final track on *Ladies of the Canyon*, "The Circle Game," is about as magical as a song can get when great lyrical storytelling is wed to beautiful instrumental and vocal artistry. From its straightforward opening guitar progression to its first words, delivered with crystalline vocal sweetness—"Yesterday a child came out to wonder / Caught a dragonfly inside a jar"—the listener is "enveloped" in a storyline and emotional landscape that leaves an unforgettable impression.[63] The voices that join in with Mitchell on the chorus—"We're captive on the carousel of time"—reinforce the song's infectious melody and resonant message, making it nearly impossible not to sing along. "The Circle Game"—a song written for Mitchell's one-time boyfriend David Crosby—captures something beautiful and almost unbearably poignant about the child's journey into adulthood.

The same might be said of Mitchell's "Both Sides Now," first recorded by Judy Collins in 1967, and earning Collins a Grammy Award for Best Folk Performance. Mitchell recorded the song herself in 1969 for the album *Clouds*, and again thirty years later in a slowed-down and lushly orchestrated version,

60. *Woman of Heart and Mind.* "She creates a musical world that you can feel," as David Crosby observes in *Woman of Heart and Mind*, "but you can't explain. And ultimately you're changed by the experience."

61. Rumsey, "Particularity and the Call to Attention," 52.

62. *Woman of Heart and Mind.*

63. Singer Tom Rush remembers receiving a cassette tape from Mitchell with six songs on it. "Before the last song, she says into the tape recorder: 'This song isn't done yet, and it really sucks, and I don't even know why I'm sending it to you,' and it was 'Circle Game.' It was one of the best songs I had ever heard." Cited in *Woman of Heart and Mind.*

featured in the 2003 film *Love Actually*.[64] Many fans consider it her finest song, all the more astonishing for having been written in her early twenties. Much like "The Circle Game," "Both Sides Now" marries a deceptively straightforward major key progression with plaintive lyrics and a vocal delivery that reflects the emotional depth and wisdom of "one of the truly great poets of our time."[65] When I listen to "Both Sides Now," especially the later version in which Mitchell's voice is deeper, older, more resonant and rougher around the edges—the result not only of age and experience but also a lifelong smoking habit—I wonder whether the emotional complexity and vulnerability of the human journey has ever been more perfectly expressed.

How does she do it? Graham Nash, her boyfriend during the late 1960s, describes watching Mitchell write songs in these early years of her career: "It's almost like she channels. She was gone for hours. I mean she was physically right there, but she wasn't there, she was gone. I'd say things to her and she wasn't even listening. She was gone. And it was *a great thing to see*, a great thing to see somebody taken away by—*vision*."[66] At the same time, Mitchell thrived in the company of other musicians, artists, and poets with whom she lived, loved, and shared ideas. Nash describes the atmosphere of Laurel Canyon where he and Mitchell made a home together:

> Laurel Canyon . . . was an incredible place to be. I can only liken it to Vienna in the turn of the century or Paris in the 30s. Laurel Canyon was very similar in that there was a freedom in the air, there was a sense that we could do anything. We were scruffy kids that were in some small way changing the world and changing the way people think about things. And there was a sharing of ideas and a true love for being in the right place at the right time.[67]

Mitchell's first manager, Elliot Roberts, describes an atmosphere of "camaraderie among all the artists" and musicians who were always coming and going "up and down the canyons from one house to another, playing new songs for each other." Above all it was poetry, he says, "even more than musicality," which was revered, and "Joan was the best poet of the time." It was a period "when she had a lot to say and everyone wanted to hear it."[68]

64. Mitchell's original studio recording is here: *https://www.youtube.com/watch?v=Pbn6a0AFfnM*; the 2003 version is here: *https://www.youtube.com/watch?v=zIYu4EHq0Lo*.

65. See 1998 Biography Series by Wally Breese, *Joni Mitchell, http://jonimitchell.com/biography/*.

66. *Woman of Heart and Mind*.

67. *Woman of Heart and Mind*. Nash would later immortalize these years with Mitchell in his song "Our House."

68. *Woman of Heart and Mind*. For her part, Mitchell gives much credit to Bob Dylan, a frequent visitor to Laurel Canyon, for shaping her songwriting in the early years. "His influence was to personalize my work: 'I feel this for you, or from you, or because of you.'" Dylan's impact on her, as for so many, was pivotal: "OK, this opens all the doors, now we can write about anything" (*Woman of Heart and Mind*).

And yet, for all this, I have to admit that it took some time for me to fully appreciate Joni Mitchell's genius. Her voice, in particular, was for me an acquired taste, especially in its highest registers, which sometimes grated on my ear. Over time and with deeper exposure to her work, I got past my initial reticence and learned to surrender to wherever she wanted to take me on the unpredictable arc of her singing.

I've been surrendering ever since. Sometimes it is precisely the artist who challenges our customary tastes and carries us outside our comfort zones from whom we have the most to gain. And as for the sometimes dizzying heights of her voice, David Crosby offers a kind of explanation that makes a great deal of sense to me, and calls to mind our discussion in chapter 2 of Claire Torry's singing on Pink Floyd's "Great Gig in the Sky."

> I think throughout Joni's work there is an effort to make the music be sky-bound, to relieve the body of temporality. And once she gets there, *whoah*, you know, *it's almost a chant*—this need for release and transcendence, to ride above the culture, to be in the sky, to reflect, to not be in it, but to look down upon it.[69]

Malka Marom, the young woman who first encountered Mitchell in a New York City coffeehouse and who would become one of her lifelong friends, likewise reaches for language that brings us very near to the theological: "She lives with a great respect for mystery, and with an openness, *inviting* this mystery. This is her great strength, because I think it requires tremendous strength to really believe in something that you cannot put your finger on."[70] Mitchell herself, when asked about her songwriting process in an early interview, responded, "A lot of it is being open, I think, to encounter, and in a way, in touch with the miraculous."[71]

Perhaps it is enough to say that the poet lives and labors at the margins of the *inarticulate*, giving voice to those moments where words, "after speech, reach / Into the silence."[72] Poets touch upon realities that we cannot manage with our minds alone, and in carrying us with them, reassures us that these, too, are trustworthy. Though we cannot easily explain or conjure at will our encounters with the ineffable, they are real, and, because they cut to the heart of our common humanity, worthy of our deepest attention.

69. *Woman of Heart and Mind.*

70. *Woman of Heart and Mind.*

71. *Woman of Heart and Mind.* She describes a similar dynamic in her painting: "It's the spirit of child-play that Picasso was trying to get back. . . . The work is very personal. I don't [do it] for an audience. If there is an audience, it's just the divine keeping me honest." Or again, more whimsically: "Well it has to do with the Irish blood, whether or not the 'blarney is flowing.' . . . One night you'll trip over your tongue, you know, and the words won't come with the same facility, and another night it's just with you. Why? Is it your biorhythms? Is it divine intervention, saying, you know, 'You can't have it tonight'?" (*Woman of Heart and Mind*).

72. T. S. Eliot, "Burnt Notion," in *The Complete Poems and Plays 1909–1950* (New York: Harcourt, Brace & Company, 1971), 121.

If it is true, then, that the contemplative and artistic spirit is not "an outside, extra thing,"[73] but points to a capacity or potentiality that lives in all of us, where does this capacity for being "in touch with the miraculous" come from? And why do some seem especially gifted in giving form and expression to this sacred fire in the bones? "My job," as Cockburn explains, "is to try and trap the spirit of things in the scratches of pen on paper and the pulling of notes out of metal."[74] In the remainder of this chapter, I want to suggest that both Joni Mitchell's and Bruce Cockburn's ability to "trap the spirit of things" in song is inseparable from their attunement to nature, a communion with the earth formed in them by the Canadian landscape of their upbringing. The wilderness is the "world behind the text" of their artistic vision.

"We Are Stardust": Born from the Womb of the Earth

In his autobiography, *Rumours of Glory*, Bruce Cockburn describes being raised in a nominally Christian but mostly secular household. The social norms of 1950s Ottawa meant that the family would go to church on Sundays, "because that's what was expected of us,"[75] but the church experiences of Cockburn's youth "were simply endured."[76] By contrast, days and weeks exploring his grandfather's farm and the surrounding Canadian wilderness form the backbone of his childhood memories.

Born in Ottawa on May 27, 1945, Cockburn had "a mild case of spina bifida,"[77] and for a time as a young child had to wear metal braces on his legs. The braces didn't prevent the boy from enjoying the grandeur of the forests, rivers, and lakes of Canada, which harbors "more surface area of fresh, clean water than any other ecosystem on earth."[78] Every year he attended summer camp in Algonquin Park, about a hundred miles from Ottawa, keeping the company "of bears and otters, raccoons, deer, chipmunks, bass and sunfish, bloodsuckers, woodpeckers, raptors, and ravens." The wilderness "fixed itself" in Cockburn's brain, he says, "as the essence of how things should be."[79] His grandfather served on the Lower Ottawa Forest Protective Association, believing "the forest to be so vast that it would last forever." As a kid, "climate change" for Cockburn meant "that the first nip of fall was drifting down from Hudson Bay, or spring buds were blinking from the seasonally bare sugar maples and magnificent elms near our home."[80]

73. Robert Henri, *The Art Spirit* (1923; repr., New York: Basic, 2007), 11; see chapter 1.

74. Nicolas Jennings, "Bruce Cockburn: Kicking at the Darkness," *https://brucecockburn.com/about/biography/*

75. Bruce Cockburn, *Rumours of Glory* (New York: Harper One, 2014), 17.

76. Cockburn, *Rumours of Glory*, 18.

77. Cockburn, *Rumours of Glory*, 12.

78. Cockburn, *Rumours of Glory*, 13, citing *National Geographic*.

79. Cockburn, *Rumours of Glory*, 16.

80. Cockburn, *Rumours of Glory*, 13–14.

In chapter 1, we considered cellist Eugene Friesen's observation that there are acoustical environments that have "a spirit, a magic of [their] own," and which "affect our improvisations."[81] For Friesen and pianist Paul Halley, the Cathedral of Saint John the Divine was a kind of third musician, everywhere present on their album. In chapter 2, we considered the fact that every human being is formed in the aural environment of the womb, where we "hear our mother's heartbeat as a steady song" and float in "an aural field . . . that keeps our growing body in place." Our mother's heartbeat and breath "entrain us with a steady pulse to lock in our own inherent patterns."[82] Here I want to suggest that the same dynamic is true of the earth, or what we call "the 'natural world,'" rather lamely, as if "nature" was a separate "thing" from the "human world." Of course rather to the contrary, these two "worlds" are not two but radically one; while distinguishable in principle, in fact they are inseparable.

And for those with eyes to see and ears to hear, the living planet is a kind of womb, a third musician, a living, pulsating presence that "affects our improvisations." But how many of us have the eyes to see, the ears to hear? How many children grow up surrounded by nothing but concrete, asphalt, fluorescent light, and metal? "When I think of 'nature,'" says Bruce Cockburn, "I think of the Canadian Shield, which returns me to a sense of freedom of spirit. When I am confronted by the degradation of our surroundings, I feel that freedom being threatened, eroded."[83]

Cockburn remembers walking through the woods as a five-year-old with his grandpa, who gave him lessons on "how to tell a red pine from a white pine or jack pine by the number of needles in a cluster."[84] Some forty years later he wrote "If a Tree Falls,"[85] a lament for the rapid destruction of the world's rainforests "at rates that might be described as biblical."[86] To this day the song is regarded as one of the most powerful and enduring expressions of the global environmental movement.[87] Sixteen years later, in 2004, Cockburn wrote "Beautiful Creatures," a song written, not incidentally, in an airport. The opening verse, sung slowly against an open G chord on the guitar, is spare, intimate, and utterly disarming: "There's a knot in

81. Bob Protzman, "Cellist Friesen Takes Music into a New Age," *Chicago Tribune,* December 11, 1986, *http://articles.chicagotribune.com/1986-12-11/features/8604020831_1_paul-winter-consort -jazz-elements-classical-music;* see chapter 1.

82. Susan Elizabeth Hale, *Sacred Space, Sacred Sound: The Acoustic Mysteries of Holy Places* (Wheaton, IL: Quest, 2007), 2–3.

83. Cockburn, *Rumours of Glory,* 16. In his popular and influential study, *Last Child in the Woods: Saving Our Children from Nature-Deficit Disorder* (Chapel Hill, NC: Algonquin, 2008), Richard Louv explores the human costs of alienation from nature and the benefits of environment-based education.

84. Cockburn, *Rumours of Glory,* 15.

85. Bruce Cockburn, *Big Circumstance,* True North, 1988.

86. Cockburn, *Rumours of Glory,* 14.

87. "In a 2008 interview the great Canadian scholar and environmental activist David Suzuki said that 'If a Tree Falls' was one of his two favourite songs; he cried when he heard it" (*Rumours of Glory,* 14).

my gut / As I gaze out today / On the planes of the city / All polychrome grey / When the skin is peeled off it / What is there to say? / The beautiful creatures are going away."[88] The bridge of the song, delivered in a piercing falsetto, simply asks, "Why? / Why?" One hears in Cockburn's anguished cry not only a lament for the loss of habitats on which nonhuman creatures depend but also for the soul of humanity. His are the questions of the prophet and of countercultural movements to this day: Is this the best we can do? At what cost do we continue to make such choices? "The beautiful creatures are going away."

Like Cockburn, Joni Mitchell was nurtured in the environs of the Canadian wilderness. Born Roberta Joan Anderson on November 7, 1943, in the small town of Fort McLeod in the Canadian province of Alberta, Joni, at age nine, moved with her family to Saskatoon, Saskatchewan, bordered by open grasslands to the south and rugged mountains, coniferous forests, rivers, and lakes, to the north. She grew up, as biographer Mark Scott writes, "in the wide open spaces of the Canadian prairie in a largely agrarian society comprised of 'sky-oriented people, geared to changing weather.'"[89] And like Cockburn, she also had to contend with physical disability. Stricken with polio shortly after the move to Saskatoon, Mitchell spent much of her days alone, gazing out the front window of the family's house, watching the train plow through snow-covered tracks on its way to somewhere else. Thus from a very young age Joni was "engrossed in the visual," and it was her love of painting, even more than music, that gave her the tools "to express her inner life."[90]

Nowhere are these tools of expression more beautifully realized than in the song "Woodstock." Made iconic by Crosby, Stills and Nash in 1969, and covered by more than three hundred artists since, to my ear the finest version remains Mitchell's own, as recorded on *Ladies of the Canyon*, as well as several stunning live performances captured on video in 1969 and 1970.[91] The album version features Mitchell accompanying herself on a Fender Rhodes electric piano, instantly recognizable for its vibrato-like chorus effect and classic blues sound. Joni is in no hurry. As a pianist myself, the recording feels to me like an intimate moment shared between friends in somebody's living room, captured on tape only by happenstance. The main evidence of studio enhancement comes after each chorus, when Mitchell overdubs herself in a kind of backup choir. Otherwise the arrangement is hauntingly spare, stripped-down, and direct. The lyric is unforgettable. "I came upon a child of God / He was walking along the road / And I asked him where are you going / And this he told me . . ."

88. Bruce Cockburn, *Life Short Call Now*, True North, 2006.

89. Mark Scott, "I Come from Open Prairie," 2014 Biography Series by Mark Scott, *Joni Mitchell*, *http://www.jonimitchell.com/library/view.cfm?id=2783*.

90. Scott, "I Come from Open Prairie."

91. For example, this October 1970 live performance: "Joni Mitchell—Woodstock (Live In-Studio 1970)," *https://www.youtube.com/watch?v=cRjQCvfcXn0*.

Verses 1 and 2 draw the listener into the classic narrative of the hero's journey, and a generation's longing to "get my soul free." With each chorus, the individual "I" of the pilgrim's journey transforms into the "We" of a destiny larger than oneself, and the plaintive plea to "get ourselves / Back to the garden." The desire to be something other than "a cog in something turning" calls to mind Pink Floyd's satirical protest against social forces seemingly beyond our control, turning human beings into "just another brick in the wall."[92] Against such forces, the journey to Yasgur's Farm promises at least temporary respite from "the smog" and anonymity of an existence buried in urban sprawl. Perhaps on the land, the song implies, I can recover my dignity and self-worth as "a child of God."[93] Verse 3 celebrates what Mitchell would call the "modern miracle" of Woodstock: a sea of people, "half a million strong," singing of love and dreaming of a day when "the bombers" would turn into "butterflies / Above our nation"— or, to place that beautiful line in context, a day when US fighter jets would stop dropping napalm over villages in Vietnam. In Mitchell's striking juxtaposition of bombers and butterflies, one almost hears a foreshadowing of Cockburn's heart-rending lament, "The beautiful creatures are going away."

Woodstock itself, of course, was perhaps the biggest cultural event of Mitchell's life that she *almost* attended. Because she was scheduled to appear the following day in New York City on The Dick Cavett Show, her agent David Geffen advised her not to attend the festival. And so Mitchell watched the iconic event unfold on a television set in her hotel room, heartbroken. By the time her friends, Crosby, Stills, Nash and Young, had flown back to New York City—and then crashed The Dick Cavett Show, where they appeared onstage with a visibly forlorn Mitchell—the song "Woodstock" was already basically written. Indeed in writing the song, as David Crosby would later say, "She contributed more toward people's understanding of that event than anybody that was there."[94] But it is worth asking, as we bring this chapter to a close, how do we remember and understand that event and those revolutionary years today, almost half a century later?

"You Don't Know What You've Got Till It's Gone": Assessing the 1960s Counterculture

Filmmaker Oliver Stone remembers the closing years of the 1960s as follows:

> My generation had this tremendous surge of hope and idealism for a better world—a "Peace Corps World," let's call it. . . . Then it just

92. Pink Floyd, "Another Brick in the Wall," *The Wall*, Columbia, 1979; see chapter 2.

93. The song "Big Yellow Taxi" from the same album—"They paved paradise / and put up a parking lot"—reinforces, if whimsically, a generation's lament for the loss of natural landscapes and of human connection to the land.

94. *Woman of Heart and Mind.*

kind of caved in so quick. Bobby Kennedy went down in the bizarrest of assassinations. Martin Luther King Jr., again in the same year, 1968. I was in Vietnam at that time. All the blacks in my unit were so upset when King was killed, and they said, "Never again! Don't trust whitey!" And it was over. You could just feel the 60s clattering down on top of you . . . it was a nightmare. And then we took drugs and dropped out, and then Nixon came in on this tremendous fear and everyone was so scared in 1968 that the world was going crazy with all these killings and assassinations. He was a face from the past and he came in and presented, like Hitler did, the concept of law and order to cure disorder. What did he give us? He promised us peace and he gave us four more years of war. He promised us order and gave us chaos. He gave us Watergate.[95]

It is not uncommon today to hear people of all ages and political persuasions make fun of the "hippies," "flower children," and "tree huggers" of the Woodstock era. While it is true that we haven't explored the darker side of Woodstock and all it has come to represent—the ego and acid trips, the misguided sexual license, the escapism of "dropping out," and so on—still I wonder what is at the root of such dismissive perspectives. In so easily caricaturing millions of young people who resisted the prevailing cultural norms of their parents' generation, and very often, in the case of the Vietnam War protests and Civil Rights Movement, put their bodies on the line in doing so, do we fail to recognize the validity and beauty of their collective dreams and aspirations? Might we even be resentful of their attempts, and arguably their courage, to imagine a different path than the conventional "arrangement": the consumer culture of late-modern capitalist society, with its alienation from nature, strong accent on individualism and materialism, and seeming addiction to war and a vast network of military-industrial machinery to preserve "the American way of life"?[96]

The American artist Robert Henri, whose classic *The Art Spirit* we discussed in chapter 1, made observations in that study about Western and American culture during the 1920s that seem to me quite resonant with Stone's assessment of

95. Cited in Karen O'Brien, *Joni Mitchell: Shadows and Light* (London: Virgin, 2001), 105. Many have drawn strong parallels between Nixon's "law and order to cure disorder" campaign and the 2016 presidential campaign, rhetorical style, and policy positions of now-President Donald Trump.

96. It's worth juxtaposing such questions alongside other iconic protest songs of the era, e.g., Marvin Gaye's 1971 classic, "What's Going On," written in response to police brutality and violence against antiwar protestors; Buffalo Springfield's 1966 song, "For What It's Worth," a response to clashes between police and young people in Hollywood, California; and Crosby, Stills, Nash, and Young's incomparably intense "Ohio," a lament for the killing of four student protesters by the National Guard at Kent State, May 4, 1970. Neil Young, composer of "Ohio," described the Kent State incident as "probably the biggest lesson ever learned at an American place of learning." David Crosby said that Young's decision to keep Nixon's name in the lyrics—"Tin soldiers and Nixon coming"—was "the bravest thing I ever heard." Cited in Frank Mastrapolo, "The History of 'Ohio': Crosby, Stills, Nash and Young's Raw Reminder of the Kent State Massacre," *UCR*, May 24, 2015, *http://ultimateclassicrock.com/csny-ohio/*.

the late 1960s, and perhaps even more, with the polarized political atmosphere of early twenty-first-century America:

> We are living in a strange civilization. Our minds and souls are so over-laid with fear, with artificiality, that often we do not even recognize beauty. It is this fear, this lack of direct vision of truth that brings about all the disaster the world holds, and how little opportunity we give any people for casting off fear, for living simply and naturally. When they do, first of all we fear them, then we condemn them. It is only if they are great enough to outlive our condemnation that we accept them.[97]

Perhaps before we judge the "Make Love, Not War" and Peace Corps generation too harshly, we should measure the path that the world and our nation has taken in the decades since, and consider what has been gained, and what values and dreams worth preserving may have been lost.

Like Oliver Stone, Graham Nash is probably typical of many artists who came of age in the 1960s and 1970s and who look back on that era with mixed feelings and a certain degree of sobriety: "We thought that we would be able to change the world instantly and we were very naïve. This planet has a certain mass and it's very difficult to change the trajectory of that mass. Maybe one is able to do it in millionth of degrees, but we thought it would happen overnight and we were wrong."[98] While Nash judges that he and his friends were "naïve" and "wrong" to believe that they "could change the world instantly," nevertheless it is impossible to overlook the note of wonder and gratitude in his voice—and the joyfulness reflected on his face in so many interviews—when he describes what it was like to be part of a creative community that dared to imagine another possible future. Perhaps being "naïve" and "wrong" in the service of a better world isn't such a bad way to spend one's life and talents, if the alternative is uncritical conformity to the "realistic" and "cynical."

The contemplative in me would say that there are critical moments of decision in all our lives, perhaps in each day, when we are invited by the mystery and beauty of life itself not to play the cynic. To opt for childlike wonder and possibility, to seek to live in ways that are less driven by fear and more attuned to the "simple" and "natural," is not the same thing as taking refuge in childish naiveté, much less fanciful irresponsibility. The truth is, almost every day I talk with students from almost every field of study—the arts, business, education, medicine, history, psychology, computer science, engineering—whose idealism and sense of possibility about the future simply blow me away. When I consider their gifts and the gifts and dreams of young people around the world today, it strikes me that Joni Mitchell's transcendent remembrance of Woodstock remains more

97. Henri, *The Art Spirit*, 144.

98. *Woman of Heart and Mind.*

daring, urgent, and beautiful than ever. In any case what seems eminently clear in interviews with Mitchell, Cockburn, Graham Nash, and many others is this: very few regret their part in a creative movement that empowered so many people to critically engage the issues of their times, and perhaps above all, "to feel themselves part of a larger Story."[99]

No doubt that story is still being written today, by young and old alike looking for ways to imagine and build a society more responsive to our innate desire for connection and meaning, for communion with the planet, for peace between cultures and nations, for the miracle of love. To "get ourselves back to the garden" is to re-vision our patterns of thinking and living in relationship with the suffering Earth and all its creatures. It is to shift from an exploitative, objectifying vision of "the natural world" to an organic and holistic one. It is to believe in the power of love, reclaim our poetic eye, and become contemplatives. For my part, I pray to grow in the courage to live my life more authentically, indeed, more artistically, in the spirit of hopefulness and love, and to make my own the words of Bruce Cockburn, "The world is getting worse. The poor are getting poorer. Tension is increasing. For most of us in the developed world, we have a choice. And we can exercise that choice with wisdom. That's what I stand for."[100]

Addendum and Additional Resources

The stories of women are often lost in the noise of contemporary political discourse, the media, and popular cultural expression in the United States. Music is one place to find those lost stories. Feminist theology is another. Once again, as noted following chapter 1, German Lutheran theologian Dorothee Soelle provides a compelling example of "the search for a new language," as she puts it, "that expresses our relationship to God more clearly, less repressively, and with less danger of misunderstanding." Soelle's theology gives expression to God-symbols "without authority or power, thus without a chauvinistic flavor." In feminist theology "the relationship of master and slave is often explicitly criticized; more particularly, it is overcome through creative language." Much as in the music of Joni Mitchell and Bruce Cockburn, Soelle—alongside remarkable poets of her generation, like Denise Levertov—uses creative language to express an artistic and religious sensitivity that has less to do with explicit beliefs or doctrines and more to do

99. The phrase is borrowed from Michael Paul Gallagher, SJ, *The Human Poetry of Faith: A Spiritual Guide to Life* (Mahwah, NJ: Paulist Press, 2003), 136; see introduction.

100. Bruce Cockburn, "Mouth That Roared: Bruce Cockburn Says He's Not an Activist But a Concerned Voice," interview with Fish Griwkowsky, *Edmonton Sun*, March 27, 2002, cited at *http://cockburnproject.net/songs&music/iiharl.html*.

with "union with the whole; belonging, not subjection." People adore God, says Soelle, "not because of God's power and glory. Instead, they sink into God's love, which is called ground, or depth, or ocean." Nature metaphors abound in mystical-poetical literature and in contemplative theologies. Canadian theologian Brian Walsh explores the nature imagery in Bruce Cockburn's music, surfacing the richly allusive relationship between Cockburn's lyrics and the Christian sacramental imagination.

First published in 1979, *Womanspirit Rising: A Feminist Reader in Religion* is a "who's who" of theologians who pioneered the field, including its coeditors, Carol P. Christ and Judith Plaskow. Plaskow's 1991 book *Standing Again at Sinai* is considered the first-ever work in Jewish feminist theology. The experiences of African American women, especially marginalized in public, ecclesial, and academic theological discourse, are foregrounded in "womanist" literature and theology. Katie Cannon, M. Shawn Copeland, Jacqueline Grant, and Delores Williams represent vibrant expressions of womanist theology in the United States.

Books

Christ, Carol P., and Judith Plaskow. *Womanspirit Rising: A Feminist Reader in Religion.* New York: HarperCollins, 1979.

Levertov, Denise. *The Stream & the Sapphire: Selected Poems on Religious Themes.* New York: New Directions, 1997.

Soelle, Dorothee. *Dorothee Soelle: Essential Writings.* Edited by Dianne L. Oliver. Maryknoll, NY: Orbis, 2006.

Walsh, Brian K. *Kicking at the Darkness: Bruce Cockburn and the Christian Imagination.* Grand Rapids: Brazos, 2011.

Williams, Dolores. *Sisters in the Wilderness: The Challenge of Womanist God-Talk.* Maryknoll, NY: Orbis, 1993; 2013.

Articles and Poetic Resources

Berry, Wendell. *Leavings: Poems.* Berkeley: Counterpoint, 2011. Select poems.

Burghardt, Walter. "Contemplation: A Long Loving Look at the Real." In *An Ignatian Spirituality Reader*, edited by George W. Traub, SJ, 89–98. Chicago: Loyola, 2008.

Greeley, Andrew. "The Apologetics of Beauty." *America* (Sept. 16, 2000): 8–14.

O'Brien, Karen. "Songs to Aging Children Come." In *Joni Mitchell: Shadows and Light*, 89–106. London: Virgin, 2003.

Pramuk, Christopher. "Rumours of Glory: Walking in the Dark Half-Light of Faith." *The Merton Annual 27* (2014): 57–71.

Rumsey, Andrew. "Through Poetry: Particularity and the Call to Attention." In *Beholding the Glory: Incarnation through the Arts*, edited by Jeremy Begbie, 47–63. Grand Rapids: Baker Academic, 2000.

Music, Audio, and Visual

Bruce Cockburn: Pacing the Cage. Directed by Joel Goldberg. True North, 2013.

Cockburn, Bruce. "If a Tree Falls." *Big Circumstance.* True North, 1988.

———. "If I Had a Rocket Launcher." *Stealing Fire.* True North, 1984.

———. "Rumours of Glory." *Humans.* Rounder, 1980.

Mitchell, Joni. "Both Sides Now." *Clouds.* A&M, 1969.

———. "Both Sides Now." *Both Sides Now.* Reprise, 2000. Featured in the 2003 film *Love Actually*.

Joni Mitchell: Woman of Heart and Mind: A Life Story. Directed by Susan Lacy and Stephanie Bennett. Eagle Rock Entertainment, 2003.

"Life Out of Balance"

Jean Giono and Godfrey Reggio: Earth and the Technological Milieu

Praise be to you, my Lord,
through our Sister, Mother Earth,
who sustains and governs us,
and who produces various fruit
with colored flowers and herbs.

—Saint Francis of Assisi

. . . listen to the voice of the wind
and the ceaseless message that forms itself out of silence.

—Rainer Maria Rilke

The greatest poverty is not to live
In a physical world . . .

—Wallace Stevens

A picture, they say, is worth a thousand words. In the 1928 photograph on the next page, a miner holds a canary in a small cage. The two creatures seem to contemplate each other intently. The man, outfitted with headlamp, oxygen tank, and breathing apparatus, looks on the bird with seeming kindness. Or is it gratitude? Or pity? Perhaps all of the above? The archival image appears on the website of the US Mine Safety and Health Administration (MSHA), which explains the historical roots of the phrase "canary in the coal mine" as follows:

Carbon monoxide, a potentially deadly gas devoid of color, taste or smell, can form underground during a mine fire or after a mine explosion.

CASE STUDIES

Jean Giono, "The Man Who Planted Trees"
Godfrey Reggio, *The Qatsi Trilogy*

Today's coal miners must rely on carbon monoxide detectors and monitors to recognize its presence underground. However, before the availability of modern detection devices, miners turned to Mother Nature for assistance. Canaries—and sometimes mice—were used to alert miners to the presence of the poisonous gas. Following a mine fire or explosion, mine rescuers would descend into the mine carrying a canary in a small wooden or metal cage. Any sign of distress from the canary was a clear signal that the conditions underground were unsafe, prompting a hasty return to the surface. Miners who survive the initial effects of a mine fire or explosion may experience carbon monoxide asphyxia.[1]

Returning to the photograph, we can now surmise that the miner and bird are about to descend into the depths of a coal mine following a fire or explosion. The miner will do so freely, if apprehensively, in the attempt to rescue his fellow miners; the bird will do so because it has no choice. It is possible that neither miner nor bird will come out alive. It is far more likely that only the miner will survive, though he may suffer some effects of "carbon monoxide asphyxia." Why did the mining industry use canaries, in particular? MSHA explains,

A 1928 photograph showing a miner holding a canary in a small cage.

US Department of Labor

> According to tests conducted by the Bureau of Mines, canaries were preferred over mice to alert coal miners to the presence of carbon monoxide underground, because canaries more visibly demonstrated signs of distress in the presence of small quantities of the noxious gas. For instance, when consumed by the effects of carbon monoxide, a canary would sway noticeably on his perch before falling, a much better indicator of danger than the limited struggle and squatting, extended posture a mouse might assume.[2]

1. "A Pictorial Walk through the Twentieth Century: Canaries," Mine Safety and Health Administration (MSHA), US Department of Labor, *https://arlweb.msha.gov/CENTURY/CANARY /CANARY.asp.*

2. "A Pictorial Walk through the Twentieth Century: Canaries."

Canaries, it seems, had the dubious fortune of being more overtly sensitive than mice to carbon monoxide poisoning. Their sensitivity made them "a much better indicator of danger."

For every "thousand words" a picture may speak to us, it hides potentially ten thousand more. On closer examination, if one ponders the historical reality "behind the text," there is something a bit unsettling in the miner's benevolent gaze on the bird, no less than the MSHA's anodyne description of a bird swaying on its perch "before falling," or the "struggle and squatting" and "extended posture" of a mouse that cannot breathe. We can be grateful, I suppose, that sophisticated carbon monoxide detectors have replaced canaries and mice in contemporary mining practice. (I hear myself saying this in reassuring tones to my fourteen-year-old daughter, who dissolves in tears at the mere thought of animals suffering.) In any case, according the MSHA, it would seem that both canaries and mice—dutiful representatives of "Mother Nature"—were glad to provide "assistance" to their human friends. The implied message: Mother Nature is generous, her gifts many and expendable in service of the needs of human beings. (Expendable: "of little significance when compared to an overall purpose, and therefore able to be abandoned."[3])

While the literal meaning of "canary in the coal mine" may no longer apply, the image of the struggling creature trapped in its metal cage retains its metaphorical power. The great poet Maya Angelou famously titled her first autobiography, *I Know Why the Caged Bird Sings*, a book she says she wrote from the deepest urge "to tell the human truth" about her life.[4]

Consider the photograph again. Imagine that the caged bird is children of color who suffer disproportionate rates of lead poisoning and chronic asthma from living near toxic industrial sites.[5] Or that the caged bird is indeed "Mother Nature" herself, the birds and honeybees, the sea creatures and forest fauna, stretched out and dying in fits of asphyxiation. In the most ironic of reversals, imagine that the caged bird is the whole human race, formerly the

3. Google definition, *https://www.google.com/#q=expendable+definition*.

4. Maya Angelou, *I Know Why the Caged Bird Sings* (New York: Random House, 1969). Maya Angelou, "Maya Angelou—I Know Why the Caged Bird Sings," World Book Club, *BBC World Service*, October 2005, *https://www.bbc.co.uk/programmes/p01zz41x*.

5. "An African American child is three times more likely to go into the emergency room for an asthma attack than a white child, and twice as likely to die from asthma attacks as a white child. African Americans are more likely to die from lung disease, but less likely to smoke"; "Environmental Racism in America: An Overview of the Environmental Justice Movement and the Role of Race in Environmental Policies," The Goldman Environmental Prize, *http://www.goldman prize.org/blog/environmental-racism-in-america-an-overview-of-the-environmental-justice-movement -and-the-role-of-race-in-environmental-policies/*. Lindsey Konkel, "Pollution, Poverty and People of Color: Children at Risk," *Scientific American* (June 6, 2012), *https://www.scientificamerican.com /article/children-at-risk-pollution-poverty/*, writes, "Low-income housing is often built where property is cheapest. Unfortunately these areas often have more pollution." An internet search under the terms "environmental racism" or "environmental justice" yields a host of recent studies and data analyses similar to these.

"miner" in the old photograph, we who have dug deep into the earth to unleash forces that now threaten to exceed our capacity to control. Having subjugated "Mother Nature" for so long to our utilitarian designs, is it possible we now find ourselves trapped, as Max Weber warned a century ago, inside the same "iron cage" in which we have imprisoned "the natural world"?[6] In the gathering threat that is climate change and habitat loss, it would seem that the miner and bird are now one in their suffering, though the miner may persist in his stubborn denials.[7]

In earlier chapters, I have spoken of Earth as a living womb, a sustaining, pulsating presence whose rhythms "entrain us with a steady pulse to lock in our own inherent patterns,"[8] and whose beauty and generative capacity "affects our improvisations."[9] For the contemplative heart and mind attuned to the soil, the wind and water, the animals, insects, and trees, Earth's present suffering cuts through consciousness like a physical wound, like the slow severing of the umbilical cord, like a tree being torn violently from its roots. There are many ways to sing, speak, or shout such warnings about this most fundamental and far-reaching challenge of our times—and just as many ways to hear (or refuse to hear) it. Of course there has been no shortage of scientists crying out for decades to the urgency of climate change. But scientific data and reasoned argument have not, it seems, been enough to transform the human heart. We need new images and new practices to generate hopefulness and breathe life back into a suffocating planet. We need new stories—and perhaps the retrieval of old and forgotten ones—to help the miner mourn the bird and begin to reconceive his happiness and flourishing as part of a much larger Story. In this chapter, the "canary in the coal mine" serves as a figure for the artist, poet, and storyteller, who, at the critical moment of struggle and death, breaks free from the cage "to tell the human truth" about our situation.

6. In sociological literature the term "iron cage" was coined by Max Weber, in his influential work *The Protestant Ethic and the Spirit of Capitalism,* to describe the ascendancy of "instrumental rationality" over classical or substantive reason, particularly in Western capitalist societies. The "iron cage" traps individuals in systems predicated on efficiency, rational calculation, uniformity, and control.

7. "Living Planet Report 2016," World Wildlife Federation, *https://www.worldwildlife.org/pages /living-planet-report-2016.* Mike Barrett, cited in Kevin Clarke, "As Mass Extinctions Threaten, Are Catholics Listening to 'Laudato si'?," *America* (Nov. 3, 2016), *http://www.americamagazine.org /issue/mass-extinction-threatens-are-catholics-listening-laudato-si,* writes, "For the first time since the demise of the dinosaurs 65 million years ago, we face a global mass extinction of wildlife. We ignore the decline of other species at our peril—for they are the barometer that reveals our impact on the world that sustains us."

8. Susan Elizabeth Hale, *Sacred Space, Sacred Sound: The Acoustic Mysteries of Holy Places* (Wheaton, IL: Quest, 2007), 2–3; see chapter 2.

9. Bob Protzman, "Cellist Friesen Takes Music into a New Age," *Chicago Tribune,* December 11, 1986; see chapter 1.

In 1953, acclaimed French author Jean Giono (1895–1970), at the age of fifty-eight, published "The Man Who Planted Trees," a short story of about four thousand words that he would later claim as one of his proudest achievements.[10] Written in French but first published in English in the American magazine *Vogue*, it tells the story of a shepherd's long and single-handed effort to reforest a desolate region in the foothills of the Alps, in the region of Provence, during the first half of the twentieth century. The story, like Giono's own life, spans two world wars and the bloodiest half-century in human history.

© Bridgeman Images

Jean Giono

Some thirty years later, in 1982, American filmmaker Godfrey Reggio (b. 1940) released *Koyaanisqatsi* (koy/an/is/kat/si), the first film in his *Qatsi* (kat/si) *Trilogy*, followed by *Powaqqatsi* (pow/a/kat/si, 1988), and finally, *Naqoyqatsi* (na/koy/kat/si, 2002).[11] Each film takes its title from the Hopi Indian language: *koyaanisqatsi*, meaning "life out of balance"; *powaqqatsi* meaning "parasitic life," or "life in transformation"; and *naqoyqatsi*, meaning "life as war." The third film was released just after the terrorist attacks of September 11, 2001, and during the buildup to the first US war in Iraq. A longtime resident of Santa Fe, New Mexico, Reggio spent fourteen years in formation as a Catholic monk, in fasting, silence, and prayer, before making *Koyaanisqatsi*. American composer Phillip Glass, one of the most influential composers of the late twentieth century, collaborated closely with Reggio in the making of all three films.

Though not precisely contemporaries and separated by a continent, Jean Giono and Godfrey Reggio share striking similarities as artists. Both gesture to humanity's profound need for silence and solitude amid the din and fog of

10. Jean Giono, "The Man Who Planted Trees" (1953; repr., White River Junction, VT: Chelsea Green, 2007).

11. *The Qatsi Trilogy*, dir. Godfrey Reggio (Criterion, 2012). This three-DVD collection includes numerous interviews with Reggio, composer Phillip Glass, and panel discussions with others about the three films, their making, and their impact.

war. Both look to nature, to nonhuman creatures, and to Earth's receding wilderness places, as the wounded and forgotten "world behind the text" of a bloodstained human history, past and present. And while they do so in dramatically different forms—one through the smaller canvas of traditional storytelling, the other through the grand canvas of filmmaking—both paint unforgettable pictures of what our Life-Story might yet become if human beings could realize a fundamental re-visioning of our relationship with Earth: in Reggio's words, to live and build human society from the realization that "the planet itself is a life form," a "mysterious unity held together through the web of diversity"; that "we are not the center of the universe"[12] but bound together with all Earth's species in a mutually dependent drama. In short, like the canary in the coal mine, both Giono and Reggio "tell the human truth" of our planetary Life-Story in ways that seek to break open

© magicinfoto / Shutterstock.com

Godfrey Reggio

the imagination, galvanize our freedom, and thereby—for those with eyes to see and ears to hear—generate hope.

We began this chapter with the image of a miner. We turn now to the image of a shepherd and a tale of simple beauty and hopefulness that has enchanted readers around the world for generations. As in previous chapters, I invite you to immerse yourself in both works—Jean Giono's "The Man Who Planted Trees," and Reggio's *The Qatsi Trilogy*, beginning with the first film, *Koyaanisqatsi*—to journal from them, and discuss them with others, before reading further.

12. "Impact of Progress," interview with Godfrey Reggio and Phillip Glass, in *The Qatsi Trilogy*.

"Who Would Dream of Such Magnificent Generosity?" The Man Who Planted Trees

Giono's tale begins in 1913, when the narrator, a young man, sets out on a walking journey through "that ancient region where the Alps thrust down into Provence."[13] After some days, the man finds himself in a broad valley of "unparalleled desolation," at the edge of an abandoned village, without water. The wind blows incessantly over the crumbling houses and ruined church, beating against the pilgrim's ears with "unendurable ferocity." "I had to move my camp." After another half-day of walking, finding no water and "nothing to give me hope of finding any," the young man notices a small figure standing against the horizon. As he draws nearer, he meets a solitary shepherd with his thirty sheep "lying about him on the baking earth." The shepherd gives him water and takes him to his cottage "in a fold of the plain."

> The man spoke little. This is the way of those who live alone, but one felt that he was sure of himself, and confident in his assurance. That was unexpected in this barren country. He lived, not in a cabin, but in a real house built of stone that bore plain evidence of how his own efforts had reclaimed the ruin he had found there on his arrival. His roof was strong and sound. The wind on its tiles made the sound of the sea upon its shore.

As the nearest village was still far away, the shepherd invites the sojourner to stay. He "shared his soup with me." After their meal, the shepherd spends several hours sorting through a pile of acorns on the table, inspecting them "one by one, with great concentration, separating the good from the bad," until he has selected one hundred perfect acorns. The shepherd's dog, "as silent as himself, was friendly without being servile." "There was peace in being with this man."

His curiosity piqued, the guest accompanies the shepherd with his flock the next morning into the valley, following at some distance, not wishing to impose himself, yet the shepherd "invited me to go along if I had nothing better to do." As they reach the top of a ridge, the shepherd takes his iron rod, which he had been using as a walking stick, and begins to thrust it into the earth, "making a hole in which he planted an acorn." The narrator is taken aback.

> He was planting oak trees. I asked him if the land belonged to him. He answered no. Did he know whose it was? He did not. He supposed it was community property, or perhaps belonged to people who cared nothing about it. He was not interested in finding out whose it was. He planted his hundred acorns with the greatest care.

13. Jean Giono, "The Man Who Planted Trees," 7.

The young man learns that the shepherd, having lost his only son and then his wife, has been planting trees for three years in the wilderness. "He had planted one hundred thousand. Of the hundred thousand, twenty thousand had sprouted. Of the twenty thousand he still expected to lose about half, to rodents or to the unpredictable designs of Providence. There remained ten thousand oak trees to grow where nothing had grown before." The man's name was Elzeard Bouffier.

The narrator leaves the shepherd the next day, and for the next five years fights in the First World War, soon forgetting about the shepherd. "An infantryman hardly had time for reflecting upon trees." In 1920, shell-shocked and longing "to breathe fresh air again," the man returns to the barren countryside and deserted village, finding that nothing has changed. Yet as his memory of the shepherd returns, he glimpses in the distance "a sort of greyish mist that covered the mountaintops like a carpet." Having seen so many men die during the war, he imagines that Elzeard Bouffier must be dead, "especially since, at twenty, one regards men of fifty as old men with nothing left to do but die."

But the shepherd was not dead. He had become a beekeeper, since his sheep had threatened the young saplings. Now the oaks of 1910, as well as "beech trees as high as my shoulder," filled the valley as far as the eye could see. Bouffier had set the beech saplings out in all those places "where he had guessed—and rightly—that there was moisture almost at the surface of the ground. They were as delicate as young girls, and very well established." Again, the narrator is struck with wonder, not only at the rebirth of the landscape, but also, and no less, the *disposition* of its cultivator.

> Creation seemed to come about in a sort of chain reaction. [Bouffier] did not worry about it; he was determinedly pursuing his task in all its simplicity; but as we went back toward the village I saw water flowing in brooks that had been dry since the memory of man. This was the most impressive result of chain reaction that I had seen. . . . The wind, too, scattered seeds. As the water reappeared, so there reappeared willows, rushes, meadows, gardens, flowers, and a certain purpose in being alive. But the transformation became part of the pattern without causing any astonishment.

One must not forget, the narrator interjects, that Elzeard Bouffier had worked "in total solitude: so total that, toward the end of his life, he lost the habit of speech. Or perhaps it was that he saw no need for it." Awestruck by this "land of Canaan" now bursting forth in a region once devoid of hope, the narrator wonders, "When you remembered that all this had sprung from the hands and soul of this one man, without technical resources, you understood that men could be as effectual as God in other realms than that of destruction." As hunters and settlers began returning to the region, enchanted by the sudden growth of this "natural forest," nobody knew whose patient labors had made it possible.

"He was indetectable." Who in the villages or government administration "could have dreamed of such perseverance in a magnificent generosity?"

Over the next twenty-five years, the narrator returns periodically to visit Elzeard Bouffier, seeing him for the last time in June 1945, under the shadow of another war, and two years before Bouffier's death. "The war just finished had not yet allowed the full blooming of life, but Lazarus was out of the tomb. On the lower slopes of the mountain I saw little fields of barley and of rye; deep in the narrow valleys the meadows were turning green." Eight years hence, in 1953, on the site of ruins the narrator had seen in 1913, now stood neat farmhouses, "cleanly plastered, testifying to a happy and comfortable life. The old streams, fed by the rains and snows that the forest conserves, are flowing again. Their waters have been channeled. . . . Little by little the villages have been rebuilt. People from the plains, where land is costly, have settled here, bringing youth, motion, the spirit of adventure." Pondering that "more than ten thousand people owe their happiness to Elzeard Bouffier," the narrator concludes, "I am convinced that in spite of everything, humanity is admirable." Indeed when an "old and unlearned peasant" is "able to complete a work worthy of God," perhaps we, too, will understand—as Giono implicitly suggests to his readers—that human beings can be as effectual as God in tasks other than destruction.

"An Obligation to Profess Hopefulness": The Vocation of the Writer

During his lifetime, Jean Giono was celebrated as one of the greatest writers in French twentieth-century literature. The author of over thirty novels, numerous essays, stories, plays, and film scripts, in 1953 he was awarded the Prince Ranier of Monaco Literary Prize for his collective work, and many of his writings are still being discussed and published. Yet for all this recognition, Giono believed he made his most valuable mark when he wrote "The Man Who Planted Trees." He refused to take royalties for the story, and granted its free use to anyone who wanted to distribute or publish it. "It does not bring me in one single penny and that is why it has accomplished what it was written for."[14] And what was it written for? In a letter responding to an American admirer of the tale, Giono explained that his purpose in creating Bouffier "was to make people love the tree, or more precisely, to make them *love planting trees*."[15]

Within a few years the story was translated into at least a dozen languages, and it has long since inspired reforestation efforts worldwide. In short, Giono's

14. Cited in Norma L. Goodrich, afterword, in "The Man Who Planted Trees," 46. The comment calls to mind Joni Mitchell's celebration of the street musician who "was playing real good for free" (see chapter 3).

15. Goodrich, afterword, 45.

goal as an artist has been realized in ways he might never have imagined. In 1987, the pioneering Canadian animator Frederic Back gave the story new life when he adapted "The Man Who Planted Trees" into a short film, narrated by Christopher Plummer, earning Back an Academy Award.[16] The film is truly breathtaking, employing a kind of impressionistic, Monet-like animation, the likes of which I have rarely seen. My students are mesmerized by both the book and the film, inevitably asking: Was Elzeard Bouffier a real person?

For many years, Giono enjoyed allowing people to believe it was so; in later years he made it clear that the account is fictional, a kind of parable or allegory. But one may ask: Does its fictional character make the story *any less true*? While Americans may hear in Giono's imaginary shepherd echoes of the real-life historical figure of Johnny Appleseed, Giono's tale, as Goodrich observes, "calmly veers away from past and present time toward the future of newer and better generations."[17]

To put it another way, the story resonates with truth and hopefulness not in spite of its fictional nature but because of it. While the tale of Johnny Appleseed describes a historical if almost magical tale of *what was*, the narrative tends to be relegated to a quaint but distant past. The reader of such a history is tempted to conclude, "Well, that's a beautiful story but it could never happen today." By comparison, the story of Elzeard Bouffier offers a vision of *what is*—the enduring beauty of meadows and mountain streams and undulating forests stretching out as far as the eye can see—and also a vision of *what is possible* when we set our minds and wills to a task yet "worthy of God." It celebrates the enduring miracle and wonder of the human being fully alive, fully present, fully generous with one's freedom.[18]

In the story's opening lines, Giono himself tells us that he most values Elzeard Bouffier as a figure for the "greatness of spirit" that human beings are capable of in the course of a lifetime. For Giono, the truly "exceptional character" is the person whose life is marked by unselfishness and generosity, "devoid of all egoism," leaving their mark on the pages of life without thought of reward.[19] In an interview with American writer Norma Goodrich shortly before his death, Giono insisted that writers, in particular, have "an obligation to profess hopefulness, in return for their right to live and write."[20] Hopefulness springs above all, he believed, from literature and the profession of poetry. Goodrich summarizes Giono's conviction about the writer's vocation:

16. "The Man Who Planted Trees," dir. Frederic Back (CBC Radio-Canada, 2004).

17. Goodrich, afterword, 50.

18. "The glory of God is the human person fully alive," declares Saint Irenaeus of Lyons. See Irenaeus of Lyons, *Against Heresies* 4.20.7.

19. Giono, "The Man Who Planted Trees," 7.

20. Goodrich, afterword, 50.

People have suffered so long inside walls that they have forgotten to be free, Giono thought. Human beings were not created to live forever in subways and tenements, for their feet long to stride through tall grass, or slide through running water. The poet's mission is to remind us of beauty, of trees swaying in the breeze, or pines groaning under snow in the mountain passes, of wild white horses galloping across the surf. You know, Giono said to me, there are also times in life when a person has to rush off in pursuit of hopefulness.[21]

Giono's perspective calls to mind the image of the caged bird, the poet's sense that the relentless pace and noise and artificiality of modern-day existence leaves many people feeling as if "paralyzed in small spaces."[22] But also, and just as importantly, that the simple act of setting out with daily intention to make the world a better place—by planting trees or writing stories or pursuing whatever path is one's particular gift and passion—is an individual's way of saving the world, a sacred endeavor, even if the name of God is never explicitly invoked.[23]

It is interesting, finally, as Goodrich notices, that Giono "termed his confidence in the future *esperance*, or hopefulness; not *espoir*, which is the masculine word for hope, but *esperance*, the feminine word designating the permanent state or condition of living one's life in hopeful tranquility."[24] This may seem a minor point, but I agree with Goodrich that it is significant. Why? It seems to me that Giono's vision of "hopefulness," bound in with the rhythms of the earth, gestures not to a temporary, episodic, or grandiose realization of "hope," as evoked by the masculine term, but rather a more organic, sustaining, and ever-present—dare I say, "womb-like"—sense of relationality, which is indeed better described as living in a state or contemplative disposition of "hopefulness." Elzeard Bouffier's attunement to the landscape is not episodic, abstract, and utilitarian; it is sustained, sensate, and "maternal," responsive day in and day out to the particular

21. Goodrich, afterword, 51.

22. Michael Paul Gallagher, "Michael Paul Gallagher: Dialogue between Faith and Imagination," *https://www.youtube.com/watch?v=JK3dpFbCtDQ*; see chapter 2.

23. Not a few real-life individuals and organizations stand as powerful contemporary witnesses to the healing of the planet such as seen in Giono's story: e.g., Indian forestry worker and activist Jadev Payeng; Sr. Dorothy Stang, SNDdeN, activist and martyr for the indigenous peoples of Brazil and protection of the rain forests; Wangari Matthai, Kenyan founder of the Green Belt Movement; indigenous leader Berta Caceras of Honduras, assassinated for her environmental activism.See Jennifer Avila, "An Eco-Defender Is Risking His Life to Protect a Honduran River," *America* (Aug. 15, 2016), *http://www.americamagazine.org/content/dispatches/hiding-honduras*. Avila writes that in 2015, "Global Witness documented 185 killings of environmental activists in 16 countries, a 59 percent increase over 2014 and the highest annual toll on record. Worst hit countries were Brazil (50 killings), the Philippines (33) and Colombia (26)." The recent film *PAD YATRA: A Green Odyssey* follows the Buddhist trek made by Tibetan nuns, community members, and His Holiness the Gyalwang Drukpa to save the Himalayas from environmental disaster and cultural extinction.

24. Goodrich, afterword, 50.

qualities and creative potentialities of the land, latent possibilities not self-evident to the casual observer but that lie dormant within the soil, "just beneath the surface." There is a "peace in being with this man" precisely because Bouffier embodies a sense of healing and attentive presence. He effects what he patiently and methodically signifies: the miraculous possibilities of presence.[25]

"Life Out of Balance": Koyaanisqatsi

Nearly the opposite sensation threatens to overwhelm the viewer of Godfrey Reggio's *Koyaanisqatsi*, the first of his three *Qatsi* films. If Jean Giono seeks to enchant the reader, to help us remember what we have forgotten—"the magical effect of certain words: hay, grass, meadows, willows, rivers, firs, mountains, hills"[26]—and he does so through traditional small-scale storytelling, then Godfrey Reggio seeks to transfix and unsettle the viewer through large-scale cinematic form that plunges the viewer into a synaesthetically immersive environment, helping us to truly see the chaotic world human beings have constructed. To put it another way, for some twenty years I have been showing *Koyaanisqatsi* in my classes, but rarely have I asked students to view the film entirely in one sitting. The effect, I worry, might be too discombobulating.

The three *Qatsi* films contain neither dialogue nor vocalized narration; their emotional tenor is set wholly by the juxtaposition of imagery, music, and silence. "The aural presence," as Reggio explains, "is co-equal with the image. . . . It is one medium motivating the other."[27] In interviews Reggio emphasizes that it is "not for lack of love of the language that these films have no words. It's because, from my point of view, our language is in a state of vast humiliation. It no longer describes the world in which we live."[28] The point, for me, calls to mind Giono's shepherd in "The Man Who Planted Trees." Formed as a monk in the desert plains of New Mexico, perhaps Reggio shares something of Elzeard Bouffier's contemplative disposition. Standing in sharp relief to an atmosphere of industry, war-making, and commerce, he had "lost the habit of speech. Or perhaps it was that he saw no need for it."[29] One reason for the enduring appeal of Reggio's films, I believe, is precisely their *lack* of spoken words. In a society in which we are ceaselessly bombarded by words, most of them trying to sell us something,

25. A phrase invoked at the end of chapter 1 in connection with the artistic and prophetic spirit. It is not incidental that one of the most persistent and beloved images of God in the Hebrew and Christian Scriptures—and of Jesus in early Christian art—is the image of the good shepherd. See, e.g., Ps. 23; 79; 95; Matt. 25:32; John 10:14, and many others.

26. Goodrich, afterword, 50–51.

27. "Impact of Progress," in *The Qatsi Trilogy*.

28. "Essence of Life," in *The Qatsi Trilogy*.

29. Giono, "The Man Who Planted Trees," 26.

The Qatsi Trilogy opens a space in our consciousness—and perhaps buried layers of *un*consciousness—for a very different kind of perception.

Yet there is one word in Reggio's lexicon that frames much of his career to follow, a word the artist borrows from the Native American southwest. As the first film begins, the Hopi word *koyaanisqatsi*—"life out of balance," "life in turmoil," "crazy life," "life disintegrating," a "state of life that calls for another way of living"—is chanted slowly in a deep solo *basso profundo* voice over the haunting score of Philip Glass.[30] The film unfolds as a sequence of slow motion and rapid time-lapse footage of cities and massive human construction projects juxtaposed against the panoramic, sweeping silences of natural landscapes, the rhythmic ebb of flowing waters and cloud-drenched skies across the United States. The most arresting sequences involve the camera fixed on human faces—thoughtful, beautiful, diverse—while car-packed freeways, subway trains, and jetliners rush by in the background, carrying their human cargo through time in a high-stakes frenzy, like so many insects in a complex web of causes and effects. Akin to Pink Floyd's "On the Run,"[31] with its human heartbeat overtaken by the frenzied sounds of an airport terminal, the effect of these sharp visual juxtapositions is jarring: one wonders just how our lives became *so* out of balance. Gazing upon sprawling urban landscapes from a "God's-eye view," as it were, from high above Earth, then plunging down to street level through Reggio's lens, what emerges is a chaotic montage of mass-human activity at a scale well beyond any single person's or society's capacity to control.

Film critic John Patterson describes a particularly unforgettable moment half-way through *Koyaanisqatsi*, after Reggio "has bathed us in torrents of retina-searing imagery," when a "single, lonely, lost-looking man in a huge crowd stares deeply and directly into the camera lens." It is, Patterson suggests, a "shocking moment, a breach of some conventional compact between viewer and subject. But it's also an island of calm amid the chaos."[32] Indeed there are many such "islands" of calm—of breathtaking beauty and jarring contemplative insight—hidden in full view, as it were, throughout Reggio's near-apocalyptic visual tone poem. And again, it is almost always the camera's fixation upon a single person's face that anchors the film's "human perspective" on otherwise cosmically-scaled events. Why? In a recent interview, Reggio explains that he wants the viewer "to have an *in-dwelling with the face*, so to speak."[33] In his latest film, another

30. Reggio gives credit to Hopi clan leader David Monongye for granting him the "theological authorization to use the term *Koyaanisqatsi*." See "Inspiration and Ideas," interview with Reggio in *The Qatsi Trilogy*.

31. From *The Dark Side of the Moon*, Harvest, 1973; see chapter 2.

32. John Patterson, "Godfrey Reggio: My 'Che Guevara' Was Pope John XXIII," *The Guardian*, March 27, 2014, *https://www.theguardian.com/film/2014/mar/27/godfrey-regio-visitors-filmmaker-koyaanisqatsi*.

33. Patterson, "Godfrey Reggio."

full-length, nonspoken narrative called *Visitors* (2013), Reggio abandons almost all background movement in favor of slow-motion close-ups of people's faces gazing directly into the camera—and at us. As in *Koyaanisqatsi*, here Reggio once again violates the norms of conventional filmmaking by "putting the audience face-to-face" with realities we habitually overlook, or "see" only superficially.

Such "in-dwellings," as Patterson points out, can be quite unsettling for the viewer, even shocking—a bit like getting caught gazing "through the keyhole,"[34] as Reggio himself admits. What also shocks is the realization of how much we habitually overlook, how little we really see of the "real world" we have built—so much of it now animated by digital, virtual, disembodied forces—and its often devastating effects on persons, the planet, and nonhuman creatures. Indeed, the most arresting face in *Visitors* may belong to an adult male gorilla named Tisk, whose eyes stare at the camera with slow-motion intensity for a full two minutes as the film opens, and then again as the film ends. As Patterson notes, it is only "after looking deep into the soul of our simian forebear" that the camera turns our gaze upon human faces. In this way, slowly, "the usual Reggio oppositions come into play: man in digi-technological ecstasy faces his analogue bestial ancestor, the origins of man face the ruins of mankind."[35]

No feeling person, I dare say, can watch *Koyaanisqatsi* or Reggio's subsequent films and not be sensually overwhelmed by the oppositions each film dramatizes between the human world, variously enthralled in "technological ecstasy" or lulled to sleep in industrialized catatonia, and the fiercely beautiful but wounded landscapes of our imperiled planet. As emphasized in our study of Pink Floyd's music in chapter 2, Reggio's trilogy likewise shows us how both the grandeur of Earth's wilderness spaces *and* the traditionally nurturing spaces of human social life have been colonized by technical-economic forces that tear at the fragile threads of social cohesion, leaving many people feeling alienated, ceaselessly "on the run," and powerless to resist—all while professing ourselves to be the most "connected" generation in history. Through Reggio's lens, the miner and the caged bird have indeed become one. At the same time, what is strangely calming in his films is the implicit permission the artist gives us to get off the treadmill and to *really see* life in all its strangeness, diversity, chaos, and breathtaking beauty—to see the *whole* of planetary life, even ourselves, the "ruins of mankind," with new eyes, and perhaps a more open, empathic heart.

Nowhere is Reggio's invitation to peer through the "keyhole" of global reality more arresting for me than in the trilogy's second film, *Powaqqatsi*. Foregoing the sped-up aesthetic of *Koyaanisqatsi* in favor of lingering slow-motion

34. Patterson, "Godfrey Reggio."

35. Patterson, "Godfrey Reggio." Reggio gives considerable credit to collaborators Glass and cinematographer Ron Fricke, "an absolute God-send for this project [and] a legitimate American genius" ("Essence of Life").

sequences, *Powqqatsi* is the most intensely spiritual chapter of the three films. Its opening sequence, filmed in the Serra Pelada gold mine in northern Brazil, pans across a sea of tens of thousands of mud-coated mine workers as they carry bags of dirt out of a massive open pit in the ground, scaling slopes and wooden ladders in lines of insect-like efficiency, moving upward toward some unseen destination. Several minutes into this disturbingly beautiful and somewhat horrifying slow-motion dance—again, the occasional fixation on individual men's faces highlights the dignity and beauty of individual persons amid unfathomable physical conditions—we see a miner being carried up the slopes by two other men, his limp and unconscious body draped over the men's shoulders as they snake their way impossibly upward. In a 2002 interview, Reggio explains that the miner had been struck by a falling rock. He describes the scene in retrospect as a kind of "Pieta" moment, the two men carrying their (expendable) brother's body up the slope, hauntingly resonant with images of Christ's body being taken down from the cross.[36]

The Hopi term *powaqqatsi*—"parasitic life," or "life in transformation"— itself becomes a powerful "framing device" or hermeneutical lens through which the viewer gains access to the artist's vision, both "behind" and "within" the visual and aural textures of the film. In the same 2002 interview, Reggio explains that in Hopi cosmology the term *powaqqa* refers to "a black magician, an entity that eats the life of another person, consumes the life of another, in order to advance her own or his own life." Combined with *qatsi*, or "way of life," the hybrid term *Powaqqatsi* refers to "a way of life that consumes another way in order to advance itself."[37] The film's title thus serves to intensify the filmmaker's narrative point of view that the cultures of the Southern Hemisphere are being consumed by the cultural norms of so-called progress and development of the Northern Hemisphere. The scene in the Serra Pelada gold mine exposes the high *human* costs of the First World's parasitic appetite for gold— the Christ-figure carried from the pit—and at once the devastating costs to *nature*, in the wasteland of the pit itself. "Nature is dead in relation to us as the host of life," Reggio says. "The new host is the technological order. We have almost no terms in which to grasp this."[38]

36. "Impact of Progress," referencing Michelangelo's *Pieta* sculpture, in which Mary is holding the dead body of Jesus.

37. "Impact of Progress."

38. "Impact of Progress." In his first visit to the United Nations, US President Donald Trump said to African political leaders, "Africa has tremendous business potential. I've so many friends going to your countries, trying to get rich. I congratulate you. They're spending a lot of money." His words were greeted with stony silence. As *Time* magazine noted of the speech, "The suggestion that wealthy Americans might be trying to enrich themselves in Africa would have been a sensitive one at the event, given that African labor and natural resources were subjected to centuries of European and American exploitation in the colonial era, including during the trans-Atlantic slave trade." Kevin Lui, *Time*, September 21, 2017, *http://time.com/4951006/trump-africa-get-rich/*.

"The Beauty of the Beast": Inside the Technological Milieu

Why, in Reggio's view, do we have "almost no terms" in which to grasp the full gravity of our global social and environmental crisis? In part, says Reggio, because a *powaqqa*—the parasitic nature of the technological order—"operates through seduction, through allurement, not through the obvious 'I'm coming to eat your heart,' like a horror show."[39] Global capitalism as such is not an outright frontal attack on human flourishing; rather it hides benevolently behind notions such as "development," "progress," and "the market." As the *Qatsi* films suggest—again, not through spoken words or philosophical debate but through images wed powerfully to music—the violence of the industrial-technological order is a "civilized violence," a "sanctioned aggression" against the force of life itself, "so ubiquitous," Reggio insists, "that we have no distinct perspective from which to judge it."[40] Its revered instruments, like the gold extracted from the Serra Pelada mine, are often shiny and beautiful, woven so seamlessly into the global industrial-economic order that they operate autonomously, self-deterministically, admitting of no substantive human intervention.

> These films have never been about the effect *of* technology, *of* industry *on* people. It's been that everyone: politics, education, things of the financial structure, the nation state structure, language, the culture, religion, all of that exists within the host of technology. So it's not the effect *of*, it's that everything exists within [the technological order]. It's not that we *use* technology, we *live* technology. Technology has become as ubiquitous as the air we breathe, so we're no longer conscious of its presence.[41]

Behind his critique of technology, Reggio acknowledges, is the influence of French philosopher and theologian Jacques Ellul, author of the influential 1964 book, *The Technological Society*.[42] Ellul describes the nature of technology—or more precisely, *technique*, from the French—not as "a machine or a computer but [as] the very organization of life itself."[43] Similar to thinkers we have considered in earlier chapters—Abraham Joshua Heschel, Bertrand Russell, Thomas Merton, Karl Marx, the critical thinkers of the Frankfurt School of philosophy—Ellul underscores the degree to which modern technology elevates the *means* of production (efficiency, utility, autonomy, profit)

39. "Impact of Progress."

40. "Inspiration and Ideas."

41. "Essence of Life."

42. Jacques Ellul, *The Technological Society* (Toronto: Knopf, 1964).

43. "Inspiration and Ideas."

over the substantive *ends* for which human beings have traditionally lived and strived to flourish as social beings (love, justice, happiness, meaning, belonging). Driven by instrumental rationality, the technological milieu enforces the logical and mechanical division of labor, the setting of universal production standards, and so forth, in an artificial system that perpetuates itself and eliminates or subjugates the natural world. What we sanguinely call "the market," however, is not morally neutral; it bears and projects a value system onto, and into, everything it touches.

To be clear, Ellul's critique has less to do with the particular tools and devices we take so much for granted today—computers, earthmovers, airplanes, smart phones—than with the ways that the systematic application and proliferation of such technologies risks overtaking human freedom, sacrificing personal dignity and agency to the collective. Instead of technology being in service of humanity, as a tool or means toward higher ends, its practical reach into every domain of life means that "human beings have to adapt to it, and accept total change."[44]

Nature likewise loses its autonomy and transcendence. Whereas nature once comprised the all-encompassing environment and power upon which human beings were dependent, and so was experienced as sacred, in the technological milieu nature is desacralized, consumed, and replaced by products—or the glittering imagery of products—well beyond actual reach of the world's poor. These products are subsequently endowed with an aura of sacred meaning by sophisticated advertising imagery. As Thomas Merton observes in one of his most prescient essays, "The time will come when they will sell you even your rain. At the moment it is still free, and I am in it. I celebrate its gratuity and its meaninglessness."[45]

Anticipating fierce debates in education today, Ellul worried about the diminished value of the humanities in the technological milieu. As young people (and their parents) begin to question the value of learning ancient languages, history, or other subjects that may seem, on the surface, to do little to advance their financial and technical state, the focus of many schools has shifted to the world of information, educating students to work with computers but knowing only their language, their logic, their relationships, and the interactions between them. The language-world of technique colonizes the whole intellectual domain and also that of conscience. Something essential of our humanity, Ellul worried, is gradually, perhaps imperceptibly, being lost. Ellul writes,

44. Jacques Ellul, *What I Believe*, trans. Geoffrey W. Bromiley (Grand Rapids: Eerdmans, 1989), 136.

45. Thomas Merton, "Rain and the Rhinoceros," in *Raids on the Unspeakable* (New York: New Directions, 1966), 9. The essay begins with Merton standing in the woods outside his hermitage during a rainstorm in the middle of the night.

What is at issue here is evaluating the danger of what might happen to our humanity in the present half-century, and distinguishing between what we want to keep and what we are ready to lose, between what we can welcome as legitimate human development and what we should reject with our last ounce of strength as dehumanization. I cannot think that choices of this kind are unimportant.[46]

In sum, to the extent that modern technology has become "a total phenomenon for civilization, the defining force of a new social order in which efficiency is no longer an option but a necessity imposed on all human activity,"[47] it becomes very difficult for individuals or societies to make discerning moral and political choices toward personal flourishing and the common good. By its nature the technological milieu operates more or less independent of human desires. "Not even the moral conversion of the technicians could make a difference. At best, they would cease to be good technicians."[48] In the end, "technique has only one principle, efficient ordering."[49]

This brings us back to Reggio. Following the sequence in the Serra Pelada mine, the first half of *Powaqqatsi* bears the viewer through a series of stunning slow-motion sequences of indigenous peoples of South America, Africa, and Asia, people as they are immersed in traditional forms of life, labor, and worship intimately linked to the rhythms of the earth: fishermen rowing through the tides in a rough-hewn boat, raising their patchwork sails in the wind; women threshing grain, barefoot and laughing in dancing rhythmic circles; turbaned men herding camels against a dust-laden orange sky; children balancing sheaves of corn in intricately woven baskets above their heads. Suddenly the imagery shifts to a series of high-tech digital images, invoking one of the most powerful "magical" forces on the planet for shaping collective human behavior: *advertising*, the visual and aural currency of global capitalism. The implication of these sharp juxtapositions is once again clear for viewers in the industrialized North: in ways that we are hardly conscious, the life-worlds we inhabit have been "taken over" by industry, machinery, consumerism, technology. Yet the transformation has been so rapid, so total, that we "have almost

46. Ellul, *What I Believe*, 140. It is worth noting that both Jacques Ellul and Jean Giono were from southern regions of France: Ellul from Bourdeaux in the southwest, Giono from Manosque, in the southeast. During WWII, Ellul was a leader in the French resistance. For his efforts to save Jews, he was awarded the title "Righteous Among the Nations" in 2001 by the Jewish Holocaust museum in Jerusalem, Yad Vashem.

47. Darrell Fasching, *The Thought of Jacques Ellul: A Systematic Exposition* (New York: Mellen, 1981), 17.

48. Ellul, *The Technological Society*, 97.

49. Ellul, *The Technological Society*, 110. For an excellent overview of Ellul's thought in dialogue with Thomas Merton and other modern philosophical and theological perspectives, see Jeffrey M. Shaw, *Illusions of Freedom: Thomas Merton and Jacques Ellul on Technology and the Human Condition* (Eugene, OR: Pickwick, 2014).

no terms in which to grasp this." The *powaqqa* consumes the life of another through allure and seduction.[50]

What are the short- and long-term consequences when societies are structured not symbiotically, within the "womb" of nature, but parasitically, within the "host" of industry, mass media, and advertising, this new sacred order, as Ellul has it, which commands our complete devotion? Returning to *Koyaanisqatsi*, Reggio's interjection of three Hopi prophecies at the end of the film, sung by a choral ensemble and translated in text across the screen, suggests a possible answer:

If we dig precious things from the land, we will invite disaster.

Near the day of Purification, there will be cobwebs spun back and forth in the sky.

A container of ashes might one day be thrown from the sky, which could burn the land and boil the oceans.

How to make sense of these enigmatic Hopi sayings, so strangely resonant with warnings issued today by the scientific community? Are we now in "the day of Purification"?

Notice the word *if* that opens the series of powerful images. Like the canary in the coal mine, the prophet's intimations of the future are *conditional*, contingent upon our response: "Act now or disaster will surely strike." In its biblical sense, prophecy is not about forecasting an irreversible future so much as it is the act of looking deeply into the signs at the moment of highest tension and naming the truth—from "a God's-eye view," as it were—that others have been unable or unwilling to speak.[51] The prophet "speaks truth to power" so as to

50. In a seminal essay, Catholic theologian David Tracy laments the darker side of modernity in which "we have seen our lifeworlds, in all their rich difference, increasingly colonized by the forces of a techno-economic social system that does not hesitate to use its power to level all memory, all resistance, all difference, and all hope. Religion becomes privatized. Art becomes marginalized. All the great classics of our and every culture become more consumer goods for a bored and anxious elite. Even the public realm—the last true hope of reason in its modern and classical Western forms—becomes merely technicized." While sounding themes deeply resonant with Ellul, Tracy nevertheless rejects the notion that we are trapped, after all, in Weber's "iron cage." David Tracy, "On Naming the Present," *Concilium* 1 (1990): 3–24. Tracy here is partly dependent on German Catholic political theologian Johann Baptist Metz, who some forty years ago described the present situation of late modernity as one in which "human beings face the threat of being transformed from being the subjects of civilization's technological process to being their product. . . . We are coming to an ever clearer consciousness of the dangers and antagonisms that arise when technological and economic processes are left to their own autonomous laws." See Johann Baptist Metz, *Faith in History and Society: Toward a Practical Fundamental Theology*, trans. J. Matthew Ashley (1977; repr., New York: Herder and Herder, 2007), especially 97–102.

51. See Walter Brueggemann, *The Prophetic Imagination*, 2nd ed. (Minneapolis: Fortress, 2001); also Walter Brueggemann, *Disruptive Grace: Reflections on God, Scripture, and the Church*, ed. Carolyn J. Sharp (Minneapolis: Fortress, 2011), especially 17–37, 129–54; and Abraham Joshua Heschel, *The Prophets* (New York: Harper & Row, 1962).

make something different happen with words—or, as in Reggio's case, through images, music, and silences. *Koyaanisqatsi* is "a film of no words about the power of one word,"[52] a visual iconography of life in turmoil.

At the same time, Reggio emphasizes that the *Qatsi* films are intended above all to create an experience and that it is up to the viewer "to take for himself or herself what it is that [the film] means."[53] As an artist his intention is not to tell us *what to think*, or still less *how to act*, but rather to mediate an encounter with reality, opening our eyes onto a much larger horizon than what is possible or permissible inside conventional ways of seeing, thinking, and acting. Like the biblical prophets of old, Reggio speaks from "within" the people but he is not "of" the people. Standing at the margins—recall his years as a monk, and many decades to this day working as a social activist among poor youth in New Mexico—the artist listens and sees, gathering in the signs, and then expresses what is seen through his work. Like Jean Giono, it seems clear that Reggio also speaks from a deep sense of vocation as an artist, "an obligation to profess hopefulness," though I confess I find it more difficult to come away from Reggio's body of work with hope.[54] Perhaps it is the sharp juxtaposition of beauty with loss that renders his films so compelling and at once so unsettling. Reggio himself describes his artistic *vocation* as *provocation*: "In animal mythology, the female lion, her cubs are born stillborn, and she roars them into life, to provoke their hearts with that roar. Beauty and provocation's root words in Greek are closely associated, almost identical: beauty is a provocation, and my particular provocation is that I want to show the beauty of the beast."[55]

At this point, however, we have to ask whether Reggio's use of the large-scale, high-tech medium of film does not reinforce the very dilemma that his work aims to critique. Sitting in a theater with strangers in the dark and viewing *Koyaanisqatsi* on an immense digital screen, immersed in Dolby surround-sound, it seems we remain spectators at the keyhole, voyeurs of our own

52. "Essence of Life."

53. "Impact of Progress." On this point Reggio follows Jacques Ellul, who emphasized that he was neither for nor against "technique." "Like an earthquake or an avalanche, he was simply describing what he sees, realizing that regardless of his own opinion on the matter, the phenomenon is here to stay." Shaw, *Illusions of Freedom*, 35.

54. This is especially so with the third film in the trilogy, *Naqoyqatsi*, or "life as war," which employs computer-generated imagery and found footage to visualize a world that has effectively completed the transition from the natural to the artificial. Ironically, the film suggests, the cacophony of our "communication" age has rendered humankind effectively post-language; we inhabit a milieu that language can no longer describe. Phillip Glass's more traditional orchestration—with cellist Yo Yo Ma featured heavily in the score—provides a more familiar base and counterpoint to so much of the film's imagery that is disconnected from the familiar. Because *Naqoyqatsi* borrows so relentlessly from the digital-virtual language that it aims to critique, it offers fewer immediately "human" touchpoints for the viewer, and perhaps for this reason has been less well received by audiences and critics than the previous two films.

55. Patterson, "Godfrey Reggio."

life, and perhaps much worse, complicit bystanders to a suffering world. Reggio acknowledges the irony of his method but insists on its validity as a subversive means—from "within the coal mine," we might say—of telling the human truth of our situation: "I don't feel it's contradictory or hypocritical to use the very medium that you're questioning. In fact, I think it's appropriate, because I'm not exempting myself from this criticism. This is something that involves us all, that we're only beginning to see. I use this medium because it's the medium that can reveal the subject most clearly." "What this is," he concludes, "is an attempt at the hour of death to rise above yourself, and to see yourself in another context, and this context is the technological order."[56]

It must also be said, and I dare say Reggio would agree, that technology as such can be framed positively, even spiritually, as the wondrous fruit of evolutionary flourishing: consider the eradication of smallpox, or the use of social media around the globe to empower struggling freedom movements. Few would deny the positive and life-giving dimensions of particular technologies when applied as means of attaining particular goods. But this in no way contradicts Reggio's deeper point: we have reached a critical tipping point where decisions about *how* we evolve and *to what purpose* we bend our technologies have profoundly far-reaching implications for social, economic, political, and spiritual life on the planet. How to direct our collective efforts toward the sanctification of the earth and not its desecration, if not by drawing from the deepest wellsprings of scientific, cultural, *and* religious wisdom? How to choose our future course wisely, with freedom from arrogance or willful blindness about the darker aspects of the technological milieu? Perhaps more to the point: can we really trust Exxon Mobile, JP Morgan Chase, or the fewer and fewer mass media conglomerates to make such choices—or mediate them politically in a wise and transparent way—for future generations? Reggio's deeper concern echoes Ellul's: the global economic-technological order has effectively become a "closed circuit" that does not admit of human intervention.[57]

56. "Impact of Progress."

57. Two examples will suffice. First, in his best-selling book *Flash Boys: A Wall Street Revolt* (New York: Norton, 2014), investigative journalist Michael Lewis describes practices of high-speed trading on the American stock exchange driven by computer algorithms at nearly light speed, moving enormous amounts of capital in a process that is "fully automated, spectacularly fragmented, and complicated beyond belief by possibly well-intentioned regulators and less well-intentioned insiders." Cited in Michael Lewis, "Michael Lewis Reflects on His Book *Flash Boys*, a Year after It Shook Wall Street to Its Core," *Vanity Fair*, April, 2015, *http://www.vanity fair.com/news/2015/03/michael-lewis-flash-boys-one-year-later*. Second, some forty years ago moral philosopher Peter Singer published *Animal Liberation* (New York: HarperCollins, 1975), arguing that industrial farming has caused more pain and misery than all the wars of history put together. Since then a host of studies have exposed the deleterious impact of large-scale farming and mass food production techniques on animals, human health, and the environment. See Yuval Noah Harari, *The Guardian*, September 25, 2015, *https://www.theguardian.com/books/2015/sep/25 /industrial-farming-one-worst-crimes-history-ethical-question*.

It is not that the Hopi Indians harbor some alternative "magic" to win our release from the "iron cage" of instrumental reason. As Reggio insists, his films are not about returning to some idyllic or romantic vision of the past. Rather they are about reclaiming ways of life and reimagining new forms of being-in-relationship that are fundamentally more human. What does that mean? It begins, as noted at the outset of this chapter, with the realization that "the planet itself is a life form," a "mysterious unity held together through the web of diversity."[58] It involves the recognition that we and our assumed cultural norms "are not the center of the universe," and that all peoples and cultures bear a sacred dignity and right to participate in the common good. In this sense, it is hard to disagree with Reggio that the Hopi Indians *do* have "a far better metaphysics"[59] than that which has dominated "Western civilization" for centuries and which still sanctions its domination of others. As New Mexico writer Mabel Dodge Luhan puts it, the Native Americans' traditional "lack of interest in material wealth, their devotion to communal values, their healthy respect for human limitations, and their adaptation to rather than exploitation of the natural environment," represent sane and even saving alternatives "to a chaotic white civilization that is heading for self-annihilation."[60]

Here, then, is our dilemma. How is a mind, as Reggio has it, "to rise above" itself and see itself "in another context" when the mind's limited view is supported by the texture of a whole civilization? If we are not persuaded to break free of the "coal mine" by the scientists of our time, whose urgent pleas about climate change sound not a little like the Hopi vision of "burning lands" and "boiling oceans," perhaps we will begin to heed the artists and poets, the mystics and indigenous peoples, whose authority rises from the wisdom of deep connection to the land through memory, ritual, song, silence, and the poetry of the human heart.

If spirituality, as suggested in chapter 3, refers to "*how one leans into life*, how one experiences life, how one sees and engages the world,"[61] then it is crucial to reflect on how our everyday habits of seeing and engaging the world might be contributing to the fundamental crisis of our time—and how we might begin to lean in *together* toward solutions. I want to turn toward a conclusion on a more personal and hopeful note by considering the human truth of our situation down at street level.

58. "Impact of Progress."

59. "Essence of Life."

60. Cited in Lois Palken Rudnick, introduction, in Mabel Dodge Luhan, *Edge of Taos Desert: An Escape to Reality* (Albuquerque: University of New Mexico, 1987), xiv. Mabel Dodge was a wealthy New York socialite who in 1918 left her life of privilege to live among the Taos Indians of New Mexico.

61. Canadian theologian Brian Walsh, cited in *Bruce Cockburn: Pacing the Cage*, dir. Joel Goldberg (True North, 2013); see chapter 3. Reggio credits his many years as a monk, beginning from age fourteen, with teaching him "something that I would have never learned in [most US] schools: discipline, the power of limits. . . . It was a life of humility, service, and prayer. . . . [The monastic life] taught me to pay attention to what stands behind the surface of things." See liner notes from *The Qatsi Trilogy*; also "Essence of Life."

"Paralyzed in Small Spaces": Toward a Spirituality of Resistance

Not long ago I was driving to work when I heard a story on public radio about the newest products being showcased at an annual technology show in Las Vegas. One of the big software companies was unveiling a kind of "virtual helmet" worn over the head that can "transport" the user into any environment of their choosing. The tech reporter spoke with great excitement about a program that would bear the wearer of the virtual helmet into—wait for it—Henry David Thoreau's *Walden Pond*, enabling the user to "see and hear everything Thoreau saw: the different birds and species of trees, the water lapping over rocks at the bank of the pond, the frogs croaking, the wisp of the wind through the cabin windows," and so on. "Now we can go to the woods and suck out all the marrow of life," the reporter gleefully concluded, "without ever leaving our living room." I nearly crashed the car.

Jean Giono, I expect, is either laughing or turning over in his grave—maybe both. Have we become so encased in virtual constructions of reality that we've forgotten what it is to be human, to feel the grass under our bare feet, to be free? Once again, to recall Ellul, the question is not necessarily directed at the technology itself—the potential good ends to which virtual reality might be directed—so much as the *perceived needs* driving the development, use of, and voracious appetite for such products. What may be gained, and what may be lost, by raising a generation of children far more intimate with gadgets and virtual mediations of "reality" than with actual woods, rivers, wind, birds, sunlight, and, lest we forget, other people?

The recent horror film *Unfriended* (2014) exploits a plot line increasingly common in Hollywood today, in which the narrative unfolds entirely on a desktop computer screen, drawing six high school students into a sort of Orwellian nightmare in which every interaction is mediated electronically by Skype calls, Facebook status updates, and instant messages. Russian producer Timu Bekmambetov explains his inspiration for the project: "I want to see movies about my virtual life. And I'm sure I'm not alone. Why should I be making movies about some physical world where I'm not really spending so much time?" His goal, in other words, "wasn't just to tell a digital horror story," but to make a film "about how people live their lives in 2015."[62]

62. Cited in Brian Truitt, "'Unfriended' Reflects Today's 'Virtual Life,'" *USA Today*, April 14, 2015, *https://www.usatoday.com/story/life/movies/2015/04/14/unfriended-horror-movie-virtual-life/25700933/*. On the other hand, a highly recommended counter-narrative or subversive critique of the TV and virtual reality world is director Peter Weir's brilliant film *The Truman Show*, for which, not incidentally, Phillip Glass composed the music, some of it borrowed from *The Qatsi Trilogy*. And an analogous cautionary tale, in a more personal and plaintive key, is offered by the critically acclaimed Spike Jonze film *Her* (Warner Bros, 2013).

Here is the gist of it: How are we actually living? And does this way of living promise meaning, fulfilment, health and wholeness, happiness? That the myriad pressures to adapt oneself to the technological milieu are "invading the whole intellectual domain and also that of conscience" seems to me a prescient and inarguable point, and probably far more true today than it was in Ellul's era. But irrespective of whether one shares these concerns or agrees with Ellul's diagnosis of the technological dilemma, the key point, it seems to me, is his insistence that we must be able to distinguish "between what we want to keep and what we are ready to lose, between what we can welcome as legitimate human development and what we should reject with our last ounce of strength as dehumanization."[63]

"We live in a society," Thomas Merton wrote in 1948, "whose whole policy is to excite every nerve in the human body and keep it at the highest pitch of artificial tension, to strain every human desire to the limit and to create as many new desires and synthetic passions as possible, in order to cater to them with the products of our factories and printing presses and movie studios and all the rest."[64] Almost seventy years later, in a widely-shared essay entitled, "I Used to Be a Human Being," British Catholic writer and popular blogger Andrew Sullivan—self-described as a "very early adopter of what we might now call living-in-the-web"—writes of his deepening addiction to "virtual living, this never-stopping, this always-updating," to the point of serious physical and emotional illness. "So much of it was irresistible, as I fully understood. So much of the technology was irreversible, as I also knew. But I'd begun to fear that this new way of living was actually becoming a way of not-living."[65] The smartphone revolution, says Sullivan, is "the final twist of this ratchet, in which those few remaining redoubts of quiet—the tiny cracks of inactivity in our lives—are being methodically filled with more stimulus and noise." Like Merton, Sullivan laments the loss of the silences and open spaces so essential to a basic awareness of the state of our being.

> [And] just as modern street lighting has slowly blotted the stars from the visible skies, so too have cars and planes and factories and flickering digital screens combined to rob us of a silence that was previously regarded as integral to the health of the human imagination.
>
> This changes us. It slowly removes—without our even noticing it—the very spaces where we can gain a footing in our minds and souls that is not captive to constant pressures or desires or duties. And the smartphone has all but banished them.[66]

63. Ellul, *What I Believe*, 140.

64. Thomas Merton, *The Seven Storey Mountain* (New York: Harcourt, 1948), 148.

65. Andrew Sullivan, "I Used to Be a Human Being," *New York Magazine*, September 18, 2016, *http://nymag.com/selectall/2016/09/andrew-sullivan-technology-almost-killed-me.html*.

66. Sullivan, "I Used to Be a Human Being."

In other words, the wholly immersive nature of our newest technologies makes it more and more difficult to separate or even distinguish the technological device itself (in this case, the smartphone) from the technological milieu that it signifies. To the degree one is wholly absorbed in the device for inordinate amounts of one's time, the device, says Reggio, "effects what it signifies." The tool itself—the computer, the smartphone, the virtual helmet, the TV—becomes a "sacrament," suggests Reggio, borrowing a term from Catholic theology: that is, a sign and instrument of "sacred presence" and of quasi-religious devotion for the user.[67] While such a claim may seem over the top, it bears out in the near-mystical language of virtual-reality (VR) pioneers, who describe VR as "the final platform," a technology which allows the user "to blur the distinction between you and the rest of the world. . . . In about a year or two, nobody will find this hard to understand. This will become totally ordinary." The ultimate aim of VR developers is to create instruments that effect for the user "what they longingly call 'presence'—when you really feel like you're inside a fake environment."[68]

The potential for immersive technologies to be utilized in dehumanizing ways is suggested by recent reports of sexual assault via VR. Indeed the potentially negative effects of inhabiting the digital world for high school and college students (but certainly not only for younger people) seem to play out especially in the realm of relationships and sexuality. Researchers are only beginning to understand, for example, the impact of regular use of online pornography on attitudes, expectations, and behaviors among men and women of all ages as they engage in short- and long-term intimate relationships. It is strange to consider that young and older people alike are increasingly experiencing "sex" and discovering the meaning of "sexual relations" in virtual isolation. Meanwhile, in the political realm, a decade ago author Bill Bishop, in his book *The Big Sort: Why the Clustering of Like-Minded America Is Tearing Us Apart*, sounded a now-familiar theme that the United States has become a nation of gated communities, of both the virtual and literal sort. In short, Americans increasingly work, live, recreate, and even worship only with people who think like themselves.[69]

67. "The utopia of the technological order is virtual immortality, hithertofore only ascribed to the gods, to the divinity. Now we have a new pantheon, the computer sits in the middle of it, not merely a sign but an instrument that produces this globalization. In that sense it is the highest magic in the world, something we are all in adoration of" ("Impact of Progress").

68. Joel Stein, "Why Virtual Reality Is About to Change the World," *Time*, August 6, 2015, *http://time.com/3987022/why-virtual-reality-is-about-to-change-the-world/*.

69. On sexual assault via VR, see the unsettling piece by Sarah Ashley O'Brien, "She's Been Sexually Assaulted 3 Times—Once in Virtual Reality," CNN Business, October 26, 2016, *http://money.cnn.com/2016/10/24/technology/virtual-reality-sexual-assault/index.html?iid=ob_homepage_tech_pool.*; on the effects of pornography usage on relationships, see Shankar Vedantum, "Researchers Explore Pornography's Effect on Long-Term Relationships," Hidden Brain, NPR, October 9, 2017, *http://www.npr.org/2017/10/09/556606108/research-explores-the-effect-pornography-has-on-long-term-relationships*; and with an eye on politics and socialization, Bill Bishop, *The Big Sort: Why the Clustering of Like-Minded America Is Tearing Us Apart* (New York: Houghton Mifflin Harcourt, 2008).

Let me hasten to add that this is by no means a line of critical questioning foreign to my college students, as if they had never considered the darker ramifications of the digital world they inhabit. Most have. And many have expressed how much they appreciate being "connected" to the world far more than previous generations, on the one hand, and yet at the same time, how much they struggle to connect with their peers face to face, to be fully present to themselves, to others, to nature, without constant distraction or social anxiety. When talking about their smartphones, for example, not a few of my students speak in terms of "addiction," and express a sincere desire to curb their use of social media and seek out alternative ways of social interaction. And though I am older by decades than most of my students, I certainly do not exempt myself from these critical observations and desires. The technological milieu is something "that involves us all," as Reggio notes, even if many of us are still trying to find the terms in which to grasp it.

For Reggio, Sullivan, Merton, and not a few other artists and thinkers of our time, all of these interrelated personal, cultural, and political realities seem to reflect a deeper spiritual malaise, a kind of paralysis, if not insanity, which prevents us from living fully, as it were, in our "right mind," not to mention in our actual physical bodies.[70] How, then, to conceive a life of greater balance and integration between the human and natural realms that sustain us all, between work and play, silence and speech, stillness and creativity, industry and art?

Of course it was more than 150 years ago that Thoreau issued his manifesto against the dehumanizing pressures of modern life: "I went to the woods because I wished to live deliberately, to front only the essential facts of life, and see if I could not learn what it had to teach, and not, when I came to die, discover that I had not lived. I did not wish to live what was not life, living is so dear."[71] As compelling and even romantic as Thoreau's witness may be, the question of human fulfilment can no longer be confined, as it tends to be in the American mythos, to the individual or private realm alone. The story and spirit of Thoreau must be translated into a much larger societal and planetary Story of the common good.

70. Not a few modern philosophers have described the lure of the technological milieu as a kind of "Gnosticism," a term with ancient Christian provenance, which views salvation or participation in the divine realm as an escape from the limits and moral corruption of the body and the embodied human community in history. While condemned as heretical to Christian orthodoxy, various forms of Gnosticism, which hinges on body/spirit dualism, have lived alongside and within Christian thought from the beginning. The enduring appeal and proliferation of science fiction fantasy and cyber-dystopian films such as *2001: A Space Odyssey* (1968), *Blade Runner* (1982), *The Matrix* (1999), and *Her* (2013), suggest a deep cultural yearning, if not a deep anxiety, about the nature of reality, humanity, and divinity in the age of the computer. In a word, what can be trusted as real, and what is illusory, merely perceived or constructed? For an interesting overview, see M. Alan Kazlev, "The Matrix and Gnosticism," Futurism, *https://futurism.media/the-matrix-and-gnosticism*.

71. Cited in Sullivan, "I Used to Be a Human Being."

"An Integral Ecology": Weaving New Stories of Belonging

In the opening paragraph of his extraordinary encyclical *Laudato si': On Care for Our Common Home*, Pope Francis cites the beloved mystic, poet, and prophet Saint Francis of Assisi to call the global human community back to the earth, "our common home, who is like a sister with whom we share our life and a beautiful mother who opens her arms to embrace us. 'Praise be to you, my Lord, through our Sister, Mother Earth, who sustains and governs us, and who produces various fruit with coloured flowers and herbs.'"[72] And then, like the canary in the coal mine, Francis gives lyrical voice to the earth's present suffering, a kind of mirror, he suggests, of the alienation and violence that infects our own hearts.

> This sister now cries out to us because of the harm we have inflicted on her by our irresponsible use and abuse of the goods with which God has endowed her. We have come to see ourselves as her lords and masters, entitled to plunder her at will. The violence present in our hearts, wounded by sin, is also reflected in the symptoms of sickness evident in the soil, in the water, in the air and in all forms of life. This is why the earth herself, burdened and laid waste, is among the most abandoned and maltreated of our poor; she "groans in travail" (Rom. 8:22). We have forgotten that we ourselves are dust of the earth (cf. Gen. 2:7); our very bodies are made up of her elements, we breathe her air and we receive life and refreshment from her waters.[73]

Like the Hopi of North America, Pope Francis reminds us that the earth is immeasurably more than "raw material" for human consumption. Integrating poetic, religious, and scientific wisdom, *Laudato si'* gives voice to an "integral ecology," a new metaphysics of the earth, a theology that dissolves crude oppositions between spirit and matter. Imagine this, Pope Francis urges: a planet that is not only self-aware but *sensually* aware of itself! In the soils and winds and waters, "the divine and the human meet in the slightest detail in the seamless garment of God's creation, in the last speck of dust of our planet."[74] An integral ecology also implies a radically integral anthropology, a far more humble and

72. Pope Francis, "*Laudato si'*: On Care for Our Common Home," no. 1, *http://w2.vatican.va /content/francesco/en/encyclicals/documents/papa-francesco_20150524_enciclica-laudato-si.html.*

73. *Laudato si'*, no. 2. Taking a global perspective resonant with Reggio's vision in *Powaqqatsi*, Cardinal Charles Bo of Yangon equates lack of action on climate change to "criminal genocide" by the rich countries against the poor. For the full text of Cardinal Bo's remarkable address, see the Pontifical Academy of Sciences, at *http://www.pas.va/content/accademia/en/publications/scriptavaria /laudato_si_cop22.html.*

74. *Laudato si'*, no. 9.

holistic understanding of proper human *limitations* in relationship to the earth and nonhuman creatures. Notions of "growth," "progress," and "development"—too often defined solely in terms of unrestrained capitalism—must be critically questioned and reexamined, literally and metaphorically, "from the ground up."

Once again, if spirituality refers to "how one sees and engages the world," then surely here, in Pope Francis's teaching, is a hopeful signpost on the way toward an integral vision for life and political engagement in the twenty-first century: to embrace the earth "as a sacrament of communion, as a way of sharing with God and our neighbours on a global scale."[75] Like Elzeard Bouffier, we are called to active cooperation in the healing and transformation of our common home. If such an ideal sounds quaint, grandiose, or otherwise delusional to our postmodern ears, perhaps it is because hopefulness itself, in God and in the human spirit, has fallen out of fashion. What can each of us do, this day and every day, to resist despair and cynicism and reignite the will to wonder in ourselves and the next generation?

In the way of Thoreau, Merton, and many other spiritual guides, we can and must begin, I believe, at the personal level, by cultivating a taste for silence in our lives, reclaiming daily practices of silence and solitude, ways of deep listening and disciplined attunement to the rhythms of the earth, unplugged from the grid. And we must do so with our children.[76]

The story of Elzeard Bouffier offers a timeless parable for the kind of contemplative disposition and practices I have emphasized in this book: where silence, as one writer puts it, "is not the absence of sounds, but a way of living in the world—an intentional awareness, an expression of gratitude, to make of one's own ears, one's own body, a sounding board that resonates in its hollow places with the vibrations of the world."[77] Moving into the social, ecclesial, and political realms of our lives, we need to create new stories of identity and belonging that challenge and extend our imaginations well beyond the "American dream" in its individualist, materialist, and politically hyperpartisan forms. We need new theologies, rising from new and ancient spiritualities, and we urgently need a new politics of social resistance, belonging, and transformation. All of these must bend toward a wholly transformed conception of our lives and societies in relationship with the living earth.

As Francis suggests, ecological justice begins with a renewed relationship to the particular places we call home: "The history of our friendship with God

75. *Laudato si'*, no. 9, citing Orthodox Patriarch Bartholomew.

76. See Richard Louv, *Last Child in the Woods: Saving Our Children from Nature-Deficit Disorder* (Chapel Hill, NC: Algonquin, 2005).

77. Kathleen Dean Moore, "Silence like Scouring Sand," *Orion* (Nov./Dec. 2008): 69. See also the wonderfully evocative film by director Patrick Chen, *In Pursuit of Silence* (Cinema Guild, 2017), and the companion book by Cassidy Hall and Patrick Chen, *Notes on Silence* (Arcadia, CA: Transcendental Media, 2018).

is always linked to particular places which take on an intensely personal meaning."[78] Protests against the Dakota Access Pipeline by and alongside the Standing Rock Sioux tribe in North Dakota are emblematic of the rise of activist movements around the globe, especially among young people, movements coming from both the center and the margins of the world's religious traditions.[79] Many people of faith are rereading their sacred texts with fresh eyes, and renewing their theologies radically from within.

It is never too late, say the poets and prophets, to plant our ten—or ten thousand—seeds of hopefulness. Dare we imagine the earth and our place more humbly within the community of all creatures as a sacrament of communion? For the sake of my children and children everywhere yet to be, I would rather live and die by such dreams than without them: that when we dream and labor together, we really can be as effectual as God in tasks other than destruction.

Addendum and Additional Resources

Though a range of revolutionary movements have transformed theology dramatically in the past fifty years, perhaps no issue has emerged with greater urgency or broader reach than the environmental crisis. In the half century since Rachel Carson's *Silent Spring*, the book that launched the modern environmental movement, the fields of eco-theology and eco-justice have burgeoned. More and more theologians today—in US Catholic circles led by distinguished feminist theologian Sr. Elizabeth Johnson—are reclaiming what we might call an indigenous metaphysic of creation, or what Pope Francis in *Laudato si'* calls an integral ecology. Today the writings of Wendell Berry, the farmer, poet, and cultural essayist from Kentucky, seem to me as critical for American Christians to engage as the spiritual writings of Thomas Merton and Henri Nouwen were for previous generations. At the same time, contemplative theologians like Douglas Christie, much in the way of Merton, remind us of the ancient wisdom of the East and the desert fathers and mothers in reorienting our eyes and ears to the rhythms of the natural world. Groundbreaking and more recent ecological primers include the following books.

Books

Annett, Anthony, Jeffrey Sachs, and William Vendley. *The Significance of Laudato si'*. Mahwah, NJ: Paulist Press, 2018.

78. *Laudato si',* no. 84.

79. See Bill McKibben, "A Pipeline Fight and America's Dark Past," *The New Yorker*, September 6, 2016, *https://www.newyorker.com/news/daily-comment/a-pipeline-fight-and-americas-dark-past.*

Berry, Wendell. *The World-Ending Fire: The Essential Wendell Berry*. Berkeley: Counterpoint, 2018.

Bowers, C. A. *Educating for Eco-Justice and Community*. Athens, GA: University of Georgia, 2001.

Carson, Rachel. *Silent Spring: 40th Anniversary Edition*. New York: Houghton Mifflin, 2002. First published 1962.

Christie, Douglas E. *The Blue Sapphire of the Mind: Notes for a Contemplative Ecology*. New York: Oxford, 2013.

Cline, Naomi. *This Changes Everything: Capitalism vs. the Climate*. New York: Simon & Schuster, 2014.

Deane-Drummond, Celia. *A Primer in Eco-Theology: Theology for a Fragile Earth*. Eugene, OR: Cascade, 2017.

DiLeo, Daniel R., ed. *All Creation Is Connected: Voices in Response to Pope Francis's Encyclical on Ecology*. Winona, MN: Anselm Academic, 2018.

Hall, Cassidy, and Patrick Chen. *Notes on Silence*. Arcadia, CA: Transcendental Media, 2018.

Jenkins, Willis. *Ecologies of Grace: Environmental Ethics and Christian Theology*. New York: Oxford, 2008.

Johnson, Elizabeth. *Ask the Beasts: Darwin and the God of Love*. London: Bloomsbury, 2014.

———. *Creation and the Cross: The Mercy of God for a Planet in Peril* (Maryknoll, NY: Orbis, 2018).

McKibben, Bill. *The End of Nature*. New York: Random House, 2006.

Weis, Monica. *The Environmental Vision of Thomas Merton*. Lexington: University Press of Kentucky, 2011.

Articles and Meditations

Avila, Jennifer. "An Eco-Defender Is Risking His Life to Protect a Honduran River." *America* (Aug. 15, 2016). *Http://www.americamagazine.org/content /dispatches/hiding-honduras*.

Fraser, Barbara. "A Theology Rooted in Balance." *National Catholic Reporter*, July 22, 2011.

Merton, Thomas. "Rain and the Rhinoceros." In *Raids on the Unspeakable*, 9–23. New York: New Directions, 1966.

Pramuk, Christopher. "Sacred Silence: Lessons from the High Desert Plains." *America* (Feb. 17, 2014): 22–24.

Sullivan, Andrew. "I Used to Be a Human Being." *New York Magazine*, September 19, 2016. *Http://nymag.com/selectall/2016/09/andrew-sullivan-technology -almost-killed-me.html*.

Music, Audio, and Visual

An Inconvenient Truth. Directed by Davis Guggenheim. Paramount, 2006.

Before the Flood. Directed by Fisher Stevens. National Geographic, 2016.

Children of Men. Directed by Alphonso Cuaron. NBC Universal, 2007.

In Pursuit of Silence. Directed by Patrick Shen. Cinema Guild, 2017.

"The Man Who Planted Trees." Directed by Frederic Back. CBC Radio-Canada, 2004.

PAD YATRA: A Green Odyssey. Directed by Wendy J. N. Lee. Jelly Bean Films, 2013.

Patel, Samir S. "Are You Listening? Hear What Uninterrupted Silence Sounds Like." NPR, August 10, 2018. *Https://www.npr.org/2018/08/10/633201540/are-you-listening-hear-what-uninterrupted-silence-sounds-like*.

Taking Root: The Vision of Wangari Maathai. Directed by Lisa Merton and Alan Dater. Mongrel Media, 2008.

The Tree of Life. Directed by Terrence Malick. Fox Searchlight, 2011.

Wild Hope. Directed by Audrey Bauduin. HaveyPro Cinema, 2017.

5

"Joy inside My Tears"

Stevie Wonder and John H. Griffin: Celebration and Resistance Down at Street Level

> Societies never know it, but the war of an artist with his society is a lover's war, and he does, at his best, what lovers do, which is to reveal the beloved to himself and, with that revelation, to make freedom real.
>
> —*James Baldwin*

> Much of the real germinating action in the world, the real leavening, is among the immobilized, the outsiders. . . . Where the good may come from is perhaps where evil is feared. The streets. The ghettoes.
>
> —*Thomas Merton*

> Jesus said to him in reply, "What do you want me to do for you?" The blind man replied to him, "Master, I want to see."
>
> —*Mark 10:51*

In 1976 Motown recording artist Stevie Wonder released a double-album masterpiece called *Songs in the Key of Life*, giving voice to the joys and struggles of life in inner-city America. With an original working title of "Let's see life the way it is," the album's seventeen songs reveal a world largely hidden from suburban, middle-class, white America. I was twelve years old when *Songs In the Key of Life* debuted at number one on the pop music charts. I remember listening to the record for the first time with my older brother in our bedroom. Though I was too young and far too insulated to grasp the social and racial complexity of the songs, I was mesmerized by the music. Forty years later, I am still mesmerized, and the full genius of Wonder's artistry still eludes me. Today, when I introduce his music to my students, I never cease to wonder at the ways the encounter with such

CASE STUDIES

Stevie Wonder, *Songs in the Key of Life*
John Howard Griffin, *Black Like Me*

Stevie Wonder

an artist opens their social horizons, much as mine were broken open as a child. Track three, for example, "Village Ghetto Land," layers images of "life the way it is" for the poor in the inner city over the serene and cultured instrumentation of a chamber quartet:

> Would you like to go with me / Down my dead end street
>
> Would you like to come with me / To Village Ghetto Land
>
> Children play with rusted cars / Sores cover their hands
>
> Beggars watch and eat their meals / From garbage cans[1]

Two tracks later, as if to say, *Don't think you understand me or my people now*, Wonder delivers "Sir Duke," an infectiously funky tribute to the genius of Duke Ellington and other black artists, followed by "I Wish," a joyful remembrance of growing up on the streets of Detroit, "Knocks Me Off My Feet," an exuberant love poem, and "Pastime Paradise," a symphonically mesmerizing cautionary tale about the search for meaning and hope in history. "Isn't She Lovely" celebrates the birth of Wonder's daughter, Aisha, followed by "Joy Inside My Tears" and "Black Man," all hymns to what it *feels like* to be alive, black, and proud, in America. Like turning a many-faceted diamond, now this way, now that, Stevie refracts the mosaic colors of life as it is for many in inner-city America, life held down to street level.

1. Stevie Wonder, *Songs in the Key of Life*, Motown Records, 1976. The original vinyl release included seventeen songs. An additional four songs were released with the special edition version of the original LP, and are included on most CD versions of the album.

Listening to the album today, one might be tempted to celebrate just how much things have changed in a so-called post-racial America. Or, to the contrary, one might lament how far too little has changed at street level for peoples of color in the United States. In any case, what most interests me is not the insight into so-called "ghetto life" that Stevie Wonder's music gives us, gives me, as a middle-class white person in America. What interests me is the critique of the *racially unconscious white listener* embedded in his music, an aspect of his legacy I didn't really notice, much less appreciate, until I was much older.

For white listeners like myself, Wonder's artistry facilitates a potentially painful realization: namely, my own nearly complete social isolation from black experience in America, my own "confinement in the prison built by racism,"[2] and the degree to which my own white habitus or groupthink conditions my very manner of seeing and judging reality. In other words, the opening of "Village Ghetto Land"—*Would you like to go with me, down my dead end street?*—still resonates today as both an accusation and an invitation: an accusation of social blindness but also an invitation to come and see life in these United States of America more intimately and clearly than I may have seen it before. To say yes to the invitation is to discover that what is at stake is not my grasp of so-called "black experience"—as if all such experience were monolithic (it certainly is not)—so much as the music of life itself, life in the key of humanity: black, white, brown, red, yellow. It is about the dance of human relationships, sorrowful and joyful, broken and redeemed. I've often wondered, how strange, sad, and beautiful, that Stevie Wonder, a blind man, would be teaching me how to see.

"The lamp of the body is the eye," says Jesus. "If your eye is sound, your whole body will be filled with light; but if your eye is bad, your whole body will be in darkness. And if the light in you is darkness, how great will the darkness be" (Matt. 6:22–23). Repeatedly in the Gospels, Jesus is seen healing the blind, both literally and figuratively. Yet, for me, the most compelling of all these miracles is the one that did not "take" the first time: his encounter with the blind man of Bethsaida. "Putting spittle on his eyes [Jesus] laid his hands on him and asked, 'Do you see anything?' Looking up he replied, 'I see people looking like trees and walking'" (Mark 8:23–24). Of course Jesus finishes the healing and sends the man on his way. But it is the man's shadowy, in-between state of partial sight and partial blindness that seems to me an almost perfect metaphor for our human condition. Slow the story down and stretch it out over the course of a lifetime, generations, and then centuries, and the blind man of Bethsaida, *before* Jesus finishes the job, becomes a fitting parable for race relations in America. We are all still on the way, each of us stumbling forward in partial blindness, seeing people "looking like trees and walking." Yet through

2. The phrase is borrowed from Eduardo Bonilla-Silva, *Racism without Racists: Color-Blind Racism and the Persistence of Racial Inequality in Contemporary America* (Lanham, MD: Rowman & Littlefield, 2010).

the eyes of faith, Christ is there, hidden in light and shadow, calling us forward into our freedom—freedom for love, for transformation, for solidarity.

In the second part of this chapter, we'll turn the clock back fifteen years from *Songs in the Key of Life* to consider *Black Like Me*, John Howard Griffin's classic autobiographical narrative of 1961 that details his experiment in "becoming black" in the Deep South during the late 1950s.[3] I am always surprised by how few students have heard of Griffin before reading *Black Like Me*, yet they are nearly always, to a person, enthralled by his story. Though Wonder and Griffin are artists of a very different kind, what links them is their remarkable capacity to open our imaginations to the life-worlds of people and places well beyond our habitual comfort zones. As we shall also see, it is not incidental that Griffin, a white journalist, musician, soldier, and farmer from Texas, also suffered a ten-year period of blindness before he wrote *Black Like Me*.

In a certain sense, through their respective artistry, both Stevie Wonder and John Howard Griffin issue the same challenge as Jesus and the prophets: "You have eyes, but do you really see? You have ears, but do you really hear?" Both invite us to grasp the world anew, through eyes of empathy, understanding, and love. With respect to race relations in America, past and present, that is no small thing. We begin with the musical genius of Stevie Wonder, a daunting task for any writer.

"You'll Cause Your Own Country to Fall": Songs in the Key of Resistance

Race is but one of many lenses through which we might explore the kaleidoscopic palette of *Songs in the Key of Life*, but given the world behind the text that was Stevie's childhood in Detroit and the social situation for many African Americans during the 1950s and 1960s, it is a fitting place to start.

After an extraordinary ten-year run with Motown Records as "Little Stevie Wonder"—he had his first Billboard number one hit at age thirteen—Wonder negotiated a new contract with Berry Gordy of Motown that gave him an unprecedented advance and full artistic control of his music. Gordy's calculated risk proved wise, as three groundbreaking albums followed: *Talking Book* (1972), including the number one hits "Superstition" and "You Are the Sunshine of My Life"; *Innervisions* (1973), featuring "Higher Ground" and "Living for the City," which both reached number one on the R&B charts; and *Fulfillingness' First Finale* (1973), including the hits "You Haven't Done Nothin'" and "Boogie On Reggae Woman." Each album earned Stevie three Grammy Awards,

3. John Howard Griffin, *Black Like Me*, 50th anniversary ed. (San Antonio: Wings, 2011). The documentary *Uncommon Vision: The Life and Times of John Howard Griffin*, dir. Morgan Atkinson (Duckworks, 2010), offers a fascinating biographical, spiritual, and artistic portrait of Griffin's story within the broad tapestry of twentieth-century events.

the latter two taking consecutive Albums of the Year. (*Songs in the Key of Life* would add another three Grammys, including his third Album of the Year.) By 1973, Wonder had become the most influential and acclaimed black artist of the 1970s.[4] Many tracks from this classic period still enjoy regular radio play nearly five decades later. But with trenchantly social-political tracks like "Big Brother" (*Talking Book*), "Living for the City" (*Innervisions*), and "You Haven't Done Nothin'" (*Fulfillingness' First Finale*), Wonder had also emerged as one of the most compelling voices on race in America.

In "Big Brother," to my mind one of the finest protest songs of the era, Stevie plays with the metaphor of sight, mocking the objectifying "outsider gaze" of the (white) listener.

> *Your name is big brother / You say that you're watching me on the tele / Seeing me go nowhere*
>
> *Your name is big brother / You say that you're tired of me protesting / Children dying everyday*
>
> *My name is nobody / But I can't wait to see your face inside my door*[5]

Some four decades ahead of the smart phone and the now-ubiquitous rants of talk radio and cable TV "news" pundits, Wonder lays bare the dehumanizing tendency to see and judge "the other" primarily through the lens of a TV screen. Turning the objectifying lens around like a mirror, he delivers the lyric with just enough restraint—or is it sass?—to suggest that he, and the (black) community of his intimate devotion—*My name is secluded / we live in a house the size of a matchbox / roaches live with us wall to wall*—may yet have the last word. The song closes with one of the most pointed indictments of the "land of the free" I've ever heard: *You've killed all my leaders / I don't even have to do nothin' to you / You'll cause your own country to fall.*[6]

Gary Byrd, Wonder's cowriter on "Village Ghetto Land" and "Black Man," locates Stevie's evolution as a social poet in the same vital stream as black artists who had come before:

> When he got to *Songs in the Key of Life*, [we see] not only his own evolution as a creative artist but the evolution of what was going on from, let's say, 1969–1970, where Curtis Mayfield begins to do a range of concept albums, and Isaac Hayes is coming with a concept [album], and then

4. Internet resources detailing Stevie Wonder's biography and discography include Stevie Wonder, *http://www.steviewonder.net/*, and "The Life and Times of Stevie Wonder," Stevie Wonder, *http://www.steviewonder.org.uk/bio/biography.html*.

5. Stevie Wonder, *Talking Book*, Tamla Motown, 1972; multiple versions, including live video recordings, are accessible online.

6. Much like "Village Ghetto Land," the buoyant major key melody of "Big Brother," sung over an infectious rhythm guitar, keyboard, and harmonica arrangement, belies the defiant imagery of the lyrics.

Marvin Gaye drops "What's Going On." I think those projects are very pivotal to understanding the point at which Stevie is doing *Songs in the Key of Life*. [He] took the idea of a concept album and laid perhaps the most massive canvas of creativity that had ever been done at that point.[7]

It is important to keep in mind that when *Songs in the Key of Life* was released, just eight years had passed since the assassinations of Martin Luther King Jr. and Robert F. Kennedy. Indeed that fact, and the justified rage, frustration, and political cynicism that those events and others—Vietnam, Kent State, Watergate—had provoked in the African American community and well beyond, makes the infectiously celebratory tenor of *Songs in the Key of Life* all the more remarkable.

"Knocks Me Off My Feet": Singing the Power of Love

The album's plaintive opening song, "Love's in Need of Love Today"—"Good morn or evening friends / Here's your friendly announcer / I have serious news to pass on to everybody"—lays out the stakes for everything that follows.[8] The personified invocation of Love itself as both giver and receiver, strong and vulnerable, generous but ever threatened by hate, draws the listener immediately into the circle of reflection. Like the imagined radio announcer who narrates the song, Wonder wants to invite the listener into a conversation, or better, a call and response, like a preacher feeding on his congregation's, "Amen, pastor, preach it now."

In Track 7, "Knocks Me Off My Feet," Stevie lets go, painting a vivid picture of love, seeming to stumble half-embarrassed in the effort to find words usually "told only to the wind / felt without being said." Love is a simultaneous turning inward and outward—"I don't want to bore you with my trouble / but there's somethin' 'bout your love." The one who has given and received love cannot keep silent. Love spills over and is diffusive of Itself. It wants to sing. Again, we hear the call and response that marks the loveliest of human relationships: the woman's voice entering in to affirm the male's trepidation. "I don't wanna bore you with it," sings Wonder. "Oh but I love you, I love you, I love you," she responds. As a piano player, I find it hard to find words for Wonder's sublime playing on "Knocks Me Off My Feet," from the opening riff to the elegant jazz stylings throughout. The same extends to the rhythm tracks, all performed *by*

7. Cited in *Classic Albums: Stevie Wonder: Songs in the Key of Life*, dir. David Heffernan (Rhino, 1999). To be sure, Marvin Gaye's "What's Going On" was a breakthrough not just for Gaye but for Berry Gordy, whom Gaye had to persuade to let him address social issues in his music, risking the alienation of Motown's white audience.

8. This and subsequent citations from Stevie Wonder, *Songs in the Key of Life*.

Wonder himself on drums, synth bass, and Fender Rhodes.[9] "Knocks Me Off My Feet" celebrates the primordial Love that keeps the world centered on its axis, even (especially) when the world seems to be spinning out of control.

Weaving their way through and rising high above the instrumentation, the astonishing melodies that saturate *Songs in the Key of Life* are easy to take for granted. There is an art and grace to writing a good melody that can elude even the most practiced songwriters. "I think melodies, you know, are like angels from heaven expressing a place for the heart to follow," Wonder says in a 2005 interview, mentioning Sam Cooke as an early influence in his songwriting.[10] Even the bleak lyrical content of "Village Ghetto Land" is rendered beautiful via a deceptively sophisticated melody. Of course the melodies that distinguish Wonder's songs are made ever more angelic by the extraordinary range and quality of his voice. The late great poet Maya Angelou had a lot to say about the human voice, and hers was one of the most beautiful and resonant I have ever heard. As a poet she deeply understood the power of language to move the soul. Yet she also understood that human words "mean more than what is set down on paper. It takes the human voice to infuse them with shades of deeper meaning."[11] The warmth and quality of soul that infuses Stevie Wonder's voice makes a welcoming and beautiful "place for the heart to follow."

"The artist is a creator of emphasized, clarified beauty, designed to make us see," writes the late Catholic priest and novelist Andrew Greeley. We live surrounded by beauty, Greeley notes. "Sometimes we notice it, sometimes, all too rarely perhaps, the beauty all around us invades us, stops us in our tracks, explodes within us."[12] Nearly every track on *Songs in the Key of Life* invokes the power of the divine-human spirit to do and make happen "what no one thought could be" ("Joy Inside My Tears"): to coax beauty from ugliness, joy from sorrow, light from darkness, fellowship from loneliness. "I think the voice has a lot to do with your spirit," Wonder says. "If your spirit feels right, then your voice will stay pretty consistently the same, from that point of maturity."[13] Like a painter choosing from a palette of infinite hues, the range of colors reflected in Stevie's singing, often in the same song, is marvelous to behold. Listen to the tender falsetto at the opening of "Summer Soft," then follow the emotional tenor of the

9. Much as we saw with Pink Floyd in chapter 2, Stevie pioneered the use of synthesizers in the early 1970s, incorporating electronic sounds seamlessly with acoustic instruments, hugely influencing the musical palette of popular music and the development of electronic musical genres.

10. Interview with British journalist Barney Hoskyns in 2005, cited from a wonderfully animated version, Stevie Wonder, "On Keys of Life," directed and animated by Pat Smith, Blank on Blank, PBS, *https://blankonblank.org/interviews/stevie-wonder-on-keys-of-life -motown-singing-lyrics-racism-god-religion-detroit/*.

11. Maya Angelou, *I Know Why the Caged Bird Sings* (1969; repr., New York: Random House, 2015), 82.

12. Andrew Greeley, "The Apologetics of Beauty," *America* (Sept. 16, 2000): 8–14.

13. Interview with Barney Hoskyns, 2005.

melody as it mellows down into the verse, builds torch-like into the chorus, back to falsetto, and then lets loose with blues-funk improvisation up and down the scales to take the song out. "Ngiculela—Es Una Historia—I Am Singing," soars in Zulu, Spanish, and English, the melody lyrically uniting all three languages.[14] For me and innumerable listeners through the years, Wonder's vocal artistry "stops us in our tracks, explodes within us," knocks us off our feet.

"In Love with the Discovery of Life Itself": Ways of Seeing (and Not Seeing)

In our brief discussion of Stevie Wonder's childhood at the beginning of chapter 1, we considered the strangely paradoxical truth that a blind person might "see" reality better than many people with working eyes. As Wonder himself put it in an interview with Larry King, "If your vision gives you preconceptions then you've got a problem with yourself." Once again, hearkening to the prenatal environment of the womb, Stevie noted that "we really feel before we see. We really hear before we see."[15]

To remember that we "feel before we see" is also to affirm our innate capacity for *empathy*, the capacity to feel deeply the life-situation of another. But because we do not and cannot literally inhabit another person's skin—save in the womb!—empathy becomes more and more, as we learn to navigate the adult world, the function of a healthy and generous imagination. Empathy is not just the *capacity* to open myself to the life-world of another, it is also the *willingness* to do so, irrespective of whether doing so benefits me or my interests directly. To act from empathy may be easier when another's life-world looks and feels something like one's own. But then think how the imagination must extend itself that much further for a blind person.

Recall that when Larry King asked him about his blindness, Stevie replied, "I think I've got a pretty good imagination."[16] Watching him behind the piano, playing the harmonica, or even during an interview, the point becomes strikingly clear as his head and upper body move constantly in rhythmic circles, like an antenna, attuning himself to the environment. By contrast, the person or community without empathy, sighted or blind, is the person or community trapped inside their own captive imagination. What strikes me most in Wonder's music

14. Alan Light, review of *Songs in the Key of Life*, by Stevie Wonder, Pitchfork, August 21, 2016, *http://pitchfork.com/reviews/albums/22174-songs-in-the-key-of-life/*. The first verse, in Zulu, says, "I am singing / for tomorrow / I sing of love / I sing that someday / love will reign / all around this world of ours."

15. Stevie Wonder, interview by Larry King, *Larry King Live*, CNN, December 5, 2010, *http://transcripts.cnn.com/TRANSCRIPTS/1012/05/lkl.01.html*.

16. Interview by Larry King; see chapter 1.

and in his witness throughout his life as a public figure is the way he poses the question of empathy precisely as a question, that is, as challenge and invitation to his (white) audience—*Would you like to go with me / to Village Ghetto Land?*—far more than as a broadside or categorical accusation. Again, Gary Byrd, on the period leading up to *Songs in the Key of Life*:

> He also had become a master of how to express those social ideas through music, and how, in effect, to communicate past the kind of human biases that especially operate in the territory and framework of the United States. And to actually reach past those and to reach people who otherwise might not want to listen to that kind of message, but through his musical genius would not only listen, but would digest it, and understand it.[17]

I recognize Wonder's impact on me, my indebtedness to his music, in Byrd's observation.

To be sure, critics have sometimes faulted Wonder for being too sanguine or racially conciliatory in his music—in a word, for putting too much faith in his white audience's capacity for empathy, much less, solidarity with the black community.[18] Yet his general refusal to play the "angry black prophet" or much less the race cynic might also be commended as a careful refusal to reduce any person or community, including whites, to the categorical abstraction, however expedient, of race. No matter what your racial identity or history, Wonder's legacy seems to suggest that to the extent your vision gives you "preconceptions" that *preempt the possibility of love*, however justified those preconceptions may seem to be, "then you've got a problem with yourself."[19]

The American rap star Coolio—who in 1995 transformed Wonder's "Pastime Paradise" into his own social-political classic, "Gangsta's Paradise"—attributes Stevie's hopefulness if not optimism around race relations to two things: his generation, and his blindness.

> Stevie is from . . . that old mode of black people [who] really believe that anybody can do anything they want to do. I don't think that he's ever felt limited in his life. He always felt that he could do anything

17. *Classic Albums: Stevie Wonder: Songs in the Key of Life.*

18. For example, the mixed reaction to "Ebony and Ivory," written by Paul McCartney and recorded as a duet with Wonder. Though a number one hit in the United States and Britain, the song was panned by many critics as too "saccharine" to be taken seriously. On the other hand, the fact that "Ebony and Ivory" was banned by the apartheid government of South Africa suggests that its simple appeal to racial harmony may be more radical than is apparent at first glance.

19. This is a complex and subtle point and could be easily misconstrued, but I offer it provisionally here as a prompt for thought and discussion. I hope the remainder of the chapter bears out the spirit if not the substance of these observations to some degree.

that he wanted. See because, because he can't see, it gave him an advantage over a lot of people, because color really, *really didn't mean shit to him*, because he never saw color anyway.[20]

Notice that Coolio speaks not with contempt on this point but with evident awe: "You know, he's blind, and you sit there and you wonder, 'This man can't even see,' but he sees so many more things than people with sight can see. It's like he sees things of the soul more than the world of 'reality.' I would place him right alongside all the greats: Malcolm X, Martin Luther King, Marvin Gaye."[21]

In a 2005 interview, asked how he dealt with the hardships of his childhood growing up in Detroit in the 1950s, Stevie reflected on his experiences of racism and racial identity:

> I think that I really didn't understand the severity of the situation or the circumstances. I think I was so in love with my mother, and my brothers, my sister, my friends—just in love with the discovery of life itself—that my focus was not on those things. I think I discovered the whole thing of color when I went down South once when my grandmother passed away. There were some kids, some white kids that lived nearby, or whatever, and the kids said, "Hey Nigger!" And I said, "What? I'm from Detroit." (laughter) I started throwing rocks over, and they said, "Oh, you better not do that, you'll get in trouble." I said, "I don't care." I hit the kid and I kept throwing stuff. I just—I have never accepted stupidity and ignorance as making me then determine how good I was, or how less I was.[22]

Perhaps Coolio is right. To some degree the inability to see has kept Wonder relatively free from the internal and external torments of race prejudice. Yet above all, as Wonder himself confesses, it was love, the love of family and friends, and "being in love with the discovery of life itself," which has grounded his vision of reality—and animated his musical genius—his whole life long. It would seem that such a love, like a spark drawing near to dry kindling, is irrepressible.

"Looking Back on When I": A Child's-Eye View of Reality

Two of the most recognizable tracks on *Songs in the Key of Life* celebrate the wonders of childhood and joys of family life, topics rarely treated in the pop

20. *Classic Albums: Stevie Wonder: Songs in the Key of Life.*

21. *Classic Albums: Stevie Wonder: Songs in the Key of Life.*

22. Interview with Barney Hoskyns.

music world.[23] The iconic bass-line groove that opens "I Wish" reminds me of the popping of an old reel-to-reel projector just before the black-and-white images hit the screen, and then—*boom!*—we are plunged into the joyful land-scape of Stevie's life-world as a child. Berry Gordy remembers the first time he heard "I Wish": "When I heard 'I Wish,' you know, it was incredible. . . . I thought, like so many other people in the world, when they heard the record, 'I wish I could be back in those days again.' . . . And not only did he express it, he did it in a rhythm that was so unique."[24] Likewise "Isn't She Lovely," introduced by the universally resonant sound of a baby crying, celebrates childbirth—in this case Wonder's daughter Aisha—and the simple pleasures of parenting. While Nathan Watts' hard-driving bassline and an uber-tight horn section charges every scene with youthful energy, Stevie's improvisations on the harmonica carry "Isn't She Lovely" into the sky, a wordless letter of gratitude spiraling toward the heavens. The name "Aisha," not incidentally, simply means "Life," life "made from love."

There is a magic that limns the memories of a happy childhood that is surely worth celebrating. To the thought of becoming a child again, our first reaction might be, like Berry Gordy's, how great that would be! No responsibilities, no battling with schedules, every day stretched out like a blank canvas of possibil-ity. On the other hand, if one's childhood was marked by trauma, loss, abuse, or loneliness, the thought of reliving such days is the last thing one would wish. In any case, I want to suggest something in Wonder's vision of childhood that is much deeper than nostalgia or sentimentality, something hard to pin down, paradoxical, ineffable.

Buddhism calls it Child Mind, a term that invokes the capacity for wonder and amazement that lives in all of us. Child Mind, sometimes called Beginner's Mind, has nothing to do with childish self-absorption or a kind of narcissistic return to an innocent past. Rather it speaks to a (lifelong) process of spiritual renewal, of seeking to cultivate what one author calls "the early mysticism known to every small child—a state of heightened experience and amazement."[25] It is something like what I see in my nine-year-old son Henry, who wakes up every morning and greets the world as if a switch has flipped inside his whole being, proclaiming, "Hey Life, what have you got for me today?!" From moment to supercharged moment, Henry emanates wakefulness to "the life force within all

23. Nor are such positive images of the ordinary, day-to-day lives of many African American families the norm in film, TV, and media. In this sense, "I Wish" and "Isn't She Lovely" comprise important counter-narratives to the imagery of "Village Ghetto Land," reminding the (white) lis-tener that "black experience" is neither monolithic nor ontologically inscribed, as it were, by poverty, victimization, suffering, violence.

24. *Classic Albums: Stevie Wonder: Songs in the Key of Life.*

25. Fiona Gardner, *The Only Mind Worth Having: Thomas Merton and the Child Mind* (Eugene, OR: Cascade, 2015), 5.

creation."[26] And if I am half-present to his wakefulness it reverberates *in me*, potentially enlightening my day from within.

As noted in chapter 1, Christianity, too, has a venerable tradition of celebrating childlike wonder following from Jesus' words in the Gospel: "Amen, I say to you, unless you turn and become like children you will not enter the kingdom of heaven" (Matt. 18:3) But what can it mean to become like a child when you are an adult living in the twenty-first century?

Both Buddhism and Christianity describe Child Mind without sentimentality as a kind of coming home to our "true self" as adults, the cultivation of an integrated spirituality in which each of us seeks to discover our way in the world not through heroic self-determination or calculated self-interest, but rather through a deepening awareness of our connectedness to others and mutual interdependence with all things, here, now, in each new moment. As emphasized in chapters 3 and 4, those "others" with whom we are always linked in the web of life include plants, wind, water, soil, trees, and nonhuman creatures.[27] To be clear, Child Mind is not solely or foremost an intellectual realization; it is a felt attunement and disciplined practice of awakening one's whole person to the sacredness of the world in which we "live, move, and have our being." (Acts 17:28) Every great religion gives testimony that those persons who have "come home" into such awareness seem to approach life with both more *and* less seriousness than most, and a great deal more spontaneity, creativity, joy, and laughter. *Songs in the Key of Life* seems to me the expression of an artist who, consciously or not, has found an infectiously powerful way to express the wisdom of Child Mind such that the whole world has heard and become the better for it.

Yet what can be said for those millions of children whose daily lives are marked by trauma and abuse, loss and loneliness? The critically acclaimed 2016 film *Moonlight* follows the life of a young African American boy as he navigates the bleak inner-city environment of Miami, where the meaning of manhood is circumscribed by violence, control, and domination. "I built myself back up from the ground to be hard," the central character laments late in the film.[28] As culture writer Bill McGarvey notes, for far too many boys the code of the street demands that "the very phrase 'Be a man' means, 'Don't feel it.'"[29] Yet as

26. Gardner, *The Only Mind*, 4. It seems worth noting that Henry's full name is Henry David, which means, "beloved ruler of the household."

27. Wonder's much-anticipated Motown follow-up to *Songs in the Key of Life* was the double-album *Journey through 'The Secret Life of Plants'* (1979), which sold very well but had a mixed critical reception. Wonder was introduced to transcendental meditation, a major influence for this album, through his marriage to Syreeta Wright. Consistent with that spiritual vision, he became vegetarian, and later vegan.

28. *Moonlight*, dir. Barry Jenkins (A24, 2016).

29. See Bill McGarvey, "When 'Being a Man' Means Hiding your Depression. What 'Moonlight' Teaches Us about Masculinity," *America* (Dec. 15, 2016), *https://www.americamagazine.org/arts-culture /2016/12/15/when-being-man-means-hiding-your-depression-what-moonlight-teaches-us-about.*"

McGarvey also notes, that same spirit of toxic masculinity "is just as pervasive on Wall Street and suburban Main Street—not to mention in the tone of our politics." Regardless of the setting, he concludes, "the consequences of this distortion are deadly." In other words, the difference between hardness and tenderness for all of us hinges considerably on whether or not we have been blessed with love, social nurturing, and physical and emotional safety during our childhood, and certainly well beyond. Whether on the streets of Miami or Detroit, on Main Street or Wall Street, Stevie Wonder's artistry stands in contrast to a reductive vision of masculinity that leaves little room for vulnerability, tenderness, mercy.

All of this serves to reiterate that the heightened amazement characteristic of Child Mind includes sensitivity not just to the beautiful but also to the hard, the painful, the unjust. Perhaps above all, to see through the eyes of the heart is to make oneself vulnerable to the joy and suffering, the dreams and hopes, *of others*. "Would you like to come with me / down my dead-end street?" As I have emphasized throughout this book, authentic spirituality is not about escaping reality but involves cultivating a more direct and truthful engagement with what is concretely real—a "long loving look at the real,"[30] to recall chapter 3. It is the loving part, I expect, that so many of us struggle with from day to day, and here Stevie Wonder's witness shines forth as truly remarkable.

"This Is the Sound of Political Theology": Music That Moves the Social Body

This brings us to one last dimension of Wonder's legacy often overlooked in reviews of *Songs in the Key of Life*: his religious faith. Could Stevie Wonder *be* Stevie Wonder without the inspiration and strength that comes from his elemental faith that anytime, anywhere, he could communicate directly "with the one who lives within," as he sings in "Have a Talk with God"? To put it differently, how might Wonder's musical genius have been expressed differently, if at all, had he not been raised in the womb of the black church? In repeated interviews he suggests that all of it—how new songs come to him, his commitment to social issues, memories of his childhood in Detroit—is inseparable from God's sustaining presence in his life, a kind of palpable friendship with the divine.

> Since I can best remember, I've had a great relationship with God. For me, God was like a father. It was always someone I could touch, and that he had me in his arms. I always felt that way. I always felt that God was about good. But, for instance, when I was in church, I was in

30. Walter Burghardt, "Contemplation: A Long Loving Look at the Real," in *An Ignatian Spirituality Reader*, ed. George Traub (Chicago: Loyola, 2008), 89–98.

a Pentecostal Church as a little boy, and back then it was a little different than now. They said, "*You know, you're singing that worldly music*," and they were criticizing what I was doing. Listen, we live in a society where black music at one time was called race music. Where jazz was considered something nasty, you know? (laughs) I don't know. I felt that if God didn't want me to sing it, he wouldn't have given me the talent to do it.[31]

As for so many black artists of his generation—as perhaps for many of us—the church was clearly both foundational and sometimes problematic for Wonder. God, however, is another story. One hears no ambivalence in his conviction that God was always near, always nurturing, always good.

Songs in the Key of Life resounds with celebratory faith. Not a buttoned-down, begrudging, obligatory, fearful *caricature* of religious faith, but an intimate, joyful, grateful, ecstatic *celebration* of faith. Joyful, it seems, because Wonder's sense of God is so intimately relational, "someone that I could touch." And his gratitude is such that he clearly wants to share it. "Have a Talk with God" gets at this most explicitly, but even here the invitation to consider faith never, to my ears, feels obnoxious or overbearing, perhaps because it *feels like* an invitation, a delightfully funky one at that, and far from a threat or warning.

Less explicitly "theological" but no less gesturing to the divine are "If It's Magic," "Joy Inside My Tears," and "As." Listen to "As" and ask yourself, who is addressing whom in the song? Is Wonder singing of his love for his wife? his children? a friend going through hard times? Or is "As" an imagined love song from God to the whole human race? *Just as hate knows love's the cure / you can rest your mind assured / that I'll be loving you always.* The song works, I think, on all of these levels simultaneously. Why? Because Wonder's music draws no sharp line between human and divine love; in the artist's telling, both flow from a single wellspring and are inseparable. Listen again to "As" and let your ears follow closely the bass line, the keyboard, and then the choir backing Stevie's increasingly ecstatic vocal. *Did you know you're loved by somebody / always.* It seems to me that "As" is as near-to-perfect an ensemble creation as any orchestral performance of Beethoven's Fifth Symphony.

Again, what seldom surfaces in commentaries on Wonder's artistic legacy is the link between his faith and his social concerns, his race consciousness, his politics. One critic comes close by half:

The year 1976 was, of course, America's Bicentennial year, and especially at a time of such frustration and distrust surrounding the government and the country's institutions, U.S. residents were bombarded with stories of our history and heroics. Songs in the Key of Life functioned as a corrective, a counter-narrative, alongside such other radical, groundbreaking

31. *Classic Albums: Stevie Wonder: Songs in the Key of Life.*

statements as Richard Pryor's *Bicentennial Nigger* and Alex Haley's *Roots*, both of which were released just a few weeks before the album.[32]

To describe *Songs in the Key of Life* as a "corrective" and "counter-narrative" to jingoistic American patriotism is exactly right. Listen to "Pastime Paradise" and hear the rising chorus of "We Shall Overcome" that carries the last chorus out.[33] See the marchers moving across the Edmund Pettis Bridge together, one and diverse, straight into the swarm of dogs and police descending on horseback. What hides in that terrifying scene—as in so much of Wonder's music—are the seeds of a deep-rooted faith that can face every trial with courage, trusting that somehow even death, even *my* death by state-sanctioned violence, will not have the final word.[34]

In one of the best treatments of the relationship among music, theology, and social resistance I've seen, Emory University theologian Don Saliers demonstrates "how singing itself can be considered an engagement with the political order that calls the *polis* to its own best being and practices—that is, singing that aims at restoring the commonweal of social and civic life."[35] Surveying hymns and psalms from the biblical tradition to the Negro spirituals to the Civil Rights Movement, Saliers traces the ways in which the act of singing in the face of oppression "becomes a political act of resistance to idols, and a prophetic call for the transformation of the order of things."

> This music comes out of struggle, pain, and courage in the face of enormous economic and social hardships. We might call music that sustained hope in difficult times a "survival art." [These were songs] of protest and affirmation rooted in a religious and moral tradition born of Christian faith. [These are songs] that "move the soul" and hence the social body. This is the sound of political theology. . . . Not the words only, but the power of the melodies and the way the whole body of the community sang the words, sounded the deep religious passion of such a theology.[36]

32. Alan Light, review of Stevie Wonder, *Songs in the Key of Life*, Pitchfork, August 21, 2016, *http://pitchfork.com/reviews/albums/22174-songs-in-the-key-of-life/*.

33. In fact, as studio engineer Gary Olazabal explains, alongside the gospel choir Wonder recorded a group of Hare Krishna devotees chanting prayers. Thus "you get the quality of the Hare Krishna against a very large gospel choir singing 'We Shall Overcome,' which makes it a very haunting song. It's Stevie's view of the whole album, which is that people should be together and take care of each other." *Classic Albums: Stevie Wonder, Songs in the Key of Life*.

34. I can think of no more memorable expression of such faith than Martin Luther King Jr.'s electrifying "mountaintop speech," delivered the night before his assassination, in which he spoke openly of the many death threats he had faced. We will consider the speech in some detail in chapter 6.

35. Don Saliers, *Music and Theology* (Nashville: Abingdon, 2007), 49.

36. Saliers, *Music and Theology*, 47, 49.

As Saliers explains so effectively here, for people of faith, music itself "becomes a theologically relevant action" insofar as it galvanizes freedom and gives us courage to raise our voices against the false idols of our culture. It was not for nothing that civil rights marchers sang "I Shall Not Be Moved" as club-brandishing policemen bore down on them. When you hear five or ten or fifty brothers and sisters singing alongside you, the words settle down deep into the bones and you feel, you *become*, their meaning. *Like a tree planted by the water / I shall not be moved*. To paraphrase the great Jewish poet and philosopher Abraham Joshua Heschel, in marching and singing we join our voices with God's own pathos, God's own dreams for the world, God's own cry for justice.[37]

In other words, to be set free in the gift of Love—divine and human—is at once to willingly bear responsibility for all those suffering the blows of injustice *on our watch*, people cut off from "the commonweal of social and civic life."[38] Listen again to "Love's in Need of Love Today," and hear the poignant urgency in Wonder's plea to stop the hate "before it's gone too far." Like the Negro spirituals, Stevie's music stands in the breach between *what is* and *what is yet possible*, daring us to imagine another possible future, a Reign of compassion, peace, justice.

But vision alone will not serve. The gap between what is and what might yet be remains unbridged, Wonder suggests, wherever people of faith do not join vision with sustained action for justice. "For as much as we know and learn," says Stevie, "is as much as we become liable for what we do and do not do—all of us we have that responsibility."[39] Stevie's witness on this point accords with the public witness and public sacrifice of the churches during the Civil Rights Movement.

In short, it is not enough for the Christian to spiritualize the struggle, much less to "build a little chapel for [ourselves] inside the Church to make things more tolerable."[40] One cannot listen to Stevie Wonder or Kanye West records in the suburbs, pray for peace "down there" in the city, and consider oneself sanctified. For a Christian, love means risking the kinds of attachments to people that may very well bear a personal cost.[41]

37. See chapter 1.

38. Saliers, *Music and Theology*, 43.

39. *Classic Albums: Stevie Wonder: Songs in the Key of Life*.

40. Thomas Merton, *Learning to Love: Exploring Solitude and Freedom*, ed. Christine M. Bochen, Journals of Thomas Merton 6: 1966–1967 (San Francisco: HarperCollins, 1997), 147, citing theologian Karl Rahner.

41. Innumerable Gospel passages leap to mind: Jesus' encounter with the rich young man, the Parable of the Good Samaritan, the judgment scene of Matt. 25, and so on. The term *love* as I use it here is analogous to solidarity and the "preferential option for the poor," persistent themes of Catholic social teaching. Solidarity for Christians is not simply an ethical commandment so much as it is a *response* that flows from the gift of life itself and God's love for all creation. We love because we have come to know God's love and companionship most intimately through Jesus (1 John 4:19).

A few years ago I heard black Catholic theologian Sr. Jamie Phelps frame the question quite simply this way: "What work are we doing to help reestablish a sense of the image of God in people of color?"[42] In other words, what are we doing to reposition ourselves so as to hear and be transformed by the joys and hopes, the dreams and struggles, of those fellow human beings who, by virtue of their skin color and their zip codes, have been structured out of the common good? We must dare to "wade in the water," as the Negro spiritual commands, for "God's gonna' trouble the water."

Piercing the Race Veil: The Witness of John Howard Griffin

We turn now to the remarkable story of a white man who dramatically repositioned himself so as to be transformed by his encounter with the African

Cover of fiftieth anniversary edition of *Black Like Me*, first published in 1961

American "Other." Many older Americans will remember reading *Black Like Me*, John Howard Griffin's riveting account of his experiment in "becoming black" in the Deep South during the late 1950s. Once required reading in many high school and college classrooms, Griffin's story today remains one of the most compelling yet strangely forgotten narratives of cross-racial solidarity during the Civil Rights era.

Griffin, like me, was a Catholic writer and lifelong student of music. Born and raised in Texas, he had a deep interest in race relations and the civil rights struggle. At age thirty-nine, he had a wife and kids, a good job, a career. He had a lot to lose. Yet, incalculably more than me, his desire to "bridge

42. See *Uncommon Faithfulness: The Black Catholic Experience*, ed. M. Shawn Copeland (Maryknoll, NY: Orbis, 2009), for Phelps's seminal essay on Catholic identity and mission with respect to social and racial justice.

the gap" between himself and the reality of inhabiting a black body in America transcended his fears about the extreme physical and emotional costs of such a radical experiment. On the book's opening page, in a few jarringly direct lines, Griffin explains why he decided to disguise himself as a black man and travel through the Deep South:

> How else except by becoming a Negro could a white man hope to learn the truth? The southern Negro will not tell the white man the truth. He long ago learned that if he speaks a truth unpleasing to the white, the white would make life miserable for him. The only way I could see to bridge the gap between us was to become a Negro. I decided I would do this.[43]

Some fifty years earlier, in his classic essay *The Souls of Black Folk*, W. E. B. Du Bois had described the "double consciousness" that drains the life-spirit of African Americans in their daily struggle to survive.[44] The history of the American Negro, Du Bois wrote, is the history of the unreconciled longing "to rise above the Veil," the veil of race separation and black nothingness. Griffin's story dramatizes a strange act of *reverse longing*: the desire as a white man to taste the hard truth of life behind the Veil, or "beyond Otherness,"[45] as he would later write of his experience.

And so in late 1959, with the support of his wife and under the care of a dermatologist in New Orleans, Griffin began taking large doses of a pigment-darkening drug and spending long hours under an ultraviolet lamp. He shaved his head and darkened his scalp with shoe polish. At last, when he could pass as an African American, he began traveling by bus and on foot through the virulently Jim Crow states of Louisiana, Mississippi, Alabama, and Georgia. Of course, as a white man, he had an escape route, and Griffin was acutely aware of that fact. Nevertheless for six weeks he went all in—body, mind, and spirit—surrendering his own skin privilege and social capital in an attempt to realize a new level of solidarity with his African American brothers and sisters.

What finally makes *Black Like Me* a classic in the canon of civil rights literature is Griffin's extraordinary gift for language. Griffin writes like an impressionist painter, evoking the inner truth of things by blending colors judiciously, and in his case, quite sparingly, on the canvas. One of my students wrote about a scene in the book that seems to have burned itself into her consciousness:

> At one point in the book Griffin splits candy bars among a black family he is staying with for the night. One of the children was salivating

43. John Howard Griffin, *Black Like Me*, 50th anniversary ed. (New York: Signet, 2010), 2.

44. W. E. B. Du Bois, *The Souls of Black Folk* (New York: Oxford, 2010), 8.

45. John Howard Griffin, "Beyond *Otherness*, 1979," in *Black Like Me*, 191.

so much from the chocolate that her mother unconsciously wiped the saliva off the child's face with her finger and put it in her own mouth. As the family went to bed, they closely embraced each other to escape the dark cold night, nights that often brought mosquitoes. This love and sense of family holds no racial boundary. Race literally is the surface of one's true being. Griffin found God that night while sleeping on the floor. He was black, but most importantly, he was human.[46]

I think my student gets it exactly right. By drawing near to the strange "other" and not pulling away, by piercing the Veil *of his own race privilege* bodily, intellectually, emotionally, Griffin became, as it were, more human. And in becoming more human—that is, more open, more vulnerable, more present to the other— he "found God that night while sleeping on the floor."

From Intellectual to Emotional Conversion: Beyond the "Prison of Culture"

In fact the seeds for Griffin's dramatic journey across the color line were cultivated many years before the *Black Like Me* experiment. His mother, a concert pianist, taught him a deep love of music as a child. Awarded a musical scholarship in France, Griffin spent his high school years studying French language and literature at the University of Poitiers. He was only nineteen, just beginning medical studies, when the Nazis invaded Paris. He joined the French resistance as a medic, using a pirated ambulance to smuggle Austrian Jews to the coast and ultimately to safety in England.

After being placed on a Nazi watch-list, Griffin returned to the United States and enlisted in the Army Air Corps. From 1943–1944, he was stationed on Nuni, a tiny island in the South Pacific. The only white person on the island, his assignment was to learn the language and study the native culture. He was good at it, though he later admitted to being ashamed of his initial prejudices regarding the "primitive" natives. Griffin had always assumed "that mine was a superior culture."[47]

But here his story takes an especially dramatic turn, a turn which draws him nearer to *Black Like Me* and, as it happens, the life-world of Stevie Wonder. In 1945, assigned to guard a munitions store on another Pacific island, Griffin was wounded during a Japanese air raid, an injury that eventually left him blind. When

46. Rachel Patterson; used with permission. The intimacy of this scene and of so many others in *Black Like Me* reflects Griffin's remarkable literary artistry, a kind of poetic or musical sensibility that plays between the lines of his spare prose. In the last decade of his life he would become a celebrated photographer, his favored subject being human faces.

47. Bruce Watson, "*Black Like Me*, 50 Years Later," *Smithsonian Magazine*, October 2011, *https:// www.smithsonianmag.com/arts-culture/black-like-me-50-years-later-74543463/?all*.

the war ended, he returned to Texas, and for ten years he would navigate the world as a blind man, forced to relearn how to do everything, as it were, in the dark. He gave piano lessons, eventually falling in love with one of his students. ("It was the way she played Chopin," he wrote.[48]) They would marry and have four children. He became a farmer, raising champion livestock. He wrote books about his years in France and essays about his blindness. Finding consolation in the writings of Thomas Aquinas and the Trappist monk Thomas Merton, Griffin became a Catholic, giving lectures at local colleges on musicology and Gregorian chant.

One day in 1955, while working in his backyard, he suddenly saw a vision of "swirling red" amid a kaleidoscope of other colors. Inexplicably, over the next few months, his sight completely returned. For the first time he could begin to make out the faces of his wife and children. And again, he felt ashamed of prejudices that had once crippled his vision as a sighted man. Paradoxically, his years without sight had taught him to "see the heart and intelligence of a man," and to realize that "nothing in these things indicates in the slightest whether a man is white or black."[49] It was this realization of his own ignorance and complicity in white supremacy that set Griffin on the path to *Black Like Me*. In 1979, a year before his death, Griffin made an accounting of the personal transformation he had described with such harrowing detail in *Black Like Me*:

> Having recognized the depths of my own prejudices when I first saw my black face in the mirror, I was grateful to discover that within a week as a black man the old wounds were healed and all the emotional prejudice was gone. It had disappeared for the simple reason that I was staying in the homes of black families and I was experiencing at the emotional level, for the first time in thirty-nine years, what I had known intellectually for a long time. I was seeing that in families everything is the same for all people. . . . I was experiencing all this as a *human* parent and it was exactly as I experienced my own children.[50]

Notice the distinction Griffin draws here between knowing something intellectually and experiencing it at the emotional level. The insight calls to mind Stevie Wonder's observation that "we really *feel* before we see," implying that our capacity for empathy is at least as foundational as cognition and intellect with respect to what makes human beings *human*. Griffin continues,

> I believe that before we can truly dialogue with one another we must first perceive intellectually, and then at the profoundest emotional level, that there is no *Other*—that the *Other* is simply *Oneself* in all the significant essentials. This alone is the key that can unlock the prison of

48. *Uncommon Vision.*

49. *Uncommon Vision.*

50. Griffin, "Beyond Otherness," 192.

culture. It will neutralize the poisons of the stereotype that allow men to go on benevolently justifying their abuses against humanity.[51]

Both musicians and both students of physical blindness, Stevie Wonder and John Howard Griffin witness to a different kind of perception than that which lay on the empirical surface of things. Both call us beyond hatreds and fears nurtured and codified within the "prison of culture."[52]

Becoming the Stranger: Breaking Free of Cultural Comfort Zones

Fifty years ago the face of white supremacy was epitomized in openly racist organizations like the Ku Klux Klan, in men like Bull Connor, the bigoted public safety commissioner of Birmingham, Alabama, and in horrific tragedies like the bombing of the 16th Street Baptist Church in Birmingham. Then it seemed quite clear what racism meant: it meant to will the nonexistence of black people, to seek their *erasure*. But institutionalized racism, then and now, has another subtler and more hidden face, though its effects are no less oppressive or potentially violent. In the decades since the Civil Rights Movement, white supremacy's implicit strategy has not been the erasure of the feared and marginal other so much as their *eclipse* from meaningful participation in society. To eclipse is to ignore, to refuse to deal with a person as a person, a somebody—a Child of God, as we say—who matters. To "eclipse" is to blot out the light. As Howard Thurman often noted, to destroy a people I don't have to kill them, I only have to convince them that they are not worth anything, or, to borrow Jesus' vivid imagery, to hold a bushel basket relentlessly over their light (Matt. 5:15). It is this form of violence, violence by systematic neglect and creeping despair, which Stevie Wonder laments in "Living for the City," "Big Brother," and "Village Ghetto Land." For many children of color the ghetto is *the place where I submit, where I give in, where I quit.*[53]

Two authors have especially opened my eyes to the scope of systemic racial injustice in the United States today. The first is Jewish educator and activist

51. Griffin, "Beyond Otherness," 192.

52. In a 2016 interview about his film *Silence*, filmmaker Martin Scorsese expresses concern that we might soon "be in a world where younger people won't even *consider* that which is not material, that which one can't see, taste, or feel. And ultimately, when everything is stripped away, . . . that's really what's left. It is the spiritual." Martin Scorsese, "Exclusive: Martin Scorsese Discusses His Faith, His Struggles, and *Silence*," interview with James Martin, *America* (Dec. 8, 2016), *https://www.youtube.com/watch?v=TbYiGdinejU.*

53. See Thomas Merton, "The Street Is for Celebration," in *Love and Living*, ed. Naomi Burton Stone and Patrick Hart (New York: Harcourt Brace Jovanovich, 1985), 46–53, an essay inspired by Merton's experiences as a young man in Harlem. The pioneering "gangsta rap" band N.W.A. wrote from their experiences of living in fear of gangs and police, and artists from Iced T, Tupac Shakur, and many others have followed. See additional resources at the end of the chapter.

Jonathan Kozol, whose books have long cast an ominous spotlight onto the plight of children of color and the state of public education in our cities. The titles of Kozol's books—*Death at An Early Age*; *Savage Inequalities: Children in America's Schools*; *The Shame of the Nation: The Restoration of Apartheid Schooling in America*— tell the story of whole populations of children, disproportionately black and Latino, whose presence in America is so provisional they might as well be absent. The second is legal scholar Michelle Alexander, whose critically acclaimed study, *The New Jim Crow: Mass Incarceration in the Age of Colorblindness*, details the devastating effects of mass incarceration and systematic disenfranchisement on communities of color in the United States. Like Kozol, Alexander's painstaking scholarship unmasks patterns of injustice directed against whole populations that most of us would rather not see, and many simply choose to deny.[54] Their work confronts us once again with the prophetic challenge: You have eyes to see, but do you see? You have ears to hear, but do you hear the cry of the marginalized?

In some ways *Black Like Me* is inevitably bound to and limited by its historical moment. It is nearly impossible to imagine today, for example, any well-intentioned white person adopting Griffin's radical method of crossing the color line—physically disguising himself as a black man—and being able to defend such an act in the court of public opinion. Griffin himself, as noted above, acknowledged the morally problematic aspects of his experiment, yet he felt that the urgency of the "race problem" as it confronted him in the late 1950s demanded of him a radical option for solidarity. As we might describe his experiment today, the privilege of his whiteness in the milieu of white supremacy, and the painful recognition of his own social blindness, compelled him to act. But even if we grant *Black Like Me* the status of a classic in the canon of civil rights literature, a book that is still sadly resonant in an age of xenophobia and Black Lives Matter, the skeptic today might counter that Griffin's experiment in crossing the color line failed before it even started.

In a word, no white man, being white, can know or experience at the deepest emotional level what it *is* to "be black" in America. Race is more than "the surface" of one's true being. If, for historical and cultural factors beyond our control, whites and blacks are *essentially* closed off from one another, then no appeal to human kinship or deepest principles of religious faith—for example, that every human being is a Child of God—can penetrate the Veil, much less remove it, not even for a moment. To the cynic, sociologist, or even the theological realist, for whom there is no "reality" that can exist outside the social dynamics of power and race privilege, *because* Griffin is white, his perception of "black experience" could only be apparent. It was not real. And therefore, his account is not

54. Jonathan Kozol, *Amazing Grace: The Lives of Children and the Conscience of a Nation* (New York: Harper, 1996); also, *The Shame of the Nation: The Restoration of Apartheid Schooling in America* (New York: Random House, 2005); Michelle Alexander, *The New Jim Crow: Mass Incarceration in the Age of Colorblindness* (New York: New Press, 2010).

trustworthy. Intellectually this is a compelling argument, and I might be inclined to agree if it weren't for elements of Griffin's story that extend beyond rational argument and resonate with my own experiences of cross-racial and cross-cultural encounter over the course of a lifetime.

I grew up in a white suburban neighborhood in Lexington, Kentucky, and had little contact with any peoples of color until my mid-twenties. Less than three miles from my childhood parish there was and still is a thriving predominantly African American Catholic church. For almost three decades of my life, I'm sad to say, I had no clue there was such a thing as black Catholics. There are some four million Catholics of African descent in the United States, more than the membership of many Protestant denominations. I did not know them. Nor was I ever taught the extraordinary history of black Catholic sisters, priests, and lay parishioners who kept the faith so often in the face of breathtaking racism and segregation in their own church. Yet when my family joined a black Catholic community in Denver, the relationships we formed there transformed our whole way of experiencing the church, of being Christian—I daresay, of being human. We were part of that community for eight years. Our first child was born there, and the church became for us, and certainly for our son, a surrogate family. Two decades later he still remembers it like a lost family.

When one feels oneself a total stranger—even if believing and hoping otherwise—it is a remarkable thing to be welcomed like a brother. It is no small grace to approach a community of strangers and, as W. E. B. Du Bois writes, "They come all graciously with no scorn nor condescension."[55] Such graced encounters, such human encounters, occur all the time, to be sure. But are they not still rare, altogether too rare, between the races? Why should it seem so remarkable when whites and blacks and all manner of folks of different racial and ethnic backgrounds share table fellowship and prayer?[56] In the immediacy of such experiences of "crossing the color line," we may have no way of explaining how, or why, or what convergence of forces pushed us beyond our familiar circles of kinship, even while we may feel a certain "rightness" and sense of trust as we move forward. Perhaps like Griffin we are, so to speak, feeling our way in the dark.

The African American mystic and theologian Howard Thurman recalls that it was not uncommon in the black church of his childhood in Florida to see the occasional white visitor seated in the pews on Sunday morning. Yet the reverse was unthinkable. Few black Christians would have dared to step foot in white Christian houses of worship for the better part of American religious history.[57] I shudder to think how the same pattern of segregation and white

55. Du Bois, *The Souls of Black Folk*, 76.

56. King's oft-cited observation that "eleven o'clock Sunday morning is the most segregated hour in America" is hardly less accurate or damning today than it was sixty years ago. See Mary Jo Bane, "A House Divided," *Commonweal* (Nov. 4, 2013): 17–19.

57. Howard Thurman, *Jesus and the Disinherited* (1949; repr., Boston: Beacon, 1976), 32.

supremacy has manifested in my own Roman Catholic Church, from the first contact of European missionaries with Native Americans, to Catholic involvement in the slave trade, to segregated worship and reticence even today among the Catholic bishops to speak more prophetically against racism.[58] If we cannot build Beloved Community in our churches, then where in God's name shall we ever find it? In retrospect, what strikes me now is the realization of how easy it would have been, and understandable, if folks at our Denver parish or any other number of predominantly black Catholic churches had rejected me and my family for what we were: outsiders.

I make no claims to universal truth or special insight, least of all on behalf of people and communities whose intentions or thought processes remain more or less hidden from me. (Indeed the deepest realms of my own life story remain a mystery to me!) At the same time, perhaps like Griffin, I believe what I have learned from these experiences and enduring relationships in communities of color, notwithstanding my own blind spots and cultural limitations, is trustworthy. As Griffin's account teaches me, we break through the race veil not by denying our own racial ignorance and cultural prejudices, but by confronting them straight on. We need communities of friendship and inclusiveness, prayerfulness and mercy, to help us do so.

Rediscovering Child Mind: Leaning into the Mystery of Encounter

Few have written more poignantly than W. E. B. Du Bois about the torment and irony of race relations. In the world of ideas and books, as Du Bois observes, he was free to fraternize with every manner of "smiling men and welcoming women"—"I sit with Shakespeare and he winces not"[59]—while the "real world" chained him stupidly behind the Veil. It was "in the early days of rollicking boyhood" in New England, he recalls, when for the first time "the shadow swept across me," the revelation of the inferior status he was accorded by his white schoolmates, and suddenly he felt "shut out from their world by a vast veil." How many children of color today feel the sting of that bitter cry, "Why did God

58. The classic study is Cyprian Davis, *The History of Black Catholics in the United States* (New York: Crossroad, 1995); see also *Uncommon Faithfulness: The Black Catholic Experience*, ed. M. Shawn Copeland (Maryknoll, NY: Orbis, 2009), and Bryan Massingale, *Racial Justice and the Catholic Church* (Maryknoll, NY: Orbis, 2010). In November 2018, the US Conference of Catholic Bishops published "Open Wide Our Hearts: The Enduring Call to Love," a pastoral letter against racism. While some individual bishops have spoken forcefully through the years, it is the USCCB's first formal statement on racism since 1979. See *http://www.usccb.org/issues-and-action/human-life-and-dignity/racism/statements-letters-against-racism.cfm*.

59. Du Bois, *The Souls of Black Folk*, 109.

make me an outcast and a stranger in mine own house?"[60] And yet I cannot help but wonder: are there not a great many white Americans, too, who long to rise above the Veil? Are there not people of all races, especially among the young, who yearn for a taste of the Beloved Community, and who would rather not wait for the afterlife to experience it?

While the seeds of cross-cultural empathy may have first stirred in me as a boy listening to *Songs in the Key of Life*, those seeds have been watered again and again over the course of a lifetime, and certainly not only in churches. Indeed, more than any other context in recent years, I have seen it flower in the university classroom, among students of every racial, ethnic, and religious background. It begins, as I would describe it, with the cultivation of Beginner's Mind: a disposition of openness and presence to everything that bears me outside my comfort zone, and the conviction that no matter what ideas, beliefs, or cultural differences may separate us, *I have something essential to learn from you* that I could not learn otherwise. I refuse to play the cynic. My heart and mind are open to you, your gifts and essential goodness, the pain and beauty that shines from within your culture. To cultivate Child Mind—which, it is worth repeating, has nothing to do with childish ignorance or willful naïveté—is to practice leaning in, lingering with, and listening to the other, especially when it is hardest to do so. The possibility of communion across the color line—not uniformity, but a unity that celebrates difference—is real, it is beautiful, and, above all, it is trustworthy.[61]

This is not to suggest that the Veil is illusory, that the sooner we all "get over it" and stop fixating on race in America, the better. To the contrary, we cannot rise above the Veil unless, like Griffin, we confront it head-on and learn to break through it, imperfectly, in fits and starts, by trial and error. By "we" I mean each of us individually and all of us collectively, in our workplaces and schools, neighborhoods and cities, courthouses and churches. To put our hands out and touch the Veil, to begin to feel our way through the darkness, is already to begin breaking through it.[62]

60. Du Bois, *The Souls of Black Folk*, 7–8. I am acutely aware that my son Henry, adopted as an infant from Haiti, will eventually have to wrestle with difficult questions of identity and belonging as he grows into his freedom as a young black man in America, and that neither the circle of his family's love nor the reach of his parents' white privilege can protect him forever. My prayer is that by virtue of our love he will never feel himself "a stranger in [his] own house."

61. By "communion" I gesture to something well beyond mere tolerance, though the latter is not a bad place to start. For a sustained discussion of racial justice and the transforming power of cross-racial and cross-cultural encounter, see Christopher Pramuk, *Hope Sings, So Beautiful: Graced Encounters across the Color Line* (Collegeville, MN: Liturgical Press, 2013).

62. Facilitating conversations about race in any context is not easy, and the classroom is no different, not least for white teachers. For me, the challenges have been considerably offset by the sheer richness of the materials at hand: in my case, African American literature, poetry, music, theology, and the depth of student responses to such. A passion for the subject and the recognition of one's own limitations goes some way in reassuring students of color who may presume that "your whiteness is preventing you from seeing our humanity," as one teacher puts it. See Melinda D. Anderson, "How Teachers Learn to Discuss Racism," and linked resources, in *The Atlantic*, January 2017, *https://www.theatlantic.com/education/archive/2017/01/how-teachers-learn-to-discuss-racism/512474/*.

There is a certain freedom in the realization that nobody enters the conversation about race a fully developed, perfectly "sighted," whole person. Each person enters the conversation (or refuses it) from a unique social location and developmental stage in the drama that is human life. And each of us bears crippling wounds and serious "blind spots." We need to be challenged with difficult truths but we also need to give each other room to grow into new ways of imagining our place in the world beyond our present horizons and habitual or defensive comfort zones.

Consider Jesus' iconic encounter with the rich young man (Matt. 19:16–30; Mark 10:17–31; Luke 18:18–30). It wasn't the young man's riches as such that were his obstacle to "salvation" or communion with God; rather it was his seeming inability to even recognize, much less cross, the great divide that separated him from his neighbor. By inviting the young man to give up his wealth and walk with the poor, Jesus was daring him to break free from his imprisoned imagination—a conception of God and of holiness made small by the prison of privilege—and to risk his freedom for love and solidarity in a way that promised more authentic fulfillment and joy than his wealth or social status ever could. To begin to confront our social blindness is already the beginning of the path toward healing it. Yet the young man "went away sad, for he had many possessions."

By some accounts the challenges facing children of color today in the United States are, on the whole, empirically worse than they were fifty years ago. This was not hard for me to believe during my ten years living in the deeply segregated city of Cincinnati, where the poverty rate among black children is second only to that of Detroit.[63] It is not hard to believe in Denver, my present home, where racial and economic segregation is no less damaging but is far more easily hidden behind a veneer of economic prosperity.[64] Short of "becoming black" in the radical manner of Griffin, how can I—how can we all—become more human in the midst of these sobering realities? The realization with Griffin that at the deepest emotional level "there is no Other—that the Other is simply Oneself in all the significant essentials," has been for me a struggle and journey of a lifetime. But it comes to me palpably as I watch Henry, my Haitian-born son, mixing it up with other kids on the playground. It comes as I recognize my own delight reflected in the faces of other parents around me, mothers and fathers of every racial and socioeconomic background.

In the way that Griffin observes the intimacy of a mother wiping chocolate from her hungry child's lips; in the way he shudders at the depths of his own prejudice; in the way he gathers all of his experiences into himself as he surrenders to

63. See the Greater Cincinnati Urban League, *The State of Black Cincinnati 2015: Two Cities, http://homecincy.org/wp-content/uploads/2015/09/The-State-of-Black-Cincinnati-2015_Two-Cities.pdf.*

64. Monte Whaley, "Denver Area Schools Continue to Battle Segregation and Related Issues," *The Denver Post,* June 19, 2017, *https://www.denverpost.com/2017/06/19/segregation-denver-colorado-schools/.*

sleep on an impoverished but generous family's floor—embracing the strangeness, the danger, the beauty, the vulnerability—there are critical moments of decision in all our lives, perhaps in each day, when we are invited by the mystery and beauty of life itself not to play the cynic. And if we are intentional about the choices we make, over time we are likely to find ourselves surrounded more and more by other benevolent spirits who recognize our desire for fellowship, inclusion, and justice for what it is—sacred—and who likewise refuse to play the cynic. Much in the way of Stevie Wonder, Griffin's witness encourages me precisely as a father *and* as an intellectual to listen to my own childlike heart, and to place my trust in its most intimate experiences of discovery in places and among peoples outside my comfort zone. As artists, both Wonder and Griffin help me to embrace the realization that "in my most childlike hour, my heart has not deceived me. I will not break faith with my childlike heart."[65]

Some years ago I was part of a team of faculty and student leaders who invited John Howard Griffin's eldest daughter, Suzy Griffin Campbell, to speak at Xavier University in Cincinnati, where I was teaching. When one of our students asked Campbell why she thought her father did what he did, she replied, after a thoughtful pause, "I think he did it for the children." It struck me that she didn't specify *whose* children. He did it for the children. He did it for *all* children.

Foretastes of Heaven: Reimagining the Present from the Future

The final Veil, of course, is that which shimmers between life and death. In his classic work *The Sabbath,* Rabbi Abraham Joshua Heschel highlights the inseparable connection between our worship practices in this world and our state of preparedness for the next:

> [The] Sabbath contains more than a morsel of eternity. . . . Unless one learns how to relish the taste of Sabbath while still in this world, unless one is initiated in the appreciation of eternal life, one will be unable to enjoy the taste of eternity in the world to come. Sad is the lot

65. The phrase is borrowed from James Finley, "Thomas Merton: Mystic Teacher for Our Age," *The Merton Annual* 28 (2015): 183. It may seem counterintuitive, if not politically naïve or laughable, to appeal to a notion such as Child Mind in a discussion of race and racial injustice in America. Yet, as I write these lines, in the wake of the 2016 US presidential election, I don't think so. The values most of us were taught as schoolchildren—being kind, especially toward the most vulnerable; respect for the power of words to lift up or tear down (i.e., "sticks and stones"); telling the truth; reverence for democratic principles—have been wantonly trampled, expediently overlooked, or cynically dismissed by the supposed adults in the room. Under what strange logic should such core values not apply to our public and political discourse? It might do us all well to revisit the basic lessons we thought we had "learned in kindergarten."

of him who arrives inexperienced and when led to heaven has no power to perceive the beauty of the Sabbath.[66]

Whether or not one shares Heschel's faith in "the world to come," his insistence on the continuity between life before death and life after death suggests a provocative thought experiment.

If we imagine heaven to be something like a great feast, as it often is imagined in the Bible, how prepared shall we be when we are seated at the heavenly banquet table? (One can imagine that the seating arrangement will be no accident!) Will I recognize those sitting next to me? Will I know their names, stories, dreams? *Will I need to ask their forgiveness before the feast is served?* Sad will be our lot, suggests Heschel, if we arrive in heaven with no prior experience of the Beloved Community, the multiracial community, and indeed, the multifaith community.

Let me bring the discussion, finally, back to music. It is worth recalling that when Heschel marched from Selma alongside Martin Luther King Jr. they sang "We Shall Overcome" and other spirituals that were the soundtrack for the Civil Rights Movement. "I felt my feet were praying," Heschel would later say. Why? Perhaps because, as Du Bois observed, the spirituals awaken an irrepressible sense of possibility in those who sing them. To listen to the "sorrow songs" is to behold "the most beautiful expression of human experience born this side of the seas."

> Through all the sorrow of the Sorrow Songs there breathes a hope—a faith in the ultimate justice of things. The minor cadences of despair change often to triumph and calm confidence. Sometimes it is faith in life, sometimes a faith in death, sometimes assurance of boundless justice in some fair world beyond. But whichever it is, the meaning is always clear: that sometime, somewhere, men will judge men by their souls and not by their skins. Is such a hope justified? Do the Sorrow Songs sing true?[67]

One could make the same observation, almost word for word, and pose the same questions of Stevie Wonder's music. Is the hope that resounds throughout *Songs in the Key of Life* justified? Does Wonder's faith in humanity "sing true"? Might his music give us even a small foretaste of heaven? Of course, nobody can answer such questions for another person. They can only be answered by way of experience, and each of us may answer differently over the course of a lifetime.

When Larry King asked Stevie Wonder whether he ever considered retiring from music, Wonder didn't hesitate: "For as long as there's life; for as long as

66. Abraham Joshua Heschel, *The Sabbath* (New York: Farrar, Straus and Giroux, 1951), 74.

67. Du Bois, *The Souls of Black Folk*, 175.

we have things happening in the world; for as long as people haven't been able to work it out; for as long as people are not trying to work it out; for as long as there's crime and destruction and hate; for as long as there is a spirit that does not have love in it, I will always have something to say."[68] James Baldwin professed a similar credo of artistic resistance some fifty years ago: "Societies never know it, but the war of an artist with his society is a lover's war, and he does, at his best, what lovers do, which is to reveal the beloved to himself and, with that revelation, to make freedom real."[69] The artist loves the world by unflinchingly revealing the world to itself, including its unrealized possibilities.

There are no guarantees that embracing such a vision of life, a "faith in the ultimate justice of things," will not make me look the fool. To envision a day when we will be judged not by the color of our skins but by the content of our character is to risk, at least on this side of death, bitter heartbreak and disappointment. On the cold surface of things, we are still a long way from such a reality. Yet every now and then, dreams and visions of things that once seemed impossible have a way of breaking into reality. Life is too short to play in small circles. We feel our way through the darkness by unclenching our fists and reaching out to hold the hands of others. We sing our way from fear and hesitation to courage and fresh hope. We make the path forward by walking it.

Let the people say Amen.

Addendum and Additional Resources

Some thirty years ago, in 1988, the Los Angeles-based hip hop group N.W.A. released their debut album *Straight Outta Compton*. Among the most influential and controversial artists of the "gansta rap" genre, their music was often banned from mainstream radio for its perceived misogynistic lyrics, glorification of violence, and expressions of deep hatred of police. Iced T, Beyoncé, and innumerable other black artists have since registered musical protest and resistance to the ongoing oppression of African Americans in systemic poverty, mass incarceration, and police brutality, from past to present.

The birth of "black theology" (or black liberation theology) may be dated at least to the 1960s with Malcolm X, Fannie Lou Hamer, and Martin Luther King Jr.—if not much earlier in Frederick Douglass, W. E. B. Du Bois, Marcus Garvey, Howard Thurman, and others. Black theology found its voice explicitly and most influentially in the work of James H. Cone, who published his landmark work, *Black*

68. Wonder, interview with Larry King.

69. James Baldwin, "The Creative Process" (1962), in *The Price of the Ticket: Collected Non-Fiction 1948–1985* (New York: St. Martin's Press, 1985), 318.

Theology and Black Power, in 1969, the year after King's assassination. Emerging more or less at the same time as second-wave feminist theologies (Daly, Ruether, Trible), Latin American liberation theologies (Gutierrez, Segundo, Gebara), and European political theologies (Metz, Moltmann, Soelle), it would be hard to name a more significant theological movement in the United States than the black theology of Cone and of many others who followed, including womanist theologians who foreground the experiences of African American women. Today it is impossible to overlook the impact of the #BlackLivesMatter Movement, which itself has profoundly spiritual, if less explicitly theological, foundations.

Thus Stevie Wonder and John Howard Griffin stand within a vast cloud of witnesses whose art, spirituality, and theology cultivate resistance and bend toward a vision of racial justice.

Books

Brooks, Maegan Parker, and Davis W. Houck. *The Speeches of Fannie Lou Hamer: To Tell It Like It Is*. Jackson, MS: University Press of Mississippi, 2011.

Cone, James H. *The Spirituals and the Blues: An Interpretation*. Maryknoll, NY: Orbis, 1972.

Copeland, M. Shawn. *Enfleshing Freedom: Body, Race, and Being*. Minneapolis: Fortress, 2009.

Dyson, Michael Eric. *Holler If You Hear Me: Searching for Tupac Shakur*. New York: Basic Civitas, 2001.

———. *What Truth Sounds Like: Robert F. Kennedy, James Baldwin, and Our Unfinished Conversation about Race in America*. New York: St. Martin's Press, 2018.

Hopkins, Dwight N. *Introducing Black Theology of Liberation*. Maryknoll, NY: Orbis, 2004.

Jones, Arthur C. *Wade in the Water: The Wisdom of the Spirituals*. Boulder, CO: Leave a Little Room, 2005.

Woodson, Jacqueline. *Brown Girl Dreaming*. New York: Puffin, 2016.

Articles and Essays

Farrag, Hebah H. "The Role of Spirit in the #BlackLivesMatter Movement: A Conversation with Activist and Artist Patrisse Cullors." *Religion Dispatches* (June 24, 2015), *http://religiondispatches.org/the-role-of-spirit-in-the-black livesmatter-movement-a-conversation-with-activist-and-artist-patrisse-cullors/*.

Griffin, John Howard. "Beyond Otherness." In *Black Like Me*, 211–12. 50th anniversary ed. San Antonio: Wings, 2011.

Martin, James, SJ. "Rejoice Always! The Surprisingly Joyful Theology of 1 Thessalonians." *America* (Oct. 3, 2011), *https://www.americamagazine.org/issue/788 /article/rejoice-always*.

Merton, Thomas. "The Street Is for Celebration." In *Love and Living*, edited by Naomi Burton Stone and Brother Patrick Hart, 46–53. New York: Harcourt Brace Jovanovich, 1985.

Nilson, Jon. "Confessions of a White Catholic Racist Theologian." *Origins* 33 (2003): 130–38.

O'Connell, Maureen. "Painting Hope: The Murals of Inner-City Philadelphia." *Commonweal* (Jan. 18, 2008): 19–23.

Pramuk, Christopher. "O Happy Day! Imagining a Church beyond the Color Line." *America* 189 (Aug. 18, 2003): 8–10.

Saliers, Don. "Singing as a Political Act: Theological Soundings of Justice." In *Music and Theology*, 43–54. Nashville: Abingdon, 2007.

Music, Audio, and Visual

Adichie, Chimamanda Ngozi. "'Americanah' Author Explains 'Learning' to Be Black in the U.S." Interview for NPR. June 27, 2013, *https://www.npr.org/2013/06/27/195598496/americanah-author-explains-learning-to-be-black-in-the-u-s*.

Alexander, Michelle. "The Future of Race in America: Michelle Alexander at TEDx Columbus." *Https://www.youtube.com/watch?v=SQ6H-Mz6hgw*.

Baldwin, James. *I Am Not Your Negro*. Directed by Raoul Peck. Magnolia Home Entertainment, 2017.

Classic Albums: Stevie Wonder: Songs in the Key of Life. Directed by David Heffernan. Rhino, 1999.

"Integrating Sunday Morning Church Service—A Prayer Answered." *Weekend Edition Saturday*, August 11, 2018. NPR. *Https://www.npr.org/2018/08/11/637552132/integrating-sunday-morning-church-service-a-prayer-answered*.

"The Ringshout and the Birth of African-American Religion." In "There Is a River." Part 1 of *This Far by Faith: African-American Spiritual Journeys*. PBS Video: Blackside, 2003. *https://www.youtube.com/watch?v=KmmTMg3e5Uo*.

Wonder, Stevie. "Big Brother." *Talking Book*. Tamla Motown, 1972.

———. "Living for the City." *Innervisions*. Tamla Motown, 1973.

Uncommon Vision: The Life and Times of John Howard Griffin. Directed by Morgan Atkinson. Duckworks, 2010.

"In the Wind We Hear Their Laughter"

Billie Holiday, Peter Gabriel, and U2: Communion with the Dead

A people no longer afraid of death is a people
who will no longer be docile in the face of oppression.

—*Fumi Tosu*

Ah but in such an ugly time the true protest is beauty.

—*Phil Ochs*

The case studies we have explored in the first half of this book witness to the power of the arts in cultivating what I have called a spirituality of wonder, resistance, and hope. To recall our discussion of Abraham Joshua Heschel in chapter 1, the will to wonder that lives in every person rebels against unthinking conformity to "the way things are," daring us to imagine again what is possible for human beings. Thus the will to wonder is a subversive act, an act of resistance against every force that would deaden our hopefulness, suppress our curiosity, and close the veil over our collective imaginations. Remember "that there is a meaning beyond absurdity," Heschel urged the youth of his time, "that every little deed counts, that every word has power, and that we can do, everyone, our share to redeem the world, in spite of all absurdities, and all the frustrations, and all the disappointment."[1] In the face of the seeming futility of our dreams, the

> **CASE STUDIES**
>
> Billie Holiday, "Strange Fruit"
> Peter Gabriel, "Biko"
> U2, "Mothers of the Disappeared"

1. Interview with Carl Stern, 1972, cited in Arnold Eisen, "The Opposite of Good Is Indifference," interview with Krista Tippet, *On Being*, NPR, June 5, 2008, *https://onbeing.org/programs/arnold-eisen-the-spiritual-audacity-of-abraham-joshua-heschel/*.

acts of hatred and violence that rend the fabric of human society, the artist dares to speak, sing, or paint a glimpse of hopefulness, of possibilities that lay dormant within the surfaces of history.

Phil Ochs, the extraordinarily gifted songwriter of the Civil Rights era, confessed that his greatest obsession as an artist was history, that is, "to instigate changes in history."[2] Remembered as a "protest singer" by many Americans who came of age during the 1960s, Ochs once defined an effective protest song, with characteristic flourish, as "a song that's so specific that you cannot mistake it for bullshit."[3] He saw his political songs as "subversive in the best sense of the word," intended "to overthrow as much idiocy as possible."[4] In the context of a history committed to so much idiocy, the art of the protest singer, said Ochs, is the art of "aesthetic rebellion"[5] against the status quo. Even more, in an American culture that has so perfected the art of selective remembering, the protest song dares to tell the stories we would rather forget, to reclaim memories that irritate the ruling consciousness and challenge collective myths. Yet what fascinates me most about protest music, and the intuition I wish to explore in this chapter, is the way it evokes something beautiful even while interrupting our reflexive assumptions about beauty. Here something beautiful "breaks through" but not without delivering a painful revelatory sting. Ochs would agree with James Baldwin's famous dictum: "Artists are here to disturb the peace."[6]

As we saw in Stevie Wonder's music, where art rises from the longing for justice and social change, the artist's appreciation for beauty is often leavened by a strong sense for the tragic and ironic. Protest art is "revelatory" insofar as it unveils a strangely paradoxical truth: that beauty often finds us in the valley of the shadow of death (Ps. 23), or kneeling at the foot of the cross, buried in layers of horror, guilt, and violence.

In what follows, I invite you to immerse yourself in the narrative and aesthetic landscape of three songs that have long haunted my imagination, songs that are subversive in the best sense of the word: Billie Holiday's "Strange Fruit," Peter Gabriel's "Biko," and U2's "Mothers of the Disappeared."[7] Each of these

2. Phil Ochs, *Farewells and Fantasies*, Elektra R273518, liner notes, 42.

3. Carnegie Hall, June 19, 1965; *Farewells and Fantasies*, 31.

4. *Farewells and Fantasies*, 42.

5. "On the white steed of aesthetic rebellion," Ochs declared in 1966, "I will attack the decadence of my future with all the arrogance of youth" (*Farewells and Fantasies*, 53).

6. Studs Terkel, "An Interview with James Baldwin," interview with James Baldwin, 1961, in *Conversations with James Baldwin*, ed. Fred L. Standley and Louis H. Pratt (Jackson and London: University Press of Mississippi, 1989), 21. Of course not every artist uses their gifts to resist, and artists are by no means the only persons to do so. As seen with our discussion of the "culture industry" in chapter 2, the arts can be and often are used in a conservative way to promote social conformity, political withdrawal, or ideologically oppressive ends. We revisit this tension in chapter 8 with attention to religious art.

7. Billie Holiday, "Strange Fruit," Commodore, 1940, composed by Lewis Allan (Abel Meeropol); Peter Gabriel, "Biko," *Peter Gabriel 3: Melt*, Mercury Records, 1980; U2, "Mothers of the Disappeared," *The Joshua Tree*, Island, 1987.

songs, I have found, has a way of breaking through to diverse listeners in powerful and unpredictable ways; each points once again to the power of music and poetic expression to touch something more elusive in human experience than either rational or formal religious language can get a handle on. In the case of these songs, it is our confrontation with the mystery of death, and the longing for resolution when death comes unjustly and far too soon.[8] Do we dare hope in a life-world beyond the grave? And what of the thousands upon millions of victims strewn across history's killing fields, people whose lives have been cut short unjustly, often horrifically, and far too soon? Are they simply gone, no more?

The question calls to mind the story of words spoken some two thousand years ago in a garden outside Jerusalem's city walls. Some friends of Jesus had come at daybreak to anoint his body—his tortured and crucified body—with spices and perfumed oils according to the Jewish custom (Luke 24:1–5). But they were astonished to find the stone at the tomb's entrance rolled away, and the body gone. Suddenly there appeared "two men in dazzling garments," who asked, "Why do you seek the living one among the dead?" The question, if we allow it, reverberates across those years and touches the rawest of human nerves. Who among us has not longed, like the women who came to anoint Jesus' body, to touch or feel the consoling presence of some beloved companion now lost to us forever? Visit any cemetery, stay for a while, and observe the people who linger in silence by particular grave markers. What draws them there? Does the presence of the beloved endure beyond death? Why do we seek the living among the dead? The question itself almost seems to mock any who would profess such an irrational hope. "*They are not here*" insists the voice of reason. "They are not *anywhere*." Yet the heart that has known love persists: "They *are* here. I can neither see nor touch their body, it is true. But I can feel their presence."

To say in one breath that the dead are not here, in this earth, this place of burial, may be to suggest in the very next breath that they *are* here: we simply need to know where to look, and how to listen.[9] "In the wind we hear their laughter / In the rain we see their tears. / Hear their heartbeat / we hear their heartbeat." So confesses the Irish rock band U2 in "Mothers of the Disappeared." Indeed the three remarkable songs we explore in this chapter are not merely "protest songs" in any simplistic sense. On the surface, each remembers and protests against something quite concrete and historically specific, "so specific that

8. Portions of this chapter were developed in Christopher Pramuk, "'Strange Fruit': Black Suffering/White Revelation," *Theological Studies* 67 (June 2006): 345–77; "Beauty Limned in Violence: Experimenting with Protest Music in the Ignatian Classroom," in *Transforming Ourselves, Transforming the World: Justice in Jesuit Higher Education*, ed. Mary Beth Combs and Patricia Ruggiano Schmidt (New York: Fordham University, 2013), 15–29; and *Hope Sings, So Beautiful: Graced Encounters across the Color Line* (Collegeville, MN: Liturgical Press, 2013), 53–66. This material is adapted here with permission and has been substantially revised.

9. For this insight and many others I am indebted to Jewish feminist theologian Melissa Raphael and her extraordinary study, *The Female Face of God in Auschwitz: A Jewish Feminist Theology of the Holocaust* (New York: Routledge, 2003), 131.

you cannot mistake it for bullshit." Yet each also gestures to something deeper and more elusive than "mere history": a sense that life somehow reverberates beyond death, and that love endures beyond any earthly power to extinguish it. "He is not here. . . . He is going before you" (Mark 16:6–7).

In the face of overwhelming violence, injustice, and the apparent defeat of hope, our acts of remembrance and resistance, I will argue in this chapter, are not only courageous and beautiful. They are efficacious, both revealing and effecting in us something more powerful than death. What name you or I might give to that mysterious "something" is secondary to the hopefulness that such remembrance generates in us both.

"Blood at the Root": Art as Dangerous Memory

We begin with what is arguably the mother of all protest songs, "Strange Fruit," recorded by Billie Holiday in 1939 and performed by her until her death in 1959. Hailed in 1999 by *Time* magazine as the "Best Song of the Century,"[10] the title "Most Disturbing" might have been more apt.

> Southern trees bear strange fruit,
> Blood on the leaves and blood at the root,
> Black bodies swinging in the southern breeze,
> Strange fruit hanging from the poplar trees.

Subsequent verses confront the listener with a series of shocking juxtapositions in which a bucolic scene of beautiful magnolia trees, "sweet and fresh," is transformed, with the "sudden smell of burning flesh,"[11] into a lynching site. The printed word cannot do justice to Holiday's 1939 recording, much less to her devastating embodiment of the song in live performances, which extended over a period of twenty years. To be sure, the song's revelatory power, whether past or present, hinges considerably on the empathy, receptivity, and lived experience of the listener, to say nothing of the social dynamics of a particular performance. Yet when I have shared the recording or video footage of the song with my students, I have been amazed and humbled, indeed, sometimes troubled, by the range of responses evoked by Holiday's rendering, which, for many listeners, still reverberates darkly into the present situation of race relations in the United States.[12]

10. *Time*, December 31, 1999, cited in Josh Sanburn, "Strange Fruit," All-Time 100 Songs, Populist, *Time*, October 21, 2011, *http://entertainment.time.com/2011/10/24/the-all-time-100-songs/slide /strange-fruit-billie-holiday/*.

11. Lewis Allan (Abel Meeropol), "Strange Fruit" (1939).

12. The documentary *Strange Fruit*, dir. Joel Katz (San Francisco: California Newsreel, 2002), chronicles the song's historical genesis and its often contentious reception when Holiday performed it live.

The late jazz writer Leonard Feather called "Strange Fruit" "the first significant protest in words and music, the first unmuted cry against racism."[13] Drummer Max Roach referred to Holiday's 1939 recording as "revolutionary," and record producer Ahmet Ertegum called it "a declaration of war . . . the begin-

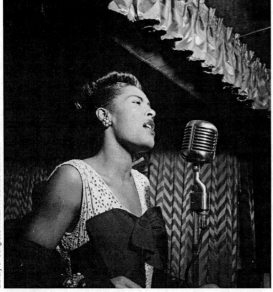

Library of Congress William P. Gottlieb Collection

Billie Holiday

ning of the civil rights movement."[14] Jazz musicians everywhere still speak of the song with a mixture of awe and fear. Perhaps the highest praise came from Samuel Grafton, a columnist for the *New York Post*, who described the record as "a fantastically perfect work of art, one which reversed the usual relationship between a black entertainer and her white audience: 'I have been entertaining you,' she seems to say, 'now you just listen to me.' The polite conventions between race and race are gone. It is as if we heard what was spoken in the cabins, after the night riders had clattered by."[15] Mal Waldron, the pianist who accompanied Holiday in her last years, was more pointed in his appraisal: "It's like rubbing people's noses in their own shit."[16]

It is no wonder that the first time Billie Holiday sang "Strange Fruit" in public she thought it was a mistake. It was February 1939, at New York City's Café Society, and as she remembers it, "There wasn't even a patter of applause when I finished. Then a lone person began to clap nervously. Then suddenly everyone was clapping."[17] The song quickly became a signature part of her repertoire. Whenever Billie sang "Strange Fruit," all service in the club stopped, and the room was darkened, save for a pin of light trained on her face. When

13. Cited in David Margolick, *Strange Fruit: Billie Holiday, Café Society, and an Early Cry for Civil Rights* (Philadelphia: Running Press, 2000), 17.

14. Margolick, *Strange Fruit*, 21, 17. Margolick underscores the fact that Holiday first sang "Strange Fruit" sixteen years before Rosa Parks refused to yield her seat on a Montgomery, Alabama bus.

15. Margolick, *Strange Fruit*, 75.

16. Margolick, *Strange Fruit*, 21.

17. Margolick, *Strange Fruit*, 16.

the song ended, the light was extinguished. No matter what kind of applause followed, the band would play no encores. These rituals—which strike me as almost liturgical in their precision and regularity—were insisted upon by the club's Jewish owner, Barney Josephson, who says he wanted people "to remember 'Strange Fruit,' get their insides burned with it."[18] Holiday herself would often be in tears after performing the song, and require considerable time before she could pull herself together for the next set.

The song worked in part because of the stark contrast between Holiday's beauty and elegance on stage and the song's implicit anger. With her voice accentuating imagery of trees that "bear," and "fruit" that is "plucked," it was clear that she understood the sexual motives unleashed in many acts of lynching, acts which frequently involved the accusation of rape, and mutilation or removal of the victim's genitals. "I am a race woman," she often said, with the integrity and force of a woman who had herself known the blows of racism.[19]

There is an extraordinary narrative behind "Strange Fruit" in the story of Abel Meeropol, a Jewish schoolteacher, poet, and musician from New York City. Deeply troubled by a photograph of a lynching he saw in a magazine, Meeropol sat down some days later and wrote "Strange Fruit."[20] Before Billie Holiday had ever heard the song, Abel's wife Anne performed it regularly for several years at teacher's union meetings around New York. Given the iconic status of Holiday's association with the song, people are often amazed to learn that it was written by a white, Jewish American. By all accounts Meeropol was a gentle man, very funny, and ill at ease in public. His son Michael, however, remembers his father as "not only one of the funniest people I know, he was also one of the angriest."[21] In a 1971 interview, Abel Meeropol said, "I wrote 'Strange Fruit' because I hate lynching and I hate injustice and I hate the people who perpetuate it."[22]

18. Margolick, *Strange Fruit*, 50; cf. Stuart Nicholson, *Billie Holiday* (Boston: Northeastern University, 1995), 112–16.

19. Cited in Robert O'Meally, *Lady Day: The Many Faces of Billie Holiday* (New York: Arcade, 1993), 136. I know of no more penetrating account of lynching in the United States than that of Ida B. Wells, *A Red Record*, 1895, *https://www.gutenberg.org/files/14977/14977-h/14977-h.htm*.

20. Margolick, *Strange Fruit*, 36–37; see also Elizabeth Blair, "The Strange Story of the Man behind 'Strange Fruit,'" *Morning Edition*, NPR, September 5, 2012, *http://www.npr.org/2012/09/05/158933012/*.

21. Interview in *Strange Fruit*, dir. Joel Katz.

22. Margolick, *Strange Fruit*, 29. There is a long history of solidarity (and periodic conflict) between the American Jewish community and the African American community, particularly in the founding and support of the NAACP and during the Civil Rights Movement. "It would be impossible," Martin Luther King Jr. noted in 1965, "to record the contribution that the Jewish people have made toward the Negro's struggle for freedom—it has been so great." *A Testament of Hope: The Essential Writings and Speeches of Martin Luther King, Jr.* (New York: Harper & Row, 1986), 370.

"At the Foot of the Tree": From Remembrance to Real Presence

For Christians whose imaginations have been shaped by the narrative of Jesus' suffering and death, "Strange Fruit" cannot help but resonate in the same "negative space"[23] as the haunting Negro spiritual, "Were You There When They Crucified My Lord?" For in the lynching site, just as in the story of Jesus' crucifixion, we behold in fear and trembling the historical irruption of irrational violence and evil, the senseless horror of man's inhumanity to man. Like "Were You There," "Strange Fruit" functions as a locus of what theologians call a "negative contrast experience": it is revelatory, first of all, of that *which should not be*.[24] Both songs draw the receptive listener into the realm of what feminist theology calls the "abject": "that site of simultaneous fascination and repulsion based on proximity to something that neither maintains the distance of an object nor attains identity with oneself as a subject"[25] The abject sets us on edge, which is to say, at the edge of rational and otherwise pleasant or normative systems of thought. But what makes both songs so disruptive, so potentially transforming, is their power to draw us not merely into a performance but into communion with a living history, a real presence. Not only *were* we there, but by entering into the song we *are* there. As one woman said of "Strange Fruit," "When Billie sings [that song], you feel as if you're at the foot of the tree."[26]

It is important to linger a moment further on the kind of remembering being invoked here, which goes beyond the simple recall of an event that happened in the past and is now done with. The kind of memory at play here is more akin to what the Catholic liturgical tradition calls *anamnesis*, living remembrance, "an epiphanic calling forth."[27] Like "Were You There," "Strange Fruit" embodies a kind of "unveiling" (Greek: *apokalypsis*) outside of historical time, where the boundaries between past and present, between the living and the dead, seem to disappear in our participation. In other words, much like the Negro spirituals, the impact of "Strange Fruit" is theological and not just psychological. The

23. On "negative capability" and "negative space" see Nathan Mitchell, "The Cross That Spoke," in *The Cross in Christian Tradition*, ed. Elizabeth A. Dreyer (Mahwah, NJ: Paulist Press, 2000), 87.

24. See Edward Schillebeeckx, *Church: The Human Story of God* (New York: Crossroad, 1990), 5–6. The revelatory dimension of a negative contrast experience resides in its participatory (not merely passive or objective) dynamic: like liturgical, artistic, or narrative remembrance, it is deep, evocative, moving.

25. Catherine Keller, *Apocalypse Now and Then* (Boston: Beacon, 1996), 23, citing Julia Kristeva.

26. Margolick, *Strange Fruit*, 60–61. In Catholic liturgy, this whole-bodied sense of being "at the edge" is realized most palpably in the passage through Holy Week, as the assembly reenacts the story of Jesus' suffering and death. As Jesuit preacher Walter Burghardt puts it in his seminal essay on contemplation, "I do not theologize about the redemptive significance of Calvary; I link a pierced hand to mine." See *An Ignatian Spirituality Reader*, ed. George W. Traub (Chicago: Loyola, 2008), 92.

27. Paul Evdokimov, *The Art of the Icon: A Theology of Beauty* (Redondo Beach, CA: Oakwood, 1990), 166.

song pulls us forcibly outside of ourselves to confront ultimate questions, painful questions rising not just from our own suffering but from the suffering of others outside our usual ken. It is precisely this opening to the suffering *of others*, without regard to cost, suggests Jesus, which is redemptive. (Thus Matt. 25:31–46: "Lord when did we see you naked, or hungry, or in prison?")

At this point even the most sympathetic listener might object that unlike "Were You There When They Crucified My Lord?"—which at least anticipates Jesus' Resurrection—there is nothing at all redemptive, much less beautiful, in "Strange Fruit." There is only horror and despair, the utter absence of anything like God or a hopeful, transcendent perspective. But here I would like to interject a comment from a former student, a young woman who was a survivor of sexual abuse and of many desolate years working in the sex industry in northern Ohio. In response to a question about "Strange Fruit" on an exam, she wrote, "The song itself does not give us anything to be hopeful for, but the act of singing it does." This wise insight—surely grounded in her own traumatic memories of sexual violence—goes some distance for me in confirming the intuition at the heart of this chapter: that the defiant cry of protest against injustice is not only holy, sharing in God's own pathos and lament for the dead; it is also beautiful, evoking wonder and galvanizing resistance in the receptive listener.[28]

Consider Chicago newspaperman Vernon Jarrett's reaction to the song: "I once heard 'Strange Fruit' while I was driving and I tried to park the car, out of respect for her—just to let her voice sink in." There was "this sense of resignation," he continues, "as if 'these people are going to have power for a long time and I can't do a damn thing about it except put it in a song.' . . . This is how most of us felt . . . [but] it enhanced my commitment to changing this stuff, that's what it did."[29] And yet, as my student also cautioned, with a wisdom once again limned in her own pain, "This kind of 'dangerous memory' is a double-edged sword, because it can lead to remembering with vengeance, instead of remembering with hope. Only hope brings an end to the suffering." Here we come to the very heart of things: how to remember and confront the most painful truths of our history without giving ourselves over to despair, resentment, or the desire for revenge?

"Good art must be hard," Henry James once wrote, "as hard as nails, as hard as the heart of the artist."[30] Billie Holiday sang "Strange Fruit" on stage

28. "Ah but in such an ugly time," said Phil Ochs, "the true protest is beauty" (*Farewells and Fantasies*).

29. Cited in Margolick, *Strange Fruit*, 43. What Walter Brueggemann says of the prophets applies well to "Strange Fruit," or better, to Abel Meeropol and Billie Holiday: "God's future rests on the lips of the truth-tellers." *Disruptive Grace: Reflections on God, Scripture, and the Church*, ed. Carolyn J. Sharp (Minneapolis: Fortress, 2011), 129–54.

30. Cited in O'Meally, *Lady Day*, 136.

until her death at age forty-four. Her recording of "Strange Fruit" was played at Abel Meeropol's funeral in 1986. Since 1939 the song has been recorded by at least thirty-six different artists, including Tori Amos, Sting, and UB40. It is not enough to describe the song as a classic, the mother of all protest songs, which it certainly is. Even "Best Song of the Century," as bestowed by *Time* magazine, risks trivializing its full force and meaning.[31] It is best described as "a dangerous memory,"[32] and thus a bearer of unexpected hope—by which I mean a *theological* hope, rooted in a hidden power and grace beyond our comprehension. Here we might recall, from chapter 5, W. E. B. Du Bois's pointed question: "Is such a hope justified? Do the Sorrow Songs sing true?"[33] At the foot of the lynching tree, dare we answer yes? And what would our yes mean?

Perhaps just this: In our commitment to naming the forgotten dead, to telling their stories, we return to them some measure of an agency that was cut short during their lifetimes. To sing the forgotten dead is to breathe them back to life in the wellsprings of our creativity and our hope. They are not "there." They are here, with us. They *are* us. The thing that is utterly new, and the free gift of grace, is the realization.

"Free at Last, Free at Last": From Real Presence to Hope for Liberation

It is worth recalling here David Tracy's account of the "classic" as explored in chapter 2. "When a work of art so captures a paradigmatic experience of [an] event of truth, it becomes in that moment normative," says Tracy. "Its memory enters as a catalyst into all our other memories, and, now subtly, now compellingly, transforms our perceptions of the real."[34] For anyone who has gotten their insides "burned" with "Strange Fruit," it becomes impossible to behold any "pastoral scene of the gallant South," as the song tells it, in the same way. Our "perception of the real" is forever changed.

31. *Time*, December 31, 1999, cited in Josh Sanburn, "Strange Fruit." The praise is not a little ironic given that six decades earlier *Time* had described the ballad as "a prime piece of musical propaganda for the NAACP," and Holiday herself as "a roly poly young colored woman with a hump in her voice," who "does not care enough about her figure to watch her diet, but [who] loves to sing" (Margolick, *Strange Fruit*, 74).

32. German theologian Johann Baptist Metz uses this phrase to describe the disruptive character of Jesus' death and Resurrection and, by extension, the remembrance of all the forgotten victims of history. Even Christian creeds and dogmas for Metz are "formulas of *memoria*," which—in a society "ever more devoid of history and memory"—"break the spell of the dominant consciousness" in a "redemptively dangerous way." *Faith in History and Society: Toward a Practical Fundamental Theology*, ed. and trans. J. Matthew Ashley (New York: Crossroad, 2007), 182–85.

33. W. E. B. Du Bois, *The Souls of Black Folk* (New York: Oxford, 2007), 175; see chapter 5.

34. David Tracy, *The Analogical Imagination: Christian Theology and the Culture of Pluralism* (New York: Crossroad, 1998), 115.

The magnificently restored plantation houses, for example, now a big tourist draw in many parts of the rural South, can no longer be seen without at once "seeing" the bodies of black men hanging from their fragrant trees, and the visage of slave women whipped raw, their bare legs chained to the hitching post just this side of the mansion's grand entrance. This is not to say that we must always remain prisoners of our nation's white supremacist and blood-soaked past. Rather it is to insist that the past, as hard as we try to "disappear" it, is always contained in the present, like the bodies of the dead who become the earth. To pretend otherwise is to be willfully and dangerously blind, like whistling Dixie with the hounds of hell at your heels. The classic "confronts and provokes us in our present horizon with the feeling that 'something else might be the case.'"[35]

As I have argued throughout this book, the capacity of artistic truth-telling to cross boundaries of time, geography, and culture is rooted in the deepest recesses of the human heart itself: in the sacred desire for life; in the need to love and to be loved and affirmed in dignity by others; in the God-haunted impulse for freedom. Once again, Du Bois cuts to the pulse of a sacred fire that burns in the breast of human beings down through history: "Someday the Awakening will come, when the pent-up vigor of ten million souls shall sweep irresistibly toward the Goal, out of the Valley of the Shadow of Death, where all that makes life worth living—Liberty, Justice, and Right—is marked 'For White People Only.'"[36] Any person with half a heart cannot fail to be moved by the yearning in African American music and literature for that elusive "Someday."

In the meantime, the bleaker side of longing for the afterlife, that is, *as an escape* from inhuman surroundings, is well documented by Jewish educator Jonathan Kozol. In his book, *Amazing Grace: The Lives of Children and the Conscience of a Nation*, Kozol interviews a thirteen-year-old boy named Anthony from Mott Haven in the South Bronx, one of the poorest congressional districts in America. Anthony says of the afterlife, "No violence will there be in heaven, no guns or drugs or IRS. If you still feel lonely in your heart, or bitterness, you'll know that you're not there. As for television, forget it! No one will look at you from the outside. People will see you from the inside. All the people from the street will be there. You'll recognize all the children who have died when they were little. God will be there. He'll be happy that we have arrived."[37] No liberal romanticizing of "the poor" or academic mystification of "the other" is needed, I think, to discern in Anthony's words one of the most persuasive articulations of Christian hope yet uttered in America by anyone.

35. Tracy, *The Analogical Imagination*, 102.

36. Du Bois, *The Souls of Black Folk*, 139.

37. Jonathan Kozol, *Amazing Grace: The Lives of Children and the Conscience of a Nation* (New York: Crown, 1995), jacket.

"You Can't Blow Out a Fire": The South African Freedom Movement

We fast forward now some forty years and to another continent. In 1980, the British pop artist Peter Gabriel recorded a spare but extraordinarily powerful song entitled "Biko"[38] in honor of Stephen Biko, the student leader and anti-apartheid activist who was tortured and killed while in police custody in Soweto, South Africa. Few songs in my experience have the capacity to generate more spirited dialogue in the classroom than this one, especially when the lyrics are studied in conjunction with historical material on Biko and the South African freedom struggle, and video of live performances of the song, available via the internet. The effect of Gabriel's spare poetic mastery is chilling: while the world turns, "Port Elizabeth weather fine," innumerable people are being crushed by injustice, people like Biko, unknown and unsung, in hidden places everywhere.

If my students' reactions are any indicator, the song resonates as much today as it did thirty years ago, rebelling against a world that divides itself in "black and white," where torture is "business as usual," a sad but necessary adaptation to the War on Terror—in the way cockroaches, for example, adapt to new toxins in the environment—and where far too many children imagine their future in "only one color dead." Yet in the context of such a world—our world—the artist galvanizes resistance, and turns the responsive community toward another possible dawn, the birth of new hope. As the song closes, Peter Gabriel seems to suggest that the powerful who traffic in death cannot and will not have the final say, once their crimes are exposed and hope is ignited in the awakened community: "And the eyes of the world are watching now, watching now."

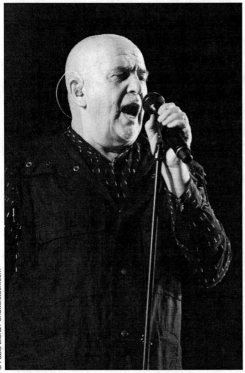

© Fabio Diena / Shutterstock.com

Peter Gabriel

38. Peter Gabriel, "Biko," *Peter Gabriel 3: Melt*, Geffen Records, 1980.

But there is more. For every invocation of Biko's name in the song, every cry of lament—*the man is dead, the man is dead*—there is another cry, *Yihla Moja, Yihla Moja*, which means, "Come Spirit, Come Spirit." In other words: the man is dead, the man is *not dead*, the man is dead, the man is *not dead*. Here the cry of protest, the act of naming and calling forth the dead, transforms into the cry of resurrection hope, the conviction that death is not the final word for Stephen Biko or any person unjustly cut down in history. Why? Because—so say the prophets and poets and saints—God's desire that we should have life and celebrate life abundantly is more powerful, more "present" even, than the waves of senseless violence and death in which our history is plunged. For Christians, the specter of violent death brings us straight back to the empty tomb and the body that "is not there." The candle has been blown out. Where has the fire gone? The Gospel dares us to believe—just as Peter Gabriel dares us to believe— that despite appearances, good is not consumed by evil. A good life, a life lived humanely, "is infinitely greater than its dying." And "that what was very good is eternally good and stands as a witness to God's creation of a good world."[39] The divine fire within Jesus of Nazareth, within Stephen Biko, has not been "disappeared." It now burns in us.

During a concert in 1986 marking the end of a worldwide Amnesty International Tour dedicated to ending apartheid, Peter Gabriel led a crowd of over a hundred thousand people from all over the globe in singing "Biko."[40] The moment, I suggest, was not only artistically electrifying, it was *liturgically efficacious* in almost every sense of the phrase. As the kick-drum pulsed relentlessly like a heartbeat and bagpipes pierced the air in a searing lament, the artist stood onstage like a priest gathering and raising the prayers of the people, all invoking a living presence, a single man, a cloud of witnesses. As Gabriel left the stage he proclaimed to the wondrously mosaic congregation, still singing and waving banners, "The rest is up to you! The rest is up to you!" Less than ten years later, under enormous internal pressures and with protests rising from every corner of the planet, apartheid was formally dismantled and free elections were held in South Africa.

"In the Wind We Hear Their Laughter": Flesh Memory and the Power of Mother Love

"Mothers of the Disappeared" is the eleventh and final track on Irish rock band U2's 1987 album *The Joshua Tree*. Inspired by lead singer Bono's experiences in Nicaragua and El Salvador in July 1986 during a period of brutal civil war devastating both of those countries, the song has been variously described as a deeply

39. Raphael, *The Female Face of God in Auschwitz*, 131.

40. Available at *https://www.youtube.com/watch?v=oFHiHZPaUxg*.

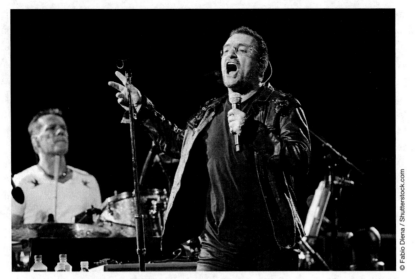

Lead singer Bono and drummer Larry Mullen Jr. of U2

"moving tribute," a "hymn to human rights," and "a simple, plaintive lament of stunning beauty and sadness."[41]

> Midnight, our sons and daughters / Were cut down and taken from us.
>
> Hear their heartbeat / We hear their heartbeat.
>
> In the wind we hear their laughter / In the rain we see their tears.
>
> Hear their heartbeat, we hear their heartbeat.

Lennox Samuels of *The Dallas Morning News* notes "an ineffable sadness in Bono's vocals, painting landscapes where 'Night hangs like a prisoner / Stretched over black and blue.'" And yet "despite the intrinsic pain" of the song, he adds, "it remains eerily cleansing. Even in the midst of decay and excess and horror, Bono can find hope and absolution."[42]

Musically and thematically, I can think of no better word for the song than *haunting*. The percussive, drone-like effect of Larry Mullen's heavily processed drum-beat—a sound that bassist Adam Clayton called "eerie and foreign and scary"[43]—draws the listener into a kind of dream-like consciousness between wakefulness and sleep, stirring memory, awakening conscience. As the track opens with the distorted percussive sounds of rain hitting a roof, entering the

41. Lennox Samuels, "U2's Latest LP: Variation on a Theme," *The Dallas Morning News*, April 5, 1987; *Don McLeese,* "'Joshua Tree' Marks Year of U2," *Chicago Sun-Times*, March 8, 1987; Adrian Thrills, "Cactus World View," *New Musical Express*, March 14, 1987.

42. Samuels, "U2's Latest LP: Variation on a Theme."

43. Colm O'Hare, "The Secret History of 'The Joshua Tree,'" *Hot Press* 31, no. 23, November 28, 2007.

eardrum as if from a distance, the listener perceives that this will be a different kind of journey than we've undertaken in the previous ten songs on the album. Centered around a mantra-like melody in the key of A, doubled by the Edge's hypnotic guitar, the arrangement washes over us like a funeral lament; Bono's lyrics, sifted through the unutterable grief of Las Madres de los Desaparecidos, invite us into the presence of the dead. "In the wind we hear their laughter / In the rain we see their tears / Hear their heartbeat, we hear their heartbeat." Note the witness—*we* hear their heartbeat—and at once the implicit command—*hear* their heartbeat, as if to say, *Can you not feel the presence of the dead?*

During a live televised performance of the song in Chile in 1998, the band brought Las Madres onto the stage with them, each mother bearing a photograph of their "disappeared" relatives, and Bono made a plea directly to Chilean President Augusto Pinochet. Bono would later recall the moment in what can only be described as both *mystical* and *political* terms: "[To be able to say,] 'Give the dead back to the living. Please, General Pinochet, tell these women where the bones of their sons and daughters are.' That was an extraordinary moment . . . certainly in my life and U2's."[44] I want to suggest that U2, in a very real though ineffable sense, had already reclaimed the dead and given them "back to the living" through the performative liturgy of the song, just as Peter Gabriel has called Stephen Biko into the realm of the living with every performance of "Biko," and Billie Holiday had, as it were, taken the lynched bodies down from their killing trees in every daring performance of "Strange Fruit."

During Catholic liturgies today in El Salvador, it is common practice that after every name spoken in the litany of murdered and disappeared human beings, the assembly shouts out, "*Presente!*" Why? To the degree that the dead are kept alive in communal ritual and prayer—a highly selective practice—their presence "haunts" the living, calling us to account for what we have done and what we have failed to do. "Hear their heartbeats / We hear their heartbeats." Adam Clayton describes Bono's vocals in "Mothers of the Disappeared" as "prehistoric," saying the song "connects with something very primitive."[45] What is that something? I suggest this: it is the intuition, across time and culture, that the dead accompany history not only as our guides and companions, but as our judges. Their tears, the rain, beats down on the roofs of our houses. Their naked bodies populate the trees. It is their silent presence that judges us.

In the opening pages of his extraordinary slave narrative, Frederick Douglass details faint memories of his mother coming to hold him in the middle of

44. Adora Mills, "Exclusive Interview with Bono," 99X Atlanta, May 8, 1998. The cause of the Mothers of the Plaza de Mayo was also immortalized by British pop artist Sting in the song "They Dance Alone." The Mothers appeared onstage with Sting in Buenos Aires in 1988, and years later with U2; in both cases their missing relatives' photographs were projected on large screens before the audience, and their names invoked in a kind of litany, one by one, as the artist and audience together sang the song. Video of these events, extraordinary moments of global solidarity through music, is readily accessible via YouTube.

45. Neil McCormick, ed., *U2 by U2* (London: HarperCollins, 2006), 184.

the night when he was a small child, at great risk to her safety. Separated from him as an infant and sold to a plantation twelve miles away, she risked a severe whipping for "not being in the field at sunrise." Still, she came.

> I do not recollect of ever seeing my mother by the light of day. She was with me in the night. She would lie down with me, and get me to sleep, but long before I waked she was gone. Very little communication ever took place between us. Death soon ended what little we could have while she lived, and with it, her hardships and suffering.[46]

Just seven years old when his mother grew gravely ill, Douglass was forbidden to visit her, and "received the tidings of her death with much the same emotions I should have probably felt at the death of a stranger." Nevertheless the memory of those nocturnal visits remained burned into his consciousness, his mother's love imprinted on his very flesh.

It is telling that Douglass opens his slave narrative with this account. Flesh memory, like love itself, moves in two directions, from giver to receiver and back again, across bounds of time and eternity. His mother's resolve, the flame of her dignity, continued to burn in him. A woman "disappeared" by all reasonable accounts, an anonymous Nothing to the history books, she is *Presente!* (Why do you seek the living among the dead? She is not "there," she is here.) Like all the disappeared of history, it is her silent presence between the lines of Douglass's narrative, her removal from what we reductively call "history," which judges us and every generation.[47]

Likewise the particular beauty and fierce witness of the Mothers of the Disappeared precisely *as mothers* cannot be denied or ignored, not least by the powers of the world. Their memory is a subversive memory, a flesh memory embedded in breast, bone, and womb, a whole-bodied connection to their loved ones that no general or torture chamber could ever steal away.[48] The Mothers

46. Frederick Douglass, "The Narrative of the Life of Frederick Douglass, an American Slave," in *My Soul Has Grown Deep: Classics of Early African-American Literature*, ed. John Edgar Wideman (Philadelphia: Running Press, 2001), 440.

47. Recall from chapter 3 that for the artistic sensibility—no less than for the prophetic—the sense of "presence" must always, and often in the same breath, contend with *absence*, with not-seeing, with longing and uncertainty, with death. In the way that music gains definition and resonance from the contrast between sound and silence, so the arts intensify the coinherence of presence and absence, "for in an absent world, the presences are all the more vital." See Andrew Rumsey, "Through Poetry: Particularity and the Call to Attention," in *Beholding the Glory: Incarnation through the Arts*, ed. Jeremie Begbie (Grand Rapids: Baker Academic, 2001), 55.

48. For the term "flesh memory" I am indebted to J. K. Rowling, British author of the Harry Potter series. The theme of motherly and grandmotherly love—embodied, fleshly, eternal—resounds throughout the poetry of Maya Angelou. One of soul singer Bill Withers's most beloved songs is called "Grandma's Hands." His live performance of the song at Carnegie Hall in October 1972 is a poignant testimony to familial love that transcends death and bodily separation. Bill Withers, *Live at Carnegie Hall*, Sussex, 1973.

are "a symbol of courage, of female courage," says the British artist Sting. "And they symbolize the search for truth, and the necessity of justice."[49]

In 2005 Amnesty International cited "Mothers of the Disappeared" as one of its reasons for honoring U2 with its Ambassador of Conscience Award. Steve Pond of *Rolling Stone* might have put it best when he noted that while the song is "built around desolate images of loss," its "setting is soothing and restorative—music of great sadness but also of unutterable compassion, acceptance and calm."[50] Bono himself described "Mothers of the Disappeared" as "a beautiful end" to *The Joshua Tree*, saying, "That song means as much to me as any of the songs on that album, it's right up there for me."[51] In part what is "soothing and restorative" about the song is precisely its daring to give voice to those "unutterable" realms of human experience that lie beyond empirical or rational control. In this respect U2 owes much to producers Brian Eno and Daniel Lanois. Renowned pioneers of "ambient music" and brilliant composers in their own right, Eno and Lanois brought to the recording of *The Joshua Tree* and to "Mothers of the Disappeared" in particular an otherworldly sound, an ambient fluidity that seems to immerse the listener in those liminal states of perception between sleep and wakefulness, memory and hope, dying and living.

Understandably, the music critics tend to run out of language here, opting for emotive terms like "restorative" and "moving," or more flatly descriptive phrases, such as "hymn to human rights." In liner notes to the album's twentieth-anniversary edition, Bono gestures to something more, just as he did on stage in Chile:

> I remember [Daniel Lanois], when we were finishing "Mothers of the Disappeared," losing his mind and performing at the mixing desk like he was Mozart at the piano, head blown back in an imaginary breeze, and it was pouring down with rain outside the studio and I was singing about . . . the tears of those who have been disappeared. And when you listen to that mix you can actually hear the rain outside. It was magical really.[52]

And so just as the panoramic whole of Pink Floyd's *The Dark Side of the Moon* owes much to studio engineer Alan Parsons (chapter 2), the beauty and enduring success of U2's *The Joshua Tree* owes much of its "eerily cleansing" magic to Brian Eno and Daniel Lanois. Even "in the midst of decay and excess and horror," the album ends on a breathtaking note of "hope and absolution."[53] Whether

49. Sting, in an incredibly moving video tribute describing the inspiration for his song, "They Dance Alone," live at Amnesty International, 1990, at *https://www.youtube.com/watch?v=5h4d-vB6NzI*.

50. Steve Pond, "Review: The Joshua Tree," *Rolling Stone* 497, April 9, 1987.

51. McCormick, ed., *U2 by U2*, 184.

52. U2, liner notes for *The Joshua Tree: 20th Anniversary Edition*, Island Records, 2007.

53. Samuels, "U2's Latest LP: Variation on a Theme."

such a hope sings true is a matter for each listener alone to decide, a wager tested against the deepest contours of one's own memory and experience.[54]

"The Angel of History": The Historical Mysticism of Walter Benjamin

Throughout this chapter I have emphasized a dimension of art as "dangerous memory" and the artist as bearer of unexpected hope, implicitly a theological hope, rooted in a hidden power and grace beyond our comprehension. Moreover, art that reclaims a shattered past paradoxically and simultaneously projects our imaginations into the future, toward that elusive Someday, as Du Bois intimates, when "the Awakening will come."

The memory of suffering within the African American community, for example, was exactly the reason why Martin Luther King Jr. insisted that blacks, indeed America, could not wait for justice any longer. "We have waited for more than 340 years for our constitutional and God-given rights."[55] King's community, the "we" of his imagination, is clearly a community of both the living and the dead: "Three hundred years of humiliation, abuse and deprivation cannot be expected to find voice in a whisper."[56] Indeed the electrifying, sometimes confrontational use of language by King and other black thinkers (witness Malcolm X) illustrates the dangerous, volatile, and politically transforming character of this particular cloud of witnesses. Put simply, the mystical cloud of the dead may not always represent a benevolent presence, a festival of friends. As cultural anthropologist John Mbiti observes of African religion, the dead "can be troublesome"; "they are wanted and not-wanted"; they are respected, in part, out of fear.[57]

54. For another deeply moving take on the song, from a mother who has experienced reproductive loss, see Lisa Zeitlinger, "Like a Song: Mothers of the Disappeared," *@U2*, June 13, 2009, *https://www.atu2.com/news/like-a-song-mothers-of-the-disappeared.html*.

55. Martin Luther King Jr., "Letter from Birmingham City Jail," in *A Testament of Hope*, 292.

56. Martin Luther King Jr., *Why We Can't Wait*, cited in *A Testament of Hope*, 519.

57. Citations from Robert E. Hood, *Must God Remain Greek? Afro Cultures and God-Talk* (Minneapolis: Fortress, 1990), 221. The veneration of ancestors in African religion should not be confused with worship and adoration, although, to be sure, "the line between popular piety and veneration of the ancestors is very thin." Clearly there is a strong resonance here with Christian piety surrounding the communion of saints—what Heb. 12:1 calls the "cloud of witnesses"—and it is not too surprising to find a rich blending of these thought-forms in the slave religion of the New World. In both belief systems "a bond of solidarity has been established between the living and the dead" (Hood, *Must God Remain Greek?*, 231). Indeed the Catholic Church at the Second Vatican Council (1965) professed a striking vision of "the pilgrim church" walking in unity with all "the brothers and sisters who sleep in the peace of Christ." Death in no way interrupts the communion experienced between earthly "wayfarers" and those who have died, "but on the contrary, according to the constant faith of the church, this union is reinforced by an exchange of spiritual goods." Whether pilgrims on Earth or in heaven, all "share in the same love of God and our neighbor, and we all sing the same hymn of glory to our God." See *Lumen gentium*, no. 49, in *Vatican Council II: Constitutions, Decrees, Declarations*, ed. Austin Flannery (New York: Costello, 1996).

To say it another way, borrowing from Catholic theologian Johann Baptist Metz, the fire that burns in the heart of social resistance movements and much of the art that rises from them is both mystical and political: "mystical, because it does not give up its interest in the salvation of past, unreconciled suffering; political, because it is precisely this interest in universal justice that continually commits it to justice among the living."[58] Moreover, in the context of a global-ized technical-economic milieu "ever more devoid of history and memory," the act of remembering the vanquished can "break the spell of the dominant con-sciousness" in a "redemptively dangerous way."[59] To suggest that the dead remain here with us is dangerous *politically* precisely because it thwarts every earthly power that would build its hope—an idolatrous hope—on the "disappearing" of all opposition. Bono was not indulging in hyperbole when he said of Las Madres that the ruling political classes in Chile, Argentina, and El Salvador are "afraid of these women."[60]

Earlier we recalled David Tracy's notion of the classic as any person, event, text, or work of art that "confronts and provokes us in our present horizon with the feeling that 'something else might be the case.'"[61] Not far from Tracy's line of thought—indeed a pivotal source for both Tracy and Metz in thinking about how classic narratives, texts, or works of art can disrupt the dominant consciousness—is the thought of Jewish philosopher Walter Benjamin. A bril-liant thinker most often associated with the Frankfurt School of philosophy in Germany prior to World War II, an enigmatic cultural critic who took his own life rather than be taken by the Nazis, Walter Benjamin has come to represent in twentieth-century intellectual history what George Steiner calls "the incon-ceivable load of a world made ash, of a civilization annihilated, of a bestiality and injustice forever irreparable, totally irreparable."[62] It is Benjamin who famously observed that the histories and cultures of conquered peoples become the spoils of the victorious ("History is written by the victors").[63] To which he adds this

58. Johann Baptist Metz, *A Passion for God: The Mystical-Political Dimension of Christianity*, trans. J. Matthew Ashley (New York: Paulist Press, 1998), 162.

59. Johann Baptist Metz, *Faith in History and Society: Toward a Practical Fundamental Theology*, ed. and trans. J. Matthew Ashley (New York: Crossroad, 2007), 182–85.

60. In recent performances, during the band's 2017 *The Joshua Tree* anniversary tour, Bono has added, "The government should fear its citizens, not the other way around." See Steve Baltin, "U2 Turn 'The Joshua Tree' into a Stirring Wake-Up Call for 2017," *Forbes*, May 22, 2017, https://www.forbes.com/sites/stevebaltin/2017/05/22/u2-turn-the-joshua-tree-into-a-stirring-wake-up-call-for-2017/#3324ca727d22.

61. David Tracy, *The Analogical Imagination: Christian Theology and the Culture of Pluralism* (New York: Crossroad, 1998), 115.

62. George Steiner, "To Speak of Walter Benjamin," in *Benjamin Studies: Perception and Experi-ence in Modernity* (Amsterdam: Rodopi, 2002), 23.

63. Christopher Carrico, "A Struggle on Two Fronts," *Stabroek News*, September 2, 2010, *http://www.stabroeknews.com/2010/features/09/02/history-this-weeka-struggle-on-two-fronts-against-reactionaries-and-against-imperialists/*.

disturbing corollary: "There is no document of civilization which is not at the same time a document of barbarism."[64] Such a pointed critique of the "dialectic of history" (see chapter 2) is not original to Benjamin, as Steiner notes: "We find it in the radical remembrances who are the Prophets in Israel. It is in every line of the book of Amos. . . . But Benjamin gives it . . . a singular intensity and urgency and dignity."[65] As emphasized throughout this book, the artist and prophet walk on common, holy ground in their attempts "to rescue from oblivion the oppressed, the enslaved, the victims of successful injustice, to bring them back to protesting life out of the strategic amnesia imposed by the history-writing of the victors."[66]

In one of his most influential texts, "Theses on the Philosophy of History," Benjamin contemplates a painting by Paul Klee that some years earlier had come into his possession.

A Klee painting named *Angelus Novus* shows an angel looking as though he is about to move away from something he is fixedly contemplating. His eyes are staring, his mouth hangs open, his wings are spread. This is how the angel of history must look. His face is turned toward the past. Where we perceive a chain of events, he sees one catastrophe, which keeps piling wreckage upon wreckage hurling it before his feet. The angel would like to stay, awaken the dead, and make whole what has been smashed. But a storm is blowing from Paradise; it has got caught in his wings with such violence the angel can no longer close them. This storm irresistibly propels him into the future

Angelus Novus, Paul Klee, 1920

© The Israel Museum, Jerusalem, Israel / Carole and Ronald Lauder, New York / Bridgeman Images

64. Walter Benjamin, "Theses on the Philosophy of History," in *Illuminations* (New York: Harcourt Brace Jovanovich, 1968), 256.

65. Steiner, "To Speak of Walter Benjamin," 22.

66. Steiner, "To Speak of Walter Benjamin," 22.

to which his back is turned, while the pile of debris before him grows skyward. This storm is what we call progress.[67]

We can imagine Benjamin seated in his study in a kind of meditative trance, gazing on the Klee painting over his desk. It is the spring of 1940. Just months from now he will be dead. But presently he gazes on the painting and beholds in Klee's angel a rather horrifying witness to history's "wreckage upon wreckage" piling up with no conceivable end in sight. The angel "would like to stay"—God would like to intervene—"his eyes are staring, his mouth hangs open"—yet the storm of human "progress" blows him helplessly into the future.

It is not hard to surmise that Benjamin saw *himself* in the "pile of debris" growing skyward, "just another Jew" in the trash heap of history. Whether he could also see, from the quiet contemplation of his study, the horror of six million more Jews yet to be "smashed" is impossible to say. But in Klee's *Angelus Novus*, we may ask, did Benjamin see the full truth? Is God rendered powerless before the ravages of human history? And if so, who will "awaken the dead, and make whole what has been smashed"? Returning to America just one year earlier, 1939, we can reasonably surmise that Billie Holiday saw something of herself, her ancestors, her children, in those "black bodies hanging in the southern breeze."[68]

If empathy is our capacity to enter into the life-world of another, than surely empathy includes our capacity to enter into the death-throes of another. (Thus the slaves sang, in fear and trembling, "Were you there when they crucified my Lord?") To the degree that we are able and willing to extend our imagination into Benjamin's life-world at the threshold of death, perhaps we, too, may see ourselves in history's growing pile of discarded refuse, no more than fragments of dust; and see God, to the degree we think of God at all, gazing down upon us, blown back powerlessly into the distant heavens. Is this all there is? Are these the stark limits to what we may hope?

But here the Christian imagination, shaped by the narrative of the gospel, beholds in Klee's angel of history another possibility: *Christ*, Son of Man and Son of God, whose wings have not gotten caught in the storm, but who enters fully without reserve into our human condition, a God who does not stand apart but who takes the part of humanity. Jesus of Nazareth, the God-man who walked the earth, is "able to stay, awaken the dead, and make whole what has been smashed."

Benjamin, too, seems to invoke such a hope, the dawning of Messianic time, against all empirical evidence to the contrary. In his "Theses" he wrote, "History is the subject of a structure whose site is not homogenous, empty time, but

67. Benjamin, "Theses on the Philosophy of History," 257–58.

68. "Art does not reproduce the visible; rather, it makes visible," observed Paul Klee, an insight darkly fitting to Meeropol's writing and Holiday's performance of "Strange Fruit."

time filled by the presence of the now."[69] To return where we began, picture the companions of Jesus gathered in fear and wonder at his empty tomb, or yourself, lingering silently at the graveside of a beloved friend. Benjamin seems to say, Quiet yourself, look deeply into the "presence of the now," and you will see both the ruins of a shattered past and at once the arrival of a redeemed future, a broken world somehow made whole. The future, after all, is not merely empty time, a receding void into which God is helplessly thrown. It is, says Benjamin, "the strait gate through which the Messiah might enter."[70]

As philosopher George Steiner and other students of Benjamin have noted, the vision of history in the "Theses" is ultimately theological, or more precisely, Benjamin is working both "within and against the grain of theology,"[71] as I think the best of protest art often does. Above all, Benjamin's mystical-prophetic sensibilities are rooted in "the explicit doctrine of what we call in Hebrew *'tikkun olam,'* which means roughly, 'the reparation,' 'the making good,' 'the rescuing to make good of what is left of this smashed world.'"[72] This fragmental, antisystematic vision of a world potentially redeemed in God stakes its ground in what William Blake called "the holiness of the minute particular." As Steiner puts it, Benjamin knows that "God lies in the detail, and that God's immensity lies in the detail, both."[73] Anticipating postmodern discourses, Benjamin's hyperrealism has little patience for "grand narratives," still less, clean, victorious endings in which death's sting is pacified, its contradictions smoothed over. Rather God's presence (or God's "present past," as Steiner has it) must be surfaced from the fragments by a kind of "calling forth," or "summons."[74]

"To articulate the past historically," writes Benjamin, "does not mean to recognize it 'the way it really was.' It means to seize hold of a memory as it flashes up at a moment of danger."

When we allow the ruins of the past to "flash up" into our consciousness in the present—"Strange fruit hanging from the poplar trees"; "September '77,

69. Benjamin, "Theses on the Philosophy of History," 261.

70. Benjamin, "Theses on the Philosophy of History," 264.

71. Steiner, "To Speak of Walter Benjamin," 19.

72. Steiner, "To Speak of Walter Benjamin," 22.

73. Steiner, "To Speak of Walter Benjamin," 21. This is to carry over the principle of "montage," as Benjamin describes it—or the notion of *bricolage*, from Claude Levi-Strauss, to "shape the beautiful and useful out of the dump heap of human life"—not only into history but *into theology*, "to discover in the analysis of the small individual moments the crystal of the total event." See Margaret Cohen, "Benjamin's Phantasmagoria: The *Arcades Project*," in *The Cambridge Companion to Walter Benjamin*, ed. David S. Ferris (Cambridge: Cambridge University, 2004): 202–3. The mystical-theological horizon of Benjamin's work, even in its inescapable tragedy and sadness, stands in some contrast to the devastating poetry and protest atheism of Romanian-born poet Paul Celan, in whose poems the desolation of the Holocaust in every "minute particular" takes center stage without hint of messianic hope.

74. Steiner, "To Speak of Walter Benjamin," 21.

Port Elizabeth weather fine"; "They have taken the Lord from the tomb, and we don't know where they put him" (John 20:2)—such memory-images interrupt our assumptions about reality, provoking insight into what might have been and opening up unforeseen possibilities for what might still be.[75] In other words, such images generate hope. "In the wind we hear their laughter / In the rain we see their tears / Hear their heartbeat, we hear their heartbeat."

When Jesus says, "Do this in remembrance of me," and we who are his companions share the broken bread around the table (his broken body), and drink together from the cup of wine (his spilt blood), perhaps we really are granted a foretaste of a hidden glory that is yet to come. The Messiah is the angel of history who is not a disembodied spirit but a flesh-and-blood human being, whose presence calms the storms wreaking havoc in Paradise, and whose mercy ensures that the living will not be found among the dead. "Hear their heartbeats. We hear their heartbeats."

"I Can Only Dream in Red": The Claim upon Us of Others' Suffering

In the afterword that concludes *The Souls of Black Folk*, the reader is astonished to discover that Du Bois has been directing his impassioned arguments not only to his human readers, but to God, the "divine reader of human hearts." "Here my cry, O God the Reader, vouchsafe that this my book fall not still-born into the world-wilderness."[76] Thus the whole of *The Souls of Black Folk* is revealed on its last page to be a kind of sustained prayer or examination of consciousness, intensely personal and at once communal, from the praying heart of its author. That is how I would describe Walter Benjamin's work, and indeed, my own. Much as Du Bois suggests that we pass our days in a kind of collective cultural "sleep," Benjamin highlights the disruptive power of historical and cultural fragments, the reassembling of the "ruins" of a shattered past to awaken us from our collective slumber. Likewise Metz locates the mystical-political power of Christianity's central story—the dangerous memory of Jesus' death and Resurrection—in its capacity to break the spell of the ruling consciousness. "The shortest definition of religion," says Metz, is "interruption." The very same need to awaken and interrupt lay at the heart of great protest art.

75. Benjamin's notion of the "dialectical image" refers to marginalized or discarded images ("ruins" or "fragments") from the past that, when suddenly interjected into the present, shock our assumptions about reality, awakening new possibilities of political agency for what might still be. See Max Pensky, "Method and Time: Benjamin's Dialectical Images," in *The Cambridge Companion to Walter Benjamin*, ed. Ferris, 177–98. Each of the protest songs explored in this chapter, we might say, masterfully employs such dialectical images.

76. Du Bois, *The Souls of Black Folk*, 165.

Without question my interpretation of these three songs—and of Benjamin's "angel of history"—is shaped by my own formation in the climate of Catholic liturgy, above all the passage each year through Holy Week, when the story of Jesus' crucifixion is reenacted by the community. As enacted remembrance the story functions as a "dangerous memory" in multivalent ways. At one level, the remembrance of Jesus' death confronts the whole church, from the youngest child to the elders and ordained, with their own complicity in social sin and state-sanctioned violence. It is the assembly, after all, which takes on the role of the mob, shouting, "Crucify him!" at the moment Pilate is prepared to set Jesus free. At another level, the story proclaims God's radical forgiveness, in and through Jesus, for "what we have done and what we have failed to do."[77] Thus the realization of one's own complicity in the world's sin is crowned by reassurances of God's mercy and the miracle of bringing life forth from death. In the revelation of love that is Jesus, it is as if God has placed over our head a crown, which for the rest of our lives we shall "keep trying to grow tall enough to wear."[78] Irrespective of whether or not I deserve it, Jesus embodies God's love and mercy *for me*, and if for me, then for all the world. *Free at last, free at last. Thank God Almighty we're free at last.*

Yet there is another "dangerous" side to this story. Far from eliciting a sense of remorse for one's own complicity in the world's sin and gratitude for God's mercy, the remembrance of Jesus' death can also stir up age-old animosities against "the Jews," whom Christians throughout the centuries have blamed *en masse* for the death of Christ. Why did Jews living in villages across Europe find themselves "on edge" every year during the Christian Holy Week? Why do artistic or film representations of Jesus' death stir up controversy even today?

Historically, Christians stirred up by the narrative of Jesus' passion have accused Jews of "deicide," that is, the murder of God. Thus the terrible irony of a story that, on the one hand, proclaims liberation from the "wages of sin" and the "sting" of death and, on the other, has incited scapegoating violence and even genocide against the very Jewish people from whom Jesus sprang.[79] History has taught Christians a painful lesson, too often forgotten, which Jews are frequently at pains to remind them. The remembrance of Jesus' death immerses believers in the emotionally charged and sometimes *pathologically dangerous* power of artistic participation. The words put into the mouths of "the Jews"

77. The phrase is drawn from the Penitential Rite of the Catholic Mass, when all in the assembly publicly confess their sins and ask forgiveness, from God and from the community, "for what [they] have done and what [they] have failed to do."

78. Howard Thurman, *Jesus and the Disinherited* (1949; repr., Boston: Beacon, 1976), 96.

79. The classic Christian study is Rosemary Radford Ruether, *Faith and Fratricide: The Theological Roots of Anti-Semitism* (New York: Seabury, 1974); and more recently from the Jewish perspective, Susannah Heschel, *The Aryan Jesus: Christian Theologians and the Bible in Nazi Germany* (Princeton: Princeton University Press, 2010).

in Matthew's Gospel—"His blood be upon us and upon our children" (Matt. 27:25)—both hide and reveal a history of virulent Christian anti-Semitism.[80]

Do such unsettling truths invalidate the potentially liberating power of performative texts such as "Were You There When They Crucified My Lord?" and "Strange Fruit," to say nothing of the crucifixion narratives in the Gospels? There is always the grave danger that communities will wield the memory of their own suffering and historical trauma as a weapon to justify hatred and erasure of the other. To recall my student's response to "Strange Fruit," the memory of suffering "is a double-edged sword, because it can lead to remembering with vengeance, instead of remembering with hope." So much depends on the intentionality and meaning we ascribe to such texts! And so much depends on the disposition of the listener!

The key point, it seems to me, is this: To listen compassionately, through the ears of the heart, is to recognize that our suffering is woven into the very same cloth as the suffering *of others*, even, if not especially, the perceived enemy; more difficult and no less essential is to recognize our own complicity in that suffering. For those in a position of social power, it is to ask: What have we done and what have we failed to do to make our world a more humane and just place for the most vulnerable members of society, those structured out of the common good? It is these least of our brothers and sisters, suggests the Gospel, with whom Christ most identifies (Matt. 25:31–46).

While it seems inevitable that every "tribe" remembers its own suffering first, it is also clear that when we open our hearts to other peoples' sacred stories of suffering and liberation, we can recognize in them, if sometimes with a shock, our common humanity. Although Jesus of Nazareth, a Jew living in Palestine under Roman occupation, died two thousand years ago and half a world away, we all bleed the same color red. It is not too surprising, yet it is no small miracle, that Africans torn from their homeland and brought horrifically through the Middle Passage would recognize in Jesus' scourging and death a prefiguring of their own plight at the hands of the slave master; nor that slaves would find in the story of the Exodus and God's liberation of the Hebrews from slavery under Pharaoh a figure of their own suffering and yearning for freedom. These were the subversive stories that became the slaves' "Bible *within* the Bible,"[81] giving many courage to resist and even to attempt the escape from slavery at

80. It is no exaggeration that anti-Semitism is woven into the fabric of Christian scripture and liturgy from the beginning. This fact was probably not lost on Barney Josephson, the Jewish owner of the Café Society, who wanted his patrons (predominantly white Christians, we may presume) to "get their insides burned" in the hearing of "Strange Fruit." For a lucid analysis of both the promises and limitations of the arts as theological text and revelatory word, see Richard Viladesau, *Theology and the Arts: Encountering God through Music, Art and Rhetoric* (Mahwah, NJ: Paulist Press, 2000), 123–64.

81. Rev. Alonzo Johnson, in "The Ringshout & the Birth of African-American Religion," in *This Far by Faith: African-American Spiritual Journeys*, part 1, "There Is a River," (PBS Video: Blackside, 2003), *https://www.youtube.com/watch?v=KmmTMg3e5Uo.*

their grave peril. Behold, the Bible proclaims, we never walk through "the valley of the shadow of death" alone (Ps. 23). We walk with a God who walks beside us in our suffering and who says to Pharaoh—and finally to Death itself—"Let my people go." Engaging the sacred narratives and art forms of another people can forge an unexpected solidarity across social boundaries and a profound cross-cultural empathy.[82]

"From That Day On They Planned to Kill Him": The Subversive Power of Resurrection Faith

Here the potentially liberating power of the Resurrection stories in the Christian Gospel come into full relief. As Catholic worker Fumi Tosu observes, "Oppressive governments the world over depend ultimately on the threat of death to subjugate their people. To maintain control over its vast territory, tax its people, and extract wealth, the Roman Empire relied on torture, imprisonment, and the death penalty." Thus when Jesus raised his friend Lazarus from the dead, he was effectively upending "an imperial order predicated on the power of death."[83] From that moment forward he was marked as an enemy of the state. Why? Because the leaders of oppressive governments, yesterday and today, recognize "that a people no longer afraid of death is a people who will no longer be docile in the face of oppression."[84] What was true for Jesus of Nazareth in Palestine two thousand years ago, was also true for Steven Biko in South Africa forty years ago, and has been true for many others who have lost their lives in the cause of justice. When a person is able to spark from within the transcendent dignity of an oppressed people, to renew their hopes for freedom over against the reigning powers of death, it is "from that day on, they planned to kill him" (John 11:53).

When Martin Luther King Jr. delivered what would be his final public speech in a crowded church in Memphis on the night of April 3, 1968, he spoke

82. In his remarkable study of the "powers of imagining" at the heart of Ignatian spirituality, Antonio de Nicolas underscores not only the public or political dimension of all human imagining, but also its transcendent (metaphysical) ground or horizon. Imagining always arises "within social and cultural contexts" and always presses, in its successful transmission and reception, toward "social transformation." See Antonio T. de Nicolas, *Powers of Imagining: Ignatius de Loyola* (Albany, NY: State University of New York, 1986), 70–71. As I intimate throughout this book, the powers of imagining to move human beings toward love and justice—the reign of God; Beloved Community—may obtain in and through "secular" art forms no less than explicitly religious or liturgical ones. This is not to baptize all art (or every act of liturgy) as beautiful, revelatory, or sacramentally efficacious, since our imaginings, secular and religious, are always crippled by sin or "concupiscence"; indeed, as an "active" and "synthetic" response to and re-visioning of the human situation, imagining "builds scenarios to be tested and painfully rebuilds them when they prove false" (de Nicolas, *Powers of Imagining*, 70).

83. Fumi Tosu, "Where Life and Freedom Are Found," Rise Up: A Lenten Call to Spirituality, Ignatian Solidarity Network, April 8, 2017, *http://us3.campaign-archive2.com/?u=8e141d38e4bb12b990251e274&id=028a3f7a8b&e=17bf23a691.*

84. Tosu, "Where Life and Freedom Are Found."

with prophetic power of the injustices being felt by the city's sanitation workers. But King went well beyond the political situation that night to speak of his own death, his own mortality. The Rev. Samuel Billy Kyles, listening to King from just a few feet away, recalls, "There had been so many death threats against his life, especially since he had come out against the war in Vietnam. But he talked about death more that night than we'd heard him talk about it in a long while." Kyles says that King "preached himself through the fear of death [that night]. He just got it out of him. He just . . . dealt with it. And we were just standing there. It was like, what did he know that we didn't know?"[85] It was as if King, like the canary in the coal mine (chapter 4), had broken free of the cage at the precise moment of death to speak with an alarming clarity and courage about the state of our situation as a people.

> Well, I don't know what will happen now. We've got some difficult days ahead. But it doesn't matter with me now. Because I've been to the mountaintop. And I don't mind. Like anybody, I would like to live a long life. Longevity has its place. But I'm not concerned about that now. I just want to do God's will. And He's allowed me to go up to the mountain. And I've looked over. And I've seen the Promised Land. I may not get there with you. But I want you to know tonight, that we, as a people, will get to the Promised Land!
>
> And so I'm happy tonight. I'm not worried about anything. I'm not fearing any man! Mine eyes have seen the glory of the coming of the Lord![86]

King ended the speech in a kind of rapture, the assembly lifting him up with shouts of encouragement and thanksgiving as he broke from the podium. Rev. Kyles remembers, "Many of us, grown men, were crying. We didn't know why we were crying. We had no way of knowing that would be the last speech of his life."[87]

What did King know that we don't know? What could he see that we cannot see? And was it his overcoming of the fear of death that finally made him, according to the reigning powers, the "most dangerous Negro" in America?[88]

85. "Remembering MLK's Prophetic 'Mountaintop' Speech," interview with the Rev. Samuel Billy Kyles, NPR, April 3, 2008, *http://www.npr.org/templates/story/story.php?storyId=89326670*.

86. Martin Luther King Jr., "I See the Promised Land," in *A Testament of Hope*, 286. James Washington, the editor of this volume, calls the speech the "most apocalyptic" of all King's sermons (279).

87. "Remembering MLK's Prophetic 'Mountaintop' Speech."

88. In 1963, the FBI dubbed King "the most dangerous and effective Negro leader in the country," and its leaders held a meeting to discuss "a complete analysis of the avenues of approach aimed at neutralizing King as an effective Negro leader." He was subsequently subject to years of harassment and intimidation by the FBI. See Ellen McGirt, "On the Anniversary of Martin Luther King's Assassination, the FBI Gets a History Lesson," *Fortune*, April 5, 2017, *http://fortune.com/2017/04/05/on-the-anniversary-of-martin-luther-kings-assassination-the-fbi-gets-a-history-lesson/*.

Standing in the breach between hope and despair, perhaps King could see what Benjamin could not quite see in Klee's painting: look deeply into the "presence of the now," and you will see not only the ruins of the past but also the beginnings of a broken world made whole. We could call it eternal life, resurrection, or grace. We might call it Beloved Community, the reign of God, the communion of saints, or a sense of consoling presence, tasted here on Earth as it is in heaven. We could call it a commitment to justice, solidarity with the dead, or the dawning of a New Creation. Whatever we call it, however we may imagine it, for my part I do not believe it is something that we can finally earn or merit, a cosmic payoff for a life well-lived. It is simply and gratuitously given, from the depths of divine love and mercy. For authentic love is its own reward, and gives itself away, without consideration of merit.[89]

To return to the protest singer Phil Ochs with whom we began this chapter: there is something more than youthful or "aesthetic rebellion" in Ochs' expressly secular but hard-bought vision of the artist's role in history. There is something of the gospel paradox itself: the faith that seeds of life are hidden even in fields of death. "It is wrong to expect a reward for your struggles," says Ochs. "The reward is the act of struggle itself, not what you win. Even though you can't expect to defeat the absurdity of the world, you must make the attempt. That's morality, that's religion, that's art, that's life."[90] Intuitively the artist understands what faith sometimes forgets: there is no human path to the reign of God save through Jerusalem, no way to Easter save through Good Friday. *Longevity has its place. But I'm not concerned about that now. I just want to do God's will.* Faith, as the witness of Dr. King and so many others bears out, is not an escape from historical risk and responsibility. It is a summons to courage and freedom, an invitation to the joys of love and solidarity, even, if not especially, when the way forward is shrouded in darkness.

Paul Klee died in Switzerland on June 29, 1940. Three months later, on the night of September 25, 1940, Walter Benjamin killed himself with an overdose of morphine tablets. The epitaph on Klee's tombstone, placed there by his son Felix, says,

89. "Behold the miracle! Love has no awareness of merit or demerit; it has no scale by which its portion may be weighed or measured. It does not seek to balance giving and receiving. Love loves; this is its nature. . . . Such an experience is so fundamental that an individual knows that what is happening to him can outlast all things without itself being lost." Howard Thurman, *Disciplines of the Spirit* (Richmond, IN: Friends United Press, 1963), 123.

90. Ochs, *Farewells and Fantasies.* Compare to Thomas Merton's oft-quoted letter in May 1966 to Jim Forest, a young Catholic Worker peace activist, which begins, "Do not depend on the hope of results," and ends with an appeal to Forest's faith that God can and will make a way out of no way: "The real hope, then, is not in something we think we can do, but in God who is making something good out of it in some way we cannot see. If we can do His will, we will be helping in this process. But we will not necessarily know all about it beforehand." Thomas Merton, *The Hidden Ground of Love: Letters*, ed. William H. Shannon (New York: Farrar, Straus and Giroux, 1985), 294–97.

I cannot be grasped in the here and now
For my dwelling place is as much among the dead
As the yet unborn
Slightly closer to the heart of creation than usual
But still not close enough.[91]

For the heart that has known love—the enduring warmth of a father's or mother's embrace; a beloved's gentle touch; a prophet's consoling words on the eve of death—it is not too difficult to see the tears of the beloved in the rainfall, to hear their laughter playing on the wind. The future is not an infinite void into which God is helplessly thrown. It is "the strait gate through which the Messiah might enter."[92] Someday, perhaps even today, the Awakening will come.

Addendum and Additional Resources

The convergence of blackness and femaleness in Billie Holiday's embodiment of "Strange Fruit" highlights the concept of "intersectionality," a term introduced to feminist theory in 1989 by Kimberle' Crenshaw. Intersectionality refers to the ways that various forms of social stratification—class, race, sexual orientation, age, gender, disability—do not exist independently but are interwoven. Forms of oppression experienced by white middle-class women, for example, are different from those experienced by black, poor, or disabled women. To sing "Strange Fruit" as a black female artist—as a woman who knew both sexual and racialized trauma—arguably intensifies the revelatory power of the song in ways well beyond what could be embodied by a white artist. Eventually the concept of intersectionality would be extended beyond the interplay of gender and race to include other forms of social marginalization, such as that experienced by LGBTQ persons. Feminists today argue that an understanding of intersectionality is critical to movements for political and social equality in the United States and around the world.

As in chapter 5, the focus in this chapter on race and ethnicity with respect to social justice movements finds resonance in black and womanist theologies: e.g., James Cone, Bryan Massingale, Delores Williams, Shawn Copeland, Emilie Townes. Also related to our discussion of Las Madres de los Desaparecidos is the emergence of "*mujerista*" theologies, rising from the stories of Hispanic and Latin American women. No less central to the content and spirit of this chapter is the notion of Christian "eschatology," or reflection on the afterlife, heaven, the "last things." Eschatology—of which "apocalypticism" is an important dimension—seeks an answer to the question "For what may we dare to hope?" with respect

91. Susannah Partsch, *Paul Klee: 1879–1940* (Koln: Taschen, 2003), 84.

92. Benjamin, "Theses on the Philosophy of History," 264.

to the afterlife, the end times, the last things. Liberation and political theologies emerging from oppressed populations around the globe ask this question especially from the vantage point of history's victims. Christian faith is eschatological—both mystical and political, as Metz emphasizes—to its very core. In the words of Jesuit theologian Jon Sobrino, "God raised a crucified man, and since then there is hope for the crucified."

Books

Angelou, Maya. *And Still I Rise: A Book of Poems.* London: Virago Press, 1986.

Benjamin, Walter. *Illuminations.* New York: Harcourt Brace Jovanovich, 1968.

Biko, Steve. *I Write What I Like: Selected Writings.* Chicago: University of Chicago, 2002.

Cannon, Katie Geneva, Emilie M. Townes, and Angela D. Sims. *Womanist Theological Ethics: A Reader.* Louisville: Westminster John Knox, 2011.

Isasi-Dias, Ada Maria. *Mujerista Theology: A Theology for the Twenty-First Century.* Maryknoll, NY: Orbis, 1996.

Kozol, Jonathan. *Amazing Grace: The Lives of Children and the Conscience of a Nation.* New York: Crown, 1995.

Margolick, David. *Strange Fruit: Billie Holiday, Café Society, and an Early Cry for Civil Rights.* Philadelphia: Running Press, 2000.

Metz, Johann Baptist. *A Passion for God: The Mystical-Political Dimension of Christianity.* Translated by J. Matthew Ashley. Mahwah, NJ: Paulist Press, 1998.

Sobrino, Jon. *No Salvation Outside the Poor: Prophetic-Utopian Essays.* Maryknoll, NY: Orbis, 2008.

Articles and Essays

Downey, John K. "Risking Memory: Political Theology as Interruption." In *Love's Strategy: The Political Theology of Johann Baptist Metz,* edited by John K. Downey, 1–10. Harrisburg, PA: Trinity, 1999.

King, Martin Luther, Jr. "I See the Promised Land." In *A Testament of Hope: The Essential Writings and Speeches of Martin Luther King, Jr.,* 279–86. New York: HarperCollins, 1986.

———. "Letter from Birmingham City Jail." In *A Testament of Hope: The Essential Writings and Speeches of Martin Luther King, Jr.,* 289–302. New York: HarperCollins, 1986.

Pramuk, Christopher. "Apocalypticism in a Catholic Key: Lessons from Thomas Merton." *Horizons* 36, no. 2 (2009): 235–64.

———. "'Strange Fruit': Black Suffering/White Revelation." *Theological Studies* 67 (June 2006): 345–77.

Music, Audio, and Visual

BlacKkKlansman. Directed by Spike Lee. Blumhouse Productions, 2018.

Carter, Joe. "The Spirituals." Interview with Krista Tippett. *On Being*. NPR. August 9, 2018. First recorded 2003. *Https://onbeing.org/programs/joe -carter-the-spirituals-aug2018/*.

Gabriel, Peter. "Biko: Live 1986." Performance at Amnesty International Conspiracy of Hope Tour. *Https://www.youtube.com/watch?v=oFHiHZPaUxg*.

"Remembering MLK's Prophetic 'Mountaintop' Speech." Interview with the Rev. Samuel Billy Kyles. NPR. April 3, 2008. *Http://www.npr.org/templates/story /story.php?storyId=89326670*.

Strange Fruit. Directed by Joel Katz. California Newsreel, 2002.

Sting. "They Dance Alone." Live performance at Amnesty International 1990. *Https://www.youtube.com/watch?v=5h4d-vB6Nzl*.

U2. "'One' and 'Mothers of the Disappeared': Santiago, Chile, February 11, 1998." *Https://www.youtube.com/watch?v=Dxw8o1xzjQE*.

Withers, Bill. "Grandma's Hands." In *Bill Withers: Live at Carnegie Hall*. Sussex, 1973.

"Love's Discovery"

Indigo Girls and the Song of Songs: Friendship, Sexuality, and the Yearning to Belong

You are so young, before all beginning, and I want to beg you, as much as I can, to be patient toward all that is unsolved in your heart and try to love the questions themselves, like locked rooms and like books that are now written in a very foreign tongue. Do not now seek the answers, which cannot be given you because you would not be able to live them. And the point is, to live everything. *Live* the questions now. Perhaps you will then gradually, without noticing it, live along some distant day into the answer.

Resolve to be always beginning—to be a beginner!

—*Rainer Maria Rilke*

Only through the body does the way,
the ascent to the life of blessedness, lie open to us.

—*Saint Bernard of Clairvaux*

When I was in eighth grade, perched precariously at the edge of puberty, the coolest kid in my parochial school class was Frank Taylor. Frank's family owned one of the most successful thoroughbred horse farms in Kentucky, a tree-lined expanse of rolling pastures and elegant barns at the outer rim of Lexington, steeped in equine history and tradition. In fact, a few years later, after I finally earned my driver's license (another riveting story), one of my favorite things to do was to escape the confines of the city and its ever-expanding ring of suburbs and drive the two-lane country roads bordering the horse farms and tobacco fields beyond the city limits. Lined alternately with antebellum fieldstone walls and freshly painted white wooden fences, these rural roadways felt enchanted, transporting me into a kind of twilight zone of thought and contemplation.

CASE STUDIES

Indigo Girls, *Indigo Girls*
Song of Songs, Chapters 1–8, Bible

By far my favorite route to drive was Old Richmond Road, a narrow spoke heading southeast out of Lexington toward the Kentucky River. My friends and I dubbed it "The Roller Coaster" for the thrills its rolling hills and blind curves gave us, gave *me* at the wheel in my brother's old hand-me-down Ford Fiesta. (At least it was a stick shift, amplifying the thrill of the drive.) We'd plan our arrival at river's edge near dusk, park at the ferry, and sit in silence as the waters rolled lazily by. I can remember more than a few times gazing across the river with a smoldering Swisher Sweet cigar in my hand, my best friend Kevin sitting at my side, smiling through a cloud of smoke.

But I'm getting ahead of the story. One day in spring, nearing the final weeks of eighth grade, Frank passed out invitations to his birthday party. To everyone's delight—and *everyone* was invited—it would be held at the farm. Some of us had been there before—for years the Taylors had hosted the annual parish picnic—and so we began to anticipate the party with almost mythic imagination. The evening did not disappoint. I remember my dad driving me out to the country, turning down the long lane at the farm's entrance, and letting me out in front of a huge red barn, where many of my classmates were already gathered. The barn was lit up from within and all around by a thousand strings of lights. It looked less like a barn to my wonderstruck eyes and more like a great wooden ship, floating on a sea of stars. This was going to be a great party, I thought. I joined my friends and together we walked through the barn's huge sliding doors.

The dirt floor was covered with fresh straw, opening onto a makeshift "dance floor" framed by vaulted wooden crossbeams. Barbecue chicken and ribs, Kentucky-style potato salad, and fresh-squeezed lemonade was laid out on long tables against the walls, and Frank's older brother, designated DJ for the evening, was spinning tunes (mostly '70s stadium rock) from a record player in the corner. Being the shy, ninety-five pound, prepubescent nerd that I was at fifteen, it took a while for my nerves to settle. Clearly I wasn't alone. Small groups of two or three of my classmates, separated by sex, congregated around the safe perimeters of the great space, until eventually a few of the braver boys approached a few of the more popular girls and the dancing began. Soon enough, everybody, including me, was out on the floor kicking up straw and singing Queen's "We Are the Champions" at the top of our lungs, one great big lump of teenagers no longer separated by gender or popularity or coolness or bravery. But *not quite* everybody. Just then I noticed two girls, the least "popular" in our class, huddled awkwardly together against the wall. My heart sank. Why aren't they out here having fun with the rest of us? Shouldn't I go over and ask them to dance? (The distance seemed monumental!) If I do, what will my friends think?

And then something remarkable happened. I watched as Frank separated himself from the rest of us and walked across the floor toward the two girls. With a smile and an outstretched hand, he coaxed them out of the corner and into the middle of the room. Their faces—Frank's included—were lit with happiness. It all happened in about ten seconds, naturally and without drama. I'm

not sure anybody else even noticed. But it made a sharp impression on me. In the first place, I remember feeling a twinge of shame. Was I so insecure, so concerned about what my classmates thought of me, that I couldn't manage a simple gesture of friendship and inclusion? At the same time, I was struck by Frank's evident freedom from all that—his lack of concern for the social hierarchy and his own place within it. And I remember the simple delight of seeing Frank and my other two classmates dancing and enjoying each other's company.

The memory of that scene captures a bit of what those adolescent years so often felt like for me: exhilarating, and so terribly fragile, at the same time. For better and sometimes for worse we are radically social creatures, formed in the womb of the social body. What is more, we are radically *embodied* creatures, built from sensory and sex organs, drawn from the tiniest cellular level into relationships with others. Who among us, child, teenager, or adult, doesn't yearn to be loved by others as we are, our whole selves, without precondition? It is a strange paradox how much the journey to "be myself"—to feel at home in my own skin—is so intimately tethered, quite literally from the womb, to the nurturing of other human beings. To be cut off from the social body feels like a kind of death; to be embraced feels like the rush of new life coursing through the arteries. And between these two forces we experiment and struggle and grow into the slow realization of our freedom to love, to allow ourselves to be loved, to become fully human.

In many ways the defining questions of young adulthood—Who am I? To whom do I belong?—get distilled out to something more elemental in the daily rough and tumble of life: Can I open myself to others in friendship and mutual vulnerability, or will I hide behind assorted masks of invulnerability? How exhilarating—and how fragile—is the discovery of love's possibilities over the course of a lifetime.

"History of Us": The Poetry of Human Desire

Musicians Amy Ray and Emily Saliers comprise the Indie folk rock duo Indigo Girls. Their breakout album of 1989, the self-titled *Indigo Girls*, is a masterwork of musicianship and storytelling, flush with the dreams and desires of young adulthood.[1] Released shortly after I graduated from college, the album's success marked a dramatic departure, especially among college-aged listeners, from the drum-machine-and-synth-saturated pop music of the 1980s (think Madonna, Michael Jackson, The Eurythmics, and Duran Duran) toward the more acoustic and introspective sound of artists like REM, Traci Chapman, and Sarah McLaughlan. For me, these latter artists spoke powerfully to the yearning for companionship and purpose that I felt during my twenties, the inarticulate

1. Indigo Girls, *Indigo Girls*, Epic, 1989.

longing to belong to something larger than myself. But perhaps none spoke more poignantly to the inner restlessness and turmoil of trying to find one's place in the world than Indigo Girls. "I'm trying to tell you something about my life," Saliers sings with youthful urgency and playfulness in the album's opening track, "Closer to Fine." Nine songs later, like a painter stepping back from the canvas to discern the shape of the whole, Saliers closes with "History of Us," a plaintive invitation to give ourselves over to life and love "while these moments are still called today," even if the journey promises considerable confusion and pain.

This chapter invites you to explore the music of Indigo Girls alongside the erotic love poetry of the Song of Songs, one of the most beautiful and underappreciated texts of the Bible. In my experience most young people, whether raised in a religious tradition or not, have never heard of the Song of Songs, and most are astonished to find such a powerful affirmation of the body and of sexual love in the Bible. Though separated by two millennia and

© CREATISTA / Shutterstock.com

Amy Ray and Emily Saliers of the Indigo Girls

vast cultural distances, both the music of Indigo Girls and the poetry of the Song of Songs gesture to *friendship* as integral to human love and happiness—friendship as a kind of welcoming atmosphere or circle of companionship in which I am free to grow and discover my authentic self, my unique vocation within the social body. Both Indigo Girls and the Song of Songs express a beautiful if hard-bought wisdom that nobody ever really explained to me when I was a young man: learning to love takes time and patience, and the unfolding journey is driven by far more questions than answers. The "history of us," and the very soul of human sexuality, find their safest harbor in the mystery of friendship.

It is not incidental that Emily Saliers and Amy Ray both identify openly as gay—both today are wed to different partners—and both were raised in deeply religious environments. Despite their openness, it would be some years after their breakout album before Indigo Girls would be publicly identified as gay by the mainstream media. Ray tends to be the more publicly outspoken of the two—"I've

always talked about it very matter-of-factly, because personally, I never felt the need to be in the closet"—whereas the more reserved Saliers admits that it took some time for her to discuss her sexuality publicly. "I've always thought of myself as a very private person, and I'd be that way whether I was straight or gay. I object to sexuality becoming a focus. I just basically did not want to be thought of as first of all gay, and then secondly as an Indigo Girl, so that the music was always secondary. . . . I finally decided that it is important—for the cause and for understanding—to come out publicly."[2] Whether or not one was raised in the church or any explicitly religious environment, the messages and assumptions—spoken and unspoken—that we inherit around sexuality, from society and from the church, are not, to put it generously, always helpful. While their sexual orientation is by no means central to an appreciation of the Indigo Girls' music, I find it to imbue their songs with another layer of authenticity and poignancy.

To borrow from the poet Rilke, in a letter to a young man who had sought his advice: Why do the people who most love us and want to help us "leave us in the lurch *just there*, at the root of all experience? . . . Why have they made our sex homeless, instead of making it the place for the festival of our competency?"[3] If a sense of "homelessness" within religious circles haunts cisgender heterosexuals like myself, how much more must it be so for LGBTQ persons? In a word, as Rilke asks, "Why do we not belong to God from *this* point?"—our bodies, our sexuality—that which is "most mysteriously ours?"[4] What appears to be true for so many of my students was certainly the case for me: issues around sexuality and dating, love and marriage, are among the chief preoccupations of their lives, yet they have very few opportunities or safe spaces in which to explore these issues in a thoughtful way with others. Like a deer caught in the headlights between the mixed messages of society and church—"Just do it!" says the culture, "Just don't do it!" says the church—we need friends we can trust to help us navigate the restless and often volatile passage toward adulthood. More than this, we need a vision of sexual love itself that is rooted in the deep waters of friendship, and is not simply reducible to sex or physical pleasure. "Such is my lover, such is my friend," proclaims the Song of Songs.

This brings me back to Frank Taylor and those twilight drives with my friend Kevin down to the Kentucky River. Of the many graces and unearned privileges I enjoyed in my youth—a stable home in a safe neighborhood, church and school environments that gave me support and affirmation—no less significant were the affection and good humor of my peers, male and female alike. It was in the atmosphere of friendship that I learned, in the words of Rilke's famous advice to his

2. See Holly Crenshaw, "Indigo Girls: Unplugged and Outspoken," *Out*, October 1994. For a wealth of interviews, discography, bios, blog, and tour dates, see Indigo Girls, *http://indigogirls.com/*.

3. Rainer Maria Rilke, *Rilke On Love and Other Difficulties: Translations and Considerations*, trans. John J. L. Mood (New York: Norton, 1975), 26, emphasis added.

4. Rilke, *Rilke on Love and Other Difficulties*, 26.

young friend, to be patient and to "try to love the *questions themselves*, like locked rooms and like books that are now written in a very foreign tongue." It is the questions themselves that honor the inherent drama and mystery of becoming a human being, not least those "locked rooms" that make up the soul of human sexuality. Even today, in the climate of friendship and intimacy that is my marriage, I would agree with Rilke: "Resolve to be always beginning—to be a beginner!"[5]

"Got My Paper and I Was Free": The Restlessness (and Recklessness) of Youth

From the opening chords of "Closer to Fine," the listener is drawn into an infectiously raucous ride on the tidal memories of youth. Two guitars, two voices, and four minutes chronicling the wayward choices of young adulthood—"I stopped by the bar at 3 a.m. / To seek solace in a bottle or possibly a friend"—interrupted by the surprising graces of friendship—"The best thing you've ever done for me / Is to help me take my life less seriously"—and culminating, perhaps, in an even more surprising wisdom: "There's more than one answer to these questions / pointing me in a crooked line/ The less I seek for some definitive / The closer I am to fine." By turns we look to religion, we look to higher education, we look to God, or alcohol, or sex, to save us, and in every case we wake up with "a headache like my head against a board / Twice as cloudy as I'd been the night before. And I went in seeking clarity." If nothing else, the playful mockery of "the doctor of philosophy" in verse 2 was worth the price of the album for me as a recent college grad. It reminded me that the realm of the intellect—and the company of really smart people—is neither the first nor the last most important thing in life's quest for meaning. There is a wisdom that can come to us in the B grade movie, a solace that can be found among other stumbling pilgrims—even in the bar at 3 a.m.

In 2015, the Indigo Girls were interviewed by Krista Tippett, the nationally syndicated radio host of "On Being," a program exploring global religion and spirituality. Older by many decades than Ray and Saliers, Tippett remarked of "Closer to Fine," "I'm kind of amazed you could write that so young. When I heard the song, I couldn't get it out of my head. And then . . . I heard it again, and now I'm singing it constantly."[6] The comment calls to mind the reactions of so many on first hearing the music of Joni Mitchell (chapter 3), whom Saliers thanks in the liner notes to *Indigo Girls*—amazement that a person "so young" could bear such wisdom into their artistry and into the world. Saliers was just 25 when the album was released, Ray was 24; both are characteristically humble, often self-deferential,

5. Rilke, *Rilke on Love and Other Difficulties*, 25.

6. Amy Ray and Emily Saliers, "Music and Finding God in Church and Smoky Bars," interview with Krista Tippett, *On Being*, NPR, November 25, 2015, *https://onbeing.org/programs /indigo-girls-music-and-finding-god-in-church-and-smoky-bars/*.

in response to such praise. "You make it sound like poetry," says Saliers. Tippett responds with a laugh, "That's what you learn as you get older. *It is poetry.*" Ray responds, "That's awesome. Thank you for that. That's cool."[7]

Tippett had asked about "Closer to Fine" in the context of "activist music" and "movement songs" such as "We Shall Overcome," a staple of the Civil Rights Movement. Ray draws an immediate parallel between the songs of those years and "telling our stories that are going on now. And I know there are people doing that, but they're not getting heard. . . . And so it's like, how do we elevate those people? And how do these songs get heard? And how do we make them into the songs of the movement? I don't know." Tippett says, "So you're all asking those questions." Ray responds,

> We're asking. We don't know the answers. . . . And I have yet to understand where we're at, cither. Because I think where we're at is as important as the Civil Rights Movement in the '60s. There is a cross-pollination of immigration reform movements, and queer movements, and poverty movements, and hunger movements. They're all coming together and they're helping each other out. It's remarkable. And I think that there's something remarkable going on. But how do we sing about it, is the question I have.[8]

If none of the ten tracks on *Indigo Girls* offers "definitive" answers, perhaps collectively the album's power—and its solace for young people especially—resides in its affirmation of the questions themselves, the hard-bought insight that comes through the struggle. And therein, arguably, resides the power of resistance and social justice movements that bring people together in common cause. The "I" of youthful searching gives way to the "we" of belonging to something larger than myself. And that process of transformation itself is a shared victory, worthy of celebration. Again, Amy Ray: "[Music] can change people because it gathers us together, and it opens you up. And when we all sing 'Closer To Fine' together as a crowd, we're having—that right there is a revolutionary moment. The barriers are coming down, we're singing this song, and . . . music is so powerful like that."[9]

"Secure Yourself to Heaven": The Yearning for Communion

It must be said that the "revolutionary" power of Indigo Girls also lies in the striking harmonies and melodic counterpoints that the two women achieve with

7. Ray and Saliers, "Music and Finding God."
8. Ray and Saliers, "Music and Finding God."
9. Ray and Saliers, "Music and Finding God."

their voices. Indeed, in 1989, at age twenty-five and a serious student of music when I first heard "Closer to Fine" on the radio, it stopped me in my tracks. I had never heard anything quite like it. How to define "it," the particular magic that plays between the two singers' voices, a synergy in which the sum yields to something much greater than the parts? Saliers points to the sheer physicality of music: "It's got your heartbeat, it's got rhythms, it's got space, it's a physiological reality, along with a mystical reality. So it's metaphysical. There's not many things in life you can point to and go, that's metaphysical. But music is."[10]

The power of movement music and songs like "Closer to Fine" also "comes from the people," Saliers continues, "and it comes from everything that's happened before it, and I love that too. I love that there's a continuum always and forevermore, [which taps into] the entirety of human existence [and is gathered up] through music, because it's come from that and will continue to [shape] everything." Ray chimes in, affirming the physical, the mystical, and even the theological rhythms, as it were, which rise up between artist and audience during live performances:

It's funny, because you can find God in music when you're gathered together singing a song, but also there are moments that I've had seeing people perform where it's just: *that's* God. They're not God, but God's there. It's like Patti Smith at Red Rocks, Prince's *Purple Rain* tour. . . . There's just these moments, and it's not the personality of the musicians anymore. Something's disappeared, and the music and the audience and everything has merged, and there's no separation between performer and audience. That is what spirituality is supposed to be. No separation. . . . Go to a show and have that experience. It's sweaty and it's not beautiful. It's transcendent, though.[11]

That description of transcendence, in which "everything has merged, and there's no separation," evokes the physicality and potential ecstasy—from the Greek, *ekstasis*: to be taken outside of or beyond oneself—of sexual love. And perhaps even a foretaste of heaven.[12]

I don't know that any of the songs on *Indigo Girls* evokes sexual intimacy in a literal sense, but in a deeper sense, it doesn't matter. The album everywhere evokes the restless longing, and the risks, of "merging" into something beyond ourselves: friendship and family, finding a vocation, building community, discovering love. The fire of *eros*—the yearning to love and be loved—burns especially

10. Ray and Saliers, "Music and Finding God."

11. Ray and Saliers, "Music and Finding God."

12. I find the same quality of transcendence and multivalent yearning in Lily Winwood's cover of "Higher Love," accompanied by her father Steve Winwood, who wrote the song: *https://www.youtube.com/watch?v=CsS4xlHKnpw*. Steve Winwood's original is here: *https://www.youtube.com/watch?v=5bcSoHoJhOc*.

intensely in track three, "Kid Fears," written by Ray, where two voices merge unexpectedly into three. Michael Stipe, fellow Georgian and lead singer for pioneering alternative rock band R.E.M., joins Ray and Saliers in a darkly beautiful lament "about the difficulty of growing up," as Ray describes the song, the costs of "getting into a world where people know where your hiding places are and what your secrets are."[13] There's an ominous quality in the minor-key acoustic landscape of "Kid Fears," the fire of a yearning that threatens to overwhelm the "you" of the song with questions too dangerous to voice out loud. "Are you on fire (are you on fire) / From the years? (from the years) / What would you give for your kid fears?" The juxtaposition of Ray's voice, "raw, urgent and scrappy," against Saliers', "soothing and light,"[14] is especially striking in "Kid Fears." But Stipe's sudden (male) presence in the third refrain takes the song to another dimension. Together the three voices achieve a communion and a power that transcends any one voice individually.

Catholic spiritual writer and Oblate priest Fr. Ronald Rolheiser suggests that at "the heart of all great literature, poetry, art, philosophy, psychology, and religion" is the attempt to name and come to terms with "a fundamental *dis-ease*, an unquenchable fire that renders us incapable, in this life, of ever coming to full peace. This desire lies at the center of our lives, in the marrow of our bones, and in the deep recesses of the soul." Spirituality, says Rolheiser, is "about what we do with that desire. What we do with our longings, both in terms of handling the pain and the hope they bring us: that is our spirituality."[15] The religious or mystical aspect of that longing is perhaps most famously expressed in the prayer of Saint Augustine, "You have made us for yourself, Lord, and our hearts are restless until they rest in you." Music, poetry, the arts—whether they appeal to explicit religious imagery or not—help us to name and come to terms with the fire that simmers in the marrow of the bones. "Spirituality is about what we do with our unrest."[16]

"I Am in Pain, I Am in Love": Between Solitude and Communion

If my own history is any measure, many young adults both feed that unrest *and* try to tame it during their college years. Much of my early twenties was spent in a strange kind of limbo, imagining that just around the corner, or maybe one

13. "Indigo Girls: Kid Fears," Song Meanings, *http://songmeanings.com/songs/view/49044/*, referring to an interview with Indigo Girls in *Spin Magazine*, 1989.

14. Crenshaw, "Indigo Girls: Unplugged and Outspoken."

15. Ronald Rolheiser, *The Holy Longing: The Search for a Christian Spirituality* (New York: Image, 1999), 3–5.

16. Rolheiser, *The Holy Longing*, 5.

night in my favorite bar, I'd run into the woman of my dreams and live happily ever after. I may be exaggerating slightly—there was one serious girlfriend during high school and into college who was dear to me in every way—but there were a number of relationships I "fell into" during and just after college that now seem to me objectively unhealthy—in a few cases self-destructive, and in one case, truly selfish on my part and damaging to the other, a memory that still stings with shame. The thing is, in nearly every case, *I knew it at the time*, deep down, at some level of my being. Knew what? That who I was in the relationship, who I was allowing myself to be, wasn't authentic, wasn't free, wasn't me. In "Blood and Fire," Ray tears off the bandages, as it were, exposing the wounds of the kind of love, as she puts it, "that a lot of people feel at one time in their lives. It's the obsessive compulsive love, which is very, very dangerous."[17]

> I am looking for someone, who can take as much as I give,
> Give back as much as I need, / And still have the will to live.
> I am intense, I am in need, I am in pain, I am in love.
> I feel forsaken, like to things I gave away.[18]

Ray says of the song, "It took a long time to write it, a couple of years to get through it,"[19] which will be little surprise to the listener, given the almost unbearably raw quality of her vocal.

Once again, the poet Rilke puts his finger on the restlessness and, perhaps most poignantly, the universal *impatience* of youth. I come back to Rilke because his insights into "love and other difficulties" seem to me deeply resonant, and so rarely expressed—or allowed to be expressed, especially by men—in a cultural milieu so obsessed with sex as an end in itself.

> To love is good, too: love being difficult. For one human being to love another: that is perhaps the most difficult of all our tasks, the ultimate, the last test and proof, the work for which all other work is but preparation. For this reason young people, who are beginners in everything, cannot yet know love: they have to learn it. With their whole being, with all their forces, gathered close about their lonely, timid, upward-beating heart, they must learn to love. But learning-time is always a long, secluded time, and so loving, for a long while ahead and far on into life, is—solitude, intensified and deepened loneness for him who loves.[20]

For Rilke, solitude and patience, paradoxically, provide the fertile soil for the ripening of a person into himself or herself, "to become world for himself for

17. "Indigo Girls: Blood and Fire," Song Meanings, *http://songmeanings.com/songs/view/48178/*.

18. Indigo Girls, "Blood and Fire," *Indigo Girls*.

19. "Indigo Girls: Blood and Fire."

20. Rilke, *Rilke on Love and Other Difficulties*, 31.

another's sake."[21] Indeed, Rilke holds that the "highest task of a bond between two people," the deepest calling of a friendship that may or may not flower one day into sexual love, is "that each should stand guard over the solitude of the other." Once the realization is accepted "that even between the closest human beings infinite distances continue to exist, a wonderful living side by side can grow up, if they succeed in loving the distance between them which makes it possible for each other to see the other whole and against a wide sky!"[22]

Yet this is precisely where "young people err so often and so grievously: that they (in whose nature it lies to have no patience) fling themselves at each other, when love takes possession of them, scatter themselves, just as they are, in all their untidiness, disorder, confusion. . . . And then what? What is life to do to this heap of half-battered existence which they call their communion and which they would gladly call their happiness, if it were possible, and their future?"[23] In a word—and Rilke's advice still speaks to me as a married man in my fifties, though differently than in my twenties—we must never forget that when it comes to love we are "beginners, bunglers of life, apprentices in love,—must *learn* love, and that (like *all* learning) wants peace, patience, and composure!"[24]

Here I think Rilke puts his finger on one of the great sources of loneliness, if not despair, in many young people of our time, male or female, gay or straight, cisgender or transgender: Who can teach or model for them the way of "peace, patience, and composure" when it comes to sex, to the ripening of their capacities for mutually sustaining, life-giving relationships? In the absence of caring adult mentors or strong communal supports, popular culture will fill the void. If "culture" can be described as the constellation of images, values, stories, and practices that we tell about ourselves, the societal "scripts," so to speak, which give shape, meaning, and purpose to our lives; if culture operates on our consciousness more or less *subconsciously*, as a kind of lens or imaginative grid through which we make sense of the world and begin to discover our place in it; then it is well worth asking: what are the prevailing images, stories, and values that our culture teaches us with respect to sexuality? And must we accept these conventional scripts without critique, or are there alternative ways of framing the mystery of sex that account more truthfully for its beauty and mystery—"the fullness and the glory of all knowing"[25]—that Rilke describes as the soul of sexuality?

"When you give someone flowers," Rilke asks his young friend, "you arrange them beforehand, don't you?"[26] The point is, who can teach us *how* to arrange the flowers? I wish to suggest that the Indigo Girls, through the power of their

21. Rilke, *Rilke on Love and Other Difficulties*, 31.

22. Rilke, *Rilke on Love and Other Difficulties*, 27–28.

23. Rilke, *Rilke on Love and Other Difficulties*, 31–32.

24. Rilke, *Rilke on Love and Other Difficulties*, 30.

25. Rilke, *Rilke on Love and Other Difficulties*, 34.

26. Rilke, *Rilke on Love and Other Difficulties*, 29.

playing and performing together, through their personal witness and social activism, through their bare poetry of human desire, have given a great many listeners of diverse ages, sexual orientations, and social backgrounds, a kind of soundtrack or musical picture book for learning how to arrange the flowers.

And in this, their artistry hearkens to another body of poetry and song, ancient and often forgotten, in the heart of the Jewish and Christian scriptures. We will return to the Indigo Girls shortly, but I want to turn now to the Song of Songs, another kind of soundtrack for deepening our appreciation of the gift of love and sexuality. If the realm of our sex can often feel "homeless" amid the swirl of messages we internalize from society and church, the Song of Songs raises some trustworthy signposts for finding our way back home, for reverencing sexual love as "the place for the festival of our competency."[27]

"On My Bed at Night I Sought Him": Seasons of Longing and Fulfillment

Outside of hearing passages from the Old and New Testaments read during weekly Mass, as a young Catholic I was never taught about the Bible in any serious or systematic way until my high school years. Even then, never, in my recollection, were my classmates and I introduced to the Song of Songs. Though we studied with great fervor the mythic poetry of ancient Rome and Greece—and were subjected to carefully scripted lessons in "sex education" by the kind nuns who ran my parochial school—the Song of Songs, it seems, was considered far too dangerous for kids who stood at the brink of a whole new moral and sexual universe. Indeed, despite its exalted status in Jewish and Christian theological commentary—it has often been called the "Holy of Holies"[28] in the Bible—the Song of Songs remains curiously hidden from ordinary believers, a kind of "secret" among the books of the Bible. Nevertheless, there is nothing in the poem itself that should give the uninitiated adult or young adult reader any pause in entering into its picturesque erotic landscape; for those familiar with the Song of Songs already, its eight chapters bear repeated readings.

As I've emphasized throughout this book, the best grasp of art is not analytical so much as it is holistic and participatory. The same is true with the sacred poetry of the Bible. The best grasp comes "not in criticism of the text," as theologian Mark Burrows reminds us, "but in the 'performance' of reading, that

27. Rilke, *Rilke on Love and Other Difficulties*, 26.

28. The first-century Jewish sage Rabbi Akiva famously defended the canonicity of the Song of Songs against its detractors, saying, "For all of eternity in its entirety is not as worthy as the day on which Song of Songs was given to Israel, for all the Writings are holy, but Song of Songs is the Holy of Holies." See Lawrence H. Schiffman, ed., *Texts and Traditions: A Source Reader for the Study of Second Temple and Rabbinic Judaism* (Hoboken, NJ: Ktav, 1998), 119–20.

moment when the mystical text becomes the occasion for a 'merging of the way of knowledge and the way of love.'"[29] If the Song of Songs is anything, it is just such a performative and mystical-poetical text, a realization of knowledge and love that awaits gestation in a new generation of readers willing to "give themselves over" to its play of images. For all of these reasons I encourage you to read and linger reflectively in the text before reading here any further. Even better, recite the poem aloud with others, taking your time, letting it stop you wherever it may, and allowing its musicality to engage your whole person.[30]

In fact, evidence suggests that the Song originated in some kind of festive performance of recitation and dance, with different singers representing the three main characters within the storyline: the two lovers, a young man and woman engaged in mutual pursuit, and the "daughters of Jerusalem," a chorus of young women observing and interjecting commentary on behalf of the community.[31] Much as Michael Stipe's vocal in "Kid Fears" intensifies Ray's and Salier's harmonic relationship and takes it to another level, the interplay of the three voices in the Song of Songs achieves a kind of social communion that transcends the narrative perspective of any single voice. In other words, the drama between the young lovers takes place in the context of the community, and is celebrated by it. The flourishing of the individuals feeds the flourishing of the whole.

None of this was necessarily evident to me the first time I read the Song of Songs. What struck me foremost was the sensual imagery that saturates the text: How could such an unbridled celebration of the human body be hidden right here in the Bible? And why hasn't anybody told me about it before?! What also struck me was the vivid nature imagery: the comparison of the lover's body to a tree laden with ripe fruits (7:8–9), the lover's teeth to the whiteness of a freshly shorn lamb (4:2). The poem becomes a lushly illustrated "garden poem" (4:12–16), like a glimpse into the Garden of Eden before, or without, the forbidden fruit and fall from grace as described in the book of Genesis.[32] The woman invites her beloved to enter the garden, to taste its fruits. The daughters of Jerusalem urge them on, "Eat, friends, drink! / Drink

29. Mark S. Burrows, "Words That Reach into the Silence: Mystical Languages of Unsaying," in *Minding the Spirit: The Study of Christian Spirituality*, ed. Elizabeth A. Dreyer and Mark S. Burrows (Baltimore: Johns Hopkins, 2005), 213; citing Michael Sells.

30. The ancient religious practice of *lectio divina* (sacred reading) involves a slow savoring of or ruminating (literally "chewing") on the text, a practice that can be adapted by individuals or groups. It is to linger over a single phrase or image and allow the text to penetrate one's whole person, to rest in it, enjoy it. The practice is to attend to any feelings, images, thoughts, memories (including deep memories or archetypes) that may arise and, within groups, to share those responses with others.

31. Ann W. Astell, *The Song of Songs in the Middle Ages* (Ithaca, NY: Cornell, 1990), 162.

32. "Adam," the name used in the book of Genesis for the first human being created by God, is closely linked to the Hebrew word '*adamah*, meaning "the soil" or "earth." Just as Adam (man, mankind) is created from '*adamah* (earth), so is Adam estranged from the earth through his disobedience, symbolized by his eating the fruit from a forbidden tree, prompted by his wife Eve, after which both are expelled from the Garden of Eden (Gen. 2:4–3:24).

deeply, lovers!" (5:1) The woman arises to open the door of her bedchamber, her hands "dripping myrrh / My fingers flowing myrrh / upon the handles of the lock." But he is gone (5:5–6). There are what seem to be haunting dream sequences (3:1–5), with hints of violence (5:7), as she wanders the city searching for her beloved (3:2; 5:7). Yet an unmistakable playfulness prevails in the poem's dance of anticipation and consummation.

There was also for me the striking effect of being invited into an intimate mutual discovery between the two lovers. This is not a report *about* a love affair; it is a first-person glimpse *from within* the unfolding state of mind, heart, flesh, and spirit of its participants.

> My lover speaks and says to me, / "Arise, my friend, my beautiful one,
> and come! / For see, the winter is past, / the rains are over and gone.
> The flowers appear on the earth, / the time of pruning the vines has come,
> and the song of the turtledove is heard in our land. / The fig tree puts forth
> its figs,
> and the vines, in bloom, give forth fragrance.
> Arise, my friend, my beautiful one, / and come!" (2:10–13)

Notice how the "ripening" of love between the two is linked to the resplendence of Nature itself. The earth becomes a kind of fourth character and palpable presence in the drama. Like the rhythms and fecundity of nature, sexual love emerges organically, as it were, in the fullness of time.

There are seasons for love's discovery, yet this also implies seasons when the earth must lie fallow, when the garden is being prepared. There are seasons, as Rilke might say, when friends must stand guard over one another's solitude. The lovers seem to understand this. One of the loveliest refrains throughout the text is a kind of cautionary note, voiced by the woman to the daughters: "Do not awaken or stir up love until it is ready" (2:7; cf. 3:5; 5:8; 8:4). Sex, in other words, is not to be trifled with. But such admonitions are framed inside a larger liturgy of anticipation, invitation, and playful celebration: "I have taken off my robe," she teases him, "am I then to put it on?" (5:3)

If it is true, as the Christian mystical tradition insists, that God is revealed in the pages of many "books"—the book of the Scriptures, the book of Nature, the book of Human Experience—what resonates here so strongly with my own book of experience is the poetry of human sexuality at its trembling and joyful best, when love's desire overflows with the radiance and pleasure of a bountiful God. But even more remarkable to ponder, it seems to me—remarkable for its *rareness* in Christian literature—is the empowerment of the female voice, of female sexuality, everywhere in the text. "Let him kiss me with kisses of his mouth" (1:2), the young woman declares in the poem's opening lines, signaling a confidence and agency that will resound throughout the Song's eight chapters.

"I am black and beautiful, / Daughters of Jerusalem" (1:5), she proclaims, with a hint of sass that says, "Don't mess with me." The point is, the picture of sexual love portrayed throughout the Song expresses "a joyous reciprocity between the lovers and highlights the active role of the female partner." The woman, inclusive of her body, "is now a pure figure to be cherished rather than an adulterous woman to be punished and abused."[33] She is not the whore, or the temptress like Eve, the bearer of the "fruit" responsible for humanity's downfall. To the contrary, the fruits of her garden—inclusive of her freedom, her initiative, her agency—are celebrated (sung!) as beautiful, sacred, and holy. It is not incidental that some scholars have argued the possibility of female authorship for at least portions of the Song. Whether or not that is in fact the case is beside the essential point: the Bible here lifts up the sacred book of experience of women.

Even more, the woman's perspective in the Song gives way to that mysterious "something more" that is shared by her lover, namely, their mutual vulnerability. "Turn your eyes away from me, / for they stir me up" (6:5), he pleads with her, in a way that calls to mind Emily Saliers in "History of Us"—"I went all the way to Paris to forget your face." In other words, it is not the woman alone but the synergy between her voice and the man's, the daughters of Jerusalem (the community), and the rhythms of the earth, which together evoke another hidden presence in the narrative: God, the divine Lover who yearns to bring together what has been separated, smashed, torn asunder. In the Song's most oft-quoted lines—"Set me as a seal upon your heart / as a seal upon your arm" (8:6)—the woman's voice seems indistinguishable from God's, as if to say, in the communion of Love there is no longer distinction. Speaking directly to her beloved—and alluding to "your mother," who might also be the very earth "beneath the apple tree"—she seems to offer an alternative ending to the garden story in Genesis, or perhaps a new beginning, after the fall:

> Beneath the apple tree I awakened you; / there your mother conceived you; there she who bore you conceived.
>
> Set me as a seal upon your heart, / as a seal upon your arm;
>
> For Love is strong as Death, / longing is fierce as Sheol.
>
> Its arrows are arrows of fire, / flames of the divine.
>
> Deep waters cannot quench love, / nor rivers sweep it away.
>
> Were one to offer all the wealth of his house for love, / he would be utterly despised. (8:5–7)

Despite what our cultural scripts proclaim, today or two thousand years ago, love cannot be bought or sold, nor bargained for, nor swept away by the rivers of

33. "The Song of Songs," United States Conference of Catholic Bishops (USCCB), *http://www.usccb.org/bible/songofsongs/0*.

chaos that include our personal sins, cultural blindness, and moral failures across so many centuries. Indeed, that love should survive and flourish in spite of the cruelty that human beings are capable of—and to which the Genesis story of the fall and expulsion from the garden hearkens—is a miracle beyond all reckoning. The love of God, a desire stamped into our being from before the beginning, "bears all things, believes all things, hopes all things, endures all things" (1 Cor. 13:7). And so we must try our best to love, "stretching our youth as we must,"[34] until the passage of all time makes history of us.

"Darkness Has a Hunger That's Insatiable": Naming the Cultural Darkness

I began this chapter by recalling memories from my adolescence not because I think my experience is normative but rather to underscore the fragility of discovering who we are in relationship to the social body. The word "fragile," of course, means *easily broken*. If anything is universal or normative about the lives of young people across cultures, perhaps it is just this: profound vulnerability. Indeed when I ponder the world that my students and my own children navigate today, it looks considerably more complex and frankly more dangerous than the world of my youth—a world that didn't include smart phones, VR technologies, or mass shootings every week. We have already considered the implications of this brave new world with our exploration of the "technological milieu" in chapter 4. It is worth asking how that milieu mediates our prevailing images and expectations around gender and sexuality. When Indigo Girls, in "Love's Recovery," cry out against "the whims of culture / that swoop like vultures / eating us away / eating us away / eating us away to our extinction," what are they getting at? Why does "love's discovery" also imply love's *recovery*, as the song suggests? Are we losing by degrees our capacities for empathy, intimacy, authentic love? Who or what are these "vultures" that eat away at our very humanity, as the song seems to suggest, and against which the young are especially vulnerable? Indeed, where to begin?

Given its outsized sway on pop culture for some forty years, a reasonable place to start is with music video. Analyzing thousands of videos broadcast on MTV and BET in the last thirty years, media critic Sut Jhally describes the dominant lens through which men and women have been portrayed in music video since the early 1980s as the "adolescent male heterosexual pornographic imagination," a "script" now so dominant in American popular culture as to be widely considered normative—the assumed standard by which all other portrayals of sexuality are measured, deemed deficient, abnormal. (Jhally wonders, for example, why images of gay male sexuality are virtually taboo across all genres of music video while lesbian imagery is rampant.) The portrayal of women in

34. Indigo Girls, "History of Us," *Indigo Girls*.

music video, and black women especially, is almost universally dehumanizing, "their value often reduced to a single part of their anatomy."[35] Several infamous hip-hop videos, for example, feature the male star running a credit card through a willing woman's buttocks. Again, surveying an enormous range of examples across genres, Jhally characterizes the portrayal of young black men in music video as possibly "the most racist set of images ever displayed in public" since D. W. Griffith's white supremacist film of 1915, *Birth of a Nation*.[36] Significantly, Jhally's critique presses far beyond the artists themselves or any single genre (rap, rock, country, hip-hop) to interrogate the powerful and mostly white male record company executives behind the camera who envision and dictate the content of music videos for public consumption. These powerful men, as Jhally intimates, are precisely "the vultures" we need to interrogate. In whose interest, he asks, are such images and scripts around sexuality created and disseminated into the culture? And to what extent have we (and our children) internalized these storylines as normative?

Video gaming culture merits similar questions. A 2012 survey reported that 92 percent of American youth, ages two to seventeen, play video games daily, while some 9 percent of players ages eight to eighteen are "pathological players," or clinically addicted. By far the most popular games among children are "first-person shooter" games, in which "you approach the world with a deadly weapon, and your job is to kill them before they kill you."[37] A respected medical journal describes video games as possibly "the most effective educational technology ever invented. Players are immersed in an environment where they are rewarded for doing well and punished when they don't. Either way, they get to keep doing it until their performance improves." In the case of the massively popular *Call of Duty: Modern Warfare 3* (one billion dollars in sales in the first sixteen days after its release) and *Grand Theft Auto*, what children "keep doing until their performance improves" is mostly kill people. "If you're being rewarded for killing female hookers," worries Dr. Michael Rich of Children's Hospital in Boston, "that's bound to teach you something over time."[38]

As noted in chapter 5, we live in a culture in which the very phrase, "Be a man," and the imagery and narratives so ubiquitously attached to it, means, "Don't feel it."[39] Psychotherapist Terrence Real argues that "typically male" problems—alcohol and drug abuse, domestic violence, failures in intimacy—are

35. *Dreamworlds 3: Desire, Sex & Power in Music Video*, directed by Sut Jhally (Media Education Foundation, 2007).

36. *Dreamworlds 3*.

37. Bruce Jancin, "Video Games: What You'd Really Rather Not Know," *Pediatric News* 46, no. 3 (March 2012): 6.

38. Jancin, "Video Games," 6.

39. See Bill McGarvey, "When 'Being a Man' Means Hiding Your Depression. What 'Moonlight' Teaches Us about Masculinity," *America* (Jan. 2, 2017), https://www.americamagazine.org/arts-culture/2016/12/15/when-being-man-means-hiding-your-depression-what-moonlight-teaches-us-about.

linked to a "covert depression" in men. "We tend not to recognize depression in men because the disorder itself is seen as unmanly," writes Real. Depression in men, he continues, carries "the stigma of mental illness and also the stigma of 'feminine' emotionality."[40] Jackson Katz, the documentarian behind *Tough Guise*, posits that the nationwide epidemic of school shootings and rampage killings—98 percent of which are committed by men—is not simply a crisis of guns and mental illness but represents a crisis of masculinity as well. "The weapon becomes an integral part of how men and boys try to establish and prove they're real men," he says, "especially when they're scared and their manhood is under attack."[41] As music critic and Catholic spiritual writer Bill McGarvey observes, "Cultural archetypes and expectations formed over generations do not change easily, but if we continue to exclude essential relational values like sensitivity and emotional connection from our definition of what it means to fully be a man, we will doom men to a state of perpetual war not only with others but with their own humanity."[42]

But clearly it is not just young people, nor only men, whose desires and expectations around sex are being shaped and *reshaped* in fundamental ways by images of sexualized violence, much of it imbibed, surely, from a subterranean culture of internet pornography, a highly addictive virtual universe in which Americans of all ages spend enormous amounts of time—and where, not incidentally, LGBTQ persons are often exposed and sometimes bullied to the point of suicide.[43] As I write these lines, the #MeToo movement is sweeping the country, with women of all ages coming forward courageously to expose patterns of sexual harassment and sexual assault in the highest echelons of big business, entertainment, and politics.[44] Who can be surprised, then, when young adults replicate the sins of their parents?

As every freshman in college learns during their first days on campus—in a necessary but sobering "orientation" ritual that must cast a pall over the spirit of eager anticipation—at least 1 in 5 college women will become victims of sexual assault, most often during their first months on campus. And as they will also eventually learn, many of their older peers, male and female alike, express conflicted feelings about reporting sexual assault in the face of enormous social pressures not to do so, especially where incidents involve alcohol (as most do) or

40. Cited in McGarvey, "Moonlight." Terrence Real is author of *I Don't Want to Talk about It: Overcoming the Secret Legacy of Male Depression* (New York: Scribner, 1997).

41. Cited in McGarvey, "Moonlight."

42. McGarvey, "Moonlight."

43. Ann P. Haas et al., "Suicide and Suicide Risk in Lesbian, Gay, Bisexual, and Transgender Populations: Review and Recommendations," *Journal of Homosexuality* 58, no. 1 (Jan. 2011): 10–51, *https://www.tandfonline.com/doi/abs/10.1080/00918369.2011.534038*.

44. See Jessica Bennett, "The #MeToo Moment: When the Blinders Come Off," *New York Times*, November 30, 2017, *https://www.nytimes.com/2017/11/30/us/the-metoo-moment.html*, and links therein.

high-profile student athletes.[45] One of the most widely viewed documentaries about sexual assault shown on many campuses is depressingly titled *The Hunting Ground.*[46] Of course, in all such cases of harassment and violence, it is never just those persons directly victimized but the surrounding community as well for whom the effects of trauma can throb, like an open wound, *forever.*

"By Grace My Sight Grows Stronger": Cultivating the Discernment of Spirits

It is against this cultural backdrop, admittedly bleak, that I hear "Prince of Darkness," the fourth track on *Indigo Girls*, and to this day one of the more empowering songs of the human spirit I've ever heard. "Maybe there's no haven in this world for tender age. / My heart beat like the wings of wild birds in a cage." As if on cue from Rilke, who urges patience and vigilance with that gift of our sex which is "most mysteriously ours," the raw emotional wreckage of Amy Ray's "Kid Fears" clears a path for the rising confidence and determination of Saliers' "Prince of Darkness," a song for any person, young or old, who feels besieged by "the whims of culture / that swoop like vultures / eating us away." The song is a celebration of authentic, generous love, and perhaps above all, our ability to recognize love when we experience it. "There was a time I asked my father for a dollar / And when I needed my mother and I called her. . . ." At the same time, it is a calling out and rejection of the forces of darkness that *masquerade* as love and would draw us—especially in our youth, and often with a benevolent smile—into their destructive circle. "I was half the naked distance between hell and heaven's ceiling / And he almost pulled me under."

The song gives courage to name the truth of our darkness, but does not leave us naked and helpless before it. To the contrary, with a driving, major-key chord progression and infectiously beautiful vocal harmonies, Saliers lifts up the inner voice of conscience and capacity for spiritual discernment that lives quietly *in every person*, if only we could learn to cultivate it. "My place is of the sun and

45. As one professor sees it, "Most of my colleagues and almost all of my students tend to be very protective of the institution and our image, and they're not eager to look too closely at anything that might raise questions." See Melinda Henneberger, "Reported Sexual Assault at Notre Dame Campus Leaves More Questions Than Answers," *National Catholic Reporter Online*, March 26, 2012, *https:// www.ncronline.org/news/accountability/reported-sexual-assault-notre-dame-campus-leaves-more-questions-answers*; also "Anything But Clear: A Report on Campus Sexual Assaults," the editors, *Notre Dame Magazine*, Winter 2011–12. In the Catholic Church nothing has more damaged the Church's credibility than the revelation of widespread sexual abuse of children and the systematic denial and obfuscation by certain bishops around the world. See John Jay College Research Team, "The Causes and Context of Sexual Abuse of Minors by Catholic Priests in the United States, 1950–2010," May 2011, *http://www.usccb.org/issues-and-action/child-and-youth-protection/upload/The-Causes-and-Context-of-Sexual-Abuse-of-Minors-by-Catholic-Priests-in-the-United-States-1950-2010.pdf*.

46. *The Hunting Ground*, dir. Kirby Dick, Anchor Bay, 2015.

this place is of the dark / (By grace, my sight grows stronger and I will not / be a pawn for the Prince of Darkness any longer)." That line, "by grace my sight grows stronger," delivered with such tenderness and strength by Saliers, seems an almost perfect expression of what the Christian mystical tradition calls the "discernment of spirits."[47] The discernment of spirits is a way of making choices, big and small, which involves paying careful attention not only to the rational reasons for following a particular course of action but also being *attuned to the language of the heart*, one's feelings, emotions, and desires, the inner "movements" of the soul or spirit. The key question one learns to ask oneself in any situation: "Where is this impulse coming from: the good spirit (of authentic love, of God), or the evil spirit (leading one away from authentic love, from God)?"[48] But how to discern the difference between the good spirit and the spirit of darkness that threatens to "pull us under"?

According to the Christian mystical tradition, the spirit of God gives "consolation" when considering a particular course of action, a sense of inner peace and freedom, a certain confidence that this path will draw me closer to my authentic self and the greater good. It is the sense that going this way will help me and others to flourish, even if the external situation appears unclear or tumultuous. The spirit of darkness, by contrast, is marked by "desolation"—a sense of agitation or lack of freedom when considering a certain course of action, even if things on the surface seem well and good. To reject the "Prince of Darkness"—the enemy of human flourishing—is to steer away from situations, or people, that would require me to be dishonest with myself or others, to wear a mask of one kind or another, to manipulate others, or to act against my true self. Saying no is not easy, especially when a certain "romance" or "spark" attaches itself to that choice or person, or when the cultural norms would urge me to "Just Do It." In the face of a choice that may seem attractive in the moment but deep down feels uneasy or unfree, a mature spirituality is able to say *no thank you*, and in the words of "Prince of Darkness," "I do not feel the romance / I do not catch the spark."[49]

Our capacity for discernment grows with self-knowledge and time, a lifetime, surely, with not a few missteps along the way. The goal is not perfection—truly,

47. I am drawing here from Ignatian spirituality, an enormously influential thread in the Christian mystical tradition flowing from the life and Spiritual Exercises of Saint Ignatius of Loyola. See David L. Fleming, SJ, *What Is Ignatian Spirituality?* (Chicago: Loyola, 2008); also George W. Traub, SJ, ed., *An Ignatian Spirituality Reader* (Chicago: Loyola, 2008).

48. Fleming, *What Is Ignatian Spirituality?*, 13–24, 49–60, 89–94; Traub, ed., *An Ignatian Spirituality Reader*, 159–220.

49. The idea of "flourishing" beautifully expresses the inherent end (or *telos*) of life at both the personal-individual level and within the whole human-planetary community, or what I have called the social body. Spiritual discernment involves measuring whether and to what extent a particular choice or path will lead me and those around me toward common flourishing, or what Catholic social teaching calls the common good. "A thing is right when it tends to preserve the integrity, stability, and beauty of the life community, it is wrong when it tends to do otherwise." Aldo Leopold, cited in Elizabeth A. Johnson, *Women, Earth and Creator Spirit* (Notre Dame, IN: St. Mary's College, 1993), 67.

who can meet such a goal?—but growth by degrees into greater freedom for love. Hence the need for patience, as Rilke counsels, so that someday we might gradually "live into the answer"; and for self-forgiveness, when the search runs aground in shallow waters, as it is bound to do. For love is a risk, a "passion play." The haunting religious imagery in "History of Us," the final track on the album, seems to evoke the renewing spirit of Life whose green blade rises even from the fields of death. The "Icons of glory smashed / by the bombs from above" might just refer to the torn pictures and fragments of statues that lie in the ruins of ancient churches. And it might also refer to us, each of us made to share in God's own vulnerability and the apparent "weakness" of incarnate Love. Beckoned to life through Salier's earthy yet transcendent vocal—"In the midst of the rubble / I felt a sense of rebirth"—"History of Us" is a psalm of faith, hinting that though the search is difficult and often confused, unfair, and painful, our deepest yearning is and will always be toward love. "Stretching our youth as we must / until we are ashes to dust / Until time makes history of us." To "feel safe within the arms of love's discovery" ("Love's Recovery") is to come home, as it were, to a place I've never been.

Thus in the realm of love and sexuality, spirituality is *learning to listen to the spirits that we choose to live our life by*, and how those spirits create or do not create life for myself and others, bring others together, or tear others apart.[50] It is learning "to discern what is the voice of the Holy Spirit of God and what is the voice of a spirit that is counter to God's Spirit."[51] But in this learning, to recall Rilke, young people often err by acting rashly with others "out of common helplessness."[52] In the attempt to avoid marriage, for example, the one convention that is held aloft by the church as the sole end of our happiness, we "land in the tentacles" of some "equally deadly conventional solution"[53] that is held aloft by our culture, namely, the hookup or one-night stand. In the case of the hookup,

50. Al Bischoff, SJ, cited in "Sexuality and Ignatian Spirituality," a video resource filmed during a seminar of the same title, organized by Catholic moral theologian Dr. Jennifer Beste in collaboration with several Jesuits and faculty in the Department of Theology at Xavier University. See *https://www.youtube.com/watch?v=eY82hFVDkMg*.

51. Monika K. Hellwig, "Finding God in All Things: A Spirituality for Today," in *An Ignatian Spirituality Reader*, ed. Traub, 51. To cultivate the habit of discernment, Saint Ignatius details a simple method of daily prayer called the *examen*, or examination of consciousness, which involves five basic steps: (1) Be still, ask God to be with you. (2) Recall the events of the day for which you feel grateful. (3) Review the day seeking awareness of where you accepted or turned away from God's grace in your encounters with others; consider where you were able to be your true self, or where you turned away from your true self, wore a false mask, or manipulated others. (4) Ask forgiveness for any sins, failures, and missed opportunities to build loving relationships. (5) Ask for the grace to follow God more closely the next day. From an Ignatian standpoint, the greatest danger to the spiritual life is not necessarily sin or failure, an inevitable part of the human journey, but getting stuck in unhealthy choices or patterns, becoming *trapped in a false script*, unable to learn and turn away from self-centered or damaging ways so as to grow more deeply into the freedom for love.

52. Rilke, *Rilke on Love and Other Difficulties*, 32.

53. Rilke, *Rilke on Love and Other Difficulties*, 32–33.

what seems to be the height of freedom may turn out to be little more than mere license to conform to another convention, void of real honesty and vulnerability, and therefore empty, "unworthy of your best possession."[54]

To be clear, for Rilke, it is not the physical pleasure of sex that is bad; rather "the bad thing is that most people misuse and squander this experience and apply it as a stimulant at the tired spots of their lives and as distraction instead of a rallying toward exalted moments."[55] In other words, authentic sexual love—or "great sex," if you prefer, which involves a mutual knowing and embracing of the whole person—is far more pleasurable than sex used as a mere "stimulant" or "distraction" could ever be. It is, implies Rilke, the flowering of a more primordial Love, a divine Lover, who takes hold of us through another.

It is as if we are designed to play Mozart with our sex and we settle for Muzak: that canned, mechanized, vapid, flattened out *imitation* of music, piped into elevators and shopping malls as background noise, meant to move human beings passively like sheep through dead-end time on our way to somewhere else—our next purchase, our next transaction—not unlike that strangely disembodied voice on your GPS, or the soulless recording that greets you when you call the power company, which tells you repeatedly how special you are and how very important your call is to us. "I love you, let's go to bed," in such a milieu, has about as much depth and staying power as the automobile salesman who says, "Baby you're gonna *love* this car, why not let's take it out for a drive?" (And when you grow tired of this one, you can trade it in for another.)

To extend the musical metaphor, the dominant religious script seems to teach young people to regard sex with so much fear and trembling (or such highly idealized notions of marriage) that they never dare to approach the piano to learn the simplest scales. By contrast, the prevailing cultural script suggests we approach sex like the child who knows how to play "Chopsticks"—or the adult who can still *only* play "Chopsticks"—and rushes to the piano to bang out any sort of tune, simply because he or she can. Neither picture, it seems to me, is worthy of us. How can we reimagine the very "notes" with which we play our sexuality?[56]

54. Rilke, *Rilke on Love and Other Difficulties*, 33. "[For] convention has tried to make this most complicated and ultimate relationship into something easy and frivolous, has given the appearance of everyone's being able to do it. It is not so" (Rilke, *Rilke on Love and Other Difficulties*, 29).

55. Rilke, *Rilke on Love and Other Difficulties*, 34.

56. Once again, I ask the question not just from my own experience and observations but from the perspective of my students over the course of some twenty-five years, young men and women, gay and straight, who yearn for honest and thoughtful conversations around sexuality—and, if often implicitly, for guidance from adult mentors whom they trust. The observations of students themselves about "hookup culture" form the basis of Christian ethicist Jennifer Beste's book *College Hookup Culture and Christian Ethics: The Lives and Longings of Emerging Adults* (New York: Oxford University Press, 2018). Beste joins careful student ethnographic research of hookup culture "through their own eyes" with fresh theological insights into what it means to "become fully human" and to build a culture of sexual justice.

"More Than One Answer to These Questions": A Home for Straight and LGBTQ Spirituality

It may be that our first task today is to take back the word "love" from the corporate spin doctors, porn producers, and car salesmen and return it fully to the mystery of God. The Bible itself and the Christian mystical tradition offer not one image or metaphor for love but at least three—*agape, philia,* and *eros*—and even these with their various shades of meaning cannot fully contain the mystery.

The kind of love most associated with God in the Bible is *agape,* an unconditional and all-embracing love that creates and sustains all things, and which human beings, made in the divine image, are called to emulate. We are called to love even our enemies, Jesus dares to insist, not because they have earned it, or because we like them, but rather because *God* loves them without measure or merit.[57] A second form of love is *philia,* brotherly or sisterly love, the bond shared between siblings, family, and close friends or people united in a common task. It was this kind of love that seemed to flow so generously between me and Kevin and the wider circle of my childhood friends, and which carried me, like a boat on choppy waters, through my adolescence. A third kind of love celebrated by the Christian mystical tradition is *eros,* a passionate love that longs to touch and be touched, to join together what is separate, to "lose ourselves" (*ecstasis*) in communion with another.[58]

The power of love that is *eros* can flower into romantic or sexual intimacy but is by no means limited to sex. More broadly and holistically, *eros* may be described as a passion and zest for life that is fully embodied and at the same time carries us beyond ourselves, as it were, into relationships with others and with the earth. It is a sense of being at home in the universe.[59] The Song of Songs gives us the clearest expression of an explicitly sexual *eros* in the Bible,

57. In the Jewish Scriptures the analogous term is *chesed,* Hebrew for "loving-kindness," "covenantal love," the ground of Jewish ethics and the human vocation to *tikkun olam,* a beautiful Hebrew phrase meaning "to repair the world"—the goal or grace-empowered end (*telos*) of human life as fashioned in the divine image.

58. The resources on *eros* in the Christian mystical tradition are rich, deep, and vast. A few good primers include Ronald Rolheiser, *The Holy Longing*; Denys Turner, *Eros and Allegory: Medieval Exegesis of the Song of Songs* (Kalamazoo, MI: Cistercian, 1995); Gillian T. W. Ahlgren, "Julian of Norwich's Theology of Eros," *Spiritus* 5, no. 1 (2005): 37–53; George A. Kilcourse, "Spirituality as the Freedom to Channel Eros," *The Merton Annual* 5 (2000): 7–15; Andrew Greeley, "Sacred Desire," in *The Catholic Imagination* (Berkeley: University of California, 2000), 55–87.

59. As the lives of many single and celibate persons bear out, a celibate person can certainly be an erotic person. Indeed, while scholarly consensus suggests that Jesus was unmarried, it is no stretch to observe that in his manner of being in the world Jesus incarnated *eros* powerfully in different ways. See Christopher Pramuk, *Sophia: The Hidden Christ of Thomas Merton* (Collegeville, MN: Liturgical Press, 2009), 252–56; also Andrew Greeley, *Jesus: A Meditation on His Stories and His Relationships with Women* (New York: Tom Doherty, 2007).

but a closer reading, as I have tried to suggest, reveals it to be a multivalent celebration of all three types of love at once. The dance of attraction and pursuit between the lovers in the Song (*eros*) flowers forth from their friendship (*philia*), which is at once linked to an organic sense of connection to the fecundity of the earth and the flourishing of the whole community. All of these flow generously from and into the other, created and sustained by the wellspring of divine love and creativity (*agape*).

These richly layered meanings of love in the Bible help to explain why the Song of Songs in both the Jewish and Christian traditions has been interpreted in two distinct but inseparable ways: the allegorical and the literal. First and foremost, the Song has been read as an allegory for divine/human love (*agape*), God's own desire for intimate relationship with human beings. God loves and pursues humanity with the passion (*eros*) of a lover, and vice versa. In Christianity this tradition is known as "bridal mysticism," where the "bride" or female presence in the text is read as an allegory for the church (or soul of the individual) and the "groom" is Jesus. In and through Jesus, God welcomes us to the "kiss of his mouth" with the love of an intimate companion and beloved friend (*philia*). "Bridal mysticism" runs especially strong in the monastic tradition, where monks have read the Song as an allegory for the life of prayer, their desire to give themselves completely to "love's union" with God. It may seem odd, at best, from our vantage point today, that the Song would exert such a powerful pull on celibate Christian monks. How would such erotic imagery be helpful to the spiritual lives of celibates? The answer is illuminating, I think, not just for monks but for any person who would desire a more intimate relationship with God.[60]

No interpretation of the Song has been more influential in Western Christianity than that of Bernard of Clairvaux, whose commentary on the Song of Songs—eighty-six sermons composed over a period of eighteen years—is revered as a masterpiece of medieval monastic literature.[61] Like many others before and after him, Bernard saw the Song as a sublime allegory on the love of God that can be experienced through contemplation. It was the paradigmatic text for monks because its poetry vividly describes the basis for the whole program of monastic life, that is, the pursuit of "love's union" with God, of which the monk may enjoy a sweet foretaste here below.

"Let him kiss me with kisses of his mouth!" Bernard requires no less than seven sermons to meditate on this single verse, and to find there an allegory of ascent to the sweetest (indeed, almost sexual) mystical union with Christ the

60. See Christopher Pramuk, "Sexuality, Spirituality and the 'Song of Songs,'" *America* 193 (Oct. 31, 2005): 8–12.

61. Bernard of Clairvaux, "Sermons on the Song of Songs," in Bernard of Clairvaux, *Bernard of Clairvaux: Selected Works*, trans. Gillian R. Evans, *Classics of Western Spirituality* (Mahwah, NJ: Paulist Press, 1987), 207–78.

bridegroom, the mediator between the sinner's soul and the hidden God. Echoing the sensual imagery of the Song itself, Bernard provokes the imagination with comparably vivid physical imagery. "How then, should you go?" he asks. "Should you who were recently covered in filth touch the holy lips? . . . Let your way be by the hand. The hand first touches you and lifts you up." Bernard invites his hearers (his fellow monks) to imagine being grasped and bodily lifted out of the mud by the merciful hand of Jesus, and finally drawn to Jesus' mouth, "which is so divinely beautiful, fearing and trembling, not only to gaze on it, but even to kiss it."[62]

The affection Bernard conveys here for Jesus is wholly innocent and beautiful, with none of the embarrassment or homoerotic associations that might give modern readers pause. Rarely does one find—save, I think, in the African American spirituals—such an intimate fixation on the loveliness of the man Jesus. "Even the beauty of angels seems tedious to me. *For my Jesus outshines them so far in his beauty and loveliness.* That is why I ask him, not any other angel or man, to kiss me with the kiss of his mouth."[63] In monastic spirituality, this kind of physical sense data is painted on the imagination and translates readily into the "spiritual senses" of affection and desire for God, a restlessness (or *eros*, nongenitally expressed) that infuses the whole person. The sensory imagination—what Bernard calls "the book of experience"[64]— opens the door to those deepest places where we remain a mystery even to ourselves. It is through the bodily senses, insists Bernard, that we come to know and "taste" intimately the presence of God in our whole being. "Only through the body does the way, the ascent to the life of blessedness, lie open to us."[65]

But all of this begs the question: Why not a "homoerotic" reading of the Song? Why not also embrace a more literal interpretation that celebrates the unitive power of sexuality as such and the flowering of erotic love in diverse forms, forms analogous to the traditional Christian ideal of heterosexual love, but not circumscribed by that single ideal? To ask another way, if the mystery of God and God's love is revealed to us through the book of human experience, *whose* experience has a favored seat at the table? Despite the distinctive cultural (and agricultural) imagery that may render the Song of Songs a bit foreign or exotic to our postmodern (and urban-industrialized) ears, arguably it would not be too difficult today for a heterosexual woman or man to "read themselves into" the Song, to feel "at home" in the text, even to pray with it, as I have. "For Love is strong as Death, / longing is fierce as Sheol. / Its arrows are arrows of fire, /

62. Bernard, "Sermons on the Song of Songs," 223–25.

63. Bernard, "Sermons on the Song of Songs," 219–20.

64. Bernard, "Sermons on the Song of Songs," 221.

65. Bernard, "Sermons on the Song of Songs," 227.

flames of the divine" (Song 8:6). But are not the "arrows of fire" that scorch the hearts of LGBTQ persons also "flames of the divine"?[66]

How better to explain the deep resonance between the Song of Songs and the music of the Indigo Girls, to cite one of a thousand possible examples? Would God have Emily Saliers and Amy Ray express their capacity for love, the very imprint of the divine *eros* in them, in some other way? To be clear, this is not to baptize every form or expression of sexual desire as good and life-giving. Indeed, there are infantile, self-centered, and self-destructive forms of sexual expression (like banging out Chopsticks on the piano) that are not beautiful, life-affirming, or worthy of any person, LGBTQ or straight. It is to suggest that the fire of *eros* is no more and no less dangerous in LGBTQ forms of expression than in its manifold heterosexual aberrations. Perhaps the time has come for straight people of faith like myself to sit humbly and quietly before LGBTQ persons and ask them to share with us, face to face, stories from their own "book of experience." Might not the Song of Songs be reclaimed as a spiritual home for them, too, as a place for celebrating "the festival of *their* competency" under the shared horizon of God's mystery and grace?

To be sure, narrowly literal or fundamentalist readings of the Song might use the text as a kind of biblical "proof-text" for heteronormativity, thus providing yet another scriptural hammer to suppress LGBTQ advocacy and reject—or worse, try to "fix"—actual LGBTQ persons. More poetical and thematic readings of the Song of Songs, by contrast, as I've suggested here, can open up imaginative space within the horizon of biblical interpretation to consider the potentially sacramental character of sexual love in LGBTQ relationships. In the meantime, there is no question that LGBTQ persons themselves are (and have long been) writing their own "sacred texts" in the form of poetry, film, queer theology, political activism, and so forth. Many have long given up on Christian

66. Sexual diversity raises the dilemma of difference in ways more primordial than racial and cultural difference, insofar as it manifests differences that are biologically inscribed and not just, or primarily, socially constructed. The relevant Church teachings, available at *www.usccb.org*, include *The Catechism of the Catholic Church*, nos. 2331–400; *Homosexualitatis problema* (*On the Pastoral Care of Homosexual Persons*, 1986); and *Always Our Children: A Pastoral Message to Parents of Homosexual Children and Suggestions for Pastoral Ministers* (1997). Especially influential among younger Catholics are John Paul II's conferences on the "theology of the body." For a balanced summary of the issues at play in contemporary debates surrounding Church teachings on sexuality, see Beth Haile, "Catechism Commentary: The Sixth Commandment," Catholic Moral Theology, June 3, 2012, *http://catholicmoraltheology.com/catechism-commentary-the-sixth-commandment/*. Retired Detroit Bishop Thomas Gumbleton is one of a very few US Catholic bishops to directly address the existential dilemma of homosexual persons in the Church and to do so with profound theological insight and pastoral sensitivity. See Thomas Gumbleton, "A Call to Listen: The Church's Pastoral and Theological Response to Gays and Lesbians," in *Sexual Diversity and Catholicism: Toward the Development of Moral Theology*, ed. Patricia Beattie Jung with Joseph Andrew Coray (Collegeville, MN: Liturgical Press, 2001), 3–21. For my own attempts to navigate these questions theologically, see Christopher Pramuk, "Imagination and Difference: Beyond Essentialism in Church Teaching and Practice," *New Theology Review* 26, no. 1 (2013): 42–52, and references therein.

churches, the Bible, and religious believers whose every message says to them that they are not really welcome as they are.

In the Catholic Church, Pope Francis has broken through some important barriers on the way to creating a more inclusive and welcoming environment in the Church, as have others. Yet theologically the Church has yet to articulate a fundamental theological anthropology in which sexual and gender diversity has a place *in God*.[67] In whose image are gays and lesbians made? Much in the spirit of Pope Francis, Christian blogger Matt Carter suggests that the only *Christian* way forward toward healing and wholeness is encounter and "radical acceptance" of LGBTQ persons.[68]

In sum, without in any way diminishing the riches that have been gathered from allegorical readings of the Song of Songs, one may still insist on the value of more literal and thematic readings for people of our time, and perhaps especially for young people. To recall Rilke, the Song reflects a much-neglected communal wisdom for teaching us how to "arrange the flowers" that are the gift of our sexuality in a number of powerful ways.

First, the Song emphasizes the ripening of a sexual love that is built on the foundation of *friendship*: "Such is my lover, and such my friend" (5:16), the woman declares, with evident gratitude for the gift, an atmosphere in which both she and her lover are free to be and become their authentic selves within the community. (It is the Prince of Darkness—not God, nor my friends, nor my beloved—who requires me to play with masks.) Second, the Song paints a picture of a loving relationship that flows from *mutual respect and commitment*: "My lover belongs to me and I to him" (2:16; cf. 6:3). This is not a transactional

67. Queer theology as such remains marginal if not wholly excluded from the normative canons of Roman Catholic theology, though some inroads have been made into the academy and in popular US Catholic consciousness. Notable authors include Catholic priest James Alison, *Faith beyond Resentment* (New York: Crossroad, 2001), and *On Being Liked* (New York: Crossroad, 2004); British author and popular blogger Andrew Sullivan, *Virtually Normal* (New York: Knopf, 1996), and *Love Undetectable* (New York: Knopf, 1999); and openly lesbian and celibate spiritual writer Eve Tushnet, *Gay and Catholic* (Notre Dame, IN: Ave Maria, 2014). Influential theologians beyond the Catholic realm include Marcella Althaus-Reid, *Indecent Theology* (New York: Routledge, 2001), and *The Queer God* (New York: Routledge, 2003); and Patrick S. Cheng, *Radical Love* (New York: Seabury, 2011), and *Rainbow Theology* (New York: Seabury, 2013). For a consideration of Pope Francis's statements early in his papacy, see Christopher Pramuk, "God Accompanies Persons: Thomas Merton and Pope Francis on Gender and Sexual Diversity," *The Merton Annual* 28 (2015): 71–87, and references therein.

68. "Real relationships," says Carter, "have to be without agenda." See Matt Carter, "How Can the Church Overcome Its Bad Reputation? A 'Radical Acceptance of Other People,'" interview with Todd VanDerWerff, *Vox*, November 29, 2017, *https://www.vox.com/2017/11/29/16716000/christian -bad-reputation-matt-carter-podcast-interview*. Likewise, Jesuit Fr. James Martin, perhaps the most widely followed Catholic spiritual writer and public figure in the United States today (excepting the pope), makes an eloquent case for unconditional pastoral inclusion without attempting to address the theological issues at play. See his *Building a Bridge: How the Catholic Church and the LGBT Community Can Enter into a Relationship of Respect, Compassion and Sensitivity* (New York: HarperCollins, 2017).

arrangement, "friends with benefits," an unspoken escape clause for both parties built into the contract. Rather—and here is the third point—the Song celebrates a flowering of love over time that protects the *solitude* of each partner, honors their *mutual vulnerability*, and counsels the wisdom of *patience*: "I adjure you, Daughters of Jerusalem, . . . Do not awaken or stir up love / until it is ready" (3:5). Implicit here is the affirmation of individual conscience, self-care, and mature *spiritual discernment*: the capacity within each of us to know when and under what conditions a particular path is life-giving for us and to surround ourselves with others who share these core human values.

"Deep Waters": Nurturing the Uncontainable Mystery

Let me step back for a moment and bring our conversation into the concrete present. My sister is a campus minister at a large, all-male Catholic high school in Louisville, Kentucky. A big part of her job for some twenty-five years has been leading retreats for students, where a group of twenty-five or thirty students leave campus and spend three or four days together at a retreat center in the woods or some rural environs, away from the noise and rush of the city. For a great many students it can be a life-changing experience. Like a lot of people today, many of these young men on the brink of adulthood have spent little time in nature or more rural environments; much less have they had opportunities to share their stories, questions, and dreams with their peers in such a contemplative, slowed-down time and space, where nothing else is asked of them, and they can "just be." I suppose it is not a little like those twilight drives down to the Kentucky River with my friends. But when I asked my sister about how she uses music during these retreats, her answer kind of blew me away.

> Music is an integral part of the retreats I direct because it doesn't discriminate between listeners. EVERY song has the potential to awaken something in the listener if we are but open to it. And then that opens us up to each other—and the desperately needed connections we ache for. Each person can hear the same song differently depending on his or her perspective, life experience, and the soul-longing in which they currently reside. It's like that moment when the song I really needed to hear just happens to come up on the Pandora playlist and I feel *known*, even as my kid is in the backseat yelling "Skip this song!" Music speaks to us; finds us in the darkness of the masks we wear; makes us feel seen and heard in a way that transcends language, gender, age, education, etc.
>
> Nature has the same Presence and power to reach our authentic Self and reflect that back to us with unconditional acceptance, like a

boundless knowing embrace. Poetry can have the same power, though the language has equal potential to be both barrier and container in the search for self—it can confound and keep us at a distance, and it can create a container to hold all that we feel and ARE and long to be.[69]

Music, nature, and poetry: it occurs to me that the Song of Songs invokes all three of these elements that reach behind the "masks we wear" and speak powerfully to the "soul-longing" of who we are and long to be. Can the Song of Songs begin to help us reimagine the music of our sexuality?

All of this begs at least one more question, by no means a minor one. What of the power of our sex to create new life, which many would say, not least the church, is the very summit of loving sexuality and one of the highest sacraments of the divine image in us? While a surface reading of the Song of Songs appears to be silent on this question, the linkage everywhere in the poem between the flowering of sexual love in the human partners and the fertility of the earth suggests a deep recognition of the latent power of young love to bring forth new life. Might not this be part of the communal wisdom of the Song that would both celebrate love's union *and* at once counsel patience? The gift of new life and the power of its nurturing is a grace beyond measure, not only for the lovers but for the whole community. Keeping in mind the Song's likely origins as a performative text, in such a context the Song seems implicitly to ask: Has the relationship come into its fullness such that we—the couple and the community—are ready to receive the gift of new life? In its celebration of the earth's fruitfulness alongside human sexuality, the Song seems to offer a resounding (if implicit) "Yes, we are ready!" to receive the fruits of love's union toward the flourishing of the whole community, even while the Song celebrates the delights of sexual union as such, without explicit reference to women's experience of childbearing or mothering.[70]

Perhaps much in the way that our images of erotic love need to be enlarged beyond "having sex," so also do our images of motherhood and fatherhood need to be enlarged beyond "procreation" in the strict biological sense. Rilke expands the idea of "maternity"—this great "secret, of which the world is full"—to include men, animals, and plants, and the whole of creation.

> Perhaps over all there is a great motherhood, as common longing. . . . And even in the man there is motherhood, it seems to me, physical and spiritual; his procreating is also a kind of giving birth, and

69. Mary (Pramuk) Emrich, email exchange with the author, December 2017.

70. As we will see in chapter 8, the Catholic imagination tends to join nature, fertility, and divinity in the figure of Mary, the mother of Jesus and "Mother of God," though occasional mystics such as Julian of Norwich look even to Jesus—and certainly God—as a mother figure. See Andrew Greeley, "The Mother Love of God," in *The Catholic Imagination*, 89–108.

giving birth it is when he creates out of inmost fullness. And perhaps the sexes are more related than we think, and the great renewal of the world will perhaps consist in this, that man and [woman] . . . will seek each other not as opposites but as brother and sister, as neighbors, and will come together as *human beings*, in order simply, seriously and patiently to bear in common the difficult sex that has been laid upon them.[71]

To truly flourish, says Rilke—to approach "the great renewal of the world"—would be to encounter one another "not as opposites" but as human beings, as neighbors, each capable of giving birth to life and love out of our "inmost fullness." By contrast, "To be in the margin is to be part of the whole but outside the main body," writes bell hooks. It is "a place of systematic devaluing," adds Elizabeth Johnson.[72] As one undergraduate puts it, quite poignantly, "The problem with institutions that don't do all in their power to show their love and care for the actual whole person—not just the straight, white, male whole person—is that they remain unsafe for the rest of us."[73]

Where, then, does this leave us with respect to sex, gender, and fertility? Can sexual loving be "fruitful" and "life-giving" without producing children? Can men embody "motherly" or "sisterly" qualities in their relationships with women, with children, with other men? Are women and women's bodies valued solely or preeminently for their childbearing capacity? These are enormously important and complex questions, especially in view of the myriad ways that our highly utilitarian and capitalist culture—and the rapid advance of reproductive technologies—often ignores the potentially grave consequences of separating love and sexual intimacy from procreation. It is crucial, in my view, not to ignore the wisdom of the world's religious traditions on sexuality in our haste to bypass these most difficult moral, ethical, and spiritual questions. When it comes to our sex and the (technological) capacity to create and shape life, religion rightly reminds us that we are indeed playing with fire, the very power of divinity.[74]

At the same time, rather than looking only to religion, science, philosophy, or other external authorities for definitive answers—"We go to the Bible, we go through the workout / We read up on revival and we stand up for the

71. Rilke, *Rilke on Love and Other Difficulties*, 34–35.

72. Cited in Johnson, *Women, Earth and Creator Spirit*, 24.

73. From *Flourishing*, 2017, a student literary magazine published at Regis University, Denver, Colorado; used with permission.

74. The story of the Fall (Gen. 2–3) is predicated on the presumption, voiced by the serpent, that "you will be like God." Through myth and symbol the story suggests that it is "Satan," the enemy of human flourishing, who tempts us to play at what we are not, to wear the false mask, to succumb to self-idolatry. To recall Aldo Leopold (n. 48 above), it is no easy or simple matter to discern which scientific, reproductive, genetic, or biotechnological advances will tend to "preserve the integrity, stability, and beauty of the life community," and which will tend "to do otherwise."

lookout"[75]—here again I believe we are also called, as every new generation is called, to search the pages of our own "book of experience," to share with one another the wisdom and grace that we discover there, and following as best we can the inner voice of conscience, to discern the way forward. What can we learn, for example, from the witness of infertile couples who choose to adopt? (Or choose not to adopt?) What can gay couples teach us about the beauty and fierceness of commitment in a culture that has so long required them to keep their love in the shadows? What can we learn from women and men in the church who have made an option for consecrated celibacy as a joyful witness and life-giving vocation? How many surprising ways can the synergy of love, generated within a couple's embrace, be turned outward in service to the life of the world?

To sing, as the Indigo Girls do, that "there's more than one answer to these questions / pointing me in a crooked line,"[76] seems to me an implicit celebration of all those lives that do not conform neatly to what cultural or religious narratives deem "normal," yet witness to the power of love to bring healing and hope to a suffering world. "At present we see indistinctly, as in a mirror, but then face to face," confesses Saint Paul in his famous hymn to love. "At present I know partially; then I shall know fully, as I am fully known" (1 Cor. 13:12). If we are going to err in our limited grasp of the great mystery at the heart of all things, let us err freely on the side of generosity and inclusion, for to be cut off from the social body is a kind of death that no person should suffer on this side of life, not while we still have a chance to accompany them.

The witness of ten thousand hidden saints can teach us to trust in the hand of grace moving quietly within our diverse life stories, painting in lines crooked and straight, drawing us ever more deeply into the mystery of Love, the love that guides the moon and stars.

Addendum and Additional Resources

Understandably, few topics capture my students' interest more than sexuality and its relationship to competing ideas about sex and love, faith and spirituality that many of us have absorbed from society, on one side, and from the church or religious teachings, on the other.

Indigo Girls are a fascinating case study in intersectionality, both in the technical sociological sense of that term and in the spiritual. Sadly too many of us have been taught that religious faith and sexual identity and expression are like oil and water. The pairing at best elicits embarrassment, and not infrequently, shame. To

75. Indigo Girls, "Closer to Fine," *Indigo Girls.*

76. Indigo Girls, "Closer to Fine."

put it frankly, most of my students are surprised, if not shocked, when I suggest that there might be such a thing as a healthy "spirituality of sexuality." Indeed the "intersectionality" of God-talk and sex-talk comes to many as a big (and welcome) surprise. That the Indigo Girls speak openly about their faith *and* their sexuality is a revelation. Even more, that the Bible would contain some of the most passionate love poetry known to humankind feels to many like a kind of liberation. "You mean I don't have to keep this part of my life, my identity, my desires to love and be loved, hidden from God?"

At the same time that we engage ancient resources of religious wisdom such as the Song of Songs, it is also crucial to develop critical tools for evaluating assumptions about sex, gender, power, and love that we absorb from the prevailing culture. Though unsettling to watch, I know of no better resource than Sut Jhally's *Dreamworlds 3* for raising awareness of pop music and media culture images around sexuality. Catholic ethicist Jennifer Beste offers a lucid ethnographic account of college hookup culture, and borrows from Johann Baptist Metz (see chapter 6) to advance a deeply Christ-haunted vision of human personhood, gender, and sexuality. James Alison, Fr. James Martin, Eve Tushnet, Andrew Sullivan, and Bishop Thomas Gumbleton explore the contested place of gays and lesbians in the Catholic Church, and womanist theologian and pastor Monica Coleman powerfully chronicles the juxtaposition of faith and mental illness in her life's journey. The website Feminist Studies in Religion, *www. feminisminreligion.com*, is a rich resource for feminist theological conversations on these topics, as is Women in Theology, *www.womenintheology.org*.

Books

Alison, James. *Faith beyond Resentment: Fragments Catholic and Gay* (New York: Crossroad, 2001).

Bernard of Clairvaux. "Sermons on *The Song of Songs*." In Bernard of Clairvaux, *Bernard of Clairvaux: Selected Works*, edited and translated by Gillian R. Evans, 207–78. Classics of Western Spirituality. Mahwah, NJ: Paulist Press, 1987.

Beste, Jennifer. *College Hookup Culture and Christian Ethics: The Lives and Longings of Emerging Adults*. New York: Oxford University Press, 2018.

Coleman, Monica A. *Bipolar Faith: A Black Woman's Journey with Depression and Faith*. Minneapolis: Fortress, 2016.

Jones, Serene. *Trauma + Grace: Theology in a Ruptured World*. Louisville: Westminster John Knox, 2009.

Martin, James. *Building a Bridge: How the Catholic Church and the LGBT Community Can Enter into a Relationship of Respect, Compassion, and Sensitivity*. New York: HarperCollins, 2017.

Rilke, Rainer Maria. *Rilke on Love and Other Difficulties: Translations and Considerations*. Translated by J. L. Mood. New York: Norton, 1975.

Rolheiser, Ronald. *The Holy Longing: The Search for a Christian Spirituality*. New York: Image, 1999.

Saliers, Don, and Emily Saliers. *A Song to Sing, A Life to Live: Reflections on Music as Spiritual Practice*. San Francisco: Wiley, 2005.

Sullivan, Andrew. *Love Undetectable: Notes on Friendship, Sex, and Survival*. New York: Knopf, 1999.

Tushnet, Eve. *Gay and Catholic: Accepting My Sexuality, Finding Community, Living My Faith*. Notre Dame, IN: Ave Maria, 2014.

Articles and Essays

Gilchrist, Tracy E. "Coming of Age with the Indigo Girls." *The Advocate*, July 13, 2018. *Https://www.advocate.com/music/2018/7/13/coming-age-indigo-girls*.

Greeley, Andrew. "Sacred Desire." In *The Catholic Imagination*, 55–87. Berkeley: University of California, 2000.

Gumbleton, Thomas. "A Call to Listen: The Church's Pastoral and Theological Response to Gays and Lesbians." In *Sexual Diversity and Catholicism: Toward the Development of Moral Theology*, edited by Patricia Beattie Jung with Joseph Andrew Coray, 3–21. Collegeville, MN: Liturgical Press, 2001.

Pramuk, Christopher. "Imagination and Difference: Beyond Essentialism in Church Teaching and Practice." *New Theology Review* 26, no. 1 (2013): 42–52.

———. "Sexuality, Spirituality, and the Song of Songs." *America* 193 (Oct. 31, 2005): 8–12.

Music, Audio, and Visual

Dreamworlds 3: Desire, Sex & Power in Music Video. Directed by Sut Jhally. Media Education, 2007.

The Mask You Live In. Directed by Jennifer Siebel Newsom. Virgil Films, 2016.

Ray, Amy, and Emily Saliers. "Music and Finding God in Church and Smoky Bars." Interview with Krista Tippett. *On Being*. November 25, 2015. *Https://onbeing.org/programs/indigo-girls-music-and-finding-god-in-church-and-smoky-bars/*.

"Sexuality and Ignatian Spirituality." *Https://www.youtube.com/watch?v=eY82h FVDkMg*. Video resource from the Department of Theology faculty and Jesuits at Xavier University.

Tough Guise: Violence, Media, and the Crisis in Masculinity. Directed by Jackson Katz. Media Education, 1999.

Winwood, Lily, with Steve Winwood. "Higher Love." *Https://www.youtube.com/watch?v=CsS4xlHKnpw*.

CHAPTER

"Images That Return Our Love"

William Hart McNichols: A Theology in Lines and Colors

If imagination is the creative power that perceives the basic resemblances between things, then all sources, no matter how exotic, resonate in me as well. Imagination is fed by metaphor. Religion and the Scriptures, if perceived as such, are not a fundamentalist prison but an open field for visionary inspiration.

—*Claire Nicolas White*

Christ flees when we try to embrace him with the intellect.

—*Saint Bonaventure*

If the spiritual life is marked by a certain yearning and restlessness to belong, to live in communion with someone or something beyond ourselves; if for many young people the journey toward love and social belonging is littered with broken masks, moments of dishonesty with self and others, long passages of confusion and searching aloneness; if the primordial questions of youth—Who am I? To whom do I belong?—are often drowned out by the relentless noise and glitter of the culture industry, selling us a thousand happy images of ourselves adorned in its products; then perhaps the evolution toward a more authentic and life-giving spirituality involves "coming home" into the mystery of a wider and deeper Love, the gradual realization of a core identity that *one already is*, and that one is beginning, *always beginning*, to discover. "Our hearts are restless until they rest in You," Saint Augustine famously confessed. If spirituality is about "what we do with our unrest," as suggested in chapter 7, it is also, paradoxically, about "coming home to rest" in the presence of One whose love already embraces every person unconditionally. Such is the Mother and Father Love of God, say the poets and prophets of the Bible. Such is the realization of the Divine

CASE STUDY

William Hart McNichols, iconography

chesed or *agape*, a love which shines, as it were, from within all things, revealed as the world's beauty and goodness. But who can believe it? Who has the eyes to see?

Throughout this book I have suggested that artists, whether by disposition or through the sheer bloody discipline of their craft, "see things more clearly than the rest of us."[1] Even artists who cannot physically see, like Stevie Wonder or, for a time, John Howard Griffin (chapter 5), nevertheless "penetrate into the illumination of being more intimately than do the rest of us. They want us to see what they can see so that we can share in their illumination."[2] It is not that the "rest of us" do not have the capacity for such vision. The artistic disposition, as I have argued, beats in our very blood, whether we want it to or not. To recall the American painter Robert Henri, whose ruminations on the "art spirit" we considered in chapter 1, "Art when really understood is the province of every human being. It is not an outside, extra thing."[3] It is not that most of us do not share the artist's capacity for wonder and radical amazement; rather, to recall Heschel, it is the artist who relentlessly cultivates the *will to wonder*, a fierce determination to gaze beneath the surface of things so that the "rest of us" might realize what we know intuitively, but have forgotten.[4]

"When Van Gogh painted his golden fields," observes Andrew Greeley, "he was endeavoring to share with us his instinctive vision of the fields and open us to their illumination."[5] Of course that we will be so opened as we gaze upon Van Gogh's golden fields is not inevitable, nor strictly logical—though plenty of theorists have tried to explain just why and how we are moved by great works of art. "Rather it is an existential tendency that is built into the structure of the human condition,"[6] says Greeley, echoing Robert Henri.

And yet this *capax Dei*, this wonderful capacity to perceive the sacred embedded in the ordinary, has to be cultivated. It is the artist who midwives our perception of the hidden God in the depths of a beautiful but broken world. Indeed in a chaotic world that *despairs* of God, the artist's task, we might say, is both priestly and prophetic: she "creates the transcendental and attests to its presence." "A little dust of this world, a board, a few colors, a few lines—and there is beauty . . . *a vision of things which cannot be seen*."[7]

1. Andrew Greeley, "The Apologetics of Beauty," *America* 183 (Sept. 16, 2000): 11.

2. Greeley, "The Apologetics of Beauty," 11.

3. Robert Henri, *The Art Spirit* (1923; repr., New York: Basic Books, 2007), 11.

4. Abraham Joshua Heschel, *God in Search of Man* (New York: Farrar, Straus and Cudahy, 1955), 117; see chapter 1.

5. Greeley, "The Apologetics of Beauty," 11.

6. Greeley, "The Apologetics of Beauty," 11.

7. Paul Evdokimov, *Woman and the Salvation of the World: A Christian Anthropology on the Charisms of Women*, trans. Anthony P. Gythiel (1949; repr., Crestwood, NY: St. Vladimir's Seminary Press, 1994), 130; alluding to Heb. 11:1, where faith is described as "the realization of what is hoped for and evidence of things not seen."

Alongside beauty, of course, there is violence and hatred and ugliness, a penchant for the demonic that lurks in the human heart and explodes across the jagged edges of history. Often the most powerful art—think of Michaelangelo's *Pieta*— is that which holds both human realities, sin and grace, trauma and beauty, in a single field of vision. If there is a God, then she is hidden behind a veil of humility—like Mary, mourning over the broken body of her dead son; like Joseph, shepherding his wife and child away from the murderous Herod and across the Egyptian desert; like Jesus, entering Jerusalem on a mule, days later to be nailed to the cross. The Christ of our times, wrote Thomas Merton in 1953, is "the Christ of the bombed city and of the concentration camp. We have seen Him and we know Him well."[8] If God *is*, then God is *inseparable* from the world's suffering.

"The glory of God is the human being fully alive," said Saint Irenaeus; yet the eye of the artist perceives the glory of God even, if not especially, in our radical suffering, vulnerability, and need. Thus Michaelangelo's *Pieta*, miraculously realized from a massive block of stone, is one of the most sublime morphological images yet created of the Mother Love of God in human form; just as Rembrandt's most famous painting, *The Return of the Prodigal Son*, dares us to ponder the very essence of God the Father as Mercy. Could God's love really be so scandalously generous? Both works give us a vision of things that cannot be seen, "sign-posts on the way to what may be."[9]

"Windows to the Sacred": The Divine Image in Human Form

The bulk of our case studies up to now have come from the realm of music. In this chapter we turn to the visual arts, and in particular, the highly distinctive form of religious art known as iconography, historically predominant in the Eastern Orthodox traditions but increasingly finding a home in the lives and churches of Western Christians and Roman Catholics.

Growing up as a Catholic, I am far more accustomed to sacred spaces filled with sculptures and stained glass than with icons. Indeed when I was younger and would stumble across an icon, perhaps in a church history book or more rarely in someone's house, the faces gazing back at me from their gold-leafed surfaces seemed strange and exotic, somewhat rigid, even a bit inhuman. Icons are often described as "windows to the sacred." Later in life would I experience this, unexpectedly, but as a younger man, I would have found it difficult to pray before icons. The people in them seemed not quite to be people; they were too

8. Thomas Merton, *Bread in the Wilderness* (New York: New Directions, 1953), 1.

9. Henri, *The Art Spirit*, 9.

otherworldly, not "realistic." They seemed to come, as it were, from the other side. Later I would understand that this visual dissonance is precisely the point.[10]

By their very nature icons attempt to do what is logically impossible: to unite the unportrayability and portrayability of God, whose presence is both hidden and manifest in the world, shining, as it were, from within all things, alight in the faces of human beings.[11] The icon for the Orthodox is not just a religious painting, a human artifact, a symbolic representation; it is also a bearer of God's Presence, a portal into the mystery of what Christians call Incarnation: the revolutionary claim that the very "image and likeness of God" dwells in every person. Thus the icon is a medium, so to speak, for the Divine Energy (we might call it Love) that pulses from within our sensual perception of the world, like the "illumination" we suddenly feel when gazing on Van Gogh's golden fields: "The countenance on the icon shines forth, and this radiation enters our spiritual center, our heart, illuminating it."[12]

As I would learn, the icon is not strictly a painting; rather it is better described as *a theology* laid down in lines and colors. Indeed religious icons are not said to be "painted," they are *written*, and the art of writing icons, the vocation of becoming an iconographer, is a carefully guarded tradition, passed down methodically and prayerfully from teacher to student. In sum, icons are not easy to "see" because they "speak more to our inner than to our outer senses. They speak to the heart that searches for God."[13]

Yet even for those accustomed to praying with icons, there is no getting around their peculiar dissonance, the fact that two seeming contradictory realities are recognized at the same time: (1) the imagelessness and therefore unportrayability of God in any human form and (2) God's "imaging according to us"[14]

10. Theologian John Dadosky notes, "Often people dismiss the icon because they think it is supposed to be a portrait. On the contrary, icons are meant to mediate a profound aspect of their subject's life and meaning—a meaning that can have a significant effect on subsequent individuals and communities. An original or genuine icon is believed to mediate the actual person in some mysterious way." See John Dadosky, *Image to Insight: The Art of William Hart McNichols*, with art by William Hart McNichols and foreword by Mirabai Starr (Albuquerque: University of New Mexico, 2018), 2.

11. Sergius Bulgakov, *Icons and the Name of God*, trans. Boris Jakim (Grand Rapids: Eerdmans, 2012), 25–26, 36.

12. Boris Jakim, "Translator's Introduction," in Bulgakov, *Icons and the Name of God*, vii.

13. Henri J. M. Nouwen, *Behold the Beauty of the Lord: Praying with Icons* (Notre Dame, IN: Ave Maria, 2007), 24.

14. Bulgakov, *Icons and the Name of God*, 26. By comparison to Western doctrine, heavily shaped by Augustine's doctrine of original sin, in Eastern Orthodoxy the Incarnation supports a highly exalted view of human nature such that human beings, like Christ, have the capacity to "become divine," as it were, a process referred to as divinization, *theōsis*, or deification. In the formulation of Saint Athanasius, "He became human so that we might become divine." Indeed, there is a sense in Orthodoxy in which the gift of deification "has already been planted in human soil" through the Incarnation: "A certain ontological reformation or regeneration of human nature was *already* accomplished in Christ, since human nature was given back its essential character of being in the image of God, i.e., of being in communion with God." J. D. Kornblatt and R. F. Gustafson, *Russian Religious*

through the mystery of Incarnation, Emmanuel, God-With-Us. If we emphasize only the former, and reject the making of any representations of the divine, then "God" becomes an abstraction, unreachable in any terms familiar to us; if we emphasize too much the latter, we risk idolatry, identifying "God" too directly with ourselves and with the world as centered on human experience. Icons thus traverse the knife's edge of Christianity's central claim, a scandal to some and stumbling block to many: that God, the creator of the universe, would "empty" Godself in Love to become one with the world.

The word "gospel" means "good news." Perhaps resistance to this central Christian mystery comes in the suspicion that it is too good to be true! Still, for my part, the dissonance I felt in gazing on icons was not purely cognitive or theological so much as it was cultural and aesthetic. Accustomed to the more "realistic" style of Western art, Eastern iconography to my eyes was a bit unsettling. Its imagery seemed to *paint over* the messiness of life as it really is in favor of highly idealized representations of the human world and the church. It smelled to me of Gnosticism, a suspicion of matter and the flesh, an escape, rather than an illumination.[15]

The Passion of Matthew Shepard: An Introduction to McNichols's Work

I have since come to see that I was wrong about icons, or better, that my reticence before them was misplaced. The dilemma was resolved when I began to see them not through my own culturally conditioned eyes but rather as they are meant to be seen, as "the presencing of the divine in and through the material form."[16] This required a fundamental shift in my default manner of seeing, a pedagogy, as it were, of seeing through the eyes of the heart. And to effect this shift, it seems, I needed a teacher.

I will not soon forget the first time I saw an icon written by William Hart McNichols, or Fr. Bill, as he is known to most. Though it is not technically an icon—I would eventually learn of the distinction in his body of work between

Thought (Madison, WI: University of Wisconsin Press, 1996), 12. Iconography seeks to make visible this mystery of divinized humanity. "The fact that the image of God is the image of man and thus of the whole world is what makes possible the icon as originating in theophany, in Divine revelation" (Jakim, "Translator's Introduction," viii).

15. As noted in chapter 4 (see n. 69), "Gnosticism" is a term with ancient Christian provenance, which views salvation or participation in the divine realm as an escape from the limits and moral corruption of the body and the embodied human community in history. While condemned as heretical to Christian orthodoxy, various forms of Gnosticism, which hinges on body/spirit dualism, have lived alongside and within Christian thought from the beginning.

16. Aristotle Papanikolaou, endorsement of *Icons and the Name of God*, back cover.

religious "icons" and "images"[17]—the image in question is called *The Passion of Matthew Shepard*. I invite you to locate it now, via the internet, and take a few minutes to gaze upon it.[18] By "gaze" I mean something more than "look."

To gaze is to linger *with* the image (temporally), to linger *over* its details (visually), and to allow what is seen to descend from the head into the eyes of the heart. It is not to analyze or dissect the image so much as it is to contemplate, and then, only then, to notice any thoughts, memories, or feelings that rise up in you between the subconscious and conscious mind.

Gazing upon icons can be a dangerous business, I have found, insofar as it risks shattering our complacent worldview. Matthew Shepard was a twenty-one-year-old college student living in Laramie, Wyoming, who was tortured and left to die in an open field by two attackers because he was gay. Beaten severely and strung up on a fence post, he was found eighteen hours later by a cyclist who had initially mistaken his body for a scarecrow. First responders reported that blood covered Shepard's face, save for tear streaks running down his cheeks. He died three days later. During Shepard's

William Hart McNichols, presiding at Mass, with his icon *The Risen Christ* in the background

copyright: © William Hart McNichols, http://frbillmcnichols-sacredimages.com

17. Not all of McNichols's works are "icons" in the traditional sense of representing saints officially recognized as such by the Orthodox or Catholic Church. Sacred "images," as Dadosky explains, "may be influenced by the style of icons, but they also take more liberty in expression and incorporate more contemporary images" (*Image to Insight*, 5).

18. For all the hazards of the technological milieu (chapter 4), arguably one of its more astonishing benefits is that works of art from around the world that we might otherwise never have seen are accessible via the internet. Such is the case with McNichols's icons, all of which can be viewed at his website, William Hart McNichols, *http://frbillmcnichols-sacredimages.com/*, where they are organized thematically into a series of galleries. *The Passion of Matthew Shepard* can be found under the final gallery on the home page, Drawings, Illustrations, Images-Wall Art. The word "passion" here doesn't mean "deep feeling" but refers to "suffering and death," as in the "passion of Jesus."

funeral in his hometown of Casper, Wyoming, protestors from Westboro Baptist Church in Topeka, Kansas, were on hand with placards that read, "God Hates Fags," "No Tears for Queers," and "Fag Matt in Hell."[19]

I remember the first thing that struck me so forcibly upon seeing McNichols's image for the first time is the aura of pain and at once the aura of light that surrounds Shepard's bare *red* body. The tear streaks on his cheeks seem to shine, as if refracting the glow from the orb of the moon. The fence post and a desolate field lie in the background, their recruitment as crude props for an execution reminiscent for me of Auschwitz—or Golgotha, the hillside outside Jerusalem where Jesus met his lonely death.

We might say that Fr. Bill's image moves all the contentious debates surrounding homosexuality and gender diversity from the head directly into the heart, from presumptions and principles about "gays" to the contemplation of real persons, people with names and stories no more or less beautiful than "the rest of us." For those with eyes to see, *The Passion of Matthew Shepard* breaks open our impoverished (theological) imaginations, perhaps with a shock, linking the suffering of LGBTQ persons directly with the crucifixion of Christ. Consequently the "illumination" that comes over the unsuspecting believer may be a troubling one, as it was for me, and might take the form of a question: What have I done and what have I failed to do for Christ who is still being crucified in our world? Much as in Michaelangelo's *Pieta*, here the person of Jesus, joined iconically with Shepard, beckons from behind a veil of extreme humility. Yet somehow, for me, the image still reverberates with hope. Completed in the year 2000, Fr. Bill released the image with the following dedication: "Dedicated to the Memory of the 1,470 Gay and Lesbian Youth Who Commit Suicide in the U.S. Each Year and to the Countless Others Who Are Injured or Murdered."[20]

Noted Catholic theologian John Dadosky, author of a superb recent study of McNichols's work, points out the striking resemblances between *The Passion of Matthew Shepard* and McNichols's earlier icon, "Jesus Christ Extreme Humility" (1993).[21] The latter depicts Jesus dead in an upright position just after being taken down from the cross, his head bowed gently to the right, just as Shepard's head is bowed to the right. The resemblance between the protracted rib cages in both images is also striking. In the earlier icon, the Greek letters in the halo surrounding Jesus' head read "the One Who Is," or "I Am Who Am," indicating that the crucified Christ is also God. Not incidentally,

19. Beth Loffreda, *Losing Matt Shepard: Life and Politics in the Aftermath of Anti-Gay Murder* (New York: Columbia University Press, 2000), 92; for the perspective of citizens of Laramie, see Melanie Thernstrom, "The Crucifixion of Matthew Shepard," *Vanity Fair*, March 1999, *https://www.vanityfair.com/news/1999/13/matthew-shepard-199903*.

20. Dadosky, *Image to Insight*, 135.

21. Dadosky, *Image to Insight*, 135.

Dadosky notes that when the icon "Jesus Christ: Extreme Humility" was written, it coincided "with the emerging sex abuse crisis in the Church in the early 1990s," a fact that "contributes to the gravity of the icon." Dadosky asks: "Is this icon a symbol of the Church? Of the children abused? Can we hope for new life from this crisis?"[22] Indeed, how to imagine another possible future for the Church in the wake of such profound institutional failure, human sin, and abuse of power?

The Passion of Matthew Shepard has taken on new depths of meaning for me since I have gotten to know Fr. Bill personally and have learned the outlines of his remarkable life story, the world of the artist behind the iconographic text. In fact, owing to his humility, it was mostly from others that I would learn the better part of Fr. Bill's story. For example, when he was a young Jesuit in the early 1980s, McNichols was one of a handful of priests in New York City who volunteered to minister to gay men who were dying of AIDS, then an unknown and terrifying new disease. The ministry took a heavy toll on him emotionally, physically, and spiritually, as one would expect. But the experience would also find its way into his iconography. In one especially haunting image from this period, *Francis 'Neath the Bitter Tree*, Saint Francis stands beneath Jesus suspended on the cross, his twisted, crucified body pockmarked with open sores. The words inscribed on the board above Jesus' head identify him as "AIDS leper," "drug user," and "homosexual."[23]

A beautifully conceived 2016 full-length documentary by independent filmmaker Christopher Summa about McNichols's life and work, *The Boy Who Found Gold*, draws from archival TV interviews and articles about his work with HIV-AIDS patients—then quite controversial, even among his fellow Jesuits—giving the viewer a window into his emerging sense of vocation as an iconographer in the early 1980s. "AIDS had to have a face that was compassionate," he says. "Christ had to be there, Mary had to be there—the deaths were so quick, and so fast, I kept trying to do drawings that would put Christ into it."[24]

Watching the TV footage from this period, two things stand out to me: first, just how young McNichols was—in his early thirties—yet how much he bears a

22. Dadosky, *Image to Insight*, 119. After the Boston Globe's landmark reporting on the child sex abuse crisis in 2002, McNichols spoke out about the danger of categorizing gay men and gay priests as pedophiles. This ultimately led to him leaving the Jesuits, after thirty-five years in the order. He remains a priest with faculties under the Archbishop of Santa Fe.

23. See "Francis 'neath the Bitter Tree 006," Saint Francis-Wall Art, William Hart McNichols, *http://frbillmcnichols-sacredimages.com/featured/francis-neath-the-bitter-tree-006-william-hart-mcnichols .html.* Catholic theologian M. Shawn Copeland likewise identifies the "marked" and "broken" body of gays and lesbians with the broken body of Christ. See her *Enfleshing Freedom: Body, Race, and Being* (Minneapolis: Fortress, 2010), 55–84.

24. *The Boy Who Found Gold: A Journey into the Art and Spirit of William Hart McNichols,* dir. Christopher Summa (Dramaticus Films, 2016), *http://theboywhofoundgold.com/,* here and subsequent quotes in this paragraph.

wisdom belying his youth. And second, just how fierce, and fiercely gentle, was his witness to God's love for all human beings, especially those on the margins: "God is giving the church an opportunity to love him with a different face," he says in one interview, as an elder journalist listens in rapt attention. "Will you love me if I look like this? How much will you love?" The picture that emerges of Fr. Bill's life story in *The Boy Who Found Gold* becomes itself a kind of icon of compassion and solidarity among the most marginalized peoples of our time.

Let me risk a few more thoughts, a bit more personal, about *The Passion of Matthew Shepard*, a reproduction of which has hung over my desk for many years. When I gaze on the image today I see not only Christ crucified but hints even of Christ risen, Shepard's head bowed gently toward us. Can you? Dare we hope that death is not the last word for Matthew Shepard and others like him?[25] Not unlike the slave songs (chapter 5) or the protest music that animates resistance movements (chapter 6), icons open a window onto the mystery of Resurrection, the darkly luminous "other side" of the tapestry of Christian faith. Much as the Eucharistic remembrance of Jesus' dying and rising beckons his Spirit back into the heart of the community, for the person or assembly at prayer, the icon is more than a mere remembering; it becomes a Real Presence, a sacrament of hope for pilgrims on this side of the journey. In the act of "painting" the dead—the "cloud of witnesses," as the Bible calls them—they are called back into the presence of the living. But can we believe it? Do we have eyes to see, hearts that can bear such a tenuous hope?

And finally there is the moon, the blue-white moon which hangs in the cobalt sky just above Shepard's left shoulder. Some years after we met, Fr. Bill told me that Shepard's mother Judy had said just after his death, "I hope he didn't die alone." "I put the moon there," he said, "because I didn't want him to be alone, to die alone. The moon was a message to his mom that he did not die alone." He explained to me that the moon in the icon tradition represents Mary. Just as Mary was present to Jesus on the cross, so Catholics believe she is mysteriously present to every person "now, and at the hour of our death," as is said in the "Hail Mary." Her love shepherds us to the other side, as it were, much as Fr. Bill did for men dying of AIDS. Mary is especially present, Catholics and Orthodox believe, to those who suffer a painful, lonely, or violent death. McNichols describes those years of accompanying the dying as being a "witness or midwife to the Second Birth"[26]—a striking image for such an arduous, death-haunted period of his life. Thus when I gaze on *The Passion of Matthew Shepard* today, and I consider the witness of Fr. Bill and so many others who minister to

25. For his mother's account, published ten years after his death, see Judy Shepard, *The Meaning of Matthew: My Son's Murder in Laramie, and a World Transformed* (New York: Hudson Street Press, 2009).

26. William Hart McNichols and Mirabai Starr, *Mother of God Similar to Fire* (Maryknoll, NY: Orbis, 2010), 10.

the marginalized of our time, I hear the words of Jesuit theologian Jon Sobrino: "God raised a crucified man, and since then there is hope for the crucified."[27] And I believe him.

"What You Gaze Upon, You Become": The Subversive Wisdom of Ignatian Spirituality

If the "art spirit" dwells in each of us, like a tiny seed waiting to break open, then the seeds of McNichols's artistic vocation took root very early. Born in Denver on July 10, 1949, to Marjory Hart McNichols and Stephen McNichols, Bill began drawing at the age of five. The atmosphere of his childhood was thick with politics and religion. When he was eight, his father was elected governor of Colorado; five years later, in 1968, his uncle William H. McNichols Jr. was elected mayor of Denver, an office he would hold until 1983.[28] His grandfather, William H. McNichols Sr. was the city auditor of Denver for twenty-five years.

These were no small accomplishments in an atmosphere rife with anti-Catholic sentiment. For much of the first half of the century, the Ku Klux Klan controlled Colorado politics. It wasn't unusual for the Klan to target Catholics and Catholic institutions. One night, when Bill's grandfather first ran for public office, the Klan burned a cross out in front of the family home, not far from the state capitol. Bill's father Stephen, a child at the time, was inside the house with his grandmother, Bill's great grandmother. As the cross burned, she gathered all the children to the window and said, "Do you see those people? They are cowards. Don't ever be afraid of people who don't have the courage to come out from behind masks."[29] His father told Fr. Bill this story on the day of his ordination to the priesthood.

McNichols's early love of art was nourished by his Catholic parochial school education in Denver. "In my own life, especially in childhood, art was the primary way I was introduced to the two thousand years of Christianity."[30] His adolescent years at Regis Jesuit High School led him to discern a vocation with the Jesuits, or the Society of Jesus, a Roman Catholic religious order founded by

27. Jon Sobrino, *Christ the Liberator: A View from the Victims* (Maryknoll, NY: Orbis, 2001), 40. For Sobrino resurrection faith is never an escape from historical commitment among the living. To the contrary, such a faith galvanizes hope for the transformation of society, what Jesus calls the reign of God, on this side of death. "The victims of history can see Jesus as the firstborn from among the dead, because they truly . . . see him as their elder brother. This gives them the courage to hope in their own resurrection, and *they can now take heart to live in history*, which supposes a 'miracle' analogous to what happened in Jesus' resurrection" (Sobrino, *Christ the Liberator*, 40).

28. See Dadosky, *Image to Insight*, 3–5.

29. Related by Fr. Bill in conversations with the author and used with permission.

30. McNichols and Starr, *Mother of God Similar to Fire*, 11.

Saint Ignatius of Loyola in the sixteenth century. Though he had endured years of bullying in grade school, which continued during high school, humor became a way to mask his suffering. And among the Jesuits at Regis he had found a home in the atmosphere of Ignatian spirituality.

> From the age of nineteen I was brought into the life of the Spiritual Exercises of St. Ignatius of Loyola, which consists of four weeks of prayer and meditation on the life of Christ. The retreat culminates with a glorious burst of light, which launches the retreatant into a life of ministry of "finding God in all things." Once these words settle in your heart, they never leave you. They become the way you live in the world with its great variety of people, as well as the Creation, both damaged and abundant.[31]

The "way you live in the world with its great variety of people," the world both "damaged and abundant"—here are the seeds of wonder at the heart of McNichols's artistic vocation.

Ignatian spirituality had formed in him a particular "way of seeing" that "becomes part of you after a period of time," as McNichols puts it. While Saint Ignatius was intimately acquainted with the world's brokenness—and above all he knew *his own brokenness*—his "intimacy with God never allowed him to sink into cynicism, suspicion, or fear of the world and God's people."[32] As a young Jesuit, McNichols studied philosophy, theology, and art at St. Louis University, Boston College, Boston University, and Weston School of Theology in Cambridge, Massachusetts. In 1979 he was ordained a priest, and in 1983 he received a Master of Fine Arts in landscape painting from the Pratt Institute in Brooklyn, New York. It was then that he began to work with the pioneering AIDS Hospice team of St. Vincent's Hospital in Manhattan. He also began illustrating children's religious books, publishing some twenty-five over the next decade. There is a "childlike awe in being called to create along with the Holy Spirit," he says, and viewing religious art "can renew our intimacy with God and the childlike stance Jesus insists upon in the Gospels."[33]

After seven years of ministering to people dying of HIV-AIDS—a life "in the eye of the storm," as he describes it, "yet a life rich with friendship, love, and the imposed altered state of being, at the beginning of a world pandemic"[34]—McNichols left New York in September 1990 for Albuquerque, New Mexico, to study with the Russian-American master iconographer, Robert Lentz. "What I hoped would be a year-long apprenticeship turned into six years

31. McNichols and Starr, *Mother of God Similar to Fire*, 9.

32. McNichols and Starr, *Mother of God Similar to Fire*, 9.

33. McNichols and Starr, *Mother of God Similar to Fire*, 10; compare to our discussion of "Child Mind" and "Beginner's Mind" in chapter 5.

34. McNichols and Starr, *Mother of God Similar to Fire*, 10.

as intense and demanding as my life in ministry to people with HIV-AIDS."[35] Perhaps best known for adapting traditional Byzantine techniques into new, innovative forms—in ways, to be sure, that traditionalists would not always approve—Lentz broke new ground by including as the subjects of his icons more contemporary images and figures, women and men not officially recognized as "saints" by the Orthodox and Catholic churches. While Lentz, a Franciscan brother, was formed most deeply in the spirituality of Saint Francis, and McNichols, in the spiritual wisdom of Saint Ignatius, both men had internalized from their respective mentors a way of being in the world that is comfortable with discomfort, a path that embraces human vulnerability, uncertainty, and risk. The iconography of both men suggests that while learning from the past is crucial, it is a mistake to bind ourselves to any "Tradition" so tightly that we would fail to discern new ways forward in response to the Spirit's promptings in history and the needs of the people of our time.

Like his teacher, McNichols represents a staggering range of subjects in his icons. Having "spent so many years with the dying," he recalls, "my new life of continual communion with the holy souls of those who had died did not feel strange to me." It was "a sacred time out of time, and it was a somewhat violent struggle for me to come out of it."[36] When he did "come out of it," McNichols remained in New Mexico, building a small studio just outside Taos, writing icons, and ministering as a priest to the people, especially the Hispanic people of Rancho de Taos Church. In 2013, he left Taos and returned to Albuquerque, where he continues to paint and serve as a priest. Across these years I can think of no better way to describe his twin vocation as priest and artist than his own words, his philosophy of art, imbibed from Ignatian spirituality: "What you gaze upon, you become." He has put it this way: "You gaze on the icon, but it gazes on you too. We need to gaze on truly conversational, truly loving images, images that will return our love."[37] It is worth dwelling on this provocative point for a moment before we consider a number of other icons.

There is good news, a liberating realization, in the fact that we are not beholden to "reality" as it is mediated to us by others—by one's parents and teachers, for example, or by the consumer culture and its ubiquitous advertising imagery. To be sure, it is no simple matter to see beyond the conventions of culture, as spiritual writer Henri Nouwen notes: "It is easy to become a victim of the vast array of visual stimuli surrounding us. The 'powers and principalities' control many of our daily images. Posters, billboards, television . . . , movies and store windows continuously assault our eyes and inscribe their images upon our memories."[38] In other words, we are not so free in the "land of the free" as we might like to believe! But Nouwen continues. "Still we do not have to be

35. McNichols and Starr, *Mother of God Similar to Fire*, 10.

36. McNichols and Starr, *Mother of God Similar to Fire*, 10.

37. McNichols and Starr, *Mother of God Similar to Fire*, back cover.

38. Nouwen, *Behold the Beauty of the Lord*, 21.

passive victims of a world that wants to entertain and distract us. We can make some decisions and choices. A spiritual life in the midst of our energy-draining society requires us to take conscious steps to safeguard that inner space where we can keep our eyes fixed on the beauty of the Lord."[39]

These observations preface Nouwen's meditations on four classic icons of the Russian Orthodox tradition, a small gem of a book that can serve to introduce newcomers to prayer practices with iconography. Nouwen suggests that by giving particular icons "long and prayerful attention," we can gradually "come to know them by heart," such that we will see them and they will speak to us wherever we go, "whether they are physically present or not."[40] The "Passion of Matthew Shepard" has become one such image for me. But there are many other icons by Fr. Bill that follow me wherever I go, as it were, images that lead to insight, which have burned themselves into my consciousness.[41] Think about it: *What you gaze upon, you become.* Implicit in this principle of iconography is a promise, the promise of human freedom and human agency. People can choose to gaze upon the images presented by big business and big media, and allow such imagery to attach itself to the heart, or they can choose to gaze upon what McNichols calls "truly conversational, truly loving images, images that will return our love."

For Ignatius the "media-event" through which *one best learns how to see reality* is the life of Jesus: in theological terms, the Incarnation, the story of God's love "become flesh" in humanity, in the person of Christ. More than an abstract idea or intellectual construct, Ignatius urges the believer to grasp the Incarnation as an encounter with a real historical person, whom each generation can "meet again" for the first time through the stories of Jesus in the Gospels.

For a person being led through the Spiritual Exercises, Christ becomes, as it were, one's centering icon, and from there, like a series of ever-expanding concentric circles in an unruly family tree, so also Mary and Joseph, Mary Magdalene and the apostles, all the holy women and men down through the centuries who have sought to follow the way of Love as reflected in the life of Jesus. As McNichols might put it, like a pebble thrown into a pond, the pattern of Jesus' life, death, and Resurrection has produced an amazing "cloud of witnesses" whose stories galvanize hope, and from whom others can learn what it means to be fully human. To gaze on "images that return our love," as McNichols has described icons, far from binding people immovably to some Dead Thing of the Past Called the Church, is for many a subversive spiritual practice, a disciplined "spiritual exercise" that aims to get the heart into its best, most human shape.

39. Nouwen, *Behold the Beauty of the Lord*, 21.

40. Nouwen, *Behold the Beauty of the Lord*, 21–22.

41. Dadosky titles his study of McNichols's work *Image to Insight*, based on Canadian theologian Bernard Lonergan's notion that "the image leads to insight." "These insights, when effectively communicated, can lead the viewer to social, cultural, political, religious, historical, and even personal understanding" (Dadosky, *Image to Insight*, 1).

It is important to be clear that Catholic and Orthodox Christians do not worship icons—nor statues, nor other such objects used in prayer—in which case the icon would become an idol, an object of worship that is a work of human hands. What, then, is going on when a Christian prays before an icon? The person is "venerating" the icon, placing herself or himself before the image as a kind of portal or "connecting point" to the realm of the sacred.[42]

When I walk past an old black-and-white photograph of my grandfather, with whom I was very close as a child, I often pause a moment to gaze on it. Sometimes I kiss my hand and then touch my grandfather's face. In no way am I under the illusion that the photograph *is* my grandfather. Rather the image connects me to a thousand memories and stories of the love that passed between us, and which still passes between us, when I open myself to his presence. In theological terms, the image is for me a "sacramental," a sign and instrument of grace: my experience of God in this man's wonderful presence to me when I was a child. There is nothing magical about the photo. My grandfather is utterly attached to my heart. For others, the picture will have no meaning. But for those connected to me and my grandpa, the photograph, no matter how torn and faded, may likewise serve as a beautiful connecting point. *Cor ad cor loquitur.* Heart speaks to heart. Such is the case with icons. When we allow ourselves to occupy the stories of the saints, McNichols suggests, when we place ourselves under their gaze, something *in us* changes. Through their eyes, God gazes on us with love, encloses us in the divine embrace.

In sum, if the spiritual life seeks an answer to the question, "What is life all about?" Ignatian spirituality offers a vision of life centered in and flowing from the heart. The "heart" is not just the emotions, though it includes emotion. In its deepest religious sense, the heart refers to people's inner orientation, the core of their being, *the totality of their response*: intellect and emotions, imagination and desire.[43] At the core of the Ignatian vision of life is the gift of God's love, which shows itself "in all things," communicating in every aspect of the creation and in the ordinary stuff of human lives. In the words of the late Jesuit spiritual writer David Fleming, for Ignatius, "*All the things of this world are here so that we can know God more easily.* We have a satellite television with 500 channels. God is broadcasting on all of them."[44]

Nevertheless while Ignatius believed that God is ever-present, he also recognized from his own profound spiritual struggles that for many people God seems to be silent, that God's "voice" is hard to discern amid the many voices, images, and ideas competing for our attention. One must learn how to listen and

42. Dadosky reinforces the point, noting that Mary and the saints "are not worshiped but venerated. Only God is worshiped." Indeed, "More than most people, the iconographer is well aware of the limits of images to adequately express divine reality" (Dadosky, *Image to Insight*, 2).

43. David L. Fleming, *What Is Ignatian Spirituality?* (Chicago: Loyola, 2008), 13–15.

44. Fleming, *What Is Ignatian Spirituality?*, 45.

see beneath the surfaces for the "movements" of the Spirit in one's life. Learning from his own struggles and insights and from the faith journeys of many others who came to him for direction, Ignatius developed techniques to do this, namely, the Spiritual Exercises.

Internalizing Ignatius's worldview as his own, Fr. Bill, I can say, is one of the most hope-filled yet deeply grounded people I have ever known. As is true of many people I have admired who have grounded their lives in Ignatian spirituality—artists, priests, intellectuals, activists—there is a fierceness in McNichols's "mysticism of open eyes" which reminds me that childlike wonder, rooted in meditation on the Gospels, is no Gnostic or aesthetic escape from reality. The legacy of Christian faith to which McNichols's whole body of work stands witness is "subversive" and "unruly" insofar as it seeks especially to make visible "all invisible and inconvenient suffering, and—convenient or not—pays attention to it and takes responsibility for it, for the sake of a God who is a friend to human beings."[45] The remainder of this chapter attempts to bear this thesis out.

"San Jose en el Rio Grande": God in Exile

If you haven't yet taken some time to browse the galleries of McNichols's website, I invite you to do so before reading further. Please don't hesitate or be concerned if you have little or no experience with religious art, or if many of the subjects of McNichols's icons are unknown to you. In fact many remain unknown to me. And be assured, there is no single "right" way to view icons, though I would offer one important suggestion. Rather than "browse" the galleries in the way we tend to scroll rapidly through our social media feeds, allow yourself to stop, to *let your eye be stopped,* by particular images, and then to linger there.

For example, you might begin with the gallery "Jesus Christ Our Lord," first simply noticing the remarkable diversity in McNichols's portrayals of Jesus. Then go deeper, spending more time with particular images. You might ponder "The Risen Christ" (image 014) and then compare it with "Jesus Christ Extreme Humility" (036); gaze on "Nuestra Salvador de las Sandias" (012) and then "El Santo Nino de Arizona" (169); contemplate "Jesus Listen and Pray" (251) and then "The Galilean Jesus" (266). What do you notice about each icon? What strikes you about their differences? If you were raised in a Christian environment, how do these images compare with images of Jesus that you may have

45. I borrow the phrase "mysticism of open eyes" from German theologian Johann Baptist Metz, who uses it describe the spirituality of Jesus himself, who "did not teach an ascending mysticism of closed eyes, but rather a God-mysticism with an increased readiness for perceiving, a mysticism of open eyes, which sees more and not less." Johann Baptist Metz, *A Passion for God: The Mystical-Political Dimension of Christianity*, trans. J. Matthew Ashley (New York: Paulist Press, 1998), 163.

grown up with? Do any especially draw you in, invite you to linger further? Do any repel? Now repeat the same process with other galleries, "Mary with Child Jesus," "Holy Women, Holy Girls," and so on, letting your curiosity guide you. Be sure to spend some time in the gallery "Drawings, Illustrations, Images," and consider "The Crucifixion by Fr. Bill at Age 5"; "Our Lady and the Holy Child Jesus Visit St. Ignatius the Convalescent in Loyola," "Princess Diana," and the two "Self-Portraits" that close the gallery.

Of course every viewer will be drawn to particular images more than others, and perhaps some viewers, to none at all. The key, as Nouwen suggests, is to try to gaze "with the heart of a lover,"[46] which is to say, do not worry about doing it "correctly," but simply open yourself to the encounter in your own way. If Saint Ignatius would be our guide, this is the only way that anyone really discovers God: *in their own way*. Why? As Ignatius himself would discover, much to his surprise, God does not wish anyone to be someone else, but loves each person, unconditionally, for the person they are.

Indeed one of the things that McNichols's diverse range of subjects makes clear is that there are no cookie-cutter saints. There is no single way to be authentically human, to be ourselves, to become "holy." Every "saint" down through history has had to discover her or his particular gifts, and for each the path was quite different. Indeed, if it is true that "what you gaze upon, you become," perhaps the key question turns back upon us: Who do I desire to become? What brings me real joy? Who inspires me? If images tell stories, and those stories attach themselves to our hearts, *what kind of images and life stories do I choose to inhabit*? Are they helping me become the person I want to be?

Like *The Passion of Matthew Shepard*, the icon "San Jose en el Rio Grande" is one of McNichols's works that most speaks to me, if for very different reasons. Besides being, to my eye, one of his most beautiful, perfectly realized icons, it stays with me because it speaks to the person I want to become, the father I strive to be. The icon was written for Saint Joseph on the Rio Grande Catholic Church in Albuquerque, where Fr. Bill has served as a priest since 2013.

Take a moment to gaze on the icon. You can find it in the gallery "St. Joseph and the Child Jesus." Let your eyes pass over the whole, and then its details. What do you see? Notice the figures in the foreground—Joseph and Jesus, their eyes, the placement of Joseph's hands, the encompassing folds and colors of his cloak—then consider the natural landscape around them—the river, the flaming scrub brush, the mountains, the sky, the moon. Again, the moon! McNichols explains, "Joseph and Child move along a path above the Rio Grande beneath the Sandias [a small mountain range running north-south just east of Albuquerque]. . . . *Sandia* is an archaic Spanish word meaning 'Fiery at Night.' This is my third Sandia icon. The Moon is present in the day, as is often the case,

46. Robert Lentz, foreword, describing Nouwen's approach to icons in Nouwen, *Behold the Beauty of the Lord*, 11.

above the Sandias. In Catholic symbolism, Our Mother, Mary is always the Moon . . . the reflected Light of her Son, so in essence . . . the Holy Family is there."[47]

Like many of McNichols's icons, "San Jose en el Rio Grande" borrows from his love affair with the American Southwest and its ancient Hispanic peoples, a land and a population he describes unambiguously in terms of the sacred. "Most of us don't live well with mystery, we don't like it," he once said to me. "But they do here. There's a respect for mystery. I don't know another place like it." The Western impulse is "to investigate it, settle it, close it, find an answer," but "everything in New Mexican culture resists that impulse. There's a deep humility there, knowing what you don't know or understand about God. And then it will come to you in its own way."

Fr. Bill continued, almost to himself, as if working it out as he spoke. "You can't make a big thing of yourself in New Mexico. It shrinks everybody down. People come and go, a lot of famous people, and it's still here. . . . You can come up close to it and describe parts of it, but the mystery remains."[48] Fr. Bill compares this kind of "knowing by unknowing" to prayer before icons, which speak to us—insofar as we are willing to let them speak, and let ourselves be "seen"—by eluding rational explanation.

The icon reveals itself over time, deepening with meditation. There is a presence in the image beyond that which is first seen on the surface. Joseph's eyes, gentle and warm, seem to gaze directly at the viewer, while Jesus looks slightly upward and outward toward a horizon outside the frame, perhaps toward the future. He seems even to be looking at the moon, guided and comforted by its presence, just as he is guided by the firm but gentle right hand of his father. The cloak encloses him, but not entirely. The Child Jesus belongs to Joseph and Mary, but he also belongs more and more to the world. Like every child, he will eventually have to find his way without them, even while their love remains with him, enfolding him along the journey. McNichols explains how the image itself led him to deeper insight: "The drawing was finished and I began to transfer the image to the clay board, 24" X 24", when I noticed the Santo Nino's halo was partially beneath Joseph's outer garment. I wanted to change it immediately but . . . then I thought . . . Joseph is guarding the Child's Light which is not ready to be fully shown, as in this image He is about 7 or 8 years old. . . . So, I left it the way it had been given to me."[49]

As I consider these words I am thinking of my two sons, Isaiah, twenty, and Henry, now nine, the former largely set free, the latter still beneath my cloak, his light "not ready to be fully shown." I am also thinking of the world "in front of

47. William Hart McNichols, letter to Msgr. Luna, November 18, 2013; used with permission of the author.

48. Conversation with the author, May 2012.

49. McNichols, letter to Msgr. Luna, November 18, 2013.

the text," a political climate in the United States today in which immigrants and people of color feel threatened, unwelcome, unsafe in their own skin.[50] The Rio Grande River along the US-Mexico border remains a symbol of freedom and a perilous entry point for many refugees from Latin America and Mexico, Haiti, and Africa. As I write these lines, the president of the United States continues to press the Congress for money to "build a wall" to keep out these "danger-ous people," whom he identifies wholesale as "rapists," "murderers," "terrorists," and "thugs." The icon "San Jose en el Rio Grande" identifies the Holy Family directly with these least of our neighbors, those feared, demonized, kept out. For them there is "no room . . . in the inn" (Luke 2:7), just as Jesus will one day say to his friends, "the Son of Man has nowhere to rest his head" (Luke 9:58), identifying himself with the homeless, the naked, the prisoner (Matt. 25:31–40).

Of writing the icon, McNichols says he "left it the way it had been given to me." How does one explain such a statement? Notice, the cloak protects but remains open; it encircles but does not smother. Joseph walks beside Jesus, utterly present, perhaps knowing he must eventually be left behind. "And you yourself a sword will pierce" (Luke 2:35), Mary was told when presenting the child in the temple, her husband Joseph at her side. And the two "were amazed at what was said about him" (2:33). For parents who have ever felt the uncer-tainty and vulnerability of love for one's children in troubling times, Mary and Joseph have been figures of shared vulnerability, trust, and hopefulness in the God who can "make a way out of no way," as the Negro spiritual goes. Perhaps what was "given" to McNichols was an insight into the loving Heart of God, which looks and feels like the loving heart of a human family.[51]

"She Who Dwells among Us": The Nearness of God in Suffering

The cloak of Joseph in "San Jose en el Rio Grande" is worth pondering for a very long time. I gaze at it, astonished at the detail of its folds, its color, its beauty, gently surrounding the boy.

One of the ancient names of God in the Jewish tradition is "Shekhinah," from the Hebrew *shakan*, which means "to be present or dwell as in a tabernacle, sanctuary, or tent." The Shekhinah emerges in rabbinic literature as "an image of

50. My son Henry, adopted from Haiti (see chapter 5), is increasingly aware of the fraught nature of his blackness in the culture around him, as I am increasingly aware that he cannot remain forever under the protective shelter of my cloak.

51. The Gospels tell us nothing of Jesus' life between the age of twelve and his baptism by John at about age thirty, the beginning of his ministry. Luke's Gospel tells us only that the child "grew and became strong, filled with wisdom; and the favor of God was upon him" (Luke 2:40). Sometimes called the "hidden" or "lost" years of Jesus, most scholars assume that he was not at all "lost" but was working alongside Joseph as a carpenter in Galilee.

the female aspect of God caring for her people in exile."[52] She is "an accompanying God whose face or presence, as Shekhinah, 'She-Who-Dwells-Among-Us,' goes with Israel, in mourning, into her deepest exile, even if Israel cannot see her in the terrible crush."[53] To my eyes, Joseph's cloak is like the Shekhinah, the breeze that touches the face of Jesus and reassures him that God is near in the midst of the gathering storm. Jesus dwells, as it were, in the encompassing presence of God, and because he feels safely held (cloaked) by his Father, he can say with assurance to others, "Do not be afraid." Gazing on the face of Joseph, who gazes back at me with reassurance, the storm in my own heart is calmed. Joseph's cloak encircles me in its paternal/maternal embrace. Here is the kind of presence I want to embody for my two sons and two daughters, now, and when I am gone.

The notion of the divine "presence" or "indwelling" brings us back to the moon's appearance against the daytime sky in "San Jose en el Rio Grande," which we also saw in *The Passion of Matthew Shepard*. One of the few paintings in McNichols's catalog that has no images but only letters or words is a painting called "The Name of God Shekhinah,"[54] inspired by Rabbi Leah Novick's book, *On the Wings of the Shekhinah*. In the image, Fr. Bill has placed the Hebrew letters of the Name in white gold leaf on blue "to represent the white clouds, in which She often manifests Herself, against the blue sky,"[55] as Dadosky explains. Dadosky describes the feminine aspect of God as "one of the most neglected dimensions" of Western religious life. "In fact, the lack of a feminine dimension of God is a gaping wound, and many are unaware of the ramifications of its absence in our collective psyche. When I first sat down to have regular conversations with Bill I was struck by how much of his work was devoted to the divine feminine. I became convinced that much of Western Christianity suffers from this lack."[56]

Reading both of these icons through the tradition of Catholic symbolism, the moon, once again, represents Mary, who in turn embodies the Mother Love of God, a love that accompanies us especially in passages of loneliness and suffering. I was astonished and deeply moved to discover that the moon has a similar resonance in Jewish literature, specifically, in the memoirs of Jewish women written during the Holocaust, where the moon is frequently revealed (and revered) as a source of divine presence, when no other human comfort is to be found. In the midst of the unspeakable depravity that was Auschwitz, we have

52. Melissa Raphael, *The Female Face of God in Auschwitz: A Jewish Feminist Theology of the Holocaust* (New York: Routledge, 2003), 82.

53. Raphael, *The Female Face of God*, 6.

54. See "The Feminine Name of God-The Shekhinah 190," Drawings-Illustrations-Images-Wall Art, William Hart McNichols, *http://frbillmcnichols-sacredimages.com/featured/the-feminine-name-of-god-the-shekhinah-190-william-hart-mcnichols.html*.

55. Dadosky, *Image to Insight*, 137.

56. Dadosky, *Image to Insight*, 137.

surviving testimonies of women taking comfort in the presence of the moon, whose "smooth, round face," as one woman's memoir has it, is always turned towards us, "even if it is darkened by shadow and cloud."[57] The record from Auschwitz is almost unbearably poignant:

> The moment it appeared, peeping through the window into the sleeping block, I said a silent prayer to it. The cool, pale moonlight did not harm or taunt us; on the contrary, it soothed and comforted us. Its light was as pale as we, who were considered dead during our lifetime. On nights when I could not sleep I would unburden my heart to it. "Soon you will disappear from my window, travelling over the city," I whispered. "Please look in the windows of my little girls, caress their head with your cool lit light, because I cannot stroke them with a mother's loving hand. Be kind to me, and when you return to my window tomorrow night tell me about my children. Are they sleeping peacefully in the strange house in that hostile city?"[58]

For this woman and for unnamed others in Auschwitz, there dwelt a power in the moon's presence that did not redeem or console by mighty intervention—like the "omnipotent" Father God who shakes the mountain with thunder and sanctions the wars of men. Hers rather was the power of silent presence and relational care, power *with*, rather than power *over*: the Shekhinah. Her indwelling, made present here by the moon and its pale penumbra, consoled women torn from their homes, branded with numbers, and packed into cattle cars to their death in Auschwitz.[59] Such accounts—like the image of the moon in McNichols's icons, or Fr. Bill himself at the bedside of dying men—suggest that perhaps the mightiest face of God, like the face of a faithful parent, friend, lover, medical professional, or priest, is revealed not in earth-shaking theophanies but in our moments of greatest weakness, fragility, and need.

In Psalm 23, perhaps the most beloved passage of the Bible, God is rendered not as a Father God of War or Great Puppeteer in the Sky, but as a Shepherd who dwells with his flock, guiding them faithfully through fields of joy and peril. Faith, as the Psalmist makes quite clear, does not save us from peril or override our freedom to create it. Though such an "accompanying God" may seem impotent in the face of earthly powers, there is consolation and strength in knowing that we do not face our burdens alone, even "though I walk through the valley of the shadow of death." As Thomas Merton says of faith, "You do not

57. Raphael, *The Female Face of God*, 116; citing Bertha Ferderber-Salz.

58. Raphael, *The Female Face of God*, 116.

59. For a more extensive discussion of Melissa Raphael's work see Christopher Pramuk, "Making Sanctuary for the Divine: Exploring Melissa Raphael's Holocaust Theology," *Studies in Jewish-Christian Relations* 12, no. 1 (2017): 1–16.

need to know precisely what is happening, or exactly where it is all going. What you need is to recognize the possibilities and challenges offered by the present moment, and to embrace them with courage, faith and hope. In such an event, courage is the authentic form taken by love."[60]

"We See Jesus in the Children of Iraq": Art Crossing the Cultural Divides

I grant that the twenty-first century mind has to travel a long way to link the herding of Jews into Auschwitz with US detention centers at the border between Mexico and the United States, where thousands of "illegal aliens" are being held as I write this, a great many of them children. Yet if we can dare to imagine both realities from the divine perspective—as McNichols's images invite us to do—their plight is not so different. Millions upon millions of refugees are today moving across the globe, driven from their homelands by war, fear, and economic necessity. Utterly vulnerable, to many they are little more than homeless chattel, with nowhere to rest their heads. To identify the Holy Family precisely *with these*, as the Christian mystical tradition dares to suggest, is to break open our hardened hearts and begin to see as God sees the world, through the eyes of a loving heart.

In his Christmas address of 2017, "Urbi et Orbi," "To the City (of Rome) and to the World," Pope Francis—not incidentally, the first-ever Jesuit pope—identifies the refugees of the world directly with the Child Jesus and the Holy Family.

> We see Jesus in the faces of Syrian children still marked by the war that, in these years, has caused such bloodshed in that country. . . . We see Jesus in the children of Iraq, wounded and torn by the conflicts that country has experienced in the last fifteen years, and in the children of Yemen, where there is an ongoing conflict that has been largely forgotten, with serious humanitarian implications for its people, who suffer from hunger and the spread of diseases. We see Jesus in the children of Africa, especially those who are suffering in South Sudan, Somalia, Burundi, Democratic Republic of Congo, Central African Republic and Nigeria. . . . We see Jesus in the many children forced to leave their countries to travel alone in inhuman conditions and who become an easy target for human traffickers. . . . Jesus knows well the pain

60. Thomas Merton, *Conjectures of a Guilty Bystander* (Garden City, NY: Doubleday, 1966), 208. It is worth recalling here our discussion of "flesh memory" and the power of mother love in chapter 6. For Frederick Douglass, his mother's physical presence to him as an infant, though barely remembered, seemed to abide with him, giving him courage and resolve long past her death.

of not being welcomed and how hard it is not to have a place to lay one's head. May our hearts not be closed as they were in the homes of Bethlehem.[61]

Is Pope Francis guilty of politicizing the Gospel? Is McNichols also thus guilty, in his portrayals of holy women and men not recognized in the official canon of prophets and saints, including many non-Christians? Or has Christianity for too much of its history been guilty of teaching a practical if not theological Gnosticism, detaching Jesus and the gospel from history, from the greater portion of humanity, from the soils and trees and waters, from the flesh?

To ask from another direction: To what extent have readers failed to appreciate the Gospels themselves as human works of art, theopoetic and often metaphorical narratives inspired by grace, each written for particular audiences to illumine central truths about Jesus while also challenging the existing order? In the words of Claire Nicolas White, "Have American fundamentalists lost the art of reading the Bible as poetry, insisting on some literal reality that makes no sense?"[62] White, the daughter of famed Dutch stained-glass maker Joep Nicolas (1897–1972), himself the heir of many generations of stained-glass makers, describes her father's vocation as the art of storytelling, "illustrating the Bible and the lives of the saints."[63] She might also have said "illuminating," as her father's stories and figures come to life only with the light of the sun.

"My father's work was the focus of our lives," remembers White. "Everything in our house was steeped in religious tradition: the food we ate, the legends we were told, the songs the maid sang to us."[64] Born in Holland but raised in New York City, White is perplexed by the strong air of biblical literalism in American Christianity, which reduces and *thins out*, often fatally, the theological meaning (luminescence!) of the Bible. The art of religious storytelling, she gently insists, must not be mistaken for "scientific history" or "factual biography"—even these cannot escape the author's interpretive lens—but neither must religious storytelling be mistaken for fantasy. The former is the fundamentalist's mistake; the latter is the rationalist's. Both fail to grasp the artistic valences of the Bible.

61. Pope Francis, *"Urbi et Orbi," Message of His Holiness Pope Francis,* Christmas 2017, *https:// w2.vatican.va/content/francesco/en/messages/urbi/documents/papa-francesco_20171225_urbi-et -orbi-natale.html.* Fr. James Martin, perhaps the best-known Jesuit priest and Catholic spiritual writer in the US today, is working hard to amplify Pope Francis's voice for an often-resistant US Catholic audience. For his commentary on Francis's 2017 Christmas message, see James Martin, "Were Jesus, Mary and Joseph Refugees? Yes," *America* (Dec. 27, 2017), *https://www.americamagazine .org/faith/2017/12/27/were-jesus-mary-and-joseph-refugees-yes.*

62. Claire Nicolas White, "And Then There Was Light: Five Generations of Stained-Glass Makers," *Commonweal* (Dec. 12, 2006): 14.

63. White, "And Then There Was Light," 12.

64. White, "And Then There Was Light," 13.

Against all such reductionisms, White celebrates the religious-artistic sensibility instilled in her by her father: "If imagination is the creative power that perceives the basic resemblances between things, then all sources, no matter how exotic, resonate in me as well. Imagination is fed by metaphor. Religion and the Scriptures, if perceived as such, are not a fundamentalist prison but an open field for visionary inspiration."[65] Enter Pope Francis's identification of the Christ Child with the children of Iraq, and McNichols's visualization of Joseph and Jesus traversing the rugged terrain of the Rio Grande river valley. Where American popular and political-economic culture makes use of the Christmas story in a conservative way—that is, to sell toys, to uphold the existing order—Pope Francis reads the Gospel against the cultural grain, reclaiming the (subversive) good news of the Incarnation especially for those for whom there is "no room at the inn," just as Luke's birth story clearly aims to do.

Then as now, those who benefit from the prevailing power structure will likely rebel against any such "political" reading of the Gospel—and Francis, to be sure, has his share of American critics, as does Fr. Bill.[66] Both men underscore those darker parts of the Nativity story our pageants and manger scenes typically leave out: the flight to Egypt and the massacre of the infants, in which Jesus is marked out from his birth as a threat to the powers of his day. When the birth stories are approached not as mere "history" but theopoetically, as inspired literary portraits of Christ's birth into a perilous world, their meaning explodes prophetically into the present.[67] The "basic resemblances" between the Holy Family and the plight of today's refugees is not so difficult to see, if we dare to gaze through the eyes of the heart.

Today the ancient town of Bethlehem, six miles south of Jerusalem, is a city of about 22,000 residents. The city is surrounded on three sides by a concrete security wall, eight meters high. For much of its length the lower half of the wall is littered with graffiti. But in one place the graffiti gives way to an extraordinary image: an overlarge icon of the Virgin Mary, known by locals as "Our Lady Who Brings Down Walls."[68] The man who wrote the icon is Ian Knowles, a British theologian and founder of the Bethlehem Icon Center, where Palestinians, with students from around the world, are learning the ancient art of icon writing, and finding their own lives illuminated by

65. White, "And Then There Was Light," 13.

66. See Andrew Brown, "The War against Pope Francis," *The Guardian*, October 27, 2017, *https://www.theguardian.com/news/2017/oct/27/the-war-against-pope-francis*.

67. See Marcus Borg, "The Meaning of the Birth Stories," in Marcus Borg and N. T. Wright, *The Meaning of Jesus: Two Visions* (New York: HarperSanFrancisco, 2000), 179–86; also Thomas Merton, "The Time of the End Is the Time of No Room," one of Merton's most powerful meditations on the "apocalyptic" meaning of the Nativity stories for our times. See Thomas Merton, *Raids on the Unspeakable* (New York: New Directions, 1966), 65–75.

68. "The Icon Painters of Bethlehem," *Heart and Soul*, BBC World Service, December 24, 2017, *http://www.bbc.co.uk/programmes/w3cswcyx*.

newfound hope. During the season of Advent tens of thousands of pilgrims come to contemplate and pray before "Our Lady Who Brings Down Walls." Knowles tries to explain why: "When you've got mothers whose children have been killed, where do you go? Here, the Christian community goes to their heavenly mother. So this image is a place where those people can come with their pain, and find some glimmer of hope."[69]

If it is possible to see the Child Jesus in the children of Iraq, as Pope Francis intimates, it is also possible to see Mary in the mothers of Palestine, South Sudan, Afghanistan, and Saudi Arabia.[70] If one opens the ears of the heart, we may hear her crying out in the mothers of Chicago and Newtown, Cleveland and Philadelphia, mothers across America who have lost their children to senseless gun violence.[71] Indeed, one can hear her crying out today from "the stones" themselves (Luke 19:40), the planet's very skin now being "fracked" to death, exhausting the limits of Earth's ancient resources.

To be sure, like other forms of religious art, liturgy, and worship, iconography can and has been used in ways that uphold the existing political and ecclesial order. For better and often for worse, religion and religious culture are often wed closely to the prevailing political-economic powers of society.[72] Thus it is no simple matter to define the place of art and the artist's vocation within the prevailing structures of a capitalist consumer society such as the United States.

For these reasons, once again, it is helpful to have some kind of theoretical framework for distinguishing art from culture. Recall that for the philosophers of the Frankfurt School, whose ideas we considered in chapter 2, authentic art "is something that's elevating and challenges the existing order, whereas culture is precisely the opposite. Culture, or the culture industry, uses art in a conservative way, which is to say it uses art to uphold the existing order."[73] In other

69. "The Icon Painters of Bethlehem."

70. See Andrew Greeley, "The Mother Love of God," in *The Catholic Imagination* (Berkeley: University of California, 2000), 89–103. "The sacramental imagination, when working properly, apparently does sense a correlation between a lurking God and equality of women. It does perceive, however dimly, that a woman's body is as much a sacrament of God's love as a man's body" (103).

71. See Maureen O'Connell, *If These Walls Could Talk: Community Muralism and the Beauty of Justice* (Collegeville, MN: Liturgical Press, 2012), which offers a breathtaking theological reading of the Philadelphia Mural Arts Program, a community movement of some 3,500 wall-sized images painted on warehouses and on schools, on mosques and in jails, in courthouses and along overpasses. I have often brought O'Connell's study into my classes as a complement to McNichols's iconography. There is more in common than might be evident at first glance between explicitly religious art-forms such as iconography and so-called secular and urban forms of contemporary art.

72. One thinks here of the uneasy but politically expedient marriage between American evangelical Christianity and the presidency of Donald Trump, or in Russia, the implicit and often explicit alliance between President Vladimir Putin and the Russian Orthodox Church.

73. Stuart Jeffries, "If You Want to Understand the Age of Trump, Read the Frankfurt School," interview with Sean Illing, Vox, December 26, 2017, *https://www.vox.com/conversations /2016/12/27/14038406/donald-trump-frankfurt-school-brexit-critical-theory*. Jeffries is author of *Grand Hotel Abyss: The Lives of the Frankfurt School* (London: Verso, 2017).

words, Christians should be wary whenever religious language, imagery, and art are marshalled in support of the ideology of the prevailing political and economic powers; self-identified Christian artists must be doubly wary. It is in this sense that Fr. Bill's body of work, like the Gospel itself, is subversive in the best sense of the word. The poetic and prophetic nature of the Bible "as an open field for visionary inspiration" is what makes it a continually fresh and vital source of hope for the "little" and "poor" across the world today, and ever-dangerous to the powers and principalities.

In sum, from a theological *and* artistic point of view it is a mistake to imagine that *either* God is One, and *only* One—as in Jesus Christ—*or* God is "all in all," in all things and all people, without exception. The incarnational good news at the heart of Christianity is not either/or, but both/and: God dwells in the One and in the Many. For Christians it is through the One, Jesus, that we behold God's intimate care for and presence in the Many. In other words, for Christians, Christ is our centering icon, the most palpable touchpoint for the divine Image coming to birth in all humanity. Such is the Ignatian option, a mysticism of open eyes, which says that God has made a radical option for the world, and every one of us is called and enabled by grace to do the same. "May our hearts not be closed as they were in the homes of Bethlehem." Gazing at icons can be a dangerous business indeed.

"Mary Most Holy Mother of All Nations": The Art of Apocalyptic Times

Earlier I noted theologian John Dadosky's description of the feminine aspect of God as "one of the most neglected dimensions" of Western religious life, a "gaping wound" in our collective psyche. In the ancient Jewish and Christian traditions, the divine feminine, when she is remembered at all, is called by many names: Shekhinah, Hokmah, Spirit, Divine Wisdom, Sophia. The name "Sophia" is the Greek term for "Wisdom." Her presence is found (and hidden) especially in the biblical Wisdom books, where she appears as a kind of divine Child or Presence immanent within creation itself, God-with-Us in the dance of Life as it springs from the soils and trees, the wind and waters (Prov. 8:22–31; Wis. 7:22–30). She is also personified as a Woman and Prophet crying out from the crossroads of the city, crying out especially to the "little" and "poor," beckoning her children to imagine a future of justice and peace (Prov. 1:20; 8:1–4).

While Jewish and Christian feminist theologies have sought for half a century to restore the divine feminine in our religious consciousness, and thus heal the wounds of her neglect, McNichols's iconography has done so as well, from a different direction. He has "put a face" on the feminine divine with his

magnificently diverse icons of Mary, Mother of God; and he has also done so with his "sophianic icons," or images of Divine Sophia.[74]

In one of his most beautifully realized and theologically subversive poems, Thomas Merton celebrates Wisdom as the feminine manifestation of God. The prose poem "Hagia Sophia" ("Holy Wisdom") is a luminous marriage of Eastern and Western spirituality, and Merton's most lyric expression of "Christ being born into the whole world," especially into that which is most poor and hidden.

> There is in all visible things an invisible fecundity, a dimmed light, a meek namelessness, a hidden wholeness. This mysterious Unity and Integrity is Wisdom, the Mother of all, *Natura naturans*. There is in all things an inexhaustible sweetness and purity, a silence that is a fount of action and joy. It rises up in wordless gentleness and flows out to me from the unseen roots of all created being, welcoming me tenderly, saluting me with indescribable humility. This is at once my own being, my own nature, and the Gift of my Creator's Thought and Art within me, speaking as Hagia Sophia, speaking as my sister, Wisdom.[75]

Anticipating the dominant note of Pope Francis's papacy, Merton describes Sophia above all as the Mercy of God in us, the tenderness with which the "power of pardon turns the darkness of our sins into the light of grace." In perhaps the most haunting lines of the poem, Merton writes of Sophia, "We do not hear the uncomplaining pardon that bows down the innocent visages of flowers to the dewy earth. We do not see the Child who is prisoner in all the people, and who says nothing."[76]

When I first encountered Wisdom-Sophia in Merton's writings, the language was both strange and strangely resonant to me. For the first time I began to discover the feminine face of God in the Bible, in the Russian school of Wisdom theologians, and in Catholic and Jewish feminist thought. But while I found the imagery of Wisdom-Sophia beautiful and inviting, I had a hard time "making sense" of it. It was McNichols's icons that took me out of my head and into the eyes of my heart. Indeed it would be hard to name any artist

74. For example, *The Advent of Hagia Sophia* (173), Divinity and Angelic Figures-Wall Art, William Hart McNichols, *http://frbillmcnichols-sacredimages.com/featured/the-advent-of-hagia-sophia -173-william-hart-mcnichols.html*, and *Hagia Sophia Crowning the Youthful Christ* (212), Jesus Christ Our Lord, William Hart McNichols, *http://frbillmcnichols-sacredimages.com/featured/hagia -sophia-crowning-the-youthful-christ-212-william-hart-mcnichols.html*. The latter icon was inspired by Viennese artist Victor Hammer's line drawing of *Hagia Sophia*, and Thomas Merton's poem of the same name.

75. Thomas Merton, "Hagia Sophia," in *Emblems of a Season of Fury* (New York: New Directions, 1963), at 61.

76. Merton, *Emblems of a Season of Fury*, 63.

or iconographer in the West whose work has done more to quietly midwife the divine feminine into consciousness than McNichols. In a word, Fr. Bill's iconography helps us—helps me—to see the divine Child who is prisoner in all the people.

In one of the first conversations I ever had with Fr. Bill about his work, he said that when Divine Sophia first dawned in his consciousness some forty years ago, she came to him "much more as a flashing red light than as a pleasant apparition."[77] The comment is perhaps not too surprising—indeed, it "makes sense"—when one considers the terrifying contents of reality for so many women and girls today, indeed for all life on the planet, tied into the fate of suffering Earth. In literary terms, I have begun to think of Wisdom-Sophia in terms of the apocalyptic genre: She is the protest of Life itself, and the irruption of hopefulness, wherever life and hope are being systematically violated. The word "apocalypse" simply means "unveiling," a flash or sudden insight into reality. Think of the moon over Auschwitz, its light "as pale as we, who were considered dead during our lifetime."[78] McNichols's iconography represents the art of apocalyptic times, like Sophia Herself, a "flashing red light" in the midst of chaos, beckoning us to see the Child who is prisoner in all the people.[79]

This brings us finally to *Mary Most Holy Mother of All Nations*, perhaps McNichols's most famous icon, and described by one of his Jesuit mentors as his greatest masterpiece. When I ponder the image, it is hard to disagree. The icon is simply breathtaking. Dadosky describes the work and its genesis as follows:

> The Mother of God embraces the planet in her arms. Initially reluctant to create this image, Bill received a flash of inspiration and saw an image of Mary holding the entire planet in her arms; no continents were distinguishable. "Then all of the sudden I imagined the Holy Spirit engulfing the entire world, hovering around it like twelve flames. Mary stands on a red-hot globe that signifies the center of the world." We are all God's children. The color of Mary's robe is unique relative to traditional iconographic depictions of her. The purpose of the gold saffron arose from his inspired vision. . . .[80]

77. Conversation with the author, March 2010.

78. Raphael, *The Female Face of God*, 116.

79. The film *The Secret Life of Bees*, dir. Gina Prine-Bythewood (Twentieth Century Fox, 2008), based on the debut novel of Sue Monk Kidd, centers on the hope and healing brought to a young white girl named Lily and a small community of African American women by the Black Madonna, an image of the feminine divine that reflects back to the women their own dignity and strength. "Because when they looked at her, it occurred to them for the first time in their lives that what's divine can come in dark skin. You see, everybody needs a God who looks like them, Lily." On racial justice and theological imagination, see Christopher Pramuk, *Hope Sings, So Beautiful: Graced Encounters across the Color Line* (Collegeville, MN: Liturgical Press, 2013).

80. Dadosky, *Image to Insight*, 85.

Like "Our Lady Who Brings Down Walls," McNichols's *Mary Most Holy Mother of All Nations* puts a face on the Mother Love of God—God who weeps for the suffering of all the world's peoples and holds the suffering Earth to her breast. In mystical-poetical terms she is the Shekhinah, who accompanies the people in exile; she is like the cloak of Joseph, or a shepherd gently guiding his flock to life-giving waters; she is the pale moon over Auschwitz, and "the air receiving the sunlight" across a dangerously warming planet. She is the "spark of Wisdom" in human beings, strengthening us in the face of despair, daring us to imagine another possible future. "I like to think of it as her preserving our planet from the negative consequences of climate change," says Dadosky.[81]

In her meditation on "Mary Most Holy Mother of All Nations," the poet and spiritual writer Mirabai Starr, one of the most sensitive interpreters of McNichols's work, writes,

© William Hart McNichols, http://frbillmcnichols-sacredimages.com

Mary Most Holy Mother of All Nations, William Hart McNichols"

81. Some twenty-five years ago, Catholic feminist theologian Elizabeth Johnson drew powerful links between the subjugation ("rape") of nature and the subjugation of women. See Elizabeth A. Johnson, *Women, Earth, and Creator Spirit* (Notre Dame, IN: St. Mary's College, 1993), and her more recent work, *Ask the Beasts: Darwin and the God of Love* (London: Bloomsbury, 2014). The 2017 film *mother!* likewise dramatizes that link from the vantage point of nonhuman creation. Though painfully difficult to watch for its cumulative violence, the film is "a haunting (because plausible) reminder of how easily the Christian narrative can be redeployed to new and destabilizing uses." See Travis LaCouter, "Nightmare Vision: The Biblical Imagery of *mother!*," *Commonweal* (Nov. 28, 2017), *https://www.commonwealmagazine.org/nightmare-vision*.

Holy Mother of all people,

erase the lines we have drawn to separate us, nation from nation,

tribe against tribe.

Melt our frozen hearts, so that we can love again.

Filled with the Holy Spirit

who flows in your wake,

how can we possibly make war

against our brothers and sisters?

Safe in your embrace,

how could we hold onto any concept of "other"?

Blessed One,

we join our voice with yours,

that your message of peace and justice

may penetrate the troubled minds of all leaders:

Let the children of all the countries of the world be one![82]

Starr underscores the "apocalyptic" or revelatory power of icons in our time to open urgently, if gently, the eyes of the heart. "In the book of Revelation, Fr. Bill points out, the dragon goes after the pregnant woman to eat her child. *We are all her children*, he says. And, in the lineage of the prophets, *we are bringing nativity into the apocalypse. . . .* Fr. Bill's icons are beacons in the darkness, beckoning us home to love."[83] Much like Merton's poetry, to "engage with Fr. Bill's offerings is a subversive act," says Starr. "It quietly overthrows the patriarchy and gently reinstates the feminine values of mercy and connection." We are seeing "the last gasp of the dark side of masculinity," says McNichols. "We are moving beyond viewing the struggle strictly as between the masculine and the feminine, to seeing the struggle as between light and darkness. Both sexes can be equally light or dark."[84] The last point is crucial, and recalls the poet Rilke, who speaks of a "great motherhood over all, as common longing," and who observes that "even in the man there is motherhood."[85]

82. McNichols and Starr, *Mother of God Similar to Fire*, 23. Used with permission from Orbis Books.

83. Mirabai Starr, foreword, in Dadosky, *Image to Insight*, x. Compare to McNichols's icon "Our Lady of the Apocalypse," Mary Mother of God-Wall Art, William Hart McNichols, *http://frbillmcnichols-sacredimages.com/featured/our-lady-of-the-apocalypse-011-william-hart-mcnichols.html*, and Starr's meditation on the same: "Queen of the Universe,/ in the midst of terrible danger/ you labor to give birth to the Prince of Peace./ In the face of violence and warfare/ you stand on the moon of mercy" (*Mother of God Similar to Fire*, 24–25).

84. Cited in Dadosky, *Image to Insight*, ix.

85. Rainer Maria Rilke, *Rilke on Love and Other Difficulties: Translations and Considerations*, trans. John J. L. Mood (New York: Norton, 1975), 34–35; see chapter 7, n. 71.

The task of the poet, the prophet, the contemplative, suggests Rowan Williams, is to interrogate the repetition of "old words for God, safe words for God, lazy words for God, useful words for God."[86] The core theological insight is not that God is male or female, nor that gender is bound by sex to "masculine" or "feminine" characteristics. Rather, the "gaping wound" that is the suppression of the feminine face of God in our times can only be healed by a kind of therapy of the religious imagination. This is what it means to "bring nativity into the apocalypse," to midwife new possibilities in the midst of evident chaos. "For she is the reflection of eternal light, the spotless mirror of the power of God, the image of his goodness. . . . Passing into holy souls from age to age, she produces friends of God and prophets" (Wis. 7:26–27). Initially resistant to icons, the eyes of my heart have been opened by Fr. Bill's work to the illumination of the world—"finding God in all things"—and of human beings as icons of the living God, "signposts," as Henri suggests, "on the way to what may be."

"Bowing before the Transcendent": The Artist as Theologian

In his "Letter to Artists" of Easter Sunday, 1999, Pope John Paul II wrote that "the divine Artist passes on to the human artist a spark of his own surpassing wisdom, calling him to share in his creative power."[87] Whether contemplating the face of another person, the face of Christ, or the face of a "damaged and abundant world," far more important than "getting it right" is letting one's heart be broken open by Love, for Christians, the "creative power" and "spark" that is the very Heart of the universe.

This is not an easy choice. Because its first principle is not survival or self-interest but communion with others, the option for love bears a cost. Many will call it foolish. But love is a real and beautiful option, I daresay a reasonable option, especially when one considers the alternatives. And therein lies the good news at the heart of faith. "If I speak in human and angelic tongues—but do not have love, I am a resounding gong or a clashing cymbal. And if I have the gift of prophecy and comprehend all mysteries and all knowledge; if I have all faith so as to move mountains but do not have love, I am nothing" (1 Cor. 13:1–2). "Love is the measure of all things Christian," writes Robert Lentz. "The mind has its place, but it is with the heart that we love." The only way to "correctly" gaze on the world and to discern our place in it is "with the heart of a lover," as Henri Nouwen suggests.[88]

86. Rowan Williams, *A Silent Action: Engagements with Thomas Merton* (Louisville: Fons Vitae, 2011), 50.

87. John Paul II, *Letter of His Holiness Pope John Paul II to Artists*, April 4, 1999, *https://w2.vatican .va/content/john-paul-ii/en/letters/1999/documents/hf_jp-ii_let_23041999_artists.html*.

88. Robert Lentz, foreword, in Nouwen, *Behold the Beauty of the Lord*, 11.

Jesuit theologian Frederick Crowe hits the mark when he describes the theologian as "one who bows before the transcendent."[89] Like the iconographer, the theologian knows better than most that all forms of human inquiry and expression fall short before the mystery of the Divine. Thus to say with Saint Bonaventure that "Christ flees when we try to embrace him with the intellect"[90] is by no means an anti-intellectual statement, as if the body of faith cannot abide the critical scalpel of reason. Indeed, Bonaventure himself was an extraordinary witness to the marriage of faith and reason. Rather Bonaventure, like Saint Francis before him and Saint Ignatius centuries later, sought to center the mind and heart on the core task of being and becoming a human being, which is Love, a mystery and grace that finally *grasps us*, and cannot be grasped by reason alone.

The experience of God's love—if it really be God, and not merely our small ideas about God—"neutralizes politics and transcends dogma," says Mirabai Starr. "It does not matter what faith, if any, you subscribe to. What matters is that you simply let yourself be loved."[91] Perhaps such a claim is too good to be true, too "weak" and too "naive" to be trustworthy in the face of the world's violence. The mystics and prophets would counter that God's love certainly is too good, too fierce, and too boundless to be confined by any single intellectual, political, or religious system. Each of us, the whole world, is "charged with the grandeur of God."[92] We *none of us* are mere flotsam in the tumultuous currents of history. Gazing on the faces of those who have gone before us, we need not feel alone as we stumble our way along the journey. Gazing as we can upon the "icon" of our beautiful but broken world with compassion, McNichols's work reassures us not to be afraid; it says that the world will, in its own way, return our love—even if it is only dimly perceived, under the pale light of the moon passing through shadow.

Let those who have eyes to see, see. It is the image that leads to the insight, and the poet, the musician, the artist who opens the door to such a faith.

Addendum and Additional Resources

Much as the presence of the Song of Songs in the Bible comes as a surprise to many, so is the presence of feminine imagery and names for God in the Bible, in religious art, and in the Christian mystical tradition, often met with disbelief, if not

89. Cited in Dadosky, *Image to Insight*, 50.

90. Cited by Robert Lentz, introduction, in Nouwen, *Behold the Beauty of the Lord*, 11.

91. McNichols and Starr, *Mother of God Similar to Fire*, 13.

92. From "God's Grandeur," by nineteenth-century English Jesuit poet Gerard Manley Hopkins.

outright opposition. While I think most Christians would agree that it is impossible to capture the mystery of God in human imagery and language, far fewer recognize the negative impact of exclusively male or white European imagery in "traditional" representations of God, Jesus, Mary, the apostles, church leadership, and so on. In her 1986 book, *Women and the Word*, Catholic biblical scholar Sr. Sandra Schneiders argued that just as images of the self and world can be healed, "so can the God-image. It cannot be healed, however, by rational intervention alone." Fr. Andrew Greeley observed that when the sacramental imagination is working properly, it "does perceive, however dimly, that a woman's body is as much a sacrament of God's love as a man's body." Today many people of faith would extend that same insight to LGBTQ persons.

Ignatian spirituality schools the imagination to discover the face of Christ in all people, indeed, "in all things." At Regis University in Denver, Colorado, the Jesuit institution where I teach, you'll find an arresting sculpture of the black Christ crucified, hidden in a grove of trees between the chapel and the Jesuit residence. "We know that there is no authentic familiarity with God," says Pope Francis, "if we do not allow ourselves to be moved to compassion and action by an encounter with the Christ who is revealed in the suffering, vulnerable faces of people, indeed in the suffering of creation."

While deeply traditional in many ways, Fr. Bill McNichols's iconography breaks open the religious imagination in ways that set free our ideas about God and God's love to be fully incarnated in "nontraditional" forms: women, children, gays and lesbians, peoples of color. Artist Alma Lopez, a Mexican-born queer Chicana artist, re-imagines Mary in ways that celebrate women's sexuality. Her image of *Our Lady*, for example, evoked a firestorm when exhibited in Santa Fe, New Mexico, in 2001. Cincinnati painter Holly Schapker likewise gives us Mary in stunningly multicultural forms, and works from her *ADSUM* series based on the life of Saint Ignatius graces the environment of Jesuit institutions around the world. Maureen O'Connell and Kimberly Vrudny are at the foreground of a new generation of theologians linking the aesthetic and the political, the contemplative and the prophetic, streams in the tradition too often kept apart.

Books

Christ, Carol P. *She Who Changes: Re-Imagining the Divine in the World*. New York: Palgrave MacMillan, 2003.

Dadosky, John D. *Image to Insight: The Art of William Hart McNichols*. With art by William Hart McNichols and foreword by Mirabai Starr. Albuquerque: University of New Mexico, 2018.

Evdokimov, Paul. *The Art of the Icon: A Theology of Beauty*. Redondo Beach, CA: Oakwood, 1990.

Fleming, David L., SJ. *What Is Ignatian Spirituality?* Chicago: Loyola, 2008.

Johnson, Elizabeth A. *She Who Is: The Mystery of God in Feminist Theological Discourse*. New York: Crossroad, 1992.

Nouwen, Henri J. M. *Behold the Beauty of the Lord: Praying with Icons*. Notre Dame, IN: Ave Maria, 2007.

O'Connell, Maureen. *If These Walls Could Talk: Community Muralism and the Beauty of Justice*. Collegeville, MN: Liturgical Press, 2012).

Raphael, Melissa. *The Female Face of God in Auschwitz: A Jewish Feminist Theology of the Holocaust*. New York: Routledge, 2003.

Schneiders, Sandra M. *Women and the Word: The Gender of God in the New Testament and the Spirituality of Women*. Notre Dame, IN: St. Mary's College, 1986.

Traub, George W., SJ, ed. *An Ignatian Spirituality Reader*. Chicago: Loyola, 2008.

Vrudny, Kimberly. *Beauty's Vineyard: A Theological Aesthetic of Anguish and Anticipation*. Collegeville, MN: Liturgical Press, 2016.

Articles and Artistic Resources

Copeland, M. Shawn. "Marking the Body of Jesus, The Body of Christ." In *Enfleshing Freedom: Body, Race, and Being*, 55–84. Minneapolis: Fortress, 2010.

Greeley, Andrew. "The Mother Love of God." In *The Catholic Imagination*, 89–103. Berkeley: University of California, 2000.

John Paul II. *Letter of His Holiness Pope John Paul II to Artists*. April 4, 1999. *https://w2.vatican.va/content/john-paul-ii/en/letters/1999/documents/hf_jp-ii_let_23041999_artists.html*.

Pramuk, Christopher. "Making Sanctuary for the Divine: Exploring Melissa Raphael's Holocaust Theology." *Studies in Jewish-Christian Relations* 12, no. 1 (2017): 1–16.

Schapker, Holly. *ADSUM*. Holly Schapker. *Https://www.hollyschapker.com/adsum*.

———. There's Something about Mary. Holly Schapker. *Https://www.hollyschapker.com/there-s-something-about-mary*.

White, Claire Nicolas. "And Then There Was Light: Five Generations of Stained-Glass Makers." *Commonweal* (Dec. 12, 2006): 12–14.

Music, Audio, and Visual

The Boy Who Found Gold. Directed by Christopher Summa. Dramaticus Films, 2016.

"The Icon Painters of Bethlehem." *Heart and Soul*. BBC World Service, December 24, 2017. *Http://www.bbc.co.uk/programmes/w3cswcyx*.

Lopez, Alma. "Our Lady." Alma Lopez. *Http://almalopez.com/ourlady.html*.

The Secret Life of Bees. Directed by Gina Prince-Bythewood. Twentieth Century Fox, 2008.

CHAPTER

"A Dream of Life"

Bruce Springsteen: Light at the Edges of Darkness

They shall beat their swords into plowshares,
 and their spears into pruning hooks;
One nation shall not raise the sword against another,
 nor shall they train for war again.

—Micah 4:3

We remain in the air, the empty space, in the dusty roots and deep earth, in the echo and stories, the songs of the time and place we have inhabited. My clan, my blood, my place, my people.

—Bruce Springsteen

Hope must be told, in image, in figure, in poem, in vision.
 It must be told sideways, told as one who dwells with the others in the abyss.

—Walter Brueggemann

The morning of September 11, 2001, began as a beautiful fall day in New York City. At 8:46 a.m., a Boeing 767 aircraft, with a crew of eleven and seventy-six passengers—and five hijackers on board—slammed into the North Tower of the World Trade Center (1 WTC) in downtown Manhattan. Seventeen minutes later, at 9:03 a.m., a second Boeing 767, with a crew of nine and fifty-one passengers—five hijackers on board—crashed into the South Tower of the World Trade Center (2 WTC). In the space of those seventeen minutes, Bruce Springsteen, like many people across the country, remembers sitting, "transfixed by a television screen, where the unimaginable was occurring."[1]

CASE STUDY

Bruce Springsteen, *Nebraska* and *The Rising*

1. Bruce Springsteen, *Born to Run* (New York: Simon and Schuster, 2016), 439.

Like Springsteen, a lot of onlookers that morning had first assumed that some inexperienced "poor bastard"[2] had flown his Cessna into the first tower. But as New Yorkers looked toward the sky, smoke billowing from the great gash in the building, there was a collective cry of horror and disbelief as another full-size passenger plane flew into the second tower.

© Fabio Diena / Shutterstock.com

Bruce Springsteen

Thirty-four minutes later, at 9:37 a.m., in Arlington County, Virginia, a Boeing 757, with a crew of six and fifty-three passengers—five hijackers on board—crashed into the Pentagon. Meanwhile Flight 93, a Boeing 757 that had left Newark airport at 8:42 a.m. with a crew of seven and thirty-three passengers, had been overtaken by four hijackers, their intended target likely the U.S. Capitol or the White House. The passengers and crew of Flight 93, having learned mid-flight of the other attacks in progress, fought to subdue the hijackers. At 10:03 a.m., the plane crashed into a field near Shanksville, Pennsylvania. Four minutes earlier, at 9:59 a.m., 2 WTC Tower collapsed; 1 WTC collapsed at 10:28 a.m. The combined attacks killed 2,996 people, and injured over 6,000.[3]

Of the nearly 3000 dead, 412 were first responders, including 343 New York City firefighters. Fr. Mychal Judge, a Franciscan priest and beloved FDNY chaplain, was in the lobby of the North Tower, saying prayers over the injured and dead, when debris from the collapse of the South Tower swept into the lobby and struck him in the head, killing him. Shortly after, an NYPD lieutenant came upon the chaplain, and with help from two firefighters and several others, carried Judge's body from the North Tower. A Reuters photographer, Shannon Stapleton, captured the scene in a photograph that would become one of the

2. Springsteen, *Born to Run*, 439.

3. *The 9/11 Commission Report*, National Commission on Terrorist Attacks upon the United States, 2004, *http://govinfo.library.unt.edu/911/report/index.htm*.

most famous from that morning, described by one newspaper as "an American Pieta."[4] I can hardly look at the photo—"iconic" in every sense of the word—without being overcome by emotion.

When the North Tower fell some thirty minutes later, Springsteen remembers "feeling like anything, truly anything, could or might happen next."[5] It was "such an impossible and confounding event" that not even the TV reporters on the scene, broadcasting live through smoke and falling ash, could describe what was happening. That afternoon, Springsteen drove from his New Jersey home to the Rumson-Sea Bright Bridge, where "usually, on a clear day, the Twin Towers struck two tiny vertical lines on the horizon at the bridge's apex. Today, torrents of smoke lifted from the end of Manhattan Island, a mere fifteen miles away by boat. . . . [A] thin gray line of smoke, dust and ash spread out due east over the water line." He went down to the beach and sat, alone, "beneath the eerie quiet of silent skies." As he got back into his car and was pulling out of the lot, a car exiting off of the bridge slowed down as it passed. The driver, recognizing Springsteen, shouted, "Bruce, we need you!"[6]

"The Crossing between This World and the Next": The Rising

Some days later, Springsteen was asked to perform in a national telethon to benefit the massive recovery efforts in the wake of the attacks. The song he wrote for that show, "Into the Fire," wasn't completed in time for the benefit, so he performed "My City of Ruins," adapting a song he had written a year earlier—not about New York City but about Asbury Park, New Jersey, where he had gotten his start as a musician. "There's a blood red circle / on the cold hard ground / and the rain is fallin' down / The church door's thrown open / I can hear the organ song / but the congregation's gone / My city of ruins."[7] On September 21, the telethon aired live, uninterrupted and commercial-free, on all four major

4. Matt Prigge, "Upward Christian Soldier," *Philadelphia Weekly*, May 3, 2006. Because his body was the first to be recovered and taken to the morgue, Fr. Mychal Judge was designated as "Victim 0001," the first official victim of September 11. Stapleton's photograph accompanies an NPR retrospective on the tenth anniversary of 9/11, "Slain Priest: 'Bury His Heart, but Not His Love,'" *Morning Edition*, NPR, September 9, 2011, *https://www.npr.org/2011/09/09/140293993/slain-priest-bury-his-heart-but-not-his-love*. For a moving remembrance of Judge, see the feature-length documentary *Saint of 9/11: The True Story of Fr. Mychal Judge*, dir. Glenn Holsten (Virgil Films, 2006). For iconographer William Hart McNichols's image, see "Holy Passion Bearer Mychal Judge," Images, William Hart McNichols, *http://frbillmcnichols-sacredimages.com/featured/holy-passion-bearer-mychal-judge-132-william-hart-mcnichols.html*.

5. Springsteen, *Born to Run*, 439.

6. Springsteen, *Born to Run*, 439–40.

7. Bruce Springsteen, "My City of Ruins," *The Rising*, Columbia, 2002.

networks. The stage behind him illuminated by candles, Springsteen opened the show playing an acoustic guitar and a harmonica, introducing "My City of Ruins" as "a prayer for our fallen brothers and sisters."[8] In his 2016 biography, *Born to Run*, titled after the massively successful 1975 album that had catapulted him into fame, Springsteen remembers the significance for him personally, artistically, spiritually, of that moment.

> Of the many tragic images of that day, the picture I couldn't let go of was of the emergency workers going *up* the stairs as others rushed down to safety. The sense of duty, the courage, ascending into . . . what? The religious image of ascension, the crossing of the line between this world, the world of blood, work, family, your children, the breath in your lungs, the ground beneath your feet, all that is life, and . . . the next, flooded my imagination.[9]

If you watch video of the telethon performance and keep in mind the scale of the horror of 9/11 for the country and certainly for the world—less than two years later American tanks would be rolling across the Kuwaiti border into Iraq—it is truly a remarkable moment. Springsteen, characteristically, offers no cheap grace, no flag-waving jingoism. With his band members behind him, lifting him up like a gospel choir, the anguished refrain of "Come on, rise up!" is a dual cry of both pain and possibility, desperation and resilience. The invocation to rise up is at once limned in painful remorse, a sense of complicity for the "ruins" in which we find ourselves as a people, as a nation, as a world. "My City of Ruins" is a cry of hope against looming despair, a plea for the "sweet bells of mercy" against the possibility that our sins are too great, that for too long we have cut ourselves loose from our most humane and sacred ideals. "Into the Fire," the song he had intended for the telethon, names those ideals explicitly, linking them with the heroism of the firefighters, and turning them into a prayer of wonder, thanksgiving, and hope: "May your strength be our strength / May your faith give us faith / May your hope give us hope / May your love give us love."[10]

In March 2002, just six months after 9/11, Springsteen went into an Atlanta studio with the E Street Band and recorded *The Rising*. "I didn't sit around wondering about whether I should or should not write about this day. I just did." Tracks directly tied to 9/11—"Into the Fire," "My City of Ruins," "You're Missing," and "The Rising," among others—would set the mood and thematic trajectory for the album, but Springsteen had felt from the beginning that "if I was

8. See *America: A Tribute to Her*oes, dir. Beth McCarthy-Miller and Joel Gallen (Warner/Reprise, 2001), aired September 21, 2001; see also Springsteen, "My City of Ruins," *https://www.youtube.com/watch?v=Mi_Tm_g6KdA*.

9. Springsteen, *Born to Run*, 441.

10. Bruce Springsteen, "Into the Fire," *The Rising*.

going to continue to write thematically, my songs could not depend on simply being tied to the event."[11] The result is a collection of fifteen songs that range widely across genres, mood, and lyrical content: from gospel lamentations and blues to straight-ahead rock anthems; from Eastern-inflected world music and intimations of the afterlife to the "awkwardness and isolation of survival." His aim was to bring together songs that were able "to breathe and find their place within the framework I created."[12] What was that framework, the interpretive vision through which Springsteen created *The Rising*? It seems to me the answer is captured in what he says about the ordinary heroes of 9/11.

> If you love life or any part of it, the depth of their sacrifice is unthinkable and incomprehensible. Yet what they left behind was tangible. Death, along with all its anger, pain and loss, opens a window of possibility for the living. It removes the veil that the "ordinary" gently drapes over our eyes. Renewed sight is the hero's last loving gift to those left behind.[13]

These lines serve well, I think, to sum up Springsteen's own legacy as a songwriter and performer spanning a career of nearly fifty years, 120 million records sold worldwide, and innumerable honors and awards. Whether singing about a small-time hustler trying to convince his girlfriend that everything is going to be alright ("Meeting across the River"), a soldier returning home from war ("Born in the USA," "Shut Out the Light"), the simple joys of the New Jersey boardwalk in summer ("Girls in Their Summer Clothes"), the frustrated dreams of working class Americans ("Used Cars," "The Ghost of Tom Joad," and about a hundred other songs), or the mythic lure of the American highway ("Born to Run," "Valentine's Day," and about five hundred other songs), Springsteen seems bent on "removing the veil that the 'ordinary' gently drapes over our eyes." *Renewed sight is the hero's last loving gift to those left behind.*

The thing is, the protagonists in Springsteen's songs are rarely those whose choices reflect an unambiguously heroic path, like the firefighters who lost their lives on 9/11. More often they are pushing hard against this side of the veil, sensing other "possibilities for the living," but not quite able to transcend the hard surface of things. "Rock and roll has always been this joy, this certain happiness that is in its way the most beautiful thing in life. But rock is also about hardness and coldness and being alone. . . . I finally got to the place where I realized life had paradoxes, a lot of them, and you've got to live with them."[14]

11. Springsteen, *Born to Run*, 441.

12. Springsteen, *Born to Run*, 442.

13. Springsteen, *Born to Run*, 441.

14. Cited in Dave Marsh, *Bruce Springsteen: Two Hearts–The Definitive Biography, 1972–2003* (New York: Routledge, 2004), 228.

Day in and day out, each of us negotiates the uneasy fault line between death and life, sin and grace, fear and love, imprisonment and freedom, longing and fulfillment. Through Springsteen's artistry, the struggle itself becomes heroic—or if art cannot make it heroic, it can, in Springsteen's rendering, make it truthful and redemptive, perhaps even beautiful. Only rarely does heroism stand out so clearly as it did on that fall morning in New York City. And even then, especially then, the gift of "renewed sight" comes so often with an unthinkable price. And yet, *and yet* . . . what is left behind, says the poet, is tangible: "the world of blood, work, family, your children, the breath in your lungs, the ground beneath your feet."[15]

What is it that keeps us bound so hard and beautiful to the blood in our veins, the breath in our lungs, the blood and breath *of others*? And what is it that pushes us out beyond the veil to flirt recklessly with the hard edges between death and life, sin and grace? When Springsteen was called out to create *The Rising*—"Bruce, we need you!"—perhaps it was because he had traversed the borderlands at the edges of darkness for so long and so unflinchingly in his music that he had earned enough trust—from himself, and from his listeners—to dare a truthful, and perhaps even redemptive, response. America, too, has paradoxes, a lot of them. And few artists have plumbed the inner promise and perils of the American mythos more tenaciously than Bruce Springsteen.

"Sir, I Guess There's Just a Meanness in This World": *Nebraska*

The opening of Springsteen's 1982 album *Nebraska* heralds a far different kind of journey than that of the hero, a narrative arc about as far as one could imagine from the triumphant textbook stories we tell schoolchildren about the American dream. The album's cover image ought to have warned us: a lonely highway stretching into bleak, black-and-white distance, the view framed by car dashboard and ice-laden windshield, the cloud-heavy horizon between road and sky as flat and unyielding as a prison-yard wall. Red block letters announce the unexpected itinerary—NEBRASKA—as if to say, put on your seat belt, lean back into the cheap vinyl of the rear passenger seat, and close your eyes.

A reverb-laden harmonica punctures the cold silence inside the narrator's head, *inside your head*; an acoustic guitar lays down a quiet pattern, just rhythmic enough to keep you breathing steady, to give your breath back to you when it's caught up short by what's to come. "I saw her standing on her front lawn / just a' twirlin' her baton / Me and her went for a ride, sir / and ten innocent people died." *Hang on*, you protest, *I didn't ask to be inside this guy's head. Who is this, and*

15. Springsteen, *Born to Run*, 441.

where is he taking me? "From the town of Lincoln, Nebraska / a sawed-off .410 on my lap / through the badlands of Wyoming / I killed everything in my path."[16]

Images of innocence and innocence shattered in a single line, a single breath: I cannot think of another album that so immediately, so completely, so disarmingly bears the listener inside another person's head as does *Nebraska*, whether you want to go there with Springsteen or not. The opening track takes us inside the mind of nineteen-year-old spree-killer Charles Starkweather, who murdered eleven people during a two-month killing spree across Nebraska and Wyoming between December 1957 and January 1958. In all but one of the murders, Starkweather was accompanied by his fourteen-year-old girlfriend, Caril Ann Fugate. Music critic William Ruhlmann describes *Nebraska* as "one of the most challenging albums ever released by a major star on a major record label."[17] Even today, after almost four decades and countless listenings, the song "Nebraska" still makes my skin tingle, the hair on my forearms stand up, takes my breath away. "I can't say that I am sorry / for the things that we have done / at least for a little while, sir / me and her we had us some fun."

About his own songwriting, Springsteen says, "My records are always the sound of someone trying to understand where to place his mind and heart. I imagine a life, I try it on, then see how it fits. I walk in someone else's shoes, down the sunny and dark roads I'm compelled to follow."[18] What makes *Nebraska* so "challenging" from start to finish—I dare say, so starkly beautiful—is the unparalleled degree to which Springsteen is willing to "imagine a life, try it on, see how it fits," and take his listeners along for the ride, no matter how dangerous or disquieting the journey may be. Dangerous because, like a mirror, Springsteen pulls back the veil to show what we human beings (Americans, not least) are capable of, and disquieting insofar as it stirs the realization that "There, but for the grace of God, go I." Across its ten spare tracks, *Nebraska* holds us almost relentlessly in the dark, like that bleak view through the windshield on the album cover. And yet between the lines of nearly every song, where the flat horizon at highway's edge meets descending clouds, hints of transcendence—or at least the yearning for it, heartbreaking and beautiful—break through.

If the opening track yields no hint of dignity or grace—"Sheriff when the man pulls that switch, sir / and snaps my poor head back / you make sure my pretty baby / is sittin' right there on my lap"—the album's final track, "Reason to Believe," blesses the listener, Springsteen's cotravelers on the highway, with shards of hopeful light, if only breaking through cracks in the battered windshield. In the album's final image, a wedding party is gathered by the riverside, as

16. Bruce Springsteen, "Nebraska," *Nebraska*, Columbia, 1982.

17. William Ruhlmann, "Review of Nebraska—Bruce Springsteen," AllMusic, *https://www.all music.com/album/nebraska-mw0000650804*.

18. Springsteen, *Born to Run*, 278.

the congregation, preacher, and groom await the bride's arrival. But then inexplicably, as the "sun sets behind a weepin' willow tree," the groom now "stands alone and watches the river rush on so effortlessly / Wonderin' where can his baby be." Each verse paints images of life and love lost, yet each verse ends with a proclamation of wonder at the strange and stubborn paradox of faith. "Still at the end of every hard-earned day people find some reason to believe." Despite the disappointments, the violence, the suffering, what is it that gives people a reason to believe? Might the seeds of resilience and yearning hidden in "the hard-earned day" itself provide some kind of an answer?

Two songs in the middle of *Nebraska* are emblematic of the "quiet violence" and "moral ambiguity and unease" that Springsteen sought to expose beneath the surfaces of workaday American life. "Highway Patrolman" and "State Trooper" were both recorded in a single take; both let us hear and feel their main characters' thoughts, ponder their choices; both wash over the listener like "black bedtime stories."

In "Highway Patrolman" we meet "Joe Roberts," a police sergeant who "works for the state." Though he has "always been an honest man / as honest as I could," Joe's honesty is trumped by his loyalty to his brother Frankie, who "ain't no good." Allusions to his brother's troubled past seem to temper, if not justify, the sergeant's moral complicity in Frankie's crimes. Love of "one's own," all others be damned, can lead us to do terrible things. "Yeah we're laughin' and drinkin' / nothin' feels better than blood on blood / Man turns his back on his family / he ain't no friend of mine."

The song that follows, "State Trooper," puts us in the passenger seat with a late-night driver on the New Jersey Turnpike, praying, pleading, hoping that "Mr. State Trooper" at the side of the road won't stop him. As Erin McKenna and Scott Pratt describe the song, "His plea seems to be as much for the state trooper as for himself, as though, if he were stopped, the trooper's life would be at risk."[19] The driver's attention shifts to the late-night radio—"just talk, talk, talk / till you lose your patience"—and then, his desperation growing, to the great beyond. "Hey somebody out there, listen to my last prayer." But it seems doubtful that anybody will listen, note McKenna and Pratt. "The feeling of being between, strung out on the highway late at night, is shared by the listener caught up in the droning rhythmic chords and the strained voice of the driver. The meaning is found in the hearing, sharing an experience that becomes transformative by growing experience at its edges."[20]

The whole of *Nebraska* might be described precisely in this way: the listening "becomes transformative by growing experience at its edges." As

19. Erin McKenna and Scott Pratt, "Living on the Edge: A Reason to Believe," in *Bruce Springsteen and Philosophy: Darkness on the Edge of Truth*, ed. Randall E. Auxier and Doug Anderson (Chicago: Open Court, 2008), 170.

20. McKenna and Pratt, "Living on the Edge," 171.

Springsteen puts it, "These songs were the opposite of the rock music I'd been writing. . . . The tension running through the music's core was the thin line between stability and that moment when the things that connect you to your world, your job, your family, your friends, the love and grace in your heart, fail you. I wanted the music to feel like a waking dream and to move like poetry. I wanted the blood in these songs to feel destined and fateful."[21] The writing of *Nebraska* "was in the details," he says, "the twisting of a ring, the twirling of a baton, was where these songs found their character." And most poignantly for me, it was in his capacity to tell the story from a child's point of view. "Mansion on the Hill," "My Father's House," and "Used Cars" were all stories, he says, "that came out of my experience with my family."[22] "Mansion on the Hill" was written first, and "My Father's House" last. Bare and deeply confessional, they might have served as bookends to the record, no less powerful than "Nebraska" and "Reason to Believe." They are for me the spiritual heart of the record.

If by "heart" we mean the core of a person, what makes a person tick, "My Father's House" lays bare Springsteen's own heart—not a fictional character's—perhaps more than any other song in his decades-long career. It begins with a dream sequence that seems to promise healing and redemption: the narrator finds himself in the forest as a child, trying to make it home "before the darkness falls." The "hard things" that have divided the man from his father are too painful and too far gone to be healed. His father no longer lives in the house of his childhood; he may even be dead. It ends with a painful "awakening," the realization that as an adult he remains stuck on this side of the "dark highway where our sins lie unatoned." The dream was just that: a dream. Yet the yearning "to cross that dark highway" haunts his waking hours.

Jesus' parable of the prodigal son comes to mind (Luke 15:11–32), the son who longs to return home and reconcile, but can't imagine that his father might be waiting and yearning for the same. The sense of loss and desire for reconciliation that permeates the song is something to which every listener can relate, whether it be reconciliation with a parent or sibling, or some other person, or ultimately, God, where all reconciliations, suggests Jesus, merge into one. Indeed, just as in Jesus' parable, the metaphor of father/Father is inescapable, and the image itself of "my father's house" comes straight from the Gospel (John 14:2). Thus the song holds the listener in an immersive space of desire for healing and lament for all the ways we remain "torn apart" from people we love, and from the God who awaits our return.[23]

In an analogous way, "Mansion on the Hill" narrates the chasm between the rich and the poor in America, the American dream and its shadow-side

21. Springsteen, *Born to Run*, 299.

22. Springsteen, *Born to Run*, 299.

23. Springsteen, *Born to Run*, 503–5.

nightmare—two worlds in one land, separated by "gates of hardened steel." In verse two, a scene of startling intimacy and alienation, the mansion becomes emblematic of Springsteen's own father's failures to make it out of the hard-scrabble working class world and carry his family to the other side. "At night my daddy'd take me and we'd ride / Through the streets of a town so silent and still / Park on a back road along the highway side / Look up at that mansion on the hill." Yet the final scene of "Mansion on the Hill" seems to relativize all such divides in the silent presence of something, or someone, whose abiding warmth seems to shine from within and beyond all human contingencies, even if it cannot unify the world it illuminates. "Tonight down here in Linden Town / I watch the cars rushing by home from the mill / There's a beautiful full moon rising / Above the mansion on the hill." Once again the moon, as we saw in chapter 8, evokes a kind of divine maternal presence, saying nothing, blessing everything in her warm light. Buried in Springsteen's autobiography is a line that seems to capture the artist's sense of faith, or better, his trust in the divine Mercy, an inner sensibility that says, despite it all, the universe is on our side: "There are irretrievable lives and unredeemable sins, but the chance to rise above is one I wish for yours and mine."[24]

The ten songs of *Nebraska* represent some of Springsteen's finest work as a storyteller and poet in a career spanning almost fifty years, each track inviting the listener to "imagine a life, try it on, see how it fits." We might call them post-industrial, post-Christian spirituals, each song almost daring us to find, through the cracks in the windshield, some reason to believe. Images of baptism, the primeval forest, the river, the full moon shining over the highway, its cars "rushing by home from the mill"—all conjuring, as if "through a glass, darkly" (1 Cor. 13:12, KJV), the heartbeat of "a love seemingly beyond love, beyond our control."[25]

It was principally from his mother, it seems, and not his father, that Springsteen learned about love, the kind of love that "has a great deal to do with humility." His mother "remains magic; people love her when they meet her, as they should." At ninety-one and living with Alzheimer's, "she delivers a warmth and exuberance the world as it is may not merit. . . . To this day she can give me a true, deeply hopeful feeling about life over the course of an otherwise-ordinary one-hour lunch at a local diner. . . . She is heart, heart, heart."[26] It is not hard to imagine Springsteen writing a song inspired by his mom, a pared-down spiritual, in which an old woman finds her way back to her waiting son in the car, "just after she's returned from the headstones at St. Rose of Lima Cemetery, visiting my dad."[27] Like the moon hanging over Linden Town, "she shone her

24. Springsteen, *Born to Run*, 503.

25. Springsteen, *Born to Run*, 416.

26. Springsteen, *Born to Run*, 416–17.

27. Springsteen, *Born to Run*, 417.

light on me at a time when it was all the light there was."[28] His mother's full-moon heart has given Springsteen—and through him, us—a reason to believe.

"Where I Wanted to Make My Stand": Poet of Blue Collar America

About ten years and five albums into his career, Springsteen's songwriting took a significant turn with the recording of *Darkness on the Edge of Town* (1978) and *The River* (1980). Having been catapulted into rock stardom at age twenty-six with *Born to Run* (1975), he worried about losing contact with the lives of those who had most shaped his: his parents, his sisters, the working-class people who lived in the apartment next door and along the street of his Catholic neighborhood in Freehold, New Jersey—the people whose dreams and spiritual longings drove the narrative of *Born to Run*. "Despite devoutly pursuing it, I viewed the world of success with great skepticism."[29]

Springsteen began to find inspiration in old and new places, listening seriously to Woody Guthrie, Hank Williams, and "to the country music I'd so long ignored";[30] he listened to Bob Dylan and gospel music, and to the British working-class blues of the Animals, all forms "that gave voice to adult lives under stress and seeking transcendence."[31] He found inspiration in the emerging punk scene in New York and Britain, young bands and a generation of youth pushing back hard against the Reagan-Thatcher era. "It was after my success, my 'freedom,' that I began to take seriously these issues," the "piece of me that lived in the working-class neighborhoods of my hometown."[32] In Woody Guthrie especially, Springsteen found inspiration. He says he was mesmerized by "the subtle writing, raw honesty, humor and empathy that's made his music eternal. In his stories of depression-era Okies and migrant workers, he revealed the folks trapped on the fringes of American life. His writing wasn't soapbox rambling but finely wrought personal portraits of American lives, told with toughness, wit and common wisdom."[33]

During their US concert tour for *The River*, Springsteen and the E Street Band began to cover Guthrie's iconic "This Land Is Your Land," intending, he says, "to give voice to stories that in Reagan 1980s America rock n' roll wasn't always telling."[34] It is a cogent point. At the height of his artistic powers and

28. Springsteen, *Born to Run*, 416.

29. Springsteen, *Born to Run*, 293.

30. Springsteen, *Born to Run*, 264.

31. Springsteen, *Born to Run*, 292.

32. Springsteen, *Born to Run*, 264–65.

33. Springsteen, *Born to Run*, 292.

34. Springsteen, *Born to Run*, 292.

potential for massive commercial success, Springsteen was discovering in Guthrie and others a body of "music that emotionally described a life I recognized, my life, the life of my family and neighbors. Here was where I wanted to make my stand musically and search for my own questions and answers. I didn't want out. I wanted in. I didn't want to erase, escape, forget or reject. I wanted to understand. What were the social forces that held my parents' lives in check? Why was it so hard?"[35] During a 2009 concert, Springsteen described *The River* as "a record that was sort of the gateway to a lot of my future writing. . . . It was a record made during a recession—hard times in the States. Its title song is a song I wrote for my brother-in-law and sister. My brother-in-law was in the construction industry, lost his job and had to struggle very hard back in the late 70s, like so many people are doing today. It was a record where I first started to tackle men and women and families and marriage."[36]

In 1981, after a triumphant tour in Europe, while browsing through paperbacks in a drug store outside Phoenix, Springsteen came across *Born on the Fourth of July*, a memoir written by Vietnam veteran Ron Kovic. A couple weeks later, he met the author by happenstance, poolside at a California hotel, when Kovic rolled up to greet him in his wheelchair. Back on tour in New Jersey he met another vet, Bobby Muller. It was the beginning of Springsteen's advocacy for the newly formed Vietnam Veterans of America, "the start of putting some piece of what I did to pragmatic political use."[37]

As *The River* tour ended, he found himself reading Howard Zinn's *A People's History of the United States*, Henry Steele Commager's *A Pocket History of the United States*, and Joe Klein's *Woody Guthrie: A Life*. His newfound interest in American history "seemed to hold some of the essential pieces to the identity questions I was asking. How could I know who I was if I didn't have a clue as to personally and collectively where I'd come from?"[38] Equipped with "a new view of myself as an actor in this moment in time," Springsteen was determined to address the issues that had begun to emerge in *Darkness on the Edge of Town* and *The River*. "I was never going to be Woody Guthrie—I liked the pink Cadillac too much—but there was work to be done."[39]

Thus at the turn of the 1980s, with Ronald Reagan in the White House and a considerable slice of pop music turning to disco, alternative rock, and glam rock escapism—synthesizers and drum machines leading the way—Springsteen was paring it down to an acoustic guitar, a harmonica, and a

35. Springsteen, *Born to Run*, 264.

36. Springsteen introducing a live performance of the album, Madison Square Garden, November 8, 2009, cited in *Irish Examiner*, *https://www.irishexaminer.com/lifestyle/artsfilmtv/how-the-river-cemented-bruce-springsteens-place-in-music-401793.html*.

37. Springsteen, *Born to Run*, 291.

38. Springsteen, *Born to Run*, 292.

39. Springsteen, *Born to Run*, 291.

four-track tape recorder in his bedroom. Above all, he had American stories to tell, stories of lives teeming with pathos. "By the end of the *River* tour, I thought perhaps mapping that territory, the distance between the American dream and American reality, might be my service, one I could provide that would accompany the entertainment and the good times I brought my fans . . . Beyond this, I personally needed to know where my family—my grandparents, my mom, dad and sisters—fell in the arc of American experience and what that meant for me, the fortunate son."[40] The key point is worth repeating: "*I didn't want out. I wanted in. I didn't want to erase, escape, forget or reject. I wanted to understand.*"

The making of *Nebraska* marked a kind of wager with himself, and with his audience, to go fully in, to understand. To paraphrase Springsteen, how can we know who we are, personally and collectively, if we haven't adequately faced and tried to understand where we've come from? As Howard Zinn said of *The People's History of the United States*, which Springsteen credits with inspiring many of the stories in *Nebraska*, "Our nation had gone through an awful lot— the Vietnam War, civil rights, Watergate—yet the textbooks offered the same fundamental nationalist glorification of country. I got the sense that people were hungry for a different, more honest take."[41]

"Baptized in Each Other's Blood": Conjuring That Ever-Elusive "Us"

I would like to pull back the lens for a few moments to consider three songs written in the twenty years between *Nebraska* and *The Rising* that illustrate Springsteen's genius for giving listeners "a different, more honest take" on America, shining a light into the darker corners of the nation's inner contradictions. The 1984 song "Shut Out the Light," though never released on a major album and too easily overlooked in his sprawling corpus, is one of Springsteen's finest. Happily it is included in *Tracks*, a 1998 four-disc box-set of demos, B-sides, and outtakes. Recorded during the *Born in the USA* sessions, "Shut Out the Light" bears the same haunted feel of tracks on that album like "I'm On Fire" and "Downbound Train." It might have also fit well onto *Nebraska* but for its more sharply produced studio sound, with the addition of backing vocals and a violin.

Inspired by Kovic's *Born on the Fourth of July*, "Shut Out the Light" tells the story of Johnson ("Johnny") Lineir, a Vietnam veteran returning home from the war and finding it impossible to return to the way things were. "This song

40. Springsteen, *Born to Run*, 294.

41. Cited in Michael Powell, "Howard Zinn, Historian, Dies at 87," *The New York Times*, January 27, 2010, *https://www.nytimes.com/2010/01/28/us/28zinn.html*.

is about leaving home and not being able to find your way back,"[42] Springsteen said when introducing it during the *Born in the USA* tour. The song's genius lay partly in its shifting narrative voice, with third-person accounts from the perspective of Johnny, his wife, his mother and father, his friends, all of which give way in the chorus to a first-person cry of vulnerability and pain.

> Oh mama, mama, mama come quick / I've got the shakes and I'm gonna be sick
>
> Throw your arms around me in the cold dark night / Hey now mama don't shut out the light / Don't you shut out the light / Don't you shut out the light
>
> Don't you shut out the light / Don't you shut out the light[43]

A sense of "loneliness envelops the song," as one reviewer notes, and while Vietnam is never mentioned, it hangs over the narrative "as a phantom presence." With spare instrumentation and clocking in at just under four minutes, Springsteen has "rarely expressed so much with so little."[44]

Much in the way of *Nebraska*, the narrative details in "Shut Out the Light" are superbly drawn, "from an anxious wife who undoes an extra button on her blouse to the 'Welcome Home' banner and polished chrome that only seem to increase the distance between Johnny who changed and the people who stayed the same."[45] The last verse finds Johnny "deep in a dark forest, a forest filled with rain," standing in "a river without a name," facing not the darkness of Vietnam so much as the unquiet demons within himself. There are striking resonances here with the dream sequence in "My Father's House," where the child breaks through the trees, comes upon his father's house, and finally "fell shaking in his [father's] arms." In "Shut Out the Light," by contrast, there is no such reconciliation, not even in a dream or someplace imagined—hoped for—on the other side of death. Johnson Lineir simply stands in the river, enveloped in darkness, dreaming only of "where he's been." It's not the first or last song in which Springsteen reaches for baptismal imagery, where his main character goes "down to the river" seeking some kind of redemption or healing that remains elusive. The same inability to reconcile might be said of America's relationship with the Vietnam War, a devastation remembered by the Vietnamese people, not incidentally, as the American War.

42. Cited in "100 Greatest Bruce Springsteen Songs of All Time," *Rolling Stone*, January 16, 2014, *https://www.rollingstone.com/music/lists/100-greatest-bruce-springsteen-songs-of-all-time-20140116/shut-out-the-light-19691231*.

43. Bruce Springsteen, "Shut Out the Light," *Tracks*, Columbia, 1998.

44. Bryan Wawzenek, "Rock's Hidden Gems: Bruce Springsteen's 'Shut Out the Light,'" Ultimate Classic Rock, *http://ultimateclassicrock.com/bruce-springsteen-shut-out-the-light/*.

45. Wawzenek, "Rock's Hidden Gems."

We scroll forward now almost ten years to early 1993, when director Jonathan Demme asked Springsteen to write a song for his film *Philadelphia*, an early mainstream film dealing with HIV/AIDS, starring Tom Hanks and Denzel Washington. *Rolling Stone* magazine describes the resulting song, "Streets of Philadelphia," as follows: "Transposing the intimate feel of recent albums into a sonic context, he went to his home studio with a drum machine and no musicians. What emerged was a sparse, haunting ballad that flew up the charts all over the world, genuinely challenged his audience and earned him a Grammy, a Golden Globe and even an Academy Award."[46] Musician Jackson Browne, one of the best songwriters of Springsteen's generation, puts the achievement in starker terms. "To write from the perspective of someone who is emaciated, with AIDS, is to forsake all of the strength Springsteen had staked his career on. It is quite a feat."[47]

Implicitly Browne puts his finger on the devastation of HIV/AIDS itself as Americans were only beginning to openly grapple with the epidemic in the early 1990s, and reluctantly at that. Springsteen turns the youthful bravado and masculine strength on which he "had staked his career" into a powerful narrative of male vulnerability and need, loneliness and marginalization—as in the film, unveiling a different kind of strength than most Americans and American males would willingly embrace. The character played by Denzel Washington in the film—a somewhat cocky, streetwise, homophobic black attorney who only reluctantly agrees to represent the character played by Tom Hanks, a highly successful corporate attorney who is dying of AIDS—gives the audience a lens through which to examine their own fears and prejudices surrounding the gay community, and HIV/AIDS in particular. In "Streets of Philadelphia," Springsteen somehow captures the pathos that continues to divide Americans from each other, even in the "city of brotherly love."[48]

Finally in 1999, two years before 9/11 and three years before *The Rising*, Springsteen wrote a song called "American Skin (41 Shots)" in response to the shooting of an African immigrant named Amadou Diallo by plainclothes NYPD officers.[49] The song is built around a kind of mantra, repeating the number of bullets fired into Diallo's body—"Forty-one shots, forty-one shots, forty-one shots"—a number, Springsteen suggests in his autobiography, which

46. Cited in "100 Greatest Bruce Springsteen Songs of All Time."

47. "100 Greatest Bruce Springsteen Songs of All Time."

48. In the video for "Streets of Philadelphia," Springsteen sings as he walks along desolate streets and abandoned lots, then past schoolyards humming with children, smiling and waving at the camera, homeless men warming themselves by a fire, and finally along the Delaware River at night. The vocal track was recorded live during the shooting, lending a raw and unrehearsed feel to the video. See *https://www.youtube.com/watch?v=4z2DtNW79sQ*.

49. Bruce Springsteen, "American Skin (41 Shots)," released first as a live version on *Bruce Springsteen and the E Street Band: Live in New York City*, Columbia, 2001, then as a studio version on *High Hopes*, Columbia, 2014.

seems "to gauge the size of our betrayal of one another."[50] Diallo was killed while reaching for his wallet, foreshadowing many more such deaths in communities of color at the hands of police in the decades to come.

In the first verse, Springsteen imagines the scene, and sympathetically, from one of the officers' perspectives: "Kneeling over his body in the vestibule / praying for his life." In the second verse, an African American mother is getting her young son ready for school, trying to impress upon him the gravity of the most innocent actions, such as reaching for a wallet, or taking one's hands off the steering wheel during a traffic stop. "She says now on these streets Charles, you got to understand the rules." The song's bridge—"Is it in your heart, is it in your eyes"—implicitly asks the listener to consider their own complicity in systems of racial injustice, as Springsteen puts it, in the "daily compounding of crimes, large and small, against one another." The third verse says perhaps what Springsteen says best in his socially oriented songs: like it or not, we belong to each other "in the land of brotherly fear."[51] "We're baptized in these waters and in each other's blood . . . It ain't no secret, no secret my friend / You can get killed just for living in your American skin."

Though Springsteen maintains that he "worked hard for a balanced voice" in the song, "American Skin" angered a lot of people, not least law enforcement officers in New York and New Jersey. "It truly pissed people off."[52] Why? In part, surely, because it was an *internal critique*: an artist and public figure on a very large stage critiquing one of his own. These were his people, after all, the cops and first responders he would honor a few years later in *The Rising*, and more broadly, the working class (white) Americans with whom Springsteen had grown up in his hometown of Freehold, New Jersey. A number of police groups called for a boycott of his performances at New York City's Madison Square Garden, and officers working security detail for the band made their displeasure quite clear, in a number of colorful New York ways.

One night in June 2000, after performing the song at the Garden, the parents of Amadou Diallo came to see him backstage, as Springsteen remembers it, "two elegant and beautiful Africans who in gentle voices spoke a little of Amadou and thanked me for writing about their son."[53] A few days later, an elderly black woman approached him as he was walking down the street in Red Bank, New Jersey. "They just don't want to hear the truth," she said. And there were, after all, a few police officers who thanked him, saying that they understood what he was saying in the song.

"American Skin," Springsteen concludes, "brought me just a little closer to the black community I always wished I'd served better."[54] The point is

50. Springsteen, *Born to Run*, 435.

51. Springsteen, *Born to Run*, 435.

52. Springsteen, *Born to Run*, 435–36.

53. Springsteen, *Born to Run*, 434.

54. Springsteen, *Born to Run*, 436.

understated, almost an afterthought, but it has to do with empathy, our capacity as human beings—black or white, rich or poor, blue collar or white collar, Republican or Democrat—to occupy another person's skin, if only for the duration of a song. And when we can do that, we're engaged in what Springsteen has called a "collective event of imagination,"[55] or a bit more irreverently, the "magic trick"[56] of his art.

As I noted in the introduction, drawing from philosopher Charles Taylor and others, when a work of art breaks open the "buffered self" to immerse us in the life-world of another—the joys and struggles, the angels and demons, the laughter and tears—we're suddenly drawn into the preconceptual realm of desire and imagination, of being seized and transformed by something beyond ourselves—precisely what Christians call "grace." As Springsteen describes it, artist and audience are drawn into "an ongoing dialogue about what living means. You create a space together. *You are involved in an act of the imagination together*, imagining the life you want to live, the kind of country you want to live in, the kind of place you want to leave your children. What are the things that bring you ecstasy and bliss, what are the things that bring on the darkness, and what can we do together to combat those things?"[57]

"More Pages Possible": We Are Still Writing Our Family History

Let me return to the epigraph by Robert Henri that opens this book. "When the artist is alive in any person, whatever his kind of work may be, he becomes an inventive, searching, daring, self-expressing creature." When others are trying to "close the book" on human possibility, says Henri, the artist "opens it, shows there are still more pages possible."[58] Clearly there are few artists, much less ordinary citizens like you and me, who wield the kind of influence Springsteen carries as a public figure. Still there are some insights that ordinary folks like us might draw from his story with respect to laboring for justice and reconciliation in our deeply divided society.

A first point I noted above, which is the power of internal critique, and with respect to white Americans, in particular, the need for prophetic witness among "our own." For at least sixty years and much longer, black artists, preachers,

55. Scott Calef, "A Little of That Human Touch: Knowledge and Empathy in the Music of Bruce Springsteen," in *Bruce Springsteen and Philosophy*, ed. Auxier and Anderson, 229.

56. Bruce Springsteen, *Born to Run*, xii.

57. Bruce Springsteen, "Bruce Springsteen: The Rolling Stone Interview," interview with Joe Levy, *Rolling Stone*, November 1, 2007, *https://www.rollingstone.com/music/news/bruce-springsteen-the-rolling-stone-interview-20071101*.

58. Robert Henri, *The Art Spirit* (1923; repr., New York: Basic Books, 2007), 11.

theologians, and public intellectuals have been wondering where the prophetic voices for racial justice are to be found among their white colleagues. In his famous "Letter from Birmingham Jail"—undoubtedly one of the most important political and religious documents of twentieth-century America—Dr. Martin Luther King Jr. considered the irony of being accused by his fellow white Christian ministers of being an "extremist." Perhaps we need a few more creative "extremists for love," he shot back, recalling that Jesus of Nazareth was similarly accused by the religious and political "keepers of the peace" in his time.[59]

The point is, the public silence and passivity of white Christians in the face of stubborn racial disparities continues to speak volumes to those communities of color most vulnerable and threatened in our time. Add to this the appalling ignorance of Americans of all races—including our current president[60]—with respect to African American, Native American, Latino American, Asian American history, and so on, which is also, plain and simple, American history, *our* collective family story. From our very beginnings, we are "baptized in each other's blood," but too few Americans know or care to remember from where, and from whom, we have come as a diverse immigrant people.[61]

A second point follows. Whatever may be our communities of identity and commitment, if we are not, like Springsteen, occasionally pissing people off, if we are not meeting with some degree of resistance in our work, if the choices we make never bring us into conflict with the prevailing powers of society, to say nothing of our family and friends—which is often where the most visceral pushback to change arises—we might ask ourselves whether we are doing the

59. Martin Luther King Jr., "Letter from Birmingham City Jail," in *A Testament of Hope: The Essential Writings and Speeches of Martin Luther King, Jr.*, ed. James M. Washington (New York: HarperCollins, 1986), 289–302.

60. "Frederick Douglass is an example of somebody who's done an amazing job and is getting recognized more and more, I notice," remarked President Trump during an oval office ceremony to mark Black History Month. At best, Trump has demonstrated a "laughably vacuous" grasp of African American history, and an embarrassingly tokenist and instrumental approach to Blacks themselves, as during the 2016 presidential campaign, when he pointed out a black man in the crowd to say, "Oh, look at my African American over here. Look at him. Are you the greatest?" See David A. Graham, *The Atlantic*, Febuary 1, 2017, *https://www.theatlantic.com/politics/archive/2017/02/frederick-douglass-trump/515292/*.

61. Springsteen's 1995 album *The Ghost of Tom Joad* is set in California amid "the increasing economic division of the eighties and nineties," its atmosphere inspired by John Ford's film adaptation of Steinbeck's *The Grapes of Wrath*. Sonically stripped down in the way of *Nebraska*, the album tells the stories of Mexican migrants and others facing "the effects of post-industrialization in the United States and the weight of lost jobs, outsourced labor and the disappearance of our manufacturing base on the citizens whose hard work built America" (*Born to Run*, 402). "I'd seen it firsthand," Springsteen explains, "when the Karagheusian Rug Mill, based in Freehold, rather than settle a labor dispute with its workers, closed up shop and shipped south for cheaper, nonunionized labor. The jobs were gone." The 2012 album *Wrecking Ball* doubles-down on Springsteen's "critical, questioning and angry patriotism," a growing sense, mirroring the Occupy Wall Street protests, that a "big promise has been broken," while few have been held accountable. See Fiachra Gibbons, "Bruce Springsteen: 'What Was Done to My Country Was Un-American,'" *The Guardian*, February 7, 2012.

hard work for justice and reconciliation that needs to be done. Consider Springsteen's advocacy for Vietnam veterans, sparked by his friendship with Ron Kovic and Bobby Muller. To what extent are we building relationships beyond our comfortable circles of kinship that might bear fruit for the transformation of our society toward the common good? And then there is Springsteen's friendship with E Street Band saxophonist Clarence Clemons, with whom he shared an iconic stage presence and some thirty years of musical collaboration. Surely Springsteen's plaintive wish to have "served better" the black community is rooted at least partly in the mutual respect he shared with "The Big Man," as Clemons was affectionately known, a friendship that endured from 1972 until Clemons' death in 2011.[62]

A third point follows. None of us is, or ever will be, perfectly heroic in our capacity to love and labor for a more just society. Like most of the characters in Springsteen's songs, no person's life—just as no nation's history—is unambiguously heroic. No matter your race or economic status, no matter your political persuasion or religious commitments, we all navigate the uneasy fault lines between sin and grace, blindness and sight, fear and love, imprisonment and freedom. And once again, in Springsteen's telling, it is through the struggle itself, the cracks in the battered windshield, that the light breaks in. To recall Phil Ochs, the gifted protest singer of the 1960s (chapter 6), "The reward is the act of struggle itself, not what you win."[63] Like Springsteen throughout his career, Ochs struggled with bouts of severe depression and considerable disillusionment with America, a country he loved deeply. Tragically, in 1976, Ochs took his own life. No person is without some cross to bear. It may not be for us to taste victory on this side of death, but art can help us *to help one another* bear our respective crosses with greater empathy and patience, forbearance and grace.[64]

Springsteen admits that the communion generated between himself and his audience is fraught with ambiguity, even "tinged with a bit of fraud." On the one hand, his stories, even if inspired by actual events, are mostly fictional. "[I am] a member in good standing amongst those who 'lie' in service of the truth . . . artists, with a small 'a.'"[65] On the other hand, something unmistakably new comes into being, something "out of this world," when artist and audience share the power of music and storytelling—"something that before the faithful were gathered here today was just a song-fueled rumor."[66] Whether in concert or in the solitude of private listening, Springsteen's music is testament to

62. Bruce Springsteen, *Born to Run*, 241–45, 471–75.

63. Cited in Phil Ochs, *Farewells & Fantasies*, Elektra R273518, inner sleeve.

64. Springsteen writes of being "crushed" by depression, on and off again, throughout his life, and especially in his early sixties, "between 60 and 62, good for a year, and out again from 63 to 64" (*Born to Run*, 272–74, 308–12, 484–87).

65. Bruce Springsteen, *Born to Run*, xi.

66. Bruce Springsteen, *Born to Run*, xii.

the truth that *we need one another across all kinds of boundaries* to mourn and resist and "combat those things that bring on the darkness."

As someone who has experienced the collective joy of a live Springsteen concert, I confess to being a believer. Though it was more than thirty years ago, I haven't forgotten the electricity that turned me and 80,000 strangers for well over three hours into something like one body, one spirit. "I am here to provide proof of life to that ever-elusive, never completely believable 'us,'" confesses Springsteen. "That is my magic trick."[67] This is not too far, I think, from the magic that draws people into communities of faith and other communities of belonging: we seek out others "to provide proof of life to that ever-elusive, never completely believable 'us,'" and to know this truth of our shared humanity not just intellectually, but *experientially*, down in the bones. At the end of the day, this may be the Truth of all truths that "will set you free" (John 8:32). I share Springsteen's conviction that the glimpses we get of such truths, on this side of death, are trustworthy.

Throughout this book I have made the case that the most powerful art is that which holds opposite or seemingly irreconcilable aspects of human experience in a single field of vision: solitude and communion, trauma and grace, death and new life, violence and beauty, struggle and joy, sin and grace. If religious iconography in the Eastern Christian tradition, as suggested in chapter 8, seeks to illuminate our original blessing, the glory of the human person created in the divine image, Springsteen's Roman Catholic sensibilities underscore what Western theology since Saint Augustine has called original sin, the brokenness of humanity, our seeming inability to realize our divine potential for goodness and compassion, joy and happiness.[68] In a now-classic essay called "The Catholic Imagination of Bruce Springsteen," Andrew Greeley observes that on the subject of human sinfulness, Springsteen "sounds like Saint Paul, who lamented that 'the good which I would do, I do not do; and the evil which I would not do, that I do.'"[69] Indeed when Springsteen put those final words on the lips of Charles Starkweather—"Well sir I guess there's just a meanness in this world"[70]—he

67. Bruce Springsteen, *Born to Run*, xii.

68. Theologically the "reconciliation of opposites"—the coinherence of life and death, light and dark, humanity and divinity—pulses at the heart of the Christian memory and experience of God from the very beginning. "The essential note of catholicity, understood as a theological category, is . . . to reconcile opposites (*coincidentia oppositorum*) after the manner of our understanding of Christology itself." Lawrence S. Cunningham, "*Extra Arcam Noe*: Criteria for Christian Spirituality," in *Minding the Spirit*, ed. Elizabeth A. Dreyer and Mark S. Burrows (Baltimore: John Hopkins University Press, 2005), 173, citing Avery Dulles.

69. Andrew Greeley, "The Catholic Imagination of Bruce Springsteen," *America* 158 (Feb. 6, 1988): 112.

70. The line bears striking resemblance to words spoken by "the Misfit" in Flannery O'Connor's short story "A Good Man is Hard to Find"—"No pleasure but meanness"—just before he kills the grandmother in the story. See Flannery O'Connor, *O'Connor: Collected Works* (New York: Penguin, 1988), 152. In repeated interviews and in his autobiography, Springsteen has acknowledged the influence of O'Connor on his music (*Born to Run*, 431).

gave voice to an experiential wisdom that resounds across every religious tradition from time immemorial. How to account for the darkness within the human heart—sometimes interrupted by religion, too often nourished by it—that spirals outward in violence toward the other?

And yet the sense of communion and joy that Springsteen embodies in his music, especially in the live concert experience, is no less palpable than the foreboding darkness. Greeley goes so far as to describe him as a "liturgist," without ever being explicit about it "or even necessarily aware of it," precisely "because his imagination was shaped as Catholic in the early years of life."[71] If Greeley is correct—and Springsteen himself has repeatedly acknowledged the significance of his Catholic upbringing[72]—we might say that in the artist himself we see both "the glory of the human person fully alive," laboring to conjure from thin air that ever elusive *Us*, and at once, the lonesome pilgrim set out on the American highway, holding on to one more "lonesome day," just this side of despair. Catholic or Protestant, Black, Latinx, Native American, Asian American, or White, Democrat or Republican, in the midst of the polarities that cripple our lives in the social body, how do we still find a reason to believe? To live and lean into that question with integrity and not to run from it is the artist's, and no less the person of faith's, magic trick. To do so and still communicate a sense of profound joyfulness, empathy, and hope in one's work is a rare gift indeed.[73]

So we return to where we began. Holding together in a single frame the flaming towers of 9/11 and the firefighters ascending the smoke-filled stairways of those same towers, Springsteen alights on the final great paradox: that death, "with all its anger, pain and loss, opens a window of possibility for the living," and that "renewed sight is the hero's last loving gift to those left behind." In the year following the release of *The Rising*, Springsteen and the E Street Band "crisscrossed the nation trying to contextualize the uncontextualizable."[74] Fifteen

71. Greeley, "The Catholic Imagination of Bruce Springsteen," 111.

72. Of his childhood Springsteen writes that he grew up "literally, in the bosom of the Catholic Church, with the priest's rectory, the nuns' convent, the St. Rose of Lima Church and grammar school all just a football's toss away across a field of wild grass. . . . I don't often participate in my religion but I know somewhere . . . deep inside . . . I'm still on the team. This was the world where I found the beginnings of my song" (*Born to Run*, 5, 13–18). In a 2012 interview, Springsteen said that it was his Catholic upbringing rather than political ideology that has most influenced his music. He noted that his faith had given him a "very active spiritual life," while also joking that this "made it very difficult sexually." He added, "Once a Catholic, always a Catholic." Editors, "Boss Talk," *The Tablet*, February 25, 2012.

73. "Rock bands try to project a lot of different things: intensity, mystery, sexuality, cool," Springsteen says in a recent interview. "Not a lot of rock bands concentrate on joy, and I got that from my relatives on the Italian side—they lived it and they passed it down to me." In Bruce Springsteen, "Bruce Springsteen: 'You Can Change a Life in Three Minutes with the Right Song,'" interview with Michael Hann, *The Guardian*, October 30, 2016, https://www.theguardian.com/music/2016/oct/30/bruce-springsteen-interview-born-to-run-change-someones-life-right-song-donald-trump.

74. Bruce Springsteen, *Born to Run*, 443.

years later, he acknowledges that the horrors of September 11 may have been "beyond music and art's ability to communicate, explain, heal or even comment upon. I don't know." And yet, he concludes, "[My] own desire to use the language I learned as a musician to sort through what was in my own head turned me to writing those songs. . . . When that guy yelled out, 'Bruce, we need you!' that was a tall order, but I knew what he meant; I needed something, someone, too. As I drove home on that lonely day to find my children, my wife, my people and you again, I turned to the only language I've ever known to fight off the night terrors, real and imagined, time and time again. It was all I could do."[75]

It is hard to imagine any other songwriter daring to attempt what Springsteen did in *The Rising*. In truth, he has been doing it fearlessly his whole career: removing the veil that the "ordinary" gently drapes over our eyes. And daring us to join him in a collective event of imagination.

Imagination: Where Hope Rises

Two of the happiest years of my life (and two of the hardest) were spent as a stay-at-home dad, when my wife was completing her medical residency and our oldest son, Isaiah, was a toddler. Most of our days together began with breakfast, and then, weather permitting, a long walk around the neighborhood, stopping whenever we met something of interest: a slug sliding and drawing a silvery path across the sidewalk; a handful of pebbles to toss, one by one, into the street; a neighbor planting flowers along her driveway. An hour or so later, we'd be back at the house, and I'd boost him up into his favorite swing, a simple fabric seat with a safety strap in front, suspended from the branch of a large flowering dogwood tree in the front yard. We called it the "Imagination Swing." And he loved it.[76]

Isaiah would lean back, eyes closed, as I drew the seat of the swing back and let go. Then back and forth he'd go, feeling the breeze and sunlight on his face, me pushing him while weaving some tall tale about a Superhero Adventurer Boy named Isaiah flying through clouds and over lakes and valleys to some faraway place on the other side of the planet. The journey in between, made up on the spot by me, of course, was full of all kinds of strange twists and turns, which Isaiah accepted entirely and without qualification. It was, after all, the Imagination Swing. Anything and everything was possible.

As the months went by, something changed. As his capacity for language developed, Isaiah would suddenly interrupt my stories and interject his own scenarios: a whale leaping out of the sea as he flew over, catching him between fins on its back, and plunging him down into the deep waters for an aquatic meeting

75. Bruce Springsteen, *Born to Run*, 443.

76. Christopher Pramuk, "A Father's 9/11 Prayer: Hopes for Children in a World Marked by Violence," *America* 215 (Sep. 12, 2016): 27–28.

with the Merpeople and the Merking and Merqueen who lived beneath the waves. All of this with his eyes shut, his fiery red hair tossed about in the breeze, his face beaming. The sheer vividness of his blossoming inner world amazed me, and even more, the ease with which he could cross the gap in his mind's eye between *what is*—the empirical world of experience—and *what is possible*, the realm of the hidden, the mysterious, the unknown—a world shimmering just behind the veil.

In these years at home with Isaiah, one memory especially stands out: September 11, 2001. It was a beautiful fall day in Denver, and it began like most days with a walk around the neighborhood. An hour later, after an unsettling phone call from my wife about events unfolding in New York City, I was fixed on the television set in the bedroom, while trying to keep Isaiah occupied in another room. I couldn't fathom the scene before my eyes. Much less could I allow the images to burn their way into the child's imagination—his precious imagination! Sometimes the boundary between what is and what is possible collapses suddenly and horrifically in a chaos of the unthinkable. And when that happens, it is only the poets and artists, the storytellers and prophets, it seems to me, who can restore our collective faith in the realm of the unseen, the hidden, the possible.

When Springsteen in "The Rising" tells the story of September 11 from the vantage point of a firefighter ascending one of the towers; when he dares to narrate some glimpse of a world beyond the veil of chaos and violence and a smoke-filled empty sky, he is painting a picture for our collective imaginations, suggesting that perhaps death and violence and retribution are not, need not be, the final word. In the last verse, as the band drops away to open a broad space beneath the empty sky, the firefighter seems to be looking back, as it were, from the other side of death, and glimpsing some other possibility for both the dead and the living.

I see you Mary in the garden / In the garden of a thousand sighs
There's holy pictures of our children / Dancing in a sky filled with light
May I feel your arms around me / May I feel your blood mix with mine
A dream of life comes to me / Like a catfish dancing on the end of my line
Sky of blackness and sorrow (a dream of life) / Sky of love, sky of tears
 (a dream of life)
Sky of glory and sadness (a dream of life) / Sky of mercy, sky of fear
 (a dream of life)
Sky of memory and shadow (a dream of life) / Your burning wind fills my
 arms tonight
Sky of longing and emptiness (a dream of life) / Sky of fullness, sky of
 blessed life

In the days and months following September 11—a national trauma and international tragedy that cannot be understood apart from the complex history of events, policy decisions, and other global cultural and religious factors that laid its groundwork—there seemed to be very few public voices trying to mediate "an ongoing dialogue about what living means," very few political leaders helping us to imagine in the wake of those events "the life you want to live, the kind of country you want to live in, the kind of place you want to leave your children."[77] Rather to the contrary, as I recall those days, the country's march toward war felt swift and virtually unstoppable, a foregone conclusion. Of course a credible case for war had to be made—thus Secretary of State General Colin Powell's now-infamous testimony at the UN about weapons of mass destruction in Iraq[78]—but few could doubt the resolve of the United States to act decisively, to settle scores old and new, to make somebody pay. It was in the period between 9/11 and the launch of the Second Iraq War that Springsteen recorded and released *The Rising*.

At one level *The Rising* was so deeply affecting for many Americans because, as philosopher Scott Calef observes, it helped us "collectively make sense of the numbingly unfathomable events of that day by reducing them to a personal scale. 'Shirts in the closet / shoes in the hall . . . / TV's on in the den / Your house is waiting / For you to walk in / But you're missing.'"[79] At still another, more elusive level, at a time when the nation was mobilizing for war, the album dared to open a space for the imagination of peace. *The Rising* seemed to say—not in political terms but in human ones—that healing cannot come from the centrifugal power of our wounded rage; still less can it arise from the terrible power of our war-making machines. (Springsteen's friendship with veterans had brought him close to the human costs of war.) Healing comes, rather, in the attempt to understand the roots of our suffering and in the repairing of long-sundered relationships. It comes in a renewed commitment to the virtues of courage and self-sacrifice celebrated in "Into the Fire."

And sometimes healing washes over us, inexplicably, when we sense the presence of those lost, loving and strengthening us, from just behind the veil. "I see you Mary in the garden, in the garden of a thousand sighs." Hope for life's flourishing on this side of death breaks in, paradoxically, from life on the other side. At times Springsteen's gestures to resurrection faith verge on the shamanic. "We remain in the air, the empty space, in the dusty roots and deep earth, in the echo and stories, the songs of the time and place we have inhabited."[80] Part

77. Levy, "Bruce Springsteen: The Rolling Stone Interview."

78. On February 5, 2003, then Secretary of State Colin Powell appeared before the UN to demonstrate the urgency of engaging a war with Iraq, a speech he would later regret and acknowledge was based on false intelligence. See Jason M. Breslow, "Colin Powell: UN Speech 'Was a Great Intelligence Failure,'" *Frontline*, PBS, May 17, 2016, *https://www.pbs.org/wgbh/frontline/article/colin-powell-u-n-speech-was-a-great-intelligence-failure/*.

79. Calef, "A Little of That Human Touch," 234, citing the song "You're Missing."

80. Springsteen, *Born to Run*, 504.

priest and part poet, he is a conjurer of magic, whose music "removes the veil that the 'ordinary' gently drapes over our eyes."

"Watching in the Night": The Audacity of Living by Faith

And here it seems to me impossible, as Andrew Greeley argued thirty years ago, to separate Springsteen's music from his Catholic sensibilities. It is no stretch to imagine him as a child absorbing with fascination the meaning-making rituals of the Catholic liturgical environment in which he was raised, the so-called "smells and bells" of Catholicism. Some of my own earliest memories involve standing outside the church doors in the darkness of night during the Easter Vigil, amid a sea of friends and family and fellow parishioners, and watching in wonder as our parish priest set aflame the great bonfire by which the community anticipates the Resurrection of Jesus. The dramatic specter of flames rising into the night sky, the sensory interplay of fire, oil, incense, and water that comes out to play during the Easter Vigil, as new members are baptized into the community, makes an indelible impression on a child's imagination.

In one of his finest meditations, Thomas Merton describes that moment when Catholics and other Christians around the world gather before the tomb of Jesus on Holy Saturday evening, "watching in the night."

> The first voice that speaks in the silent night is the cold flint. Out of the flint springs fire. The fire, making no sound, is the most eloquent preacher on this night that calls for no other sermon than liturgical action and mystery. That spark from cold rock, reminds us that the strength, the life of God, is always deeply buried in the substance of all things. It reminds me that He has power to raise up children of Abraham even from the stones. . . .
>
> [For] there is nothing lost that God cannot find again. Nothing dead that cannot live again in the presence of His Spirit. No heart so dark, so hopeless, that it cannot be enlightened and brought back to itself, warmed back to the life of charity.[81]

By "the life of charity" Merton means simply the life of love. *There is no heart so dark, so hopeless, so alienated, so cold, that it cannot be "warmed back" to its capacity for love.* Not to put too fine a point on it, but Springsteen in *The Rising* seems to want to immerse us analogously, almost liturgically, in the "warming" fires of love, where hope can rise again from within the deepest "substance of all things." To ascend "into the fire" thus bears multivalent meanings, dangerous

81. Thomas Merton, *The New Man* (New York: Farrar, Straus and Giroux, 1961), 238, 241–42.

and beautiful. Fire destroys, and fire brings light, sometimes terrible, awe-inducing light; yet fire can break open seeds of new life, springing forth, seeming miraculously, from fields of death.

Several months after September 11, 2001, I remember reading an article in *The Denver Post* that detailed a curious phenomenon in the lives of American women. Obstetricians around the country were reporting a significant spike in the rate of conceptions. Far from a decline in the number of pregnancies one might expect in dangerous and uncertain times, health care professionals were seeing just the opposite. Like the tender shoots of saplings poking their heads through fire-ravaged soil, new life was bursting forth in the wombs of American women. A woman named Stacey Stapleton said that before September 11, "My whole life was about what I could and couldn't afford. Now, really, the only thing that's important is that I have my husband and that I'm able to have a family."[82] Stacey and her husband Paul, who worked in New York City just three blocks from Ground Zero, decided to have a child "as fighter jets flew over their Manhattan apartment."

How to explain such a moment? And how many times in war-torn human history has this curious phenomenon replayed itself, defying forecasts of gloom and credible causes for despair? Not only in New York City or Sandy Hook or Las Vegas but in places like El Salvador during its brutal civil war, where for ten years helicopter gunships financed by the United States routinely strafed the night and dawn skies; or in the Warsaw Ghetto, where one can dare to imagine the joyful ritual of a man and woman laying aside clothes marked with the yellow star.

"If imagination is the creative power that perceives the basic resemblances between things, then all sources, no matter how exotic, resonate in me as well."[83] As the metaphors of my own deeply embedded Catholic imagination might dare to say, there is something of the brilliant moon in the human race, something like a deep throbbing and palpable urge for life. No amount of darkening sky or endlessly careening abyss can blot it away. "I am," the full moon proclaims, even as it draws its light from another source, and gives it lovingly away. Wheeling away behind the moon's stubborn silver solidity, the darkness of the cosmos is a nothing. It pretends to swallow the moon, but cannot, for it is only a negation. Indeed the moon shines brightest in a starless sky. So say the people of the earth, who lay naked together on beds of clay, where life renews itself in the eyes of the beloved, and wombs tickle with the dance of fresh saplings.

82. Martha Irvine, "Conceiving Life in Tragedy's Wake," *The Denver Post*, November 28, 2001, accessible via *The Berkeley Daily Planet*, November 28, 2001, *http://www.berkeleydailyplanet.com /issue/2001-11-28/article/8584?headline=Couples-getting-pregnant-as-answer-to-terrorism--By -Martha-Irvine-The-Associated-Press.*

83. Claire Nicolas White, "And Then There Was Light: Five Generations of Stained-Glass Makers," *Commonweal* (Dec. 15, 2006), *https://www.commonwealmagazine.org/and-then-there-was-light.*

"Disarming the Mob": Recognizing Ourselves in the Enemy

One of the most memorable stories in the Gospels is the story of Jesus and the woman caught in the act of adultery (John 8:1–8). Most interpretations focus on the power of mercy and forgiveness that Jesus offers the woman in the face of clear religious sanction for the penalty of death. Yet the story is also about the power of stillness and self-reflection when the violence of mob justice is about to be unleashed.

The scene is rife with pathos and irony. The woman's crime, which has torn the fabric of the community (no mention here of the man), can be cleansed by an act of religiously sanctioned violence. The logic of violence is neat, clean, and simple. By means of stoning the adulteress, says the Bible, "thus shall you purge the evil from your midst" (Deut. 22:24). A similar logic applies to much of our public and political discourse. By means of preemptive war, drone attacks, the death penalty, reflexive deportation, mass incarceration, we shall destroy our perceived enemies before they destroy us.

Jesus measures the situation, bends down and runs his fingers through the earth. The deeper truth, Jesus knows, is far from so neat, clean, and simple. And the mob realizes it the moment he singles them out as individuals: "Let the one among you who is without sin cast the first stone." By opening a space for silence and self-examination, Jesus disarms the mob, "one by one, beginning with the elders" (John 8:7–8). Jesus opens a pregnant space for the unexpected, the seemingly impossible to happen, no less astounding than the raising of Lazarus from the dead.

It seems to me that Springsteen, through the gift of his music, opened up a similarly reflective and potentially redemptive kind of space—a disarming of the mob—when he wrote, recorded, and toured the country with *The Rising*. The album invited the nation collectively to take a deep breath, to confront the shock, loss, and pain of the attacks, and in passing through the hard work of grief to bring a spirit of healing and hope back into the world, rather than reflexively to perpetuate the violence. No doubt the hardest part of grief-work involves coming to terms with the people (or nations) who have hurt you the most, if not by forgiveness, then through an effort to understand and address honestly the causes of the decimated relationship. In the song "Paradise," notice how the narrative perspective shifts between verses. As Springsteen describes the song, "a young Palestinian suicide bomber contemplates his last moments on Earth"; "a navy wife longs for her husband lost at the Pentagon, the absence of the physical, the smells, the human longing for a return to wholeness." In the last verse, the narrator "swims deep into the water between worlds and there confronts his lost love," her eyes "as empty as paradise." Once again, baptismal imagery evokes the longing for purification, and the unifying of "different impressions of an afterlife."[84]

84. Springsteen, *Born to Run*, 442.

The song "Worlds Apart," just after "Empty Sky" at the album's midpoint, pulses with Middle Eastern rhythms, and narratively with "other situations than just American ones. . . . I wanted Eastern voices, the presence of Allah. I wanted to find a place where worlds collide and meet."[85] The famous Pakistani singer Asif Ali Khan and his group are featured on the track. The songs "Nothing Man" and "You're Missing" hearken back to "Streets of Philadelphia," capturing poignantly the isolation and paralysis of survival. But then Springsteen, true to form, also weaves into the tapestry a number of straight-ahead rock and roll songs, joyful, tearing-down-the-house, party music. "Mary's Place," "Let's Be Friends," "Further On," and "Skin to Skin" each in different ways narrates the coming together and risking of new relationships, the beautiful flowering, skin to skin, of that "ever elusive, never completely believable 'us.'"[86] Here is the real power of community, the album seems to suggest: when it leads not to self-righteous retribution and outward-flung violence but to inward-directed remembrance and lamentation, and the healing of broken relationships, so that life might flourish, and hope come to birth in the human community, on this side of death.

When the prophet Micah gave voice to his astonishing vision of a future in which the nations would "beat their swords into plowshares" (Mic. 4:3), he was painting a picture for his people's collective imagination, a Hebrew nation that had grown weary with war and could no longer bear to bury its children. The likelihood of actually realizing Micah's vision of peace in those ancient times was arguably no more, and no less, than it is today. "It is only a poem," says biblical scholar Walter Brueggemann, "a vision, a hunch, a hope." And yet such a hunch "on the lips of a bold poet is enough" to generate hope, says Brueggemann, because the "many folk who show up for the poetry hunch the truth and wait to have it given voice."[87] In other words, God's desire for peace already pulses deep in the heart of the people. Yet to kindle such a dormant hope—a newness breaking into the world we no longer thought possible—the community needs an image, a song, a cry, a summons to freedom. "God's future," says Brueggemann, "rests on the lips of the hope-tellers."[88]

As noted in chapter 1, when Jesus prefaced his teachings with the words, "let those with eyes to see, see, and those with ears to hear, hear," scholars tell us he was speaking as a teacher of Jewish wisdom, appealing not just to the head but to the heart and imagination, the body and the senses, the whole person of the listener. Jesus loved to tell stories laden with images from everyday life: the kingdom of God is like a great wedding banquet, or a woman putting her last coin in the temple collection, or a farmer casting seeds onto the soil. "Unless a

85. Springsteen, *Born to Run*, 442.

86. Springsteen, *Born to Run*, xvi.

87. Walter Brueggemann, *Disruptive Grace: Reflections on God, Scripture, and the Church*, ed. Carolyn J. Sharp (Minneapolis: Fortress, 2011), 148, 145.

88. Brueggemann, *Disruptive Grace*, 149.

grain of wheat falls to the ground and dies, it remains only a grain of wheat" (John 12:24). Christ brings hope to a suffering world not from far above the fray but from within the valley of the human, as one who dwells with others in the abyss. In a similar way, when Dr. King dared us to dream of a day when our kids are measured not by the color of their skin but by the content of their character, he was painting pictures for our collective imagination: *God is doing something new in us; it is right out in front of us. I can see it, can you?*

Springsteen is a poet of the sort that "hunches the truth" pulsing within the heart of the people and is gifted with an extraordinarily empathic imagination to give it voice. And because he does so from "within" the people, and not from high "above," the truths he sings resonate, the hints of transcendence ring true, if only for the duration of a song. As Brueggemann puts it, truth and hope-telling must be "told sideways, told as one who dwells with the others in the abyss."[89] Even in the wake of enormous commercial success, as we have seen, Springsteen has committed himself as an artist to remaining "with the others in the abyss," his music gifting us, his cotravelers on the highway, with reason to believe in the possibilities of life and of love, on both sides of death.

Springsteen describes "The Rising" as "Secular stations of the cross, steps of duty irretraceable, the hard realization of all the life and love left behind . . . the opening sky."[90] If the dead are not simply lost to us, hidden behind an impenetrable veil, but raised up bodily "in a sky full of light," what kind of power do they hold over our collective memory, our freedom, our faith in the future of the human family? The Jesuit theologian Jon Sobrino, himself the survivor of a brutal civil war in El Salvador, has suggested that we receive from the dead "a saving power: they summon to conversion, bring light and salvation."[91] The question is: what *kind* of conversion, what *kind* of salvation? While our prayerful remembrance of the dead may profoundly console and comfort us, and rightly honor them, the highly selective way we remember may be tearing us apart as a global community. In other words, *whose* dead, *which* dead, really matter?

The children of Afghanistan have never known a time of peace. As of this writing, at eighteen years the war in that country stands as the longest by far in US history. We have acclimated ourselves to protracted warfare—and the commitment of unfathomably vast human and economic resources toward the military-industrial complex—as a national way of life. Meanwhile most Americans remain insulated from the real costs, sacrifices, and moral hazards of waging war, a luxury the children of Iraq and Afghanistan—and the families of US soldiers—do not have. For Americans who call themselves Christians, can our hope be a Christian hope if it does not include all of these children and families, here and around the world?

89. Brueggemann, *Disruptive Grace*, 153.

90. Springsteen, *Born to Run*, 442.

91. Jon Sobrino, et al., eds., *Rethinking Martyrdom* (London: SCM, 2003), 21.

In sum, in a post 9/11 world, how do we begin to replace the imagination of war with the imagination of peace?[92] To my mind this is one of our most urgent and beautiful tasks today: to teach to the imaginations of young people, to feed their wonder, to dare them to imagine, in spite of it all, a future of peace.

"A Vision, a Hunch, a Hope": Who Are the Hope-Tellers of Our Time?

This brings us, finally, back to the Imagination Swing. Of course one could point out that my son's journeys in the swing were purely fictional, indeed fantastical, without any basis in concrete reality, like reading *The Lord of the Rings* or a Harry Potter tale. Yet like such stories they taught him, I believe, and reminded me, that there is far more to the "real world" than what lay empirically on the surface of things. In other words, it was the movement itself between the real and the imagined that lay the foundation for my son's creative development, and indeed, for his faith, that amazing human capacity "to see a way out of no way," as the spiritual goes—or, as the Epistle to the Hebrews has it, the "assurance of things hoped for, the conviction of things not seen" (Heb. 11:1).

The whole of this book in one way or another bends toward the following conclusion: We cannot build a more beautiful, just, inclusive, and sustainable future unless we can first begin to imagine it, and imagine it together, imbibing deeply from lessons of the past, even as we lean forward, like my son in the swing, with hearts open onto the future. Who still dares to speak of a day when nations will bend their swords into plowshares, their spears into pruning hooks, and study for war no more? If our planet today is increasingly colonized by a certain captivity of imagination, then the task before us must be to cultivate an alternative set of images that break open and free our minds and hearts for other possibilities. We need the poets and prophets, the artists and saints, to help us imagine again, to risk even the miraculous, as we open ourselves to possibilities hidden just behind the veil.

In our own times, I think of Jesuit Fr. Greg Boyle, the founder of Homeboy Industries in Los Angeles, and his widely celebrated book, *Tattoos on the Heart: The Power of Boundless Compassion*. Begun in 1988 as a job training program for high-risk youth, today Homeboy Industries employs more than two hundred formerly gang-involved and recently incarcerated young men and women, and serves thousands more annually through free outreach programs in mental health counseling, tattoo removal, legal services, job development, parenting, substance abuse, budgeting, art, and other areas of self-development. Much in

92. I borrow the phrase "imagination of peace" from poet Denise Levertov. See "Making Peace," in Denise Levertov, *Making Peace* (New York: New Directions, 2006), 58.

the way of Jesus and Dr. King, Fr. Boyle paints pictures for the imagination, challenging us to radically reconsider who it is that we call neighbor:

> No daylight to separate us. Only kinship. Inching ourselves closer to creating a community of kinship such that God might recognize it. Soon we imagine, with God, this circle of compassion. Then we imagine no one standing outside of that circle, moving ourselves closer to the margins so that the margins themselves will be erased. We stand there with those whose dignity has been denied . . . with those who have had no voice.[93]

I think of Sr. Thea Bowman, an African American Franciscan nun, scholar, and singer, and an electrifying speaker who inspired millions with her singing and message of God's love for all races and faiths. "My basic approach," Sr. Thea said, "was to try to promote activities that help different groups get to know one another. As we learn to know [and] appreciate one another, then we grow to love one another. [You bring people] into situations where they can share your treasure, your art, your food, your prayers, your history, your traditions, the coping mechanisms that enabled you to survive." And, she added, "I think a sense of humor and a whole lot of fun can help."[94]

Mutual sharing opens the way for "points of convergence" to emerge between strangers, and a new sense of kinship and responsibility is born. Speaking at Howard University in 1968, not long after the assassination of Martin Luther King Jr. she both affirmed and challenged her young audience with words that perhaps resonate no less powerfully today than they must have fifty years ago.

> I know that the younger generation is ready to do something for civil rights. Our young people have risked their lives to attend meetings, to march, to boycott, to demonstrate, to sit in. These things are useful and good. But I'm asking our young people for something better and something bigger. How many of you the educated, the elite, are willing to prepare yourselves to lead?
>
> To write for your people? To speak for your people? To represent us in the courtroom? To see that justice is done?
>
> Martin Luther King is dead. Will you speak for us, write for us, organize, lead? Will you lead us into the Promised Land?[95]

93. Gregory Boyle, *Tattoos on the Heart: The Power of Boundless Compassion* (New York: Free Press, 2010), 190.

94. Cited in Charlene Smith and John Feister, *Thea's Song: The Life of Thea Bowman* (Maryknoll, NY: Orbis, 2009), 245.

95. Cited in Smith and Feister, *Thea's Song*, 109.

It is not incidental that Sr. Thea approached the world as an artist and singer. Though she didn't have a stage nearly as vast as Springsteen's, by all accounts she had a tremendous gift for awakening in people a palpable sense of solidarity and love in the service of justice, of belonging to that "ever elusive, never completely believable 'us.'"

My son Isaiah is now twenty and in college. At two years old, what he "knew" about the world was almost literally nothing. But what he had, what he knew in his whole being without yet knowing it rationally, was the disposition of a poet, the attentive eye of the artist. It is the Beginner's Mind that Jesus celebrates in children, which Buddhism cultivates in daily mindfulness practice, and Judaism infuses in the rituals of Sabbath. *"The readiness is all,"* said Shakespeare, through Hamlet. What thrills me and renews my hope every day in the classroom is the prospect that the "readiness" of my son's wonder-saturated horizon and that of my students will not be narrowed and relegated to a quaint but distant past during their college years, but intensified and deepened by a rigorous immersion in the humanities: the arts, music, philosophy, history, literature, poetry, film—and even, allow me to hope, theology.

To my kids and to young people everywhere I would like to say the pen of the poet is indeed mightier than the sword of the soldier, and the imagination of peace is far worthier of your freedom than the banal uncreativity and horror of war. *The readiness is all.* Pay attention to the poets and prophets, the artists and saints—better yet, be one—and for as long as I'm able, I'll be right behind you, beside you, pushing and laughing and dreaming with you.

Addendum and Additional Resources

"They're both Christian football players, and they're both known for kneeling on the field, although for very different reasons." Thus begins an article by Michael Frost in the *Washington Post*, reflecting on the differences between NFL quarterbacks Colin Kaepernick and Tim Tebow. The former ignited a protest movement and a storm of controversy by taking a knee during the national anthem, intending to draw attention to police violence against African Americans. For his actions he has been maligned by the US president and many fans, and blackballed by NFL owners. The latter, a Heisman Trophy winner and a prominent member of the Fellowship of Christian Athletes, has preached in churches, prisons, schools, youth groups, and evangelical conferences. Both, as Frost notes, are prayerful and devout. "This is the tale of two Christian sports personalities, one of whom is the darling of the American church while the other is reviled. And their differences reveal much about the brand of Christianity preferred by many in the church today."

In her book *Public Dimensions of a Believer's Life*, Monika Hellwig explores the tensions that Christians face between "conformity and critical dissent" in their relationship with society. While conformity to the norms of one's society is generally a virtue to be cherished and taught to children, she argues, history teaches us that there are exceptions, "and to miss the exceptions can be disastrous." Here is the challenge for religious educators as Hellwig frames it: What kind of Christian formation will "bring believers to a maturity that allows them to be loyally critical to the institutions to which they belong"? She concludes, "Unless the essentially prophetic, redemptive character of the Christian commitment is emphasized, most Christians will settle quietly into the routine of established observances and never realize that a critical dimension of the faith is missing."

Conformity or critical dissent? Patriotism or discipleship? A critical dimension of education and faith formation is learning how to discern those "exceptions" when our conscience—the human spirit attuned to the divine Spirit—steers us down the road less traveled. In many ways Springsteen embodies the principle of "loyal critique" even while celebrating the ordinary gifts and glories of being "Born in the USA." Sometimes the role of the artist, says James Baldwin, is "to disturb the peace." Perhaps the same is true of the NFL athlete, the business professional, the farmer, the waiter, the teacher, the college student.

Books

Hellwig, Monika. *Public Dimensions of a Believer's Life: Rediscovering the Cardinal Virtues*. Lanham, MD: Rowman & Littlefield, 2005.

Martin, James, SJ. *Searching for God at Ground Zero*. New York: Sheed & Ward, 2002.

Springsteen, Bruce. *Born to Run*. New York: Simon and Schuster, 2016.

Articles and Poetic Resources

Calef, Scott. "A Little of That Human Touch: Knowledge and Empathy in the Music of Bruce Springsteen." In *Bruce Springsteen and Philosophy: Darkness on the Edge of Truth*, edited by Randall E. Auxier and Doug Anderson, 223–34. Chicago: Open Court, 2008.

Frost, Michael. "Colin Kaepernick vs. Tim Tebow: A Tale of Two Christians on Their Knees." *The Washington Post*, September 24, 2017.

McKenna, Erin, and Scott Pratt. "Living on the Edge: A Reason to Believe." In *Bruce Springsteen and Philosophy: Darkness on the Edge of Truth*, edited by Randall E. Auxier and Doug Anderson, 161–72. Chicago: Open Court, 2008.

Levertov, Denise. "Making Peace." In *Breathing the Water*, 40. New York: New Directions, 1987.

Pramuk, Christopher. "A Father's 9/11 Prayer: Hopes for Children in a World Marked by Violence." *America* 215 (Sep. 12, 2016): 27–28.

Music, Audio, and Visual

America: A Tribute to Heroes. Directed by Beth McCarthy-Miller and Joel Gallen. Warner/Reprise, 2001. Aired September 21, 2001.

Martin, James, SJ. "A Prayer at Ground Zero." *America* (Aug. 22, 2011). Video. *Https://www.youtube.com/watch?v=Jdra46PYovc*.

Saint of 9/11: The True Story of Fr. Mychal Judge. Directed by Glenn Holsten. Virgil Films, 2006.

Springsteen, Bruce. "The Ghost of Tom Joad." *The Ghost of Tom Joad*. Columbia, 1995.

———. "Shut Out the Light." *Tracks*. Columbia, 1998.

———. "Streets of Philadelphia." Official video. *Https://www.youtube.com/watch?v=4z2DtNW79sQ*.

———. "Bruce Springsteen Performs 'You're Missing' on Grand Piano During a Rehearsal in 2002." *Https://www.youtube.com/watch?v=40LBbNFPTiw*.

Sting. "Sting—'The Rising' (Bruce Springsteen Tribute)—2009 Kennedy Center Honors." *Https://www.youtube.com/watch?v=tmWYg4W9CaY*.

Woods, Keith. "My Father Stood for the Anthem, for the Same Reason Colin Kaepernick Kneels." *All Things Considered*. NPR. August 31, 2016. *Https://www.npr.org/sections/codeswitch/2016/08/31/492086321/my-father-stood-for-the-anthem-for-the-same-reason-that-colin-kaepernick-sits*.

Conclusion
A New Kind of Humanity

How
did the rose
ever open its heart

And give to this world
all its
beauty?

It felt the encouragement of light
against its being,

Otherwise,
we all remain

Too
Frightened.

—Hafiz

At a celebration some years ago marking the one hundredth anniversary of the Jesuit-run Sophia University in Japan, Fr. Adolfo Nicolás, then Superior General of the Society of Jesus (Jesuits), made some remarkable comments about religious faith that struck me deeply. Religion, said Fr. Nicolás, is less a code of doctrines and moral teachings than it is a sensitivity to the dimensions of "transcendence, depth, gratuity, and beauty" that underlie our human experiences. Likening religious experience to an appreciation of the intricacies of classical music, Fr. Nicolás said, "religion is first of all very much more like this musical sense than a rational system of teachings and explanations."[1] Addressing his fellow Jesuits and lay educators from Jesuit schools around the world, he continued,

> We are not in education for proselytism, but for transformation. We want to form a new kind of humanity that is musical, that retains this sensitivity to beauty, to goodness, to the suffering of others, to

1. See William Bole, "'He Never Went Back Home': The Jesuit Journey of Adolfo Nicolás," *Jesuits*, September 16, 2016, *http://jesuits.org/story?TN=PROJECT-20160915012837*; also Joshua McElwee, "Jesuit Head: Religion Isn't Doctrine, but Sensitivity to Human Experience," *National Catholic Reporter*, March 18, 2014, *https://www.ncronline.org/news/world/jesuit-head-religion-isnt-doctrine-sensitivity-human-experience*.

compassion. But of course, this is a sensitivity that is threatened today by a purely economic or materialist mindset which deadens this sensitivity to deeper dimension of reality.

Just as this musical sense is being eroded and weakened by the noise, the pace, the self-images of the modern and postmodern world, so is religious sensitivity.[2]

What to do about this gradual deadening of "musical" and religious sensitivity—a situation Fr. Nicolás has described elsewhere as "the globalization of superficiality"?[3]

I suggest that mission today . . . must first of all work toward people helping discover or rediscover this musical sense, this religious sensibility, this awareness and appreciation of dimensions of reality that are deeper than instrumental reason or materialist conceptions of life allow us.

Competition, the search for higher rankings for the sake of even more economic gain, has become the driving force for some institutions. It would be a tragedy if our [Jesuit] universities simply replicated the rationality and self-understandings of our secular, materialist world. Our reason for being in education is completely different.[4]

I had already liked Fr. Nicolás before this speech; after it, I loved him. At the same time, I am challenged by his words. What can he mean by "forming a new kind of humanity that is musical"?

There is another theme that runs like a golden thread through Fr. Nicolás's tenure at the helm of the worldwide Jesuits: his insistence that people everywhere today yearn to recover and cultivate spaces for silence in the midst of their busy and often overstimulated lives. Indeed, a critical dimension of both religious and musical sensitivity is a "taste for silence." The "education of our hearts," he says, the path toward forming a new kind of humanity, begins in silence. "The chapel we carry within ourselves, all the time, no? . . . We can live in great simplicity in the middle of people and yet be carriers of silence."[5]

In emphasizing such themes, Fr. Nicolás is not, I think, indulging in spiritual hyperbole or rhetorical overreach. Still less is he offering a broadside social

2. Bole, "The Jesuit Journey of Adolfo Nicolás."

3. Adolfo Nicolás, "Depth, Universality and Learned Ministry: Challenges to Jesuit Higher Education Today," Mexico City, April 23, 2010, *http://www.sjweb.info/documents/ansj/100423_Mexico%20City_Higher%20Education%20Today_ENG.pdf*, a remarkable address given to educators from Jesuit institutions around the world.

4. Bole, "The Jesuit Journey of Adolfo Nicolás."

5. Adolfo Nicolás, interview with *The Jesuit Post*, July 22, 2013, *https://www.youtube.com/watch?v=0MAsji_kSdU*.

critique with implications only for Jesuit education. Rather, with a characteristically Jesuit wide-angle lens on the global human situation, he is drawing to our attention a deep spiritual malaise at the root of the present human predicament, and offering a vision grounded in Ignatian spirituality—but by no means limited to it—for the recovery of our deepest humanity.

Music serves here as a guiding metaphor for a certain sensibility or disposition, a cast of mind and imagination, a way of listening deeply and responding to reality that goes beyond explicitly religious ways of knowing to touch on all our relationships in every realm of our lives, not least in the education and spiritual formation of young people. Silence is the necessary counterpart to musical and religious sensitivity, for music is, in a very real sense, *a patterning of silence*, just as fruitful and life-giving speech and other forms of loving action are the outgrowth of contemplation, study, and reflection. To form "a new kind of humanity that is musical" has to do with the careful attunement of silence and speech, contemplation and action, active listening and creative expression—in a word, the art of spiritual discernment.

To recall our consideration in chapter 1 of cellist Eugene Friesen and pianist Paul Halley, birthing miracles from the great womb of silence that is the Cathedral of Saint John the Divine, always and everywhere a third musician haunts our movements in time and space, galvanizing our courage, calling us to participate in life's renewal and flourishing. Are we listening? Are we awake? How shall we respond to the invitation? Heschel calls it "the forgotten mother tongue," and Henri calls it "the art spirit." Buddhism calls it "Beginner's Mind," and Saint Ignatius calls it "finding God in all things." Burghardt calls it "contemplation," a "long, loving look at the real," and Metz calls it a "mysticism of open eyes." Bruce Cockburn calls it "an ongoing process of trying to understand things more deeply," and "being a conduit for whatever it is that comes through." Joni Mitchell describes it as "being open to encounter, and in a way, in touch with the miraculous." Whatever one may call it, I first *felt it* as a child reverberating through my whole being, physically, metaphysically, synaesthetically, as I was learning to play the piano.

Clearly I am not alone in this experience. While it is true that not everyone will link the gift and dynamism of the arts with faith or a religious sensibility, neither is it necessary to do so to validate this inner capacity for heightened perception, creativity, and discernment that I have sought to affirm in this book. "When the artist is alive in any person, whatever his kind of work may be, he becomes an inventive, searching, daring, self-expressing creature. . . . Where those who are not artists are trying to close the book, the artist opens it, shows there are still more pages possible."[6] To wrest the seeds of promise from each moment is the labor and the gift of hope, a flowering of imagination endemic to

6. Robert Henri, *The Art Spirit* (1923; repr., New York: Basic Books, 2007), 11.

282 The Artist Alive: explorations in music, art & theology

all, whether or not one describes the gift in religious terms. For people of faith, hope is a theological virtue, the fruit of grace, which breaks open our captivity to the "way things are." Fr. Nicolás seems to be urging all who work in the orbit of religious education not to lose sight of the fundamental thing: our deepest capacity, precisely in the midst of the secular city, to help one another discern and respond to God's hidden presence in the world, calling us to its renewal.

"It is customary to blame secular science and antireligious philosophy for the eclipse of religion in modern society," Rabbi Abraham Joshua Heschel once observed. "It would be more honest," he continued, "to blame religion for its own defeats. Religion declined, not because it was refuted, but because it became irrelevant, dull, oppressive, insipid."[7] I agree with Heschel. As in past generations, many young people are abandoning formal religious practice today not because secularism has made faith appear irrelevant or incredible but because religious belief and practice as so often presented to them lacks empathy and imagination, vitality and prophetic spirit. Too often, it lacks what matters most: love, mercy, and a passionate commitment to justice. But notice that Heschel was also saying that if this is your experience of religion then it isn't authentic religion that you are being presented. It is a false imitation, a deadly counterfeit of the religious experience and wisdom of the prophets, mystics, wisdom teachers, and saints down through the ages.

To say it another way, the enemy of authentic religion is the lie that there are "no new gifts to be given,"[8] no new dreams, no new pages yet to be written in the life-story of God and humankind. What matters is keeping your head down, not asking questions, doing what is required of you. Religion in such a guise becomes little more than a mausoleum, a repository of old words for God, lazy words for God, dead words for God. For many of my students, "the church" as they've experienced it is foremost a place of rules and regulations, its leaders overly (and often hypocritically) preoccupied with sexuality. The church for them often has not been a community of living faith where all are welcome, on pilgrimage together, seeking new ways to embody Christ in the world. Some will continue to show up and pray for the poetry and prophetic spirit to return. A great many have already taken their dreams for life, love, and joy, elsewhere.[9]

7. Abraham Joshua Heschel, *God in Search of Man: A Philosophy of Judaism* (New York: Farrar, Straus and Giroux, 1955), 3; also Arnold Eisen, "The Opposite of Good Is Indifference," interview with Krista Tippett, *On Being*, NPR, June 5, 2008, *https://onbeing.org/programs/arnold-eisen -spiritual-audacity-abraham-joshua-heschel/*.

8. Walter Brueggemann, *Disruptive Grace: Reflections on God, Scripture, and the Church* (Minneapolis: Fortress, 2011), 136.

9. See *Going, Going, Gone: The Dynamics of Disaffiliation in Young Catholics* (Winona, MN: Saint Mary's Press, 2018), a national, narrative-based study by Saint Mary's Press in collaboration with the Center for Applied Research in the Apostolate (CARA) at Georgetown University. John Vitek, one of the two principal authors of the study, suggests that the church and religious educators might begin by listening to young people. "It will require letting go of our belief that we need to control

As I have intimated throughout this book, the much-maligned "secular" is not some cultural space "out there" but is the air we all breathe, those of us who belong to churches, synagogues, and mosques no less than those who identify as "spiritual but not religious." Fr. Nicolás has it right: "The chapel we carry within ourselves, all the time, no?" What I learned implicitly at the piano as a child I have learned again and again in the fluid boundaries between the arts and the human poetry of faith. There is a music in the world that calls out to us always and at once reverberates within our whole being because it moves and breathes inside of us, too. How, then, to "rediscover this musical sense, this religious sensibility, this awareness and appreciation of dimensions of reality that are deeper than instrumental reason or materialist conceptions of life allow us"?

I began this book with the confession that my interest in these pages is not neutral. What Bruce Springsteen says of his art is also, for me, true of theology. "First, you write for yourself . . . always, to make sense of experience and the world around you. It's one of the ways I stay sane." In these chapters I have "turned to the only language I've ever known"[10] to try to make sense of my experience and the world around me: the distinct but inseparable language-worlds of music, art, and theology. Where my efforts have fallen short—as every attempt to speak of God must ultimately fall short—or where I may have irked, offended, or assumed too much of the reader, I ask your pardon. But I trust that you have filled in the gaps along the way with your own images and memories, your own music and poetry, your own silence. I hope the journey has been worthwhile.

With gratitude for his witness to the life of faith in a tumultuous world, I end where we began, with Rabbi Heschel, "a brand plucked from the fire" of Hitler's Europe, whose counsel I offer again as my own: above all, "remember that the meaning of life is to build life as if it were a work of art. You're not a machine. When you're young, start working on this great work of art called your own existence."[11]

And, with Hafiz, the great Sufi poet, I offer this prayer: Whenever you are afraid, may you feel, like the rose, the encouragement of light upon your being.

the message," Vitek said, "and instead, trust in the grace that flows from authenticity, respect and honor the stories of people's lives." Anna Waddelove, "Going, Going, Gone: St. Mary's Press Releases Study on Disaffiliation," review of *Going, Going, Gone*, Christian Brothers Conference, January 25, 2018, *https://www.lasallian.info/2018/01/going-going-gone-saint-marys-press-releases-study-on-disaffiliation/*.

10. Bruce Springsteen, *Born to Run* (New York: Simon & Schuster, 2016), 443.

11. Interview with Carl Stern, 1972; cited in Arnold Eisen, "The Opposite of Good Is Indifference," interview with Krista Tippet, *On Being*, NPR, June 5, 2008, *https://onbeing.org/programs/arnold-eisen-the-spiritual-audacity-of-abraham-joshua-heschel/*.

Appendix A

Discussion Board Posts and "Set the Table"

As an alternative or supplement to regular quizzes, students may be invited to post regular online "discussion board" comments in response to artistic case studies and assigned readings from this book and secondary resources. These posts allow students to dialogue online with their classmates about the material and help lay the groundwork for class discussions. I recommend discussion posts be submitted the night before each meeting, which allows both teacher/moderator and students an advance glimpse into diverse responses to the material. The teacher may adjust the content, frequency, terms of submission, and percent of overall grade for these posts as is fitting.

Prepare Handout and "Set the Table" for Student-Led Discussion

As a way of cultivating a student-centered learning environment and fresh responses to the course material, invite one or two students to prepare and "set the table" for class discussion, independently, each session. Depending on the number of students in the course, each student should be given the opportunity to lead the discussion at least once, including providing a handout with key points and discussion questions inspired by the readings. The teacher may schedule table-setters in advance, or request volunteers from session to session for the next meeting from among those who haven't yet done so, or who might like to lead the discussion on a particular topic.

Guidelines for students: setting the table

Review carefully the primary and secondary reading(s) for the class session for which you are responsible. Find the "gems" in the text: quotes or insights you find most thought-provoking. On a half sheet of paper, quote

Continued

Guidelines for students: setting the table Continued

2–3 key points (total) directly from the readings that you would like the class to discuss. Then formulate, in your own words, 2–3 questions (total) for discussion. Add your questions to the half page with your name and date for this session, and print enough copies for everyone. Your goal is to formulate questions that will help the class make larger connections between the readings, the artistic case study at hand, and larger themes that have surfaced around a particular case study.

During the session itself, the teacher/moderator will choose when to turn the discussion over to the table-setter(s), at which point you can distribute your prepared handouts and take a seat at the front of the room; or alternately, if possible, the seats can be arranged in a circle. As table-setters you can then share your quotes, taking care to explain the passage in the context of the author's larger argument, and why you found this particular passage or idea compelling. You can then present your question(s) to the class to begin the discussion. You may wish to present your quotes and questions all at once, or in sequence, one at a time (often this works best).

If there are two table-setters, the first may present their questions and lead discussion before moving on to the second person, or alternately, you can alternate freely from one table-setter to the other as the discussion unfolds (often this works best). Either way, as table-setters you will have primary responsibility to moderate the discussion, call on others in the class, etc., with the course instructor interjecting points for emphasis and redirection only if and when the discussion stalls or begins to drift too far afield.

A last point: strive to be comfortable with a certain degree of silence, allowing time for reflection, and simply waiting, when necessary, for others to enter into the discussion. Such silences often are a good thing. If the question posed is not clear, the instructor may step in to ask for clarification or encourage other students in the class to do so. The instructor may also extend or expand the discussion as the spirit moves, provide boundaries and ground rules where necessary, and draw discussion to a close and transition to lecture points or other activities as needed.

Appendix B

Structuring Classroom Activities

The course material and case studies presented in this book may be organized into four or five units, depending on the length of the term. The teacher/moderator may wish to assign a unit thesis paper or some other opportunity for creative synthesis and demonstration of learning outcomes at the end of each unit. Guidelines for a possible final paper are provided in Appendix E.

The teacher should feel free to experiment and play with different models for structuring classroom activities, while aiming, as much as possible, to create a contemplative environment of time slowed down, and leaning toward qualitative methods of mutual discovery over quantitative or didactic delivery of content. Some of these classroom activities may include the following:

1. contemplative listening (or viewing) together of particular songs (or images) from the case study, followed by shared response, reflection, or journaling

2. introducing additional pieces of music, art, or poetry from the same period or genre as the case study and which touch on analogous themes relevant to the discussion at hand

3. playing or singing together: if the teacher has facility with piano, guitar, voice, or another instrument, this may be an effective means for "getting inside" particular songs via instrumental analysis of musical elements (key, voice, tone, etc.); or provide lyrics and invite the class to sing together

4. lecturing: offering context for readings and case studies; illuminating cultural or historical factors relevant to the work (the "world behind the text"), elements of the case study itself ("world within the text"), or its contemporary resonances ("world in front of the text"). The teacher should be careful, however, *not to impose a particular or singular interpretation* on the case study, but aim, rather, to surface multiple possible meanings, resonances, etc., and to help the students draw connections to themes broached in the book. The teacher should aim *to model a process* as much as seek to deliver content.

5. utilizing internet and video resources, historical or archival material from the same period or genre, or interdisciplinary and cross-cultural materials, to further get inside a particular case study or help to illumine the historical-cultural-social context of the artist

6. excerpting and sharing from particular student discussion board posts that the teacher finds especially insightful, provocative, compelling

7. working in small groups: discussing case studies in a more intimate circle, brainstorming ideas for papers, sharing journal excerpts, working on a team presentation, etc.

8. presenting: showcasing team presentations near the end of the course (guidelines in Appendix D)

Appendix C

An Ignatian Guide to Listening and Journaling

"Opening the Eyes and Ears of the Heart"

The journal is each student's venue for recording and sharing privately with the teacher/moderator their personal response to the artistic case studies explored in this course. Unlike more formal papers that students may be required to write for this course, journal entries are not intended to be "scholarly" or "analytical" so much as a personal forum for reflecting on the artistic case studies in a contemplative, holistic, even prayerful way.

I recommend students keep a writing journal distinct from their class notebook for responses to the case studies, but typically do not require such. The journal may be a physical notebook or a running computer document, as stipulated by the teacher. Periodically students may be asked to submit an excerpt from their journal that records their contemplative response to a particular case study. A rule of confidentiality should be made clear in the syllabus and reiterated before journals are submitted, as well as any limits or content advisories as the teacher deems appropriate. (For example, content shared in the journal that might require a teacher to report to a Title IX officer or other parties.) As with discussion board posts, the teacher may adjust the content, frequency of submission, and percent of overall grade for the journal submissions as is fitting.

Guidelines for students: journaling

This real I look at. I do not analyze or argue it, describe or define it; I am one with it. . . . To look wholly means that my whole person reacts. Not only my mind, but my eyes and ears, smelling and touching and tasting. . . . Contemplation is not study, not cold examination, not a computer. To contemplate is to be in love.

—*Walter Burghardt, SJ*

Continued

Guidelines for students: journaling *Continued*

It is profitable to use the imagination and to apply the five senses [to the scene], just as if I were there. I will see, listen, smell, and taste, I will embrace and kiss the places where the persons walk or sit. Then, reflecting upon myself, I will draw some profit from this.

—*Saint Ignatius of Loyola*

Saint Ignatius offers a simple prayerful or contemplative method for getting "inside" a story (such as the Gospels), the life-world of another person or place, and certainly works of music, visual or tactile art, poetry, or literature. This involves allowing the object of our attention to saturate the senses, imagination, emotions, intellect, and spirit in a holistic way. The following method can be adapted to your encounter with the artistic case studies and to reflecting on them in your journal.

- *Slow down. Remove distractions. Allow yourself to* linger within *the work. Let it penetrate your heart, rest in it, let it provoke. Simply notice. Pay attention to any feelings, images, thoughts, memories that arise. Linger, savor, and attend, without consideration for how much time is passing. Then begin to allow yourself to reflect more deeply through the following layers of potential insight:*

 1. *What is going on? What is the music/artist saying? [world "within" and "behind" the text]*
 2. *What is the music (or lyric) saying to me? [world "in front of" the text]*
 3. *Is God stirring something in me through the music?*
 What do I wish to say to God in response? [world of contemplation/prayer]
 4. *What difference might this realization make in my life?*
 How can these insights become real? [world of freedom, action, relationships]

- *Use your journal to record images, thoughts, memories, or emotions that arise as you engage the case studies in this course. When something arises in you, write it down at the top of your journal entry, savor it for a while, then simply begin writing.*
- *It is important not to edit or censor yourself as you listen, think, pray, or write, but to allow your journal to be a sacred space and time for open "conversation" with the material, with yourself, perhaps even with God, as the process awakens things in you spontaneously. (Remember, you will never be required to submit anything you are not comfortable sharing with the teacher.)*

You may be surprised at what emerges.

Appendix D

Guidelines for Team Presentation
(12–15 minutes + Q & A)

The purpose of the team presentations, scheduled near the end of the course, is to provide a forum for students to apply the tools of artistic engagement learned during the course in a focused way to a work of art of special significance to them. The team project is integral to the vision of interdisciplinary, communal learning from which this book rises. As ever, the teacher/moderator may adjust the guidelines below, number of students per team, and percent of grade as is fitting.

Guidelines for students: preparation

1. *Meet with your partner(s) to discuss your ideas for possible case studies, and come to a mutual decision about the work you would like to present to the class. Be sure you select something everyone on the team is excited about, even if the work chosen is not your own first choice.*

2. *Consider how the particular work can most effectively be presented to your classmates, given the time allotted, classroom resources, etc. If your work is a piece of music, will you play a portion of it or the whole? If a visual image, will you project or otherwise display it? Can the image (also) be reproduced on a handout?*

3. *Contemplate: as a team, get "inside" the text, music, or image and share your thoughts on artistic elements that you find compelling, moving, beautiful, disturbing, etc. (world within the text). Then spend some time talking about how the work speaks to you and the group in the present (world in front of the text). Finally, select secondary readings or other resources from the class that help further illuminate the work.*

4. *Delegate responsibilities: one of you might take charge of researching background information about the work (world behind the text), while another prepares the handout, and another works on a Powerpoint. Take care to share the work as equally as possible.*

Continued

Guidelines for students: preparation *Continued*

5. *Create a single-page handout that includes your names / artist / title and date of work*

 a. *World behind the text: one paragraph on the social/historical background from which the work comes*

 b. *World within the text: in some way represent the work for your audience*

 c. *World in front of the text: in one paragraph or bullet points summarize how the work speaks to you, the group, and our world today. Important: here you should include your quotes from secondary sources that reinforce the observations and themes your team wishes to emphasize in the work.*

6. *Work out your presentation and practice. Because your time is limited in the presentation, focus during the class presentation on parts b and c above (part a can be summarized on the handout). As much as possible, give your classmates an encounter with the work itself, followed by your team's analysis (the world within the text), and then your discussion of how the work might speak to our world today (world in front of the text). Run through your presentation until your team feels confident and you are sure you're comfortably within the time limit.*

7. *Copy enough handouts for the class.*

Evaluation will be based on evidence of careful preparation and collaboration; the quality of the handout detailing three worlds of the text; how well secondary resources are utilized; how well your team communicates the tools of artistic engagement developed in the course; and last but not least, did you have any fun?

Appendix E

Art and Spirituality Paper

(6–8 pages, double-spaced)

The following is one of many possible measurements a teacher or moderator may use for evaluating a student's grasp of course learning outcomes, and which does so in a way that cultivates the "art spirit" itself as a creative capacity within students. By offering a range of possible genres or imagined audiences to whom the student is addressing his or her paper, it allows the student to speak from the heart, as it were, and to develop any one of a number of possible literary or rhetorical "voices."

Guidelines for students: description, method, resources

Description

This course (book) has been built on the conviction that the arts cultivate ways of seeing and of plunging "into the valley of the human" (William Lynch, chapter 2) that can lead not only to deepening wonder and self-understanding but also greater empathy, understanding of others, and a commitment to justice across social boundaries. The arts, I have suggested, nurture seeds toward a spirituality of wonder, resistance, and hope. Yet as we have also seen, the arts may be utilized in a negative way to reinforce biased, self-centered, objectifying, or otherwise distorted visions of reality mediated by culture.

Do you agree? Of the many ideas, critical questions, case studies, and life-stories we have encountered in this course, which do you find most compelling, challenging, inspiring, or helpful with respect to your own intellectual or spiritual journey? More broadly, which speak most powerfully to the global situation in which we find ourselves today? What does the "art spirit" mean to you? Is it worth cultivating and keeping alive in the world today?

Continued

Guidelines for students: description, method, resources *Continued*

Method

The aim of this paper is to articulate your own artistic, spiritual, or theological vision statement, drawing from course materials and your experiences up to this point in your life's journey and anticipating the future. How does art or the "art spirit" figure into your journey? How do the arts help you and others see beyond the surfaces and respond to the world we live in today? *The paper asks you both to "look back" and to "look forward," drawing from any course materials you wish, to articulate why and how the "art spirit" is worth keeping alive today. Or, conversely, the paper can be used to argue that the significance of the arts is limited, unable to provoke a response to the most urgent issues of our times, or even that the arts are part of the problem.*

Here are some possible genres and imagined audiences for the main body of your paper:

a. *Thesis/synthesis paper—the most straightforward or typically academic mode of writing*

b. *Roundtable interview or dialogue: an imagined conversation between any of the artists studied in the course, or between yourself and any of these with whom you would most like to have a conversation*

c. *Talk to be given to incoming freshmen students*

d. *Commencement address to graduating students*

e. *Address or open letter to the president of the university and its board of trustees*

f. *An open letter to a friend or family member, or to any artist, dead or alive, of your choosing*

g. *An open letter to God*

h. *Your ideas?*

You are encouraged to write for an audience and in a genre that excites you. Ask yourself: with whom would I most like to share or explore insights and ideas that I take from this course?

The subtext (intended for the secondary audience or reader, i.e., your teacher) *Whichever genre and audience you choose, your paper* must be heavily footnoted *to make explicit what may be more or less implicit in the text, namely, the source of the ideas or insights in play. Thus where the main body of the paper aims to express your vision of "art and spirituality"*

Continued

> ## Guidelines for students: description, method, resources *Continued*
>
> *in your own words, in a style fitting for your audience, the subtext of the paper, or footnotes, should make clear to your reader (i.e. your teacher) the sources you are drawing from, whether explicitly or implicitly. The aim of the footnotes is to make explicit the connection between your own vision of art and spirituality as it stands today and the materials, including this book, you have engaged in the course. A strong paper will draw insights from (with connections in the footnotes to) at least 5–7 sources from any part of the class, or any combination of case studies and readings of your choice.*
>
> ### Resources/Starting Points
>
> *As you think about possible topics for your paper, you may want to consider*
>
> > *—any artistic case studies explored during the course, in this book, or in student presentations*
> >
> > *—any resources or ideas drawn from this book—artistic, scholarly, theological, philosophical, etc.*
> >
> > *—any secondary readings, videos, or other artistic resources you found especially helpful*
> >
> > *—any previous papers, discussion board posts, or journal entries that you or others wrote for the class that were especially meaningful to you, or ideas that most lit you up in the course of our learning together*

Index

Note: The abbreviations *i* and *n* that follow the page numbers indicate illustrations and footnotes, respectively.